**Photo Icons
1827–1991**

Hans-Michael Koetzle

# Photo Icons
## The Story Behind the Pictures
## 1827–1991

**TASCHEN**

KÖLN LONDON LOS ANGELES MADRID PARIS TOKYO

# Contents

# Reading pictures
*Hans-Michael Koetzle*

The photographic era was heralded in 1827 by a camera picture produced by an exposure lasting over several hours, using a simple asphalt-coated plate. Meanwhile, official statistics tell us that over five billion photographs are printed each year in the big laboratories in Germany. There can be no doubt about it: we are living in an age of technically produced images. Photographs, pictures from films, television, video and digital media all fight to catch our attention. They try to seduce us, to manipulate, eroticise and even at times to inform us. People talk of how we are being deluged by images, which sounds threatening, but at heart this points above all to a phenomenological problem: how do we deal with all of these images? How do we select between them? What in fact do we manage to take in? And what, on the other hand, still has a chance of entering our collective memory?

We find ourselves at the moment in a paradoxical situation. While traditional analogue photography is losing its influence in its traditional territories, such as photojournalism or amateur photography and snapshots, the conventional camera photograph is becoming increasingly the object of a public discourse. Photographic images are now an accepted fact in art galleries and museums, at art fairs and auctions. The question as to whether photographs are actually art appears to have answered itself. Six-figure dollar cheques for key works from the history of photography, or for works by contemporary photo-artists, have long since ceased to be a rarity. A young generation has discovered in photography the same thing that previously investors found in antiques. Photography is starting to reach a ripe old age, and yet is more relevant now than ever before. As a medium of the more contemplative kind, it has found – in unison with mostly flickering images – a new, forward-looking role.

The media scientist Norbert Bolz has spoken in this connection of the "large, quiet image" that grants something like a secure foothold in the current torrent of data. Where television, video or Internet at best produce a visual "surge", the conventional photographic picture – as the

"victory of abstraction" – is alone in having the power to take root in our memory and engender something akin to a memory. The doyen of advertising, Michael Schirner, put this to the test in the mid-Eighties in his exhibition "Bilder im Kopf" [Pictures in Mind]. The show simply presented black squares with captions added in negative lettering: "Willy Brandt Kneeling at the Monument to the Heroes of the Warsaw Ghetto", for instance. Or "The Footprint of the First Man on the Moon". Or "Albert Einstein Sticking out His Tongue". Photography, as the Dusseldorf photographer Horst Wackerbarth puts it succinctly, is "the only genre that can achieve a popular effect on the immediate, visible level, and an elitist one after its initial impact on a deeper, more subtle level."

This book presents photographs from some 170 years, all arranged in chronological order. And every one of them is a key image from the history of the medium: images that have pushed photography forward in terms of either its technology, aesthetics or social relevance. There is a tradition to viewing "icons" such as these by themselves, each on their own. Best known in this context is John Szarkowski's classic book *Looking at Photographs*, first published in 1973. But going beyond Szarkowski's associative, journalese style, the present volumes also provide in-depth analyses of the contents. With the history of the picture's reception, we arrive at the question of when and in what way the motif became exactly what it is: a visual parameter for central categories of the human experience. Almost every technical approach and every major field of application (from portraiture to landscapes, from the nude to the instantaneous shot) has been included here, making the two volumes simultaneously a "potted history of photography". This prompts us to read pictures critically, to look at them more attentively and with greater awareness. As early as the 1920s, Moholy-Nagy pointed to the dangers of visual analphabetism. That applied to the era of silver salts in the photographic lab. Yet it applies more than ever to the age of satellite TV, video and Internet.

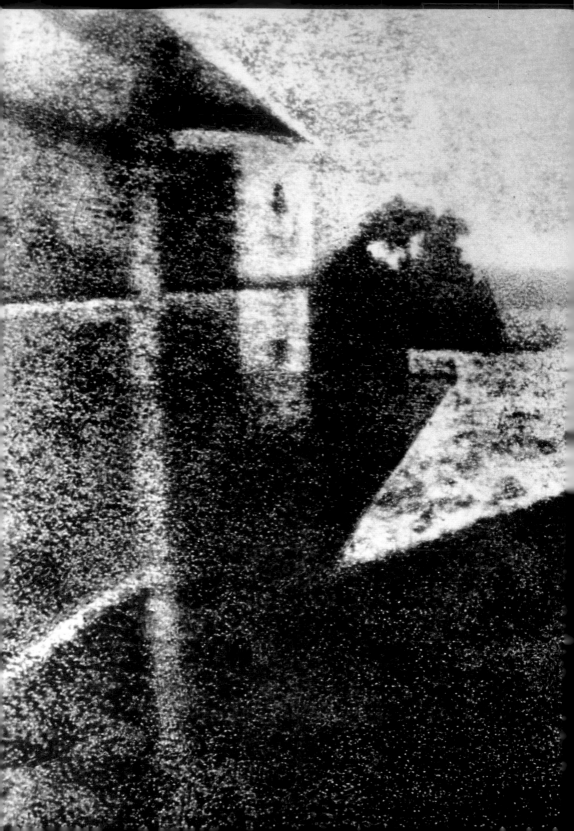

# 1827  Nicéphore Niépce
# View from the Study Window

**The public announcement of Louis-Jacques-Mandé Daguerre's photographic process in August 1839 is usually accepted as the birth date of photography. But in fact, Daguerre's compatriot Nicéphore Niépce had succeeded in fixing images with a camera obscura a good decade earlier.**

The view must have been very familiar to the photographer. After all, what does a thoughtful person do when the flow of ideas is blocked, and though merely spin in circles around the problem without advancing further? One looks out the window, beyond the limitations of one's own desk, and seeks new ideas and inspiration from the distance. The study of Joseph Niépce – who signed himself Niépce, but by the end of 1787 had adopted a second forename, Nicéphore – was located on the second floor of his family estate Maison du Gras, in the village of Saint-Loup-de-Varennes, just under three miles from the village of Chalon-sur-Saône in French Burgundy. Just how often Niépce must have glanced out the window of this room we can only guess, but what he saw is a matter of absolute certainty: to the right is an at least partially visible barn roof; somewhat to the left, a dovecote; to the far left, a recessed baking kitchen; and finally, in the background, the pear tree, whose leafy crown nonetheless allows a clear glimpse of the sky to show through in two places, even in the summer months. And what he saw, he captured with the camera. *View from the Study Window* at Maison du Gras, taken in June or July 1827, is in all probability the first permanent – although mirror-reversed – image in the history of photography.

**Long way from permanent camera images**
Nicéphore Niépce had returned to Burgundy in 1801 after a number of years spent in Italy, on the island of Sardinia, and in Nice. Now, as a gent-

leman-farmer, he raised beets and produced sugar; financially, however, he was in fact independent, for in spite of the vicissitudes of the French Revolution and the Napoleonic era, his inheritance was large enough to support him comfortably. With the years, he increasingly devoted his time to scientific experiments, busying himself as a private scholar and developing (together with his brother Claude) the so-called pyréolophore, a combustion engine meant to revolutionize human locomotion, but which in fact turned into a financial debacle. Furthermore, Niépce attempted to find a substitute for indigo, which had become scarce as a result of the Continental Blockade, invented a kind of bicycle, and last but not least, set himself the task of fixing the fleeting images produced by the camera obscura.

Niépce had already produced his first heliographs, as he called the results of his experiments, in the spring of 1816. And already at this point, it was precisely the view from the window that he attempted to depict in his 'sun drawings'. One wonders what motivated Niépce again and again specifically to aim the eye of his camera from his study down onto his property in Le Gras. Was it sentimentality? Or did the experiment of capturing precisely the view that he knew so well appeal to him because its very familiarity would make it easier for him to check its precision and accuracy – the qualities that he was most striving for? In all probability, the reason lies elsewhere: Niépce could work with his camera on the window sill at length, without interruption and without having to answer questions of the curious – and without alerting possible competitors to the progress of his experiments. For he knew that discovery was in the air. "My dear friend," he wrote in May 1816 with unusual candor to his brother Claude, now living in Paris, "I am rushing to send you my four latest test results. Two large and two small ones, all considerably clearer and more exact, which I succeeded in making with the help of a simple trick: namely, I reduced the aperture of the lens by means of a piece of paper. Now less light makes its way into the interior of the camera. As a result, the image becomes more lively, and the outlines as well as the light and shadows are clearer and better illuminated."

And what does Claude see in the pictures, insofar as he can make out anything at all? For Nicéphore has not yet found a means of permanently fixing the silver-chloride images made with the help of his home-made camera obscura. Together with Nicéphore, he gazes out the window of

Nicéphore Niépce

Born 1765 in Chalon-sur-Saône as the son of a royal tax-collector. Works as a teacher. 1792–94 lieutenant in the Revolutionary Army. From 1801 administers the family's country estate at Chalon. At the same time develops a ship engine (pyréolophore) together with his older brother Claude. From 1813 explores the possibilities of lithography. 1816 first experiments with a camera obscura. From 1822 on first successes with photochemical reproduction of images. 1827 meets Daguerre on his way to England. Gives a report on heliography to the Royal Society. 1829 forms a partnership with Daguerre. 1833 dies unexpectedly of a stroke

their hereditary Maison du Gras: before him are the two wings already described, the dovecote, the dominating slate roof of the baking kitchen. Admittedly, all that he sees is reversed from left to right; similarly, the shadows and light appear as negative images; and the whole is merely black and white. Niépce is still a long way from either positive or permanent camera images. At the same time, he remains confident and confides in his brother in order to convince himself of his own progress. He has no inkling that it will in fact take him another ten years to produce a permanent photographic image.

## Searching for a new technology

Nicéphore Niépce, born the scion of a wealthy family in March 1765, was not the only one searching at the turn of the nineteenth century for a new technology that would produce images appropriate to the new positivistic age. It had been four hundred years since Gutenberg introduced a true textual revolution. In contrast, the development of the visual image had stagnated, at least in the technical sense. Of course Aloys Senefelder's invention of lithography (1797) signified an important flat-printing process for the graphic arts. But here also – and in this, lithography did not differ from woodcuts or copper engraving – the active hand of the artist remained necessary to the creation of a picture. Still missing was a quasi-automatic process that would be both fast and inexpensive. Above all, the new technology had to be dependable, objective, and precise in detail – in short, it must correspond to a rational age oriented to exactitude. To this end, research and systematic experiments were being conducted in almost all the lands of Europe, but nowhere more intensively than in England and France. After all, the principles behind an analogue process for producing pictures were already long familiar: the operation of the camera obscura, known from the Renaissance, and Johann Heinrich Schulze's discovery of the light sensitivity of silver salts in 1727. Actually, it was only necessary to combine the two principles – the physical and the chemical – together.

## Views according to nature

In his quest, Niépce was a child of his age; his research was not at all directed toward the discovery of a new medium of artistic expression. He strove for a pictorial mass medium: quick, cheap, and dedicated to the

realistically oriented Zeitgeist of a bourgeois age. Niépce had actually begun quite early to employ various acids for etching transitory images onto metal and stone. "This kind of engraving," claimed Niépce in 1816, "would be even better than the [the silver chloride images] because they can be so easily replicated and because they are unalterable." In the end, however, his efforts, whether to obtain a direct positive image or to produce plates that could be used for printing, remained unsuccessful. Not until 1822 did Niépce discover in bitumen, an asphalt-like substance used by both copper engravers and lithographers, a medium capable of holding an image. He realized that bitumen eventually bleaches out and, more importantly, hardens under the influence of light; on the other hand, bitumen kept in the shade remains soluble and can be rinsed away. Niépce succeeded in copying a portrait of Pius VII by using oil to make the copperplate print transparent, placing it on a bitumen-coated glass plate, and laying it in the sunlight. After two or three hours, the exposed portions had hardened to such an extent that the shadowed areas could be rinsed away with a solution of lavender oil and turpentine.

*Homage to Niécpe: double-page spread from Miroir du Monde, June 17, 1933. His View from the Study Window had yet to be discovered.*

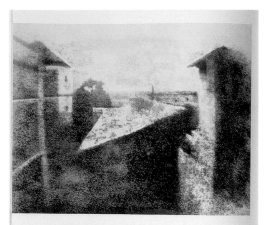

DIE ERSTE PHOTOGRAPHIE DER WELT

On the advice of his brother, Niépce soon replaced the glass plates with copper or, often, tin, which reflected more light and was thus more suited to his intention of creating "views according to nature." Now, with his discovery of the missing clue, Niépce took up his earlier experiments with the camera obscura again around 1825, replacing his home-made camera in February 1827 with a 'professional' model that had double convex lenses using bitumen-coated tin plates. In the summer he succeeded in making a $6^1/_2$ x $7^3/_4$ inch direct positive image with left-to-right reversal. In the picture, the lustrous bitumen rendered the light, while the tin, washed clean with lavender oil, reproduced the shadows. His shooting point was his study in Le Gras, and experts have calculated that the exposure time must have been more than eight hours. It is for this reason that the two opposite wings of the building are both in sunlight. Clearly recognizable at the edges of the picture are the curved and out-of-focus vertical lines produced by the lenses.

What we are looking at – and here historians of photography are unanimous – is clearly the world's first photograph. Initially, Niépce left it behind in Burgundy when he journeyed to England in September 1827 to visit his seriously ill brother Claude, who was now living in Kew, near London. Among the acquaintances he made on the visit was that of the botanist Francis Bauer, who immediately took a strong interest in Niépce's heliographic experiments and proposed making a report on the process before the Royal Society. Niépce sent at once for his pictures, including *View from the Study Window*, and immediately drew up a memorandum, point-black identifying himself as the inventor of what he called 'heliography': a process of "capturing the pictures reflected in the camera obscura in gradated tones from black to white solely with the help of light."

Niépce avoided, however, giving precise information about his method of procedure, a reticence which led the Royal Society to reject the report.

*"The first photograph in the world". This article in* Fotomagazin *(May 1952) is probably the first reference to the sensational discovery in a German specialist publication.*

Niépce returned home to France, undoubtedly disappointed, in January 1828, having turned over all his experimental pictures to Francis Bauer as a gift. The botanist was well aware of the significance of the seemingly insignificant objects: "Monsieur Niépce's first successful experiment of fixing permanently the Image of Nature," he inscribed on the back of the picture which makes its way into every history of photography as *View from the Study Window*.

After Bauer's death in 1841, Niépce's pictures and other documents passed first into the ownership of Dr. Robert Brown for a sum of 14 livres and 4 shillings, and later into the hands of J. J. Bennett, both of whom were members of the Royal Society. Bennett subsequently sold one portion of the legacy to the photographer Henry Peach Robinson, and a second to Henry Baden Pritchard, the publisher of *Photographic News*. In 1898, the 'heliographs' surfaced once again within the framework of a photographic exhibit in the London Crystal Palace. And then they disappeared without a trace into the depths of history. We would still probably be speculating about the content and whereabouts of Niépce's view of Le Gras today if Alison and Helmut Gernsheim had not set out on a seemingly hopeless search for the pictures a few years after the end of the Second World War. In April 1948, the two researchers published a brief report in the London *Times* with all their findings gathered up to that point, but the article found no immediate resonance. Two years later, they made a second attempt, and this time the aged son of Henry Baden Pritchard responded in a corresponding article in the *Observer* – without, however, offering any information on the whereabouts of the pictures, last seen in 1900. Months passed until Mr. Pritchard Jr. was heard from again at the end of 1951: tucked between books and clothing, Niépce's picture (in the meantime framed) had turned up in the family attic in a suitcase belonging to his mother, who had died in 1917. The joy at the discovery was muted, however, because the motif was hardly discernible to the naked eye, and was furthermore not reproducible. There followed long and arduous attempts by the research department at Kodak until a certain P. B. Watt finally succeeded in photographing the image in such a way that the picture – today owned by the University of Austin, Texas – became legible: the contours of the buildings at Le Gras emerge recognizably behind the initially reflective surfaces. Niépce's *View from the Study Window* had thus been exposed, so to speak, a second time.

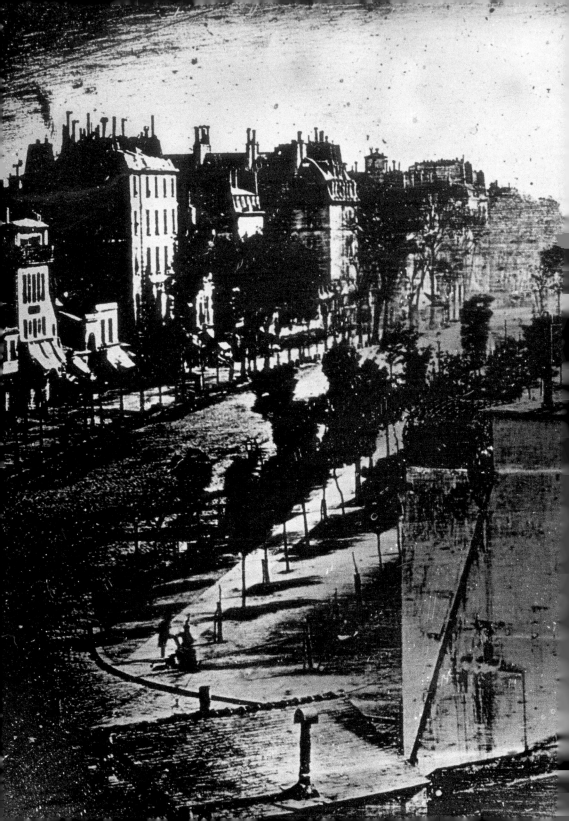

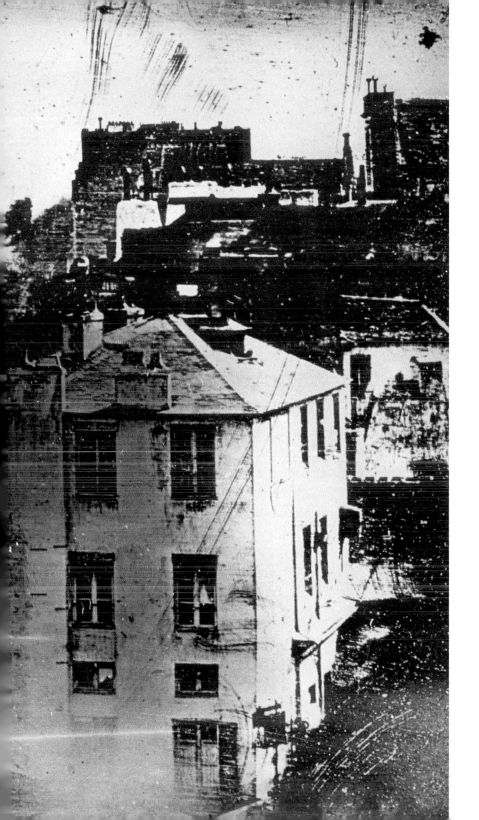

# 1838 Louis-Jacques-Mandé Daguerre
# Boulevard du Temple

**Around 1835, Louis-Jacques-Mandé Daguerre succeed-
ed for the first time in fixing permanent photographic
images through the process that later became known
by his name. His most famous daguerreotype, almost
certainly taken in the spring of 1838, was long thought
to be the first photographic image of a human figure.**

The image was anything but perfect – its creator realized this full well.
The painter, inventor, and diorama owner Louis-Jacques-Mandé Daguerre
belongs – together with Niépce and Talbot – to the great triumvirate of
photographic history. Of the three, however, Daguerre was surely the
most skilled tactician, possessing what we would today call a highly de-
veloped sense of PR. Ever since the 1820s, Daguerre had been looking for
a process to enable the technical production of pictures based on the
images produced by the camera obscura. Finally, in 1835 he achieved suc-
cess, and now the issue became how best to exploit the potential of the
new medium. Daguerre's view of the Boulevard du Temple was intended
to be a link in a visual chain of argumentation for his new process. Admit-
tedly, as remarkable as his picture was for the conditions of his time (or
rather, for the limitations of his process), his 5 x 6 ¹/₂-inch format image
remained nonetheless modest in comparison with what painting, draw-
ing, or graphics could offer. In short, from the very beginning, photo-
graphy had to compete with the 'fine arts'. And in this contest, the new
medium labored under numerous disadvantages: Daguerre's photo-
graph, for example, reproduced the reality it sought to capture in very
small format – and 'merely' in black-and-white (as the early critics noted
with disappointment as early as 1839). Furthermore, the photograph,
which consisted of a single direct plate, was necessarily a reverse image,
and on top of this, the reflecting surfaces of the plate itself interfered
with viewing the image: according to how one held the daguerreotype,

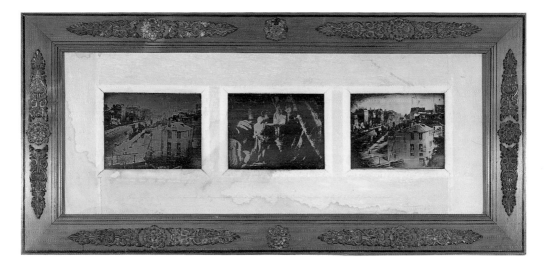

the picture flipped from a positive to a negative image. But perhaps worst of all was that nothing was to be seen of the pulsating life of the Boulevard with its trade and activity and traffic, in the form of carts and horse-drawn wagons. These were left to be imagined. The deadening effect of the daguerreotype is evident in an encyclopedia entry for "Paris" written in 1866, which describes precisely this length of the Boulevard as the former "main square for the true life of the people of Paris, ... [where] quacks, somnambulists, rope-dancers, etc., compete with lots of larger and smaller theaters, whose audiences as a rule found entertainment in such blood-curdling pieces that the street was called the boulevard du crime." Our picture, however, conveys none of this. In the left foreground is merely a gentleman in a frock coat, a tiny figure, apparently having his shoes polished – and even contemporaries suspected that Daguerre had hired two people to play the parts by maintaining a pose for the still lengthy exposure time of several minutes. As Jean-Pierre Montier once put it, their shadows were "impregnated" onto the plate. Whatever the case, this picture remains the first photographic image of a human being, or rather, two of them – if one omits the recently discovered portrait of a certain "M. Huet", dated 1837, also attributed to Daguerre.

## Curious onlookers are unwelcome

A view out the window. A view from above down into a world that now existed to be photographically explored, investigated, exploited, and

recorded. Niépce had already gazed out of the window of his estate in Le Gras. Talbot, the inventor of the negative-positive process and Daguerre's true competitor in the struggle for the copyright to photography, had already bequeathed us even more than a view from a window: perhaps the most famous of his works is his calotype of the Boulevard des Capucines. As so often in the early stages of photography, the photographers here, too, consciously turned to a theme that had already been formulated by traditional panel and canvas painting. In the early days of photography, when a photographer aimed a camera out a window – whether from his house (Niépce), his room (Daguerre), or even a hotel (Talbot) – he had a completely pragmatic reason, beyond that of iconographic reverence for the traditions of painting. These early researchers feared too much publicity and sought to exclude a curious audience from taking note of their endeavors. This was one reason they searched out a photographic 'hiding place'. Furthermore, their work was easier if they could conduct it close to the home laboratory; more precisely, the lab was what made early photography possible in the first place. The French science minister Arago estimated that the preparatory work for a single daguerreotype amounted to 30–45 minutes – and Daguerre wanted always to make three exposures in a row for the sake of underlining the usefulness of his process, so to speak: one taken in the morning, one at noontime, and one in the afternoon.

We find ourselves at 5 rue des Marais. We can be fairly certain that it was from the window of his private apartment that Daguerre made his three exposures, of which only two have survived, albeit in heavily damaged condition. Anyone looking for the house today is on a fool's errand, for the rue des Marais, like so many tranquil – or, phrased negatively, dim – corners of old Paris fell victim to the colossal urban renovations of Baron Haussmann. But we can imagine the house to be approximately where the Boulevard de Magenta runs into the Place de la République, that is, in the 10th Arrondissement. In Daguerre's day, Paris housed around 800,000 inhabitants. The city limits in the west were defined by the Field of Mars, in the east by the Père Lachaise, in the south by the Montparnasse Cemetery, and in the north by today's Pigalle. This is the Paris of Balzac and Hugo, Ingres, Delacroix, and the young Dumas – the Paris in which Rodin would be born in 1840, Sarah Bernhardt in 1844. All this makes the city sound like the world art capital – which the city certainly

was in the nineteenth century. But Paris was something else as well, namely narrow, dark, close, dirty, and in this age before sewers, filled with what was then called a miasma. As the writer Maxime Ducamp pertinently remarked, "Paris as it existed on the eve of the Revolution of 1848 had become unlivable."

## A pictorial diversion for the broad masses

In the spring of 1838, Daguerre tuned the lens of his camera obscura, which had been built by the Paris opticians Charles and Vincent Chevalier, down onto the Boulevard du Temple. He was not at all interested in a nostalgic look at 'Old Paris' threatened with (possible) extinction; that is a theme that such photographers as Atget would explore decades later. Instead, Daguerre, wholly in the role of a technician and inventor, sought within the panorama of his city a picture that would be at once as rich in detail, as sharp and effective, and as large as possible (in spite of the very small aperture) – and that at the same time that could function as a metaphor of the cradle of the invention. And in fact it was the many tiny objects in the picture that captivated the first viewers of the photograph. Among these was no less a figure than the American painter and inventor Samuel F. B. Morse, who looked up Daguerre in Paris in March 1839 "to see these admirable results." Morse expressed himself charmed "by the exquisite minuteness of the delineation" but noted at the same time: "Objects moving are not impressed. The Boulevard, so constantly filled with a moving throng of pedestrians and carriages was perfectly solitary, except an individual who was having his boots brushed."
The Parisian inventor, born Louis-Jacques-Mandé Daguerre in 1787, already had several careers behind him as a scenic artiste, stage and costume designer, and the creator and director of a diorama, before he developed an interest in the possibility of permanently capturing the fleeting images produced by the camera obscura. Daguerre was what we might today call a media person – someone who recognized the need of his times for pictures and sought to commercialize this need in as many ways as possible. Whereas the diorama offered an almost archaic form of the cinema – a pictorial diversion for the broad public, a spectacle produced by means of illusionistic painting united with skilled lighting effects – the new medium of photography, which still remained to be invented, sought a process of picture-making that would correspond to the posit-

Louis-Jacques-Mandé Daguerre

Born **1787** in Cormeilles-en-Parisis. **1801–03** trains in an architect's practice in Orléans. From **1803** in Paris. **1816–22** works as a scenic artist. **1822–30** builds and runs a diorama. **1829** forms a partnership with Niépce. **1839** the diorama is destroyed in a fire. Public presentation of the daguerreotype that same year. The state purchases the rights to the method. **1841** returns to the country. **1844** last daguerreotypes. Dies **1851** in Bry-sur-Marne

ivist age: a process at once fast and exact, economical and objective. Daguerre, who had worked together with Nicéphore Niépce, had realized the light sensitivity of silver iodide already in 1831, a discovery which in turn led him to an improvement in the process that bears his name. A popular anecdote claims that in 1835 it was merely by chance that Daguerre discovered the so-called latent image, which meant that the exposure time could be reduced to a sensational 20 to 30 minutes – thus raising Daguerre's hopes for the genre of picture that was of greatest interest to him, namely the portrait.

## The delicacy of the contours, the purity of the forms

The daguerreotype, however fascinating, has always been termed a dead end of photography – an accusation that refers primarily to the production of a single, irreproducible plate, in contradiction to the real aim of an economical mass medium. The daguerreotype has in fact neither predecessors nor successors. All of this may be true, but nevertheless overlooks the importance of daguerreotypy as the first truly practical photographic process, which in some countries – such as the USA – remained viable until into the 1860s. From the technical point of view, the daguerreotype is a direct positive image in a (then) maximum full-plate format of $8\frac{1}{2}$ x $6\frac{1}{2}$ inches. To produce a picture, a silvered copper plate was sensitized with iodine vapor, exposed in the camera obscura, developed in mercury steam, and finally fixed in a solution of salt or sodium thiosulfate. The result was a reflective and one-of-a-kind image, whose finely chiseled lines, even down to tiny details and shadings of tone, produced a picture of the world that addressed the scientific interests of the time. Daguerre's discovery placed him on the horns of a dilemma. His process was still far from mature, especially because portraits, which at this point continued to require an exposure time of ten minutes in sunlight, remained more or less out of the question. On the other hand, the inventor was involved in an international race, and he felt intense pressure to go public with his process. Therefore, in the autumn of 1838, Daguerre appealed to leading scientists for help in interesting the government in his invention. He found his chief supporter in François Arago, the secretary of the Academy of Sciences. It would also be Arago who convinced the French Parlement to buy the rights of the process and to make it internationally available. On 19 August 1839, the two official bodies held

*Enlarged section from Boulevard du Temple: the image of the shoeshine is regarded as the first successful depiction of a person (or rather: two people) in photography.*

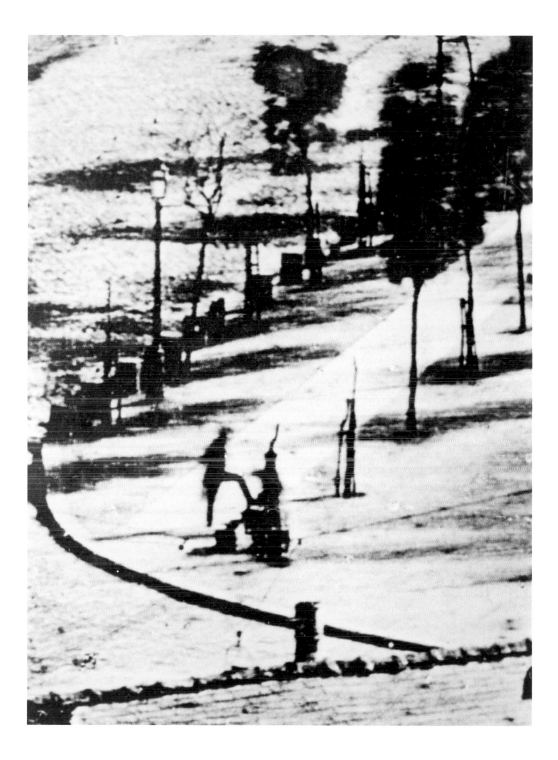

their memorable meeting in which the technical details of daguerreotypy were presented. The age of photography had begun.

The initial reports concerning the announced discovery appeared early in 1839, and the photographs of the Boulevard du Temple became the focus of amazement among contemporary scholars and journalists. The *Pfennig Magazin*, for example, announced in 1839 that in one of the pictures, a man could be seen "having his boots polished," and continued, "He must have held himself extremely still, for he can be very clearly seen, in contrast to the shoeshine man, whose ceaseless movement causes him to appear completely blurred and imprecise." What intrigued John Robinson, the secretary of the Royal Society of Arts, were the differences between the three plates caused by the changes in light. In addition, "delicacy of the outlines, the purity of the forms, and the precision and harmony of the tones, the aerial perspective, the thoroughness of even the smallest details" also earned praise (Eduard Kolloff, 1839). Daguerre's invention was clearly greeted as a sensation. Soon 'daguerreotypomania' spread throughout France and the rest of Europe.

## Excitement among artists and art-lovers

We do not know precisely what moved Daguerre late in 1839 to send a sample of his 'artworks' to the ruling houses of Russia, Prussia, and Austria. Gernsheim (1983) speculates about an initiative of the French foreign minister; in any case, the list of selected monarchs included the Bavarian King Ludwig I, who received – along with a dedication by Daguerre – what were even then already the world's most famous photographs, namely two of the three views of the Boulevard du Temple and, in the middle of the framed triptych, a still life which has not survived, along with an inscription by Daguerre. "Noon" wrote the photographer in his own hand under the picture on the left. "Huit heures du matin" (eight o'clock in the morning) is legible below the photograph with the shoeshine man – information that later formed the basis of the attempt to determine the exact date of the picture. Using contemporary maps and diagrams, and taking into account the length of the shadows and the camera position of $51^1/2$ feet above the street, Peter von Waldhausen has been able to date the view of the boulevard to the period between 24 April and 4 May 1838. The identity of the shoeshine man and his customer, however, remain matters for speculation.

In October 1839, the three daguerreotypes arrived in Munich, where they were on display at the Arts Association after 20 October. They immediately caused excitement, particularly among "artists and art-lovers." According to commentary in the *Allgemeine Zeitung*, the pictures were absolutely free of error and "by demonstrating all the advantages and wonder of the [new] invention, they teach us also about its relation to art." After the exhibit closed, the daguerreotypes returned to the private royal household, and after the regent's death, became part of the collection at the National Museum of Bavaria. The pictures, however, received no special attention, at times being included in the permanent exhibit. As a part of this collection, they were evacuated for storage during the Second World War, and were heavily damaged. In any case, by the time the plates were turned over by the National Museum to the Munich Photography Museum as a permanent loan, they were suffering so severely from oxidation that the still life in the center – a picture contradictorily described by contemporaries – was totally beyond recognition. An inexpert attempt at cleaning Daguerre's two remaining plates in the 1970s succeeded only in erasing their content. Thus, one hundred forty years after their creation, nothing more of the Boulevard du Temple was to be seen. The photohistorian Beaumont Newhall, however, had earlier made reproductions of the plates for an exhibit at the New York Museum of Modern Art entitled "Photography 1839–1937." Based on these plates, Peter Dost of Nuremberg and Bernd Renard of Kiel were able to produce facsimiles. Our *Boulevard du Temple* as seen on these pages is thus no more than a technical (i.e., screened) translation of the original daguerreotype based on one of the modern reproductions of the original plate. As cynical as it may sound as far as the cultural loss is concerned, photography as a technical pictorial medium nonetheless won the day.

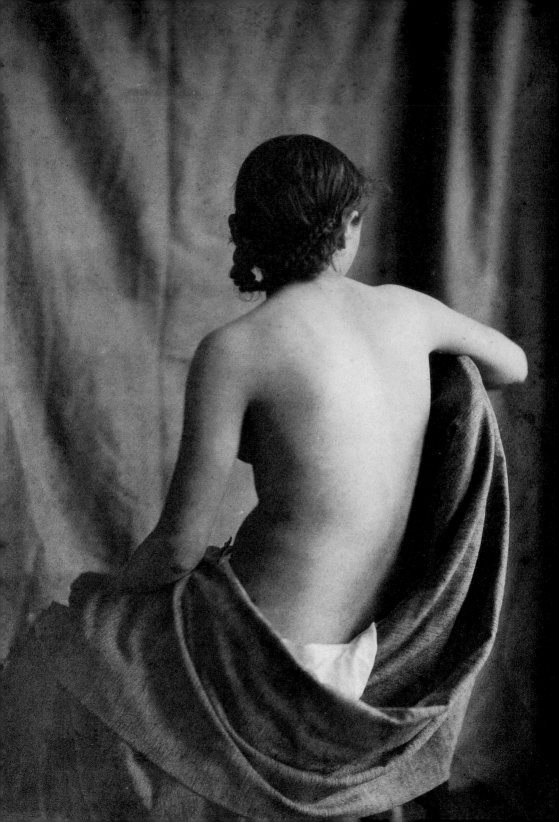

# Eugène Durieu/Eugène Delacroix
# Nude from Behind

ca. 1853

**Paris, June 1854: working together, the painter Eugène Delacroix and the amateur photographer Eugène Durieu completed a series of nude photographs. The nearly three dozen studies that have survived constitute one of the artistic high points of early nude photography.**

Charm and Quiet Modesty

We know neither her name nor her age. In all probability, she is a professional model. She averts her face in a movement that may be partially interpreted as calculated caution, as a conscious attempt at anonymity. Nonetheless, there are three other variations in the series in which the narrow, serious, young face is visible. The turning away from the camera is therefore part of a carefully thought-out scene. The combination of revealing and concealing, charm and modesty, lasciviousness and humility, eroticism and innocence succeed in achieving a rare balance. Even a hundred and fifty years after the photograph was made, the image seems amazingly modern: simple in concept, superb in lighting, radical in its rejection of ornamentation or typical contemporary accessories. Only a self-confident photographer, sure of his style and obeisant only to his own taste, could have created an image of such timeless validity in the midst of the nineteenth century. Eugène Durieu, so the story still goes, handled the camera, while the painter Eugène Delacroix directed the scene. This constellation would go a long way in explaining the excellence of the result. But the real ground for the photograph's success may lie elsewhere. Eugène Delacroix: the quintessential 'romantic' and antithesis to Ingres; the painter once described by Baudelaire as a volcano whose crater was artfully hidden by a bouquet – a remark that elegantly highlights the unparalleled productivity of this great nonconformist to French art of the nineteenth century. When Ferdinand-Victor-Eugène Delacroix died at age sixty-five in his studio on the Place de Furstenberg on 13 August 1863, he left behind 853 paintings, 6,629 drawings, 24 etchings, 109 lithographs,

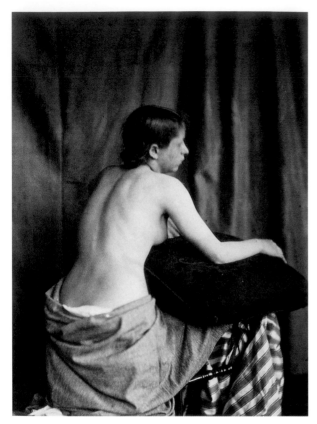

*Eugène Durieu/*
*Eugène Delacroix:*
*Plate XXXII from the*
*Uwe Scheid Collec-*
*tion, albumin print,*
*ca. 1853*

and 1,525 watercolors, ink drawings and pastels. In addition, his estate included more than 60 sketch books, an impressive number of writings important for art history, and one expressed wish: in no case, decreed the artist, should a death mask, drawing, or photograph be made of his face: "I expressly forbid it." The last testament comes as a surprise. For one thing, it was entirely customary to photograph the deceased in the nineteenth century. In addition, during his lifetime, Delacroix had done everything he could to foster his own image and guarantee himself lasting fame. As far as his own photographic portrait was concerned, by 1842 – that is, only a few years after the announcement of the photographic process –

Delacroix had himself daguerreotyped several times by Léon Riesener, only to claim subsequently in dogmatic tones that, "If we take a closer look at daguerreotype portraits, we must admit that among a hundred, not one is tolerable."

Delacroix's attitude toward the new pictorial medium was markedly ambivalent. The painter was thoroughly appreciative of photography as a handmaiden to the artist that provided a fast and comfortable process for capturing an image. Photography had, as Jean Sagne emphasizes, "enriched [Delacroix's] vision and strengthened his mode of working." But the artist was reticent in approving photography as an independent artistic form of expression. In his essay *On the Art of Drawing*, he admits, "daguerreotypy is certainly a good purveyor of the secrets of nature," but, he continues, when it comes to bringing us closer to certain truths, a photograph is nonetheless not an independent work. For Delacroix, photography was an ancillary medium, a visual lexicon – but its productions

could never be more than a cold and artificial imitation of reality.

## Drawn and painted from photographs

Did Delacroix himself take photographs? In all probability, he did not; at any rate, there are no photographs from his own hand. Furthermore, the estate auction held in 1864 contained no technical equipment that would point to photographic experiments of any kind. Delacroix was too busy as a painter; why would he have additionally involved himself in the still very complicated and time consuming pictorial medium of photography, especially when he maintained friendly contact to well-known photographers such as Riesener and Durieu, who regu-

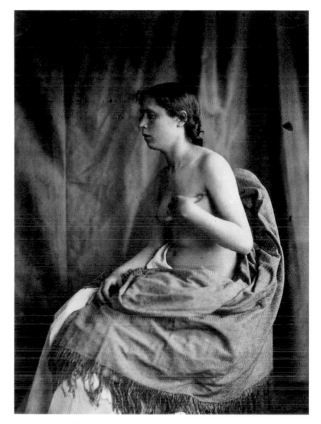

This female nude is also attributed to Eugène Durieu. Albumin print, ca. 1855, from the Uwe Scheid Collection

larly provided him with photographs, including, often enough, nude studies? Delacroix used these photographs to sketch from and to train his hand at drawing. He clearly carried nude photographs along to the popular bathing resort Dieppe in 1854, for example – and into the Church of Notre Dame as well, where it is said he had drawn from nude photographs during the Mass. In short, Delacroix maintained a sober and pragmatic approach to the medium. He did not join the public polemic against photography, begun in 1862 when Ingres, together with such prominent artists as Flandrin, Fleury, and Puvis de Chavannes, declared war on the new medium. To the contrary, in 1851 Delacroix became the sole painter to become a founding member of the Société héliographique. A slap in the face to Ingres and his supporters? Perhaps: "Which of them," Delacroix is reputed to have asked, "would be capable of such perfection of line and such delicacy of modeling? But no one may speak about this aloud."

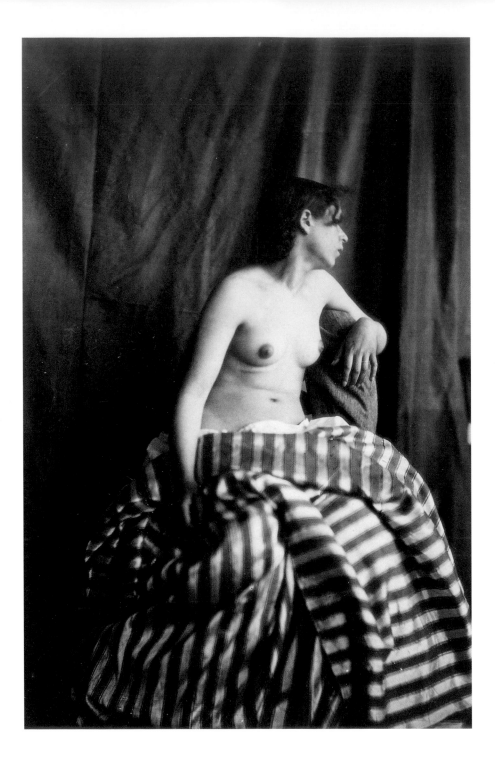

How Delacroix reacted to the sensational news of Daguerre's process in August 1839 is not known. His diary is silent on the years between 1824 and 1849; but we may well assume that the artist paid close attention to the emergence of this new, quasi automatic pictorial medium. After 1850, numerous, if scattered, entries in his journal indicate an alert, engaged, and at times amazed interest in photography, such as for 13 August 1850: "Read in Brussels that someone in Cambridge set up an experiment to photograph the sun, moon, and even the stars. They obtained prints of the constellations Alpha and Lyra [with stars] the size of pinheads. The report also includes a true but curious insight: if one assumes that the light of the daguerreotyped stars has taken around twenty years to reach us, then it follows that the beam that engraved itself into the plate had left the heavens long before Daguerre made his discovery."

Delacroix's short-term interest in the Cliché-verre process that he learned from Constant Dutilleux remained merely a passing episode. Delacroix was an avid collector of photographs, but he used them only for purposes of study. (That he had his portrait taken a number of times in the 1850s by photographers such as Pierre Petit or Nadar is noted only for the sake of completeness.) As far as Delacroix's relation to photography was concerned, what was most important was his collaboration with his friend Jean Louis Marie Eugène Durieu (1800–74), an administrative official and – beginning in 1848 at the latest – an enthusiastic amateur photographer with a studio in Paris located at 10 rue des Beaux-Arts. On 18 and 25 June 1854, Durieu and Delacroix scheduled an appointment with male and female models at the studio to take a series of nude photographs. "Eight o'clock at Durieu's," Delacroix noted in his journal. "Had them pose the whole day. Thévelin sketched, while Durieu took photographs, one or one-and-a-half minutes per picture."

The results of this early collaboration have survived in the form of an album of thirty-two photographs that the art critic Philippe Burty, whom Delacroix appointed administrator of his estate, bought from the estate auction. The note on the half-title stems from Burty's hand: "I bought the following series of photographs at the posthumous sale of the studio of Eugène Delacroix. He often used the pictures as models. And the folders held a considerable number of pencil drawings based on precisely these photographs." Today, in the Musée du Louvre, Paris or in the museums in Besançon and Bayonne, for example, one can find entire series of small-

Jean Louis Marie Eugène Durieu

Born 1800 in Nîmes. Lawyer in governmental service. Around 1845 astrophotography in collaboration with Baron Gros. From 1848 first calotypes. 1851 founder member of the Société héliographique. 1854 founder member of the Société française de photographie. 1855–58 chairman of the S.F.P. 1856 represented with his works at the World Exposition in Brussels. Dies 1874 in Paris. Works are presently in the keeping of the Bibliothèque Nationale, Paris, the collection of the S.F.P., and George Eastman House, Rochester

*Eugène Durieu/ Eugène Delacroix: Plate XXXI from the Uwe Scheid Collection, albumin print, ca. 1853*

format pencil drawings from these photographs. Delacroix also took inspiration for his oil paintings from the album. Apparently Plate XXIX served as the model for the small odalisque, today in the Niarchos Collection in London. Delacroix had begun to conceive the painting already in October 1854: "Painted a little on the odalisque from the photograph," he wrote in his journal, "but without much energy."

At Philippe Burty's death, the album passed into the hands of Maurice Tourneux, who in turn bequeathed the outwardly unassuming notebook to the National Library in Paris in 1899. There it was duly entered as Gift No. 9343 in the collection of the Cabinet des Estampes. On a number of occasions since the 1970s, portions of the series – in particular our nude from the rear – have been reproduced and exhibited. Jean-Luc Daval used the image on the cover of his work, *La photographie, histoire d'un art,* Paris (*Photography: The History of an Art*). Beyond this, the picture has appeared in almost every exhibit of the nude in photography. The complete sequence was first shown at the exhibit "L'art du nu" in 1997 at the Bibliothèque nationale de France, after the album had been disassembled by art experts. It is probably not too much to claim that the series today presents the best-known contribution to the theme of the nude in early photography – although it is likely that Delacroix's name has contributed significantly to the reception of the photographs. But what part did the painter really play in the series?

Let's take a closer look at the sequence of thirty-two photographs in various formats. The smallest is 4 x 4$^1$/$_2$ inches; the largest, 7$^3$/$_4$ x 5$^1$/$_4$ inches. Plates I through XXIX were processed as calotypes, that is, as waxed and unwaxed salted paper prints made from paper negatives. Plates XXX to XXXII, however, are albumin prints produced from wet-collodion negatives, a process which explains their clearly improved sharpness and brilliance of half-tones. There are eighteen male and five female nudes, with the combination of a male and a female models occurring nine times. In the first twenty-nine plates, the poses do not at all seem to be a matter of chance: we may assume they were taken at the direction of the painter to suit his concrete needs. Jean Sagne has compared the photographs with other works of Durieu, such those in an album now residing in the George Eastman House in Rochester, New York: "The props in the form of rocks or draperies constitute a well thought-out form of setting a scene. The Bibliothèque nationale has no

*Plate XXIX from the total of 32 motifs in the series. Calotype, ca. 1853*

prints which compare with these. Dutilleux insists quite properly on the substantial influence of Delacroix, who may well have posed the bodies and determined the lighting. Durieu's role was certainly that of an operator, his actual contribution, that of a clever technician."

## Quiet areas for the eye to rest

Beyond this, Sagne speaks of the thirty-two photographs as a series that is generally homogenous – a position contradicted by Sylvie Aubenas in a recent study. The curator of the Bibliothèque nationale argues that in terms of their technical production alone, the first twenty-nine photographs distinguish themselves from the last three. What is remarkable in this connection is that Durieu remained true to calotypy until far into the 1850s. There are also clear indications that Delacroix also preferred the glaze of the salted paper to the brilliance of the wet-plate process. Quite decidedly he adopted a position against the detailed richness of daguerreotype and glass negatives in favor of "an ineffableness, a rest zone for the eye, that prevents it from concentrating too much on individual details." What also must be not overlooked is that Plates XXX to XXXII are clearly carefully formulated, consummate images of decisively classical composition. In contrast, Plates I to XXIX are clearly 'academy photographs', that is, studies of the human body produced for artists. In

addition, the pictures possess a clearly experimental character, play with various degrees of focus, indistinct contours, and movement. Interestingly, after the last three nude photographs, whose composition is more reminiscent of an Ingres or David, Delacroix stopped drawing. In contrast, the pencil sketches based on the majority of the salted paper motifs have survived. And something else is puzzling: Durieu, the amateur, never tried to sell his photographs. Examples of his work are extremely rare, and those resulting from his collaboration with Delacroix are known only from our album – with the exception of precisely the last three, which are in the collections of the Getty Museum (Plate XXX), or of Uwe Scheid (Plates XXXI, XXXII, and variation), or of Robert Lebeck (Plates XXX and XXXI). Is it therefore possible that our rear nude is by a third, heretofore unknown, photographer? But who could have been the photographer of such a picture? The album has been only recently restored. In the process, photographs were removed from their backgrounds, but contain no stamp or signature. That contemporary nude photographers such as Moulin, Belloc, or Vallou de Villeneuve could have produced them is out of the question: their creations are too enamored of decoration and trimmings. Closest in style to the nude are the photographs of a nude from the rear by Paul Berthier (1865) or Nadar's portrait study of the actress Marie Laurent (1856), a picture which Sophie Rochard once described as a "miracle of charm."

But we are nonetheless brought back to Durieu by a child nude ascribed to him, which was auctioned at Beaussant Lefèvre in Paris in 1993. The simplicity of the picture, the reduction of accessories to a piece of cloth, the interplay between concealing and revealing all resemble our rear nude rather closely. But even more decisively, it is clear that the albumin print of $7^3/4 \times 4^1/2$ inches, today owned by Manfred Heiting of Amsterdam, was taken before the same neutral curtain and with the same lighting. Moreover, the folds of the background are of such astonishing similarity that one must conclude that the picture was created not only in the same ambient as our motif: if one assumes that a soft, movable curtain can hardly hold its shape for a longer period of time, the nude must have been made close to the same time as the albumin print. But the reverse of the child nude bears neither date nor signature. In the face of many questions, one point is certain: whoever the creator of our nude from the rear may be, he succeeded in creating a true "miracle of charm."

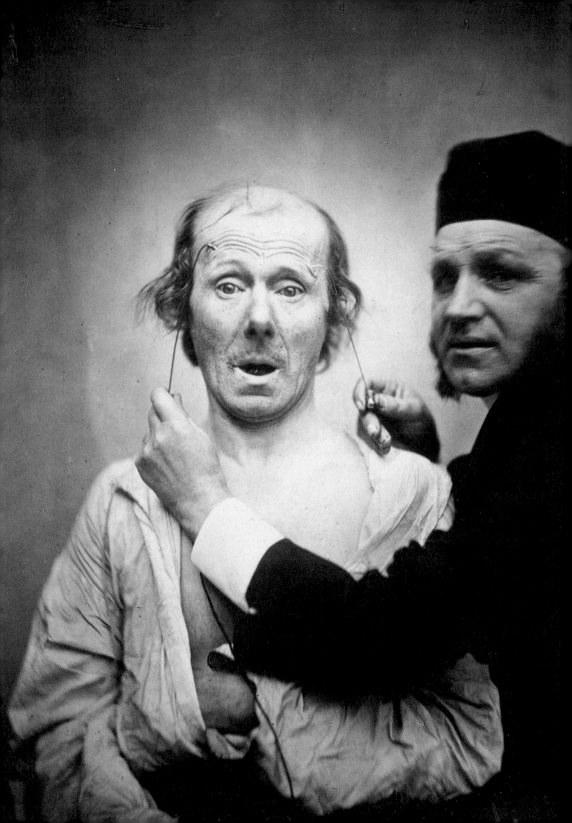

# Duchenne de Boulogne    1856
# Contractions musculaires

**The French medical doctor Guillaume Duchenne de
Boulogne may not have been the first to seek and dis-
cover applications for the new pictorial medium in the
realm of medicine. But, unlike his predecessors, he
had a conceptual grasp of the medium and moreover
sought to establish a bridge to the fine arts.**

A Grammar
of Feeling

Why is he looking at us? Why must he peer into the camera like that?
Wouldn't Dr. Duchenne de Boulogne, here left in the picture, not have
been better advised to concentrate on the subject of his experiment? To
take care that the two electrodes maintain their contact, and thus pro-
duce the desired effect. It is of course possible that an operator in the
foreground is giving him directions, but that would be possible also with-
out eye contact, especially since this is not the first photograph that has
been produced according to a certain plan and on the basis of pre-formu-
lated guidelines. Nonetheless, this is the sole exemplar from the almost
one hundred photographs of the cycle in which Dr. Duchenne is wearing
this unique cap that hides his 'high forehead'. "Look at me," his face
seems to say, with a trace of some amount of vanity. "Here I am: Dr. Guil-
laume-Benjamin-Amand Duchenne, known as Duchenne de Boulogne,
medical doctor, scientist, member of the Société de médecine in Paris,
specialist in the field of electrophysiology, and at this moment, conduct-
ing precisely the experiment with which I hope to change both the history
of medicine and of photography."
In 1856, the year in which the photograph was supposedly taken, the tech-
nical processes of photography had already been in use for around a de-
cade and a half. The age of the daguerreotype and the calotype was draw-
ing to an end. With his wet-collodion process, the Briton Frederick Scott
Archer had given the photographic world not only a more sharply defined
process based on glass negatives, but also a technology which was

twenty times more sensitive to light than the earlier processes. Instantaneous photographs now became at least theoretically possible. Photography was being applied to more and more fields. The positivist notion of inventorying the world by means of the purely 'objective' medium of photography seemed to have taken a bold and irrevocable step forward. Photography appeared to be useful in all possible areas of life – becoming the medium of seduction in nude photography, of memory in the portrait, of inventories in ethnic studies, of reflection in death portraits, and of identification in criminal photography, to mention just a few of the ways in which photography was being applied specifically to the human body.

It was bound to be only a matter of time before the medical sciences also would take up the medium. And in fact, Duchenne de Boulogne, born in 1806, was not the first to place photography at the service of medical research. In 1844 Léon Foucault had succeeded in making daguerreotypes of human blood corpuscles. But this early exploratory attempt – moreover by means of a process whose results consisted of one-of-a-kind, saucer-sized reflecting plates – was hardly suitable for conveying the desired knowledge in a comprehensible manner. Moreover, doctors were divided over the use of photography as a pictorial medium. For a long period, many medical experts held that the traditional kind of illustration that had been in use since the Renaissance was preferable to photography because it allowed the presentation of finer distinctions and hierarchies. From this standpoint, Duchenne de Boulogne, although not the first medically trained photographer, was nonetheless the first modern doctor to use photography scientifically, in that he worked conceptually; in other words, he arranged his subjects with a view toward the medium. De Boulogne thought beyond the successful individual picture in terms of the larger connections. He thus reflected the communicative function of photography, and last but not least, he understood and accepted the medium on its own terms, including the principles of trimming, perspective, and light. In fact, his well-composed scenes and subtly illuminated pictures provide far more than merely an early visualization of certain bodily phenomena for purposes of study. Not only do his physiognomies *au repos* pass for excellent portraits, but also his experimental pictures evoke nothing less than amazement, even today, a hundred and fifty years later. One cannot help but wonder what was really going on here.

## Art of reading character from facial features

Duchenne de Boulogne began his experiments, which were rooted in a combination of anatomy, physiology, psychology, and art, in the early 1850s. The way had already been pointed out by the writings of Lavater, whose *Essai sur la physiognomie* (1781–1803) – a much respected piece in its age, and praised by Goethe – described the art of reading character from facial features. In the realm of art, character typologies had existed since the seventeenth and eighteenth centuries, and were a part of the standard program in academic instruction, as is evident from painters such as Charles Le Brun and Henry Testelin. The technical basis of de Boulogne's work lay in the discoveries of Luigi Galvani, who was the first to prove the existence of electrical currents in muscles, and also in the work of Michael Faraday, whose discoveries in the area of electromagnetic induction (1831) proved directly beneficial to Boulogne's experiments. It is highly unlikely, however, that Duchenne de Boulogne would have been familiar with the anatomical studies and drawings of Leonardo da Vinci residing in the library of Windsor Castle (these would become available to the broader public only later through the carefully prepared edition of Théodore Sabachnikoff *I manoscritti di Leonardo da Vinci della Reale Biblioteca di Windsor* (1898).

## A slight anesthesia in the region of the head

Joy and fear, wonder and disappointment, horror and amusement – these constitute fundamental human states of being that communicate themselves in a universally understandable manner through facial expressions. The impulses behind these expressions are provoked by certain muscles. If one stimulates these muscles systematically, one after the other, then one should be able to produce a kind of grammar of the feelings, an atlas of the emotions – thus Duchenne's hypothesis. Beginning in 1852, five volunteers stood available to the doctor as guinea pigs: two women, one younger, one older; a young anatomy student named Jules Talrich (who was also able to mime feelings without induction current); an alcoholic worker; and, as the central figure in the series of experiments, a former shoemaker, whom Duchenne himself described as "old and ugly." The man was furthermore intellectually handicapped and suffered under a slight 'anesthesia', or lack of feeling, of the head, a condition which presumably helped to make the application of electric cur-

### Duchenne de Boulogne

Born Guillaume-Benjamin-Amand Duchenne in **1806** at Boulogne-sur-Mer. From **1826** studies medicine in Paris. **1831** doctorate (*Essai sur la brûlure*) and return to Boulogne. From **1842** back in Paris. **1847** embarks on his scientific researches in the field of electrotherapy. Regular publications in medical journals. **1851** member of the Société de médecine in Paris. **1857** and **1864** applies unsuccessfully for the Prix Volta. **1862** publication of his (photographically illustrated) work *Mécanisme de la physiognomie humaine ou analyse électro-physiologique de l'expression des passions applicable à la pratique des arts plastiques*. **1871** correspondence with Darwin. Numerous photographs by Duchenne are included by Darwin in his *The Expression of the Emotions in Man and Animals* (**1872**). Dies **1875** in Paris

rent painless. According to Duchenne, he selected the man as a subject because the age wrinkles in his face responded well to the effects of the current, and thus provided especially clear delineation of facial expressions. The man's gauntness additionally increased the clarity of the facial creases and made the precise points for the placement of the electrodes easier.

Between two and four electrodes were used to stimulate the muscles, the source of the electric current being a generator (today in the Parisian Musée d'histoire de la médecine), which we may imagine to be located to the lower left, just outside the frame of the photograph. Duchenne's experiments, which are looked at askance by experts, are one thing; their photographic documentation, however, is another issue. Might Duchenne have been inspired to his efforts by the experiments of his colleague H. W. Diamond, who daguerreotyped mentally ill patients in British asylums? Probably not. What is certain, is that beginning in 1852 Duchenne sought the advice of respected photographers in Paris, possibly including Gustave Le Gray, Alphonse Poitevin, and even Louis Pierson. He certainly had contact with Nadar's younger brother, Adrien Tournachon.

## The advancement of science

Tournachon had studied medicine for a while and might therefore have already been acquainted with the doctor. We may suppose that the young man introduced Duchenne to the technology of photography; but what is certain is that the younger Tournachon photographed some of the motifs – otherwise why would the stamp 'Nadar Jne' appear on eleven prints in the Archives nationales? Beyond this, Duchenne claimed sole authorship for most of the photographs; "I myself," he wrote in the second edition of his *Mécanisme*, "have produced the majority of the seventy-two pictorial examples in the scientific portion of the work, or was at least present [as they were made]." Proof of the claim exists also in the clearly visible (also evident in our photograph) black fingernails, revealing the ugly, but unavoidable, evidence of the professional photographer in the age of the wet-collodion process. Duchenne described the method of exposure: "The light was so placed that the creases stimulated by the electric impulse would be defined as clearly as possible... An assistant sensitized the plate with wet collodion. Before placing it in the camera, the photographer, with the help of the assistant, attempted to find a pose that

*Duchenne de Boulogne:* Effroi, sujet vu de profil *(Fright, subject viewed in profile),* Plate 42 from Duchenne's Album personnel, *1855–56*

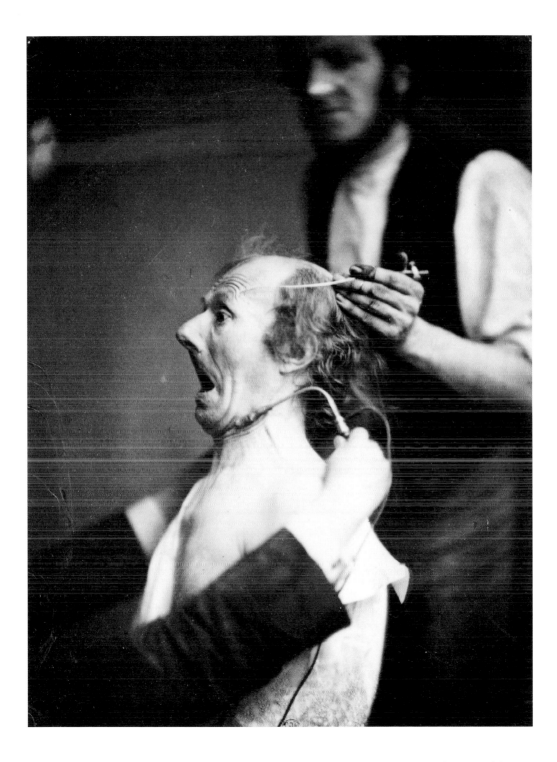

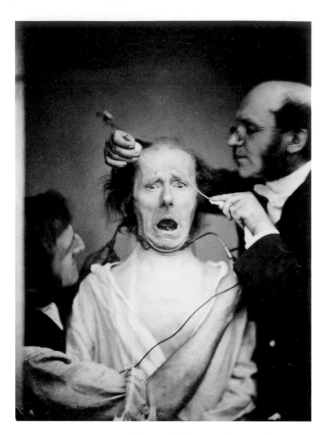

*Duchenne de Boulogne: Effroi, mêlé de douleur, torture (Fright, pain, agony), Plate 45 from Duchenne's* Album personnel, *1855–56*

would illustrate the subject in sharp detail, without disturbing the already sharp focus of the subject … At an agreed sign the assistant opened and closed the lens. Finally, the experimenter himself did the developing."

We have no information about where our motif was taken. In other photographs, Duchenne's private apartment at 33 boulevard des Italiens, where it is known that the doctor maintained a *laboratoire*, is recognizable. In the case of our picture, a completely neutral background provides an atmosphere at once concentrated and anonymous. The lighting indicates the direct influence of Nadar, whereas the posture of the subject, whose right hand disappears into the neck of his simple white shirt, could be read as a reference to the Second Empire, for Louis Napoleon, the nephew of Napoleon I, had dissolved the National Assembly and had taken over the government in 1851 in the course of a coup. That the ambitious emperor was particularly interested in supporting the sciences and industry is well known, and the revival of the Prix Volta for pioneering practical research in the area of electrophysics was a result of his initiative. Duchenne de Boulogne applied for the attractive prize with its award of 50,000 francs with his works on "human physiognomy" in both 1857 and 1864, but without success.

Duchenne's investigations and his photographs – including our motif, which represented the emotion 'surprise' – appeared in a work published in 1862 under the title *Mécanisme de la physiognomie humaine ou analyse électro-physiologique de l'expression des passions applicable à la pratique des arts plastiques*; that is, they were presented in a book whose visual and educational material was primarily directed toward artists in the fine

arts. But Duchenne's pasted-in albumin prints chiefly depicting a debilitated old man apparently interested the creative sector that the doctor had in mind just as little as they impressed his colleagues in the field of medicine. The book remained almost wholly without a public, a circumstance that no less a figure than Charles Darwin remarked upon in the introduction to his *The Expression of the Emotions in Man and Animals* in 1872 when he noted that Duchenne's work had either not been taken seriously by his fellow countrymen, or had been completely ignored. In fact, the first French translation of Darwin's study created a certain level of attention for Duchenne de Boulogne. In 1875, one year after the publication of the French title, the doctor died in Paris. In the context of a questionnaire à la Proust, Duchenne de Boulogne was once asked what he most liked to do. His answer: "To research." His photographically illustrated *Mécanisme de la physiognomie*, which straddles a bizarre line between science and art, is without a doubt the most original contribution to its field.

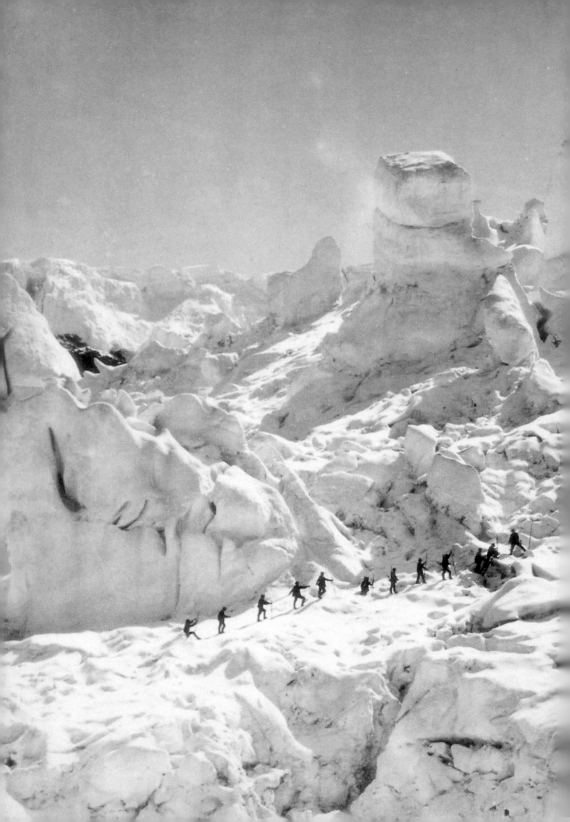

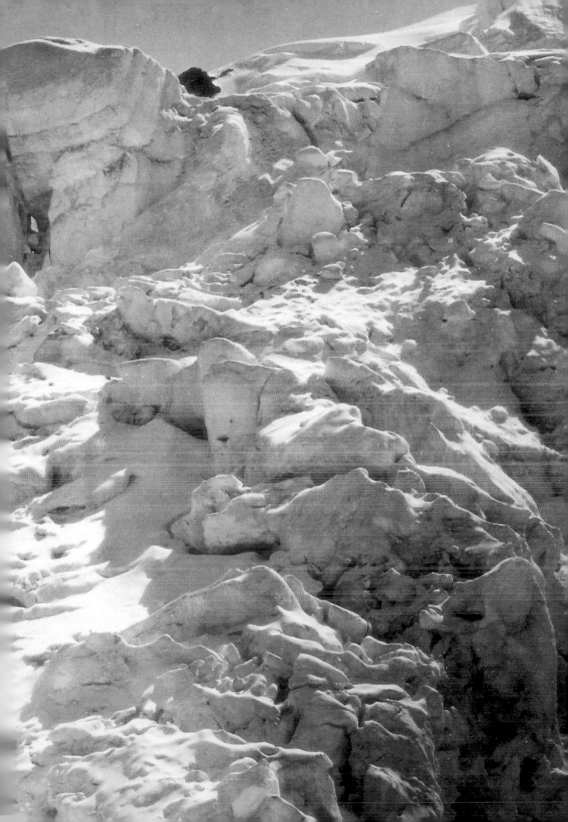

# 1862 Auguste Rosalie Bisson
# The Ascent of Mont Blanc

## The Architecture of the Alpine Peaks

**The eighteenth and nineteenth centuries — the age of industry and technology — discovered nature anew. The idealized landscapes of classical painting were replaced by scenes of an environment as perceived through the analytic eyes of science, and photography came into its own as a pictorial medium suited to the needs of the age. In the new, realistic interpretation of landscape, the younger of the two Bisson brothers was a leading pioneer.**

They photographed architecture — ever and again architecture. Along with Edouard-Denis Baldus, Gustave Le Gray, and Henri Le Secq, they number among the most important architectural interpreters of the nineteenth century. Their large-format photographs manifest an amazing feel for the power of light, for the modulations produced by the interplay of light and shadow. In short, the photographs of the Bisson brothers represent an attempt to convey the reality of architecture in the form of a two dimensional image. But what is it that lent their unpeopled topographies such clarity and artistic power? Was it the slowness of their large plates? The complexity of the photographic process? Or the atmosphere of an age capable of greater concentration than ours? After 1860, at any rate, the name of the firm, "Bisson frères," was known even beyond the borders of France as a synonym for the quickly growing genre of architectural photography. But the brothers did not rest with views of the Louvre, Paris or the cathedrals of Chartres or Reims. They undertook lengthy journeys to Italy, Spain, and Germany. In Heidelberg they used a platform to achieve a new and unfamiliar view of the castle ruins; in Paris, the towers of Notre Dame offered the opportunity to formulate several views of the city from the airy heights. A panorama with the astounding dimensions of $17^3/_4 \times 41^1/_2$ inches, composed of three negatives depicting the interior of

the Musée du Louvre in Paris won a positive review from the photography journal *La Lumière*: one must praise the "great harmony of light, and all the fine and numerous details of this sculptural jewel," which was here "reproduced with rare harmony." For the sake of completeness, it must be noted that the brothers also produced daguerreotypes, fulfilled portrait contracts, photographed art works, and also placed their talents at the service of science. But most importantly, theirs were the first successful photographs of the peak of Mont Blanc in 1861 – an impressive achievement in terms of skill both in mountaineering and photographic technology. Their achievement not only caused much excitement at the time, but it also constituted an important contribution to the history of photography and secured the Bisson brothers a place among the six most important French photographers of the pioneer age: Bernard Marbot, Nadar, Nègre, La Gray, Baldus, and finally, the Bisson brothers themselves, who, as "diligent pilots of a large firm," were thus also intermediaries between industry and art.

Two brothers: Louis Auguste, born in 1814 and Auguste Rosalie, twelve years younger. It was intended that Louis Auguste become an architect, but in fact he worked for twelve years in the Paris city administration before turning to daguerreotypy in the early 1840s – a surprising decision from today's point of view. But we must remember, at that time, the medium, still young, was a playground for any entrants into the field who could demonstrate courage, a readiness to take risks, an interest in pictures, and the spirit of an inventor. Reviewing the original professions of the early photographers, Hans Christian Adam came up with a list that included portrait painters, scientists, lithographers, and even a coal dealer. The Bissons' father, Louis François Bisson, was a ministerial official who painted coats-of-arms on the side, before he took up the still-young process of daguerreotypy in 1841. The family was thus from the very beginning a part of that much-cited 'daguerreotypomania' that took root in France and elsewhere after 1840. It is therefore not surprising that Auguste Rosalie also soon gave up his job as an official in the Office of Weights and Measures and turned to photography. He began with portraits, but also reproduced paintings, and gave instruction in photography. By 1849 at the latest, the two brothers were working together as partners and in 1852 they opened a joint studio, initially located at 50 rue Basse du Rempart, then at 62 rue Mazarine, and finally at 8 rue Garan-

**Bisson frères**

**1814** birth of Louis Auguste Bisson in Paris. **1826** Auguste Rosalie born in Paris. **1843** Louis Auguste and Bisson senior open up a portrait studio in Paris. **1848** Auguste Rosalie opens a studio. From **1852** the two brothers work openly together ("Bisson frères"). **1854** first presentation of large format views of monuments. Become founder members of the Société française de photographie in that same year. **1856** Napoléon III visits their studio. **1858** views of the Mont Blanc range and of Switzerland by Bisson the younger. **1860** further shots of the Mont Blanc range. **1861** views of the peak of Mont Blanc. **1862** second successful ascent of Mont Blanc. Exhibition of prints in Amsterdam and London (World Exposition). **1863** the firm goes bankrupt and is liquidated. **1876** death of Bisson senior in Paris. **1900** death of Bisson the younger in Paris

cière, where they occupied a total of twelve rooms on three stories for their private and professional needs.

Although the Bisson frères, as they were officially known as a firm after 1852, were active in all the early genres of photography except the nude, their real domain remains that of architectural photography. They advertised an impressive selection of offerings, including "photographic reproductions of the most beautiful examples of architecture and sculpture of antiquity, the Middle Ages, and the Renaissance." The photographs were pasted into books or albums, or alternatively were made available to the educated public in the form of original single sheets. In addition to all this, at the beginning of the 1850s, the brothers began to take an interest in landscape photography. A six-foot-long panorama of the Pavillon de l'Aar probably represents their first zenith as photographers of nature – and is said to have moved the Alsatian clothing-manufacturer Daniel Dollfus-Ausset to buy his way into the Bisson brothers' firm as a limited partner for a sum of one hundred thousand francs. Dollfus-Ausset took a lively interest in Alpine glaciers, and felt confident that in Louis August and August-Rosalie Bisson he had finally found a team who could guarantee him the photographic exploration of the mountain world. Dollfus-Ausset's affinity for the mountains heights must be understood in the context of the new understanding of nature. Beginning with Rousseau at the latest, the traditional, normative concepts of nature had begun to dissolve: the traditional image of the ideal landscape as found in literature and the fine arts was now being replaced by an empirical model. This approach had already entered the sciences, and by the time of the Napoleonic wars, had increasingly made its way into the military. It is no accident that fields such as geology, geodesy, and geomorphology blossomed for the first time precisely during these years of increasing nationalism and imperialism.

**Photography in the cold, thin mountain air**
Even before establishing his connection with the Bisson brothers, Daniel Dollfus-Ausset had already spurred other photographers on to make pictures of the high ranges of the mountains. Thus, Jean Gustave Dardel was the first to succeed in taking photographs of the Alpine landscape, producing approximately a dozen pictures in 1849. Similarly on the initiative of Dollfus-Ausset, Camille Bernabé made daguerreotypes of several Alpine

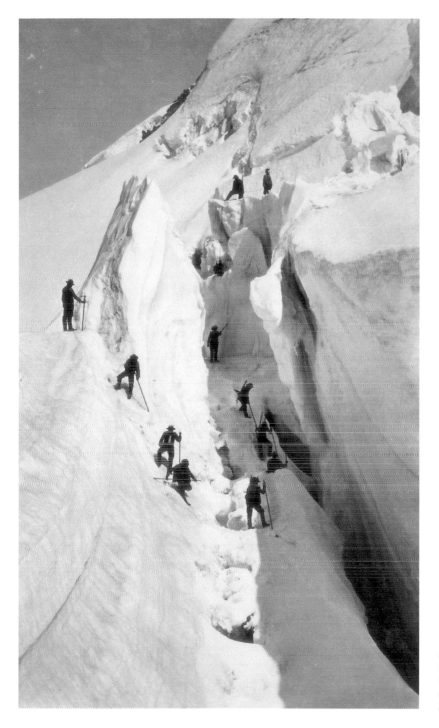

*Auguste Rosalie Bisson:* Ascent of Mont-Blanc *(via a crevice),* albumin print, 1862

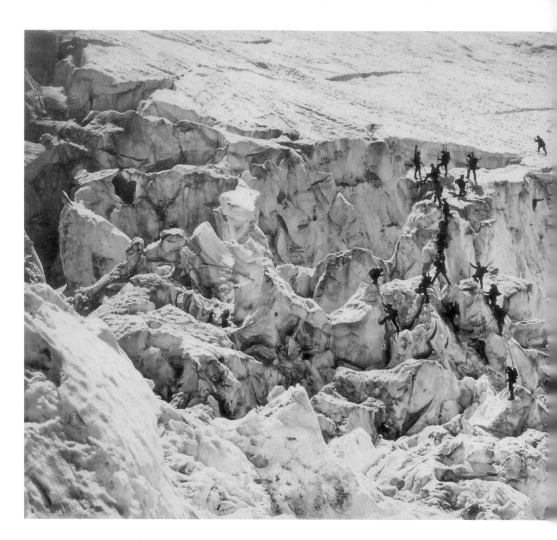

*Auguste Rosalie Bisson:* Meeting point of the Bosson and Taconnaz glaciers *(abandoned attempt to ascend Mont Blanc), albumin print, 1859*

glaciers and peaks in August 1850. The midpoint of the century also found other photographers such as Friedrich von Martens, Aimé Civiale, Edouard-Denis Baldus, and the Ferrier brothers at work in the mountains. Although Auguste Rosalie Bisson was not the first to set up his camera in the high Alpine ranges, he was the first photographer to succeed in conquering the heights of Mont Blanc. Furthermore, unlike the majority of the photographers cited above, he employed the more modern, albeit more complex, wet-collodion process, which, it must be added, had not yet been tested under the extreme weather conditions of the mountain heights. What he brought back from his successful expeditions of 1861

and 1862 was more than a mere 'I-was-there' variety of proof: Auguste Rosalie Bisson's large-format negatives and prints also conform to the highest aesthetic standards.

In August 1859, Auguste Rosalie Bisson started his first attempt to ascend to the peak of Mont Blanc. It is difficult for us today to imagine the difficulty of such an undertaking. In the first place, in 1859 mountain climbing was still in its infancy, the equipment of the mountain climbers had not yet been perfected, and the participants as a rule were insufficiently trained. But even without all this, Mont Blanc represents a particularly dangerous and moody peak, which had been first conquered only in 1786, and significantly bore the nickname *montagne maudite*, or 'damned mountain'. Furthermore, the challenge facing the younger Bisson was not merely to reach the nearly sixteen-thousand-foot peak, he also wanted to take photographs there – specifically using the wet-collodion process that was as yet untested in the thin mountain air and extremely cold temperatures.

The collodion process, announced in 1851 by the Englishman Frederick Scott Archer, was the most complex of all the early black-and-white photographic processes, calling for a glass plate as the vehicle for the photographic layer. The use of the glass plate offered the advantages of considerably increased light sensitivity and a more brilliant and precise image. The disadvantage lay in the no fewer than eighteen various steps that the process required, from the sensitizing the plate with a fluid mixture of

ether alcohol, collodion, iodine and bromide salts, through the exposure of the plate in the camera, and ending in the development and fixing of the negative. Because the plates had to be exposed while still wet, a traveling photographer had to carry along – in addition to the camera, tripod, glass plates and chemicals – a complete darkroom tent. In reality, no fewer than twenty-five men accompanied Auguste Rosalie Bisson on his excursion; in addition to the necessary porters, there were also experienced mountain guides such as Mugnier and Balmat.

## Milestones of early photography

On 16 August 1859, the party set out from Chamonix. Initially, the weather looked promising, but worsened considerably in the course of the day. A hut on the glacial lake served as their quarters for the night. Now it started to snow and the temperature sank to ten degrees Fahrenheit; nonetheless, Bisson and four guides reached the final rock face before the summit on the next day. Buffeting winds and whirling snow prevented the final ascent, however, and taking photographs was out of the question. Thus the first attempt was given up without result. A year later, on 26–27 July 1860, a second attempt also resulted in Bisson's retreat from the peak without pictures. It was not until the third try on 24 July 1861 that the photographer finally succeeded in climbing "the giant among mountains with his equipment," as La Lumière commented with admiration. Once again, the weather seemed favorable. The group set off from Chamonix on the morning of 22 July. By evening they reached the Grand Moulets at a height of more than ten thousand feet. They rested for an hour, and reached the great plateau around six o'clock in the morning. Proceeding to the Petits Moulets at a height of more than fifteen thousand five hundred feet, the group was greeted with storm winds and snow, and was forced to turn back. Some of the men began to give out; they were sent back to Chamonix, and replacements were sent up. Toward midnight of the second day, they set off again, finally attaining the peak at morning. "The tent was erected," as described in a contemporary report, "the camera placed on the stand, the plate coated and sensitized, exposed, and the view was taken. And what a view! What a panorama! As the picture was being developed, there was no water at hand to rinse it. It was assumed one could melt snow with the lamps, but in this atmosphere, the lamps burned only with a very small flame... One man was

assigned to the lamps, to keep them burning; he fell asleep. Another re-
placed him, but the same thing happened. Finally Mr. Bisson himself
managed to obtain enough of the precious substance. He hurried to his
tent, at whose door only Balmat was still standing, and completed pro-
cessing his negative."

In this first successful expedition to the summit of Mont Blanc, Bisson
succeeded in taking a total of three photographs. On a second ascent in
1862, he brought back six more. These were not to be his last pictures
from the mountains, but they remain his most spectacular: in the tech-
nique, aesthetics, and logistics of the entire process, these stand as mile-
stones of early photography. Whether or not Bisson used a green filter to
even out the extreme differences in contrast in the negative, we do not
know. Nor do we have information about the exact format of the plates,
the camera, or the lenses that he used. What stands out in the pictures is
their aesthetic content, undoubtedly wrung from Bisson's routine archi-
tecture interpretations; his sure sense of style; his experience with light,
composition, reduction, and the golden section – from all of which he
could profit. Bisson, as Milan Chlumsky rightly has said, was the first to
prove that the "deserts of snow possess unmistakable aesthetic qualities.
He was the first to capture the majesty of the Alps by photography." We
know that the Bisson brothers had assumed they would make money
from the spectacular undertaking. But ironically, more than a year after
the second ascent of Mont Blanc, the firm went bankrupt and went under
the auctioneer's hammer on 7 April 1864. The buyer, a certain Emile
Placet, paid the ridiculously low sum of 15,000 francs for the entire in-
ventory, the negatives, and the rights to the pictures – including the
legendary photographic conquest of Mont Blanc.

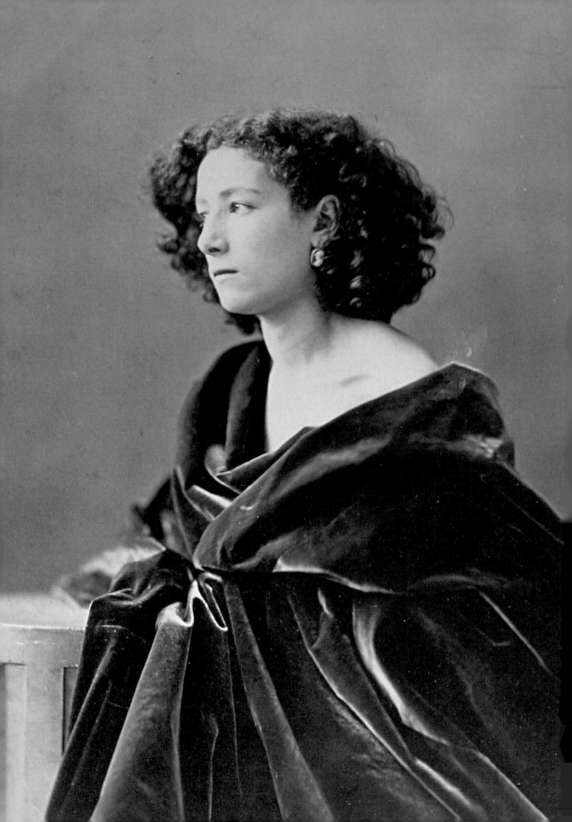

# Nadar
# Sarah Bernhardt

ca. 1864

**She was a true child of the age of photography. Fascinated with the new pictorial medium that photography represented, Sarah Bernhardt understood how to wield photography to foster her growing fame.**

Lady at
Ease

At some point in the course of 1864, the young Sarah Bernhardt had her portrait taken in the studio of the Paris photographer Félix Tournachon, known as Nadar. The precise day and month have not been recorded but researchers nevertheless have agreed. At the time, Henriette Rosine Bernhardt, the daughter of a Hungarian Jewish mother, was twenty years old, and it would be an exaggeration to term her a famous actress. At this point even the word 'promising' might be too much – although she had been a conscientious student at the Paris Conservatory, and had passed the final exams as the second in her class. But even so, coming directly from school, she would never have been engaged by the Comédie Française – at that time still the leading theater in France – without the support of her mother's influential friends. One cannot speak, however, of the beginning of a brilliant career; in fact, rather the opposite. "Her debut," writes Cornelia Otis Skinner, one of Bernhardt's biographers, "was not at all sensational; it wasn't even good." In particular, the stage fright from which she was to suffer throughout her life weakened her self-confidence during her performances. Accordingly, the critics responded with restraint. Francisque Sarcey, for example, initially commented positively on the way the young actress carried herself and spoke in her first appearance in Racine's Iphegenie – but shortly afterward rescinded his faint praise. Similarly, the influential critic of *Le Temps* found her performance unsatisfactory. If she seem to have made an impression at all, then it was thanks to her appearance: "Mademoiselle Bernhardt ... is a tall and pretty young person of slender build and very pleasant facial expression. The top half of her face is remarkably beautiful; her posture is good and her

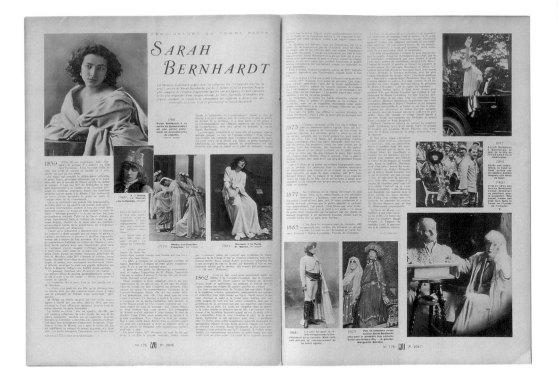

## SARAH BERNHARDT

*La librairie Gallimard publie dans la collection des "Témoignages du temps passé", une vie de Sarah Bernhardt, par G.-J. Geller. C'est le premier livre qui compose de l'illustre tragédienne, par les uns les figures et les portraits et les plus originales d'une époque révolue. Le Sarah Bernhardt complété ses étapes, composé ou simplement commentées qui suffisent à donner une idée d'ensemble la forme et de l'envergure de cette grande actrice.*

*Sarah Bernhardt à la sortie du Conservatoire où, elle avait commencé au deuxième prix de comédie.*
— André Nadar

*1861*

*1859*

*1869 — À l'Odéon, rôle de Zanetto.*

*1873 — Phèdre, à la Comédie Française.*

*1881 — Nanah, à la Porte St-Martin, revival.*

*1877*

*1862*

*1885*

*1900 À la fin pour la première représentation de la carrière. Mais cette date marque le commencement de la succès.*

*1923 Peu de semaines avant la mort de Sarah Bernhardt. On la voit triomphe, "à gauche. Marguerite Moreno.*

*1917 Sarah Bernhardt à Bénévins la tête du film de l'Indépendance reconstituée.*

---

*"Sarah Bernhardt after leaving the Conservatory". Article in the French glossy VU, August 12, 1931*

*The date of Nadar's photograph is given here as 1861.*

pronunciation completely clear. More," according to Sarcey, "cannot be said at this point."

By 1864, Sarah Bernhardt had two years of stage experience behind her. She had appeared in pieces by Molière and Racine, and had also held her own in now-forgotten plays by writers such as Barrière, Bayard, Laya, and Delacourt. But until the time of the photograph, she had garnered more attention from a certain extravagance of clothing and appearance, as well as a series of moderate-sized scandals, which initially were anything but helpful to the progress of her career. A slap she delivered on the public stage in early 1863 gained her not only dismissal from the Comédie Française but the reputation of being difficult, stubborn, and arrogant. She was, and remained, without permanent engagement. On top of all this, she was now pregnant. The child – a son named Maurice – was born in December 1864 on the wrong side of the blanket. All in all, the young actress was not in an enviable position. "This young person," her teacher at the Conservatory is said to have prophesied, "will either be a genius or a disaster." In 1864, the latter seemed the more likely prognosis.

In precisely this unpromising year, the young actress determined to visit Nadar's atelier. The studio was not just any of the by-then numerous photography establishments in Paris: it was the largest and probably the best known. Opened in 1860 at 35 Boulevard des Capucines, the studio tended to draw customers of name and rank, if not precisely the power elite of the Second Empire, from whom the republican sympathizer Nadar kept a critical distance. Instead, his clientele included the members of the bohemian circles from which Félix Tournachon himself had arisen, even if his meanwhile well-developed sense for business distinguished him from the "water-drinkers," as he called them.

## Pantheon of prominent personalities

Gaspard-Félix Tournachon, who began to style himself 'Nadar' in 1838, had started his career as a theater critic, writer, publisher of literary magazines, draftsman, and caricaturist. His project of creating a lithographic *Pantheon of Famous Contemporaries*, begun in 1851, won him attention, even though financial problems prevented him from producing more than a first issue. In the same year, Nadar also turned to the still-young field of photography, a decision that at first glance seems logical for technical reasons: photography was faster and cheaper than lithography, thus making it easier to construct his 'pantheon' of prominent personalities, for example. Furthermore, a new process had just become available that, although rather complicated, was many times more sensitive to light: the wet collodion process, which Félix Tournachon set to immediate use in his very first photographs. Nadar began making portraits of family members; soon, however, his artist friends were also stepping in front of his camera: Baudelaire, Champfleuri, Doré, Delacroix, Rossini, and Berlioz – a collection of simple, concentrated studies that "even today still retain their directness" (Françoise Heilbrun). Within a very short time, Nadar refined his portraiture to a remarkable level, a feat for which no doubt his familiarity with his subjects, his years of work as a caricaturist, as well as his "general curiosity about human beings" (Heilbrun) proved of great value. Nadar himself was thoroughly conscious of his abilities – of his own 'genius' – as demonstrated in a sensational civil suit against his own brother Adrien, who was in competition with him. During the trial, the self-assured Nadar declared that in photography, one could learn much for oneself, but not everything; excellent portraits, in particular, depend-

**Nadar**
Actually Gaspard-Félix Tournachon. Born **1820** in Paris. Studies medicine, without finishing. **1838–48** unsettled bohemian life. Friends with Murger and Baudelaire. First caricatures. **1851** preliminary work on a Pantheon of famous contemporaries. **1854** turns to photography, opens a studio. **1858** first exposures using electric light **1860** founds Atelier Nadar on Boulevard des Capucines. **1861** pictures of the Paris catacombs. **1886** photo interview with the 100 year-old chemist Chevreul. **1887** ceases studio work. **1897–99** new studio in Marseille. **1910** dies, is buried at Père-Lachaise

ed chiefly on the talent of the artist behind the camera. This evaluation was picked up by Philippe Burty in his criticism of the photographic Salon in 1859: "Mr Nadar," as he wrote in the *Gazette des beaux-arts*, "has made his portrait photographs into unquestionable works of art in the truest sense of the word specifically through the manner in which he illuminates his models, the freedom with which they move and assume their postures, and in particular by his discovery of the typical facial expression of each. Every member of the literary, artistic, dramatic, and political classes – in short, the intellectual elite – of our age has found its way to his studio. The sun takes care of the practical side of the affair, and M. Nadar is the artist who supplies the design."

For almost a decade, portraiture seems to have engrossed Nadar's artistic energies. Afterwards, so the story goes, he became bored by photography, although not to such an extent that he gave it up entirely. In 1861 he took impressive photographs of the catacombs of Paris using artificial light, and later he also photographed from balloons. Furthermore, he remained involved in portraiture, although his large new studio which opened in 1861 was primarily devoted to the quasi-'mechanical' production of photographs that had become almost universally popular. The process introduced by Disdéri allowed the production of up to twelve saucer-size portraits quickly and cheaply. Nadar's answer to the commercial challenge was his new studio in the Boulevard des Capucines that is supposed to have cost an unimaginable sum of two hundred thirty thousand francs – of borrowed money. Rumor has it further that he employed fifty workers, who could finish up to ten portraits a day; until that time, the upper limit had been three. It is not difficult to imagine why this 'mass production' was unable to achieve the desired 'character balance' sought-after in more 'intimate portraits'. If Nadar's studio was still important in the 1860s, it was chiefly because of its size and his advertising methods, which were unusual for the age. Attached to the façade of the building facing the boulevard was the owner's name in red script, which was furthermore illuminated at night. Nadar and his young client Sarah Bernhardt at least shared the feel for the grand entrance.

## New food for his lens

Sarah Bernhardt had visited Nadar's studio for the first time in 1862. The proof is a visiting card in the Bibliothèque nationale that already evinces

*Nadar:* Sarah Bernhardt,
*ca. 1864*

all the signs of the standardized portrait. Whereas Nadar had rejected the use of props in his early portraits, such accessories, considered indispensable accouterments in the photography studios of this age of rapid commercial expansion, now began making their way into Nadar's studio, too. The typical example of these studio props was the supposedly antique-looking stump of an ancient column, made if necessary of papier maché and left unlacquered to avoid reflections. Such a column is clearly evident in the well-known Bernhardt portrait of 1864, and was present in the photograph of 1862 as well. In the older photograph the pose is conventional, the lighting unconvincing. The picture is, in short, flat, like the scene itself. The light-colored drape across the actress's shoulders emphasizes the thinness of her arms, a 'fault' which had often been ridiculed in her stage appearance, just she had often been teased as a child for her thick, curly hair. For the portrait, the 'blond Negress', as she was sometimes called, had combed her dark hair back into a braid and bound it. If there is anything that this insignificant photograph of Sarah Bernhardt does not exude it is precisely the quality that later characterized her whole being, namely, self-confidence and pride to the point of defiance. It is no accident that her chosen life-motto was Quand même – "Despite everything."

It is highly unlikely that Nadar personally took this first photograph; on the other hand, we may well assume that it was precisely he who undertook two years later to portray Sarah Bernhardt's often-praised beauty so convincingly in a single sitting. Art critics reckon the photograph of the young, still unknown actress to be among Nadar's "most inspired" works (Silvie Aubenas), and one of his best after 1860. The background of the portrait is neutral; the stump of a column hidden behind a pose that seems purely natural. The transfigured gaze is directed into the distance; there is no jewelry to compliment her beauty – the small cameo on her left ear in the photograph is hardly noticeable. She is wearing her hair loose; the burnoose that she has thrown off emphasizes the pyramidal composition of the entire photograph. This time, the actress's slim upper torso is skillfully presented, with only the tip of the left shoulder showing, to give the picture a suggestive note. There is here both a clearer contrast between dark and light elements and a selectively sharper focus that together increase the sculptural effect of the picture. Only on a few, rare occasions, according to Françoise Heilbrun, one of the leading experts on

Nadar's work, did Nadar again achieve a portrait of this quality: in his later years, only when he was fascinated by the subject – or, more precisely, the person.

Three versions of the Bernhardt portrait have survived, and each may well be accounted successful in terms of offering a convincing image of the actress's personality. In all three, the actress is presented in a half-length portrait, leaning against the remains of a column. Her hair is loose, the burnoose is on one occasion replaced by a black velvet drape. In any case, Nadar succeeded in eliciting the touching beauty of the young actress, whether en face or in three-quarters profile, for viewers even a hundred and thirty years later. That no contemporary print (vintage print) of the photographs exists is explained by the fact that the twenty-year-old was still unknown. On the other hand, this public insignificance seems to be precisely what provided a particular challenge to the photographer. "Our photographic hero finds the greatest joy and an unimaginable enthusiasm there where his lens makes out an unknown food," wrote one of Nadar's contemporaries. Shortly thereafter, once the 'divine' Sarah Bernhardt had become a legend, she was no longer of interest to the photographer.

# François Aubert
# Emperor Maximilian's Shirt

**François Aubert stood at the side of the unfortunate Emperor Maximilian of Mexico as court photographer. The photographs he made of the final phase of the "imperio" were of particular interest to many of his European contemporaries, and are even said to have served Edouard Manet in the creation of his famous historical paintings.**

Decision in Querétaro

In the summer of 1867, the news broke like a bombshell in the carefree Parisian salons: the emperor Maximilian of Mexico, together with his generals Mejía and Miramón, had been executed in Querétaro. In spite of the numerous foreign dispatches that had alerted to the danger, in spite of appeals for mercy from figures like Giuseppe Garibaldi and Victor Hugo, the news came as a shock. To the nineteenth-century understanding of justice, execution was a thoroughly accepted concept, and ever since the French Revolution the violent death of a monarch was of course recognized as one of the possible outcomes of the historic process. What shook the self-confidence of great European powers, especially Austria and France, was the fact that in this case the "upstart", Benito Juárez García, was of Indio background. He had successfully challenged the Old World and had put a definitive end to at least the French attempt at hegemony in Central America. Rumor had it that Napoleon II spontaneously broke out in tears when the news reached him on 30 June. After all, it had been he who had sent Maximilian to Mexico, but then left him to his own devices, without military or political support. Prince and Princess Metternich demonstratively walked out of a fête associated with the Paris World Exhibition. The Count of Flanders and his wife did not even appear. Emperor Franz Joseph of Austria probably greeted the news with mixed feelings. He had always mistrusted the political instincts of his younger brother, but had also more or less encouraged him to undertake what

*François Aubert: Maximilian's Embalmed Body in His Coffin, albumin print, 1867*

The medical Dr. Vicente Licea of Querétaro was responsible the procedure, which involved fitting the corpse with blue glass eyes.

was in any case a very risky venture.

Maximilian's doomed mission to Mexico might be understood as a strategic diplomatic power play for political influence. But it was also a personal debacle of a passionate and emotional man, who was literally destroyed between the interests of clever tacticians working according to different plans. And because the fate of individuals moves the thoughts and feelings of contemporaries more powerfully than abstract political configurations, Maximilian succeeded in becoming one of the great tragic figures of the nineteenth century whose fate remained a matter of interest, at least in Europe, for a considerable length of time. It was hardly by chance that Edouard Manet, upon learning that the death sentence had been carried out, immediately began working on a large-format painting of the scene – a painting that remains not only one of his most important works but also an apotheosis of historical painting.

Today it is generally accepted that Manet, one of the leading Impressionists, derived much inspiration from photographs – although it must be borne in mind that the painter was not primarily concerned with the simple portrayal of historic events. If we nonetheless 'read' the painting as a document – as the title, *The Execution of Emperor Maximilian*, suggests – then it is chiefly because the photograph itself does not offer us the decisive moment. François Aubert was denied permission to document the execution photographically. In spite of this, in the early morning of 19 June 1867, Aubert, a trained painter, hurried off to the Cerro de las Campanas, the so-called 'Hill of Bells', to capture the scene at least by pencil. His small-format sketch, today in possession of the Musée Royal

de l'Armée in Brussels, offers in fact the most authentic visual witness to the moment of execution.

Born in 1829 in Lyons, France, François Aubert graduated from the local art academy, studied under Hippolyte Flandrin, and by 1864 was active as photographer in Mexico. In addition to his private work, he also served as court photographer to the Emperor Maximilian – although he hardly had to undergo the formalities that normally surrounded such an appointment in the courts of Europe. Soon after the arrival of the designated monarch in Mexico, Aubert began to make portraits of him, the court, and his staff of generals. We might well picture Aubert – a powerful figure with a broad face, bearded and with a full head of hair – more as an itinerant photographer and adventurer than as a serious courtier. Furthermore, he was a clever reporter and an instinctive businessman who well knew how to take commercial advantage of the growing public interest in photography.

Although Aubert wasn't allowed to photograph the actual execution, he at least managed to document the 'scene of the crime' afterwards: the site of execution is marked with wooden crosses and an iron-wrought 'M' with a crown. Also clearly evident on the photograph are parts of the clay wall that had been hastily erected for the execution – a backdrop that also appears in two of Manet's four versions of the scene. In addition, Aubert photographed the execution squad, and the embalmed and freshly dressed corpse of Maximilian in his coffin; nor was Aubert shy of capturing the bullet-ridden, blood-spattered clothing of the emperor for a curious public. He photographed the emperor's black frock coat, vest, and blood-flecked shirt before as neutral a background as possible. The photographs were subsequently distributed and sold internationally by the firm A. Pereire, which had presumably purchased the photographic plates and rights from the photographer.

## A cosmopolitan with liberal tendencies

In the tradition of Christian reverence for relics, Aubert placed the emperor's shirt in the center of his composition, thereby making it into the determining element of his photograph. The dark door frame in the background, the window, and the curtain behind it serve to concentrate the observer's attention on the most important artifact. The photographer attached the shirt to the door with two nails in such a manner as to make

François Aubert

Born 1829 in Lyon. Studies at l'Ecole des Beaux-Arts, under among others Hippolyte Flandrin. 1851 participates in the Salon. Emigrates to Central America. 1864 opens a studio in Mexico City. 1864–69 portraits of French, Belgian and Austrian soldiers. Unofficial pictorial chronicler at the court of Kaiser Maximilian. 1867 present as photographer at the capture and execution of the Emperor. 1890 return to Algeria, where he photographs the battle fleet. Dies 1906 in Condrieu, Dep. Rhone

the pleated front clearly visible; having less interest in the presentation of the arms, he allowed them to fall rather more carelessly to the side. Clearly visible also are six circular bullet holes at chest level. According to Maximilian's personal physician, Dr. Basch, the bullets had all passed through the emperor's body, puncturing heart, lungs, and the large arteries: "From the nature of these three wounds, the death struggle of the emperor must have been extremely short." Aubert's photographs substantiate the doctor's statement and relegate rumors that Maximilian died only after receiving a *coup de grace* to the realm of legend – although it must be stressed that Aubert did not at all consider his work to be forensic. Instead, he was concerned with producing commercial icons – images that would satisfy the visual curiosity of an international public and thus allow them to participate in the fate of a young man who had failed in his endeavors.

A brilliant conversationalist, gallant social figure, talented dancer, art collector, and belletrist who expressed himself in the form of travel accounts and poetry; a cosmopolitan with liberal tendencies, who could converse in at least four languages – so runs the description of Maximilian, born the second son of Archduke Franz Carl and his wife Sophie of the noble house of Wittelsbach in 1832. Maximilian enthusiastically devoted his energies to the creation of a modern Austrian fleet on the British model, incorporating the newest technology, including steam power, screw-driven propellers, and iron hulls. In addition, he founded a marine museum and hydrographic institute and furthered the construction and fortification of a new shipyard in Pola. Appointed rear admiral at age twenty-two, he shortly thereafter was named supreme commander of the navy as well, and was subsequently designated governor-general of the Lombard-Venetian kingdom. When his sober-minded brother withdrew these important offices from him in 1859 under threat of impending war with France, Archduke Maximilian came to feel the weakness of his position at home. This made him all the more susceptible to an offer from Paris, where Napoleon III had sought a candidate for the imperial throne he wanted to establish in Mexico – by today's standpoint an absurd idea.

## Walking to his death with an upright posture

The background of the Mexican experiment was the attempt of several western European powers to revive Old World influence in Central and

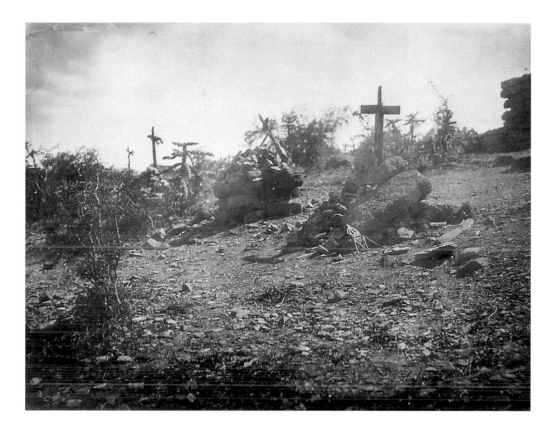

South America and simultaneously to "balance the Protestant-republican power of North America with the counterweight of a Latin-Catholic empire" (Konrad Ratz). A unilaterally imposed moratorium on repayment of the overdue Mexican state debt declared by President Benito Juárez García provided France, Spain, and England with a welcome excuse for immediate military intervention and the establishment of Maximilian's 'imperio'. For his part, the Archduke of Austro-Hungary made his agreement dependent on the outcome of a plebiscite – which Napoleon and his Mexican vassals quickly served up. Thus Maximilian considered himself to have been "elected by the people," and on 10 April 1864 accepted the crown in the palace of Miramar. Four days later he set sail from Triest aboard his favorite ship, the Novara, headed for Vera Cruz.

What turned out in the end to be merely a short Central American regency reflects the internal contradictions of a monarch who swung oddly between court etiquette and liberal sentiments, between a zeal for re-

*François Aubert: The Place of Execution at Querétaro, Mexico, albumin print, 1867*

*Maximilian and his generals were executed at this spot.*

form and de facto highly authoritarian decisions. In an attempt to satisfy all parties – monarchists, republicans, liberals, and the Catholic Church – he placed himself politically between various political positions without having a firm basis of his own. On top of this, he faced an increasingly hopeless military situation. The end of the American Civil War had provided Benito Juárez García – who in any case was far from defeated on his own turf – with an unexpected ally in the form of the USA. Simultaneously, Napoleon, succumbing to internal pressures, lost interest in his American adventure and withdrew his troops from Mexico. As a result, Maximilian's twenty thousand imperial troops – in part recruited by force – confronted what eventually amounted to more than fifty thousand republican soldiers. Maximilian's offer to negotiate remained unanswered. As a result, everything depended on a swift military solution to the problem.

It is 14 May 1867. Since February, Maximilian and his remaining troops have been entrenched in the small Mexican city of Querétaro, one hundred twenty-five miles northwest of Mexico City. The strategy, particularly supported by the Indio General Tomás Mejía, was to gather all forces for

a final and decisive blow to the republican troops far from the capital. In fact, however, the imperial troops had maneuvered themselves into a trap, which they now planned to break out of on the morning of 15 May. It is no longer a matter of debate that Colonel Miguel Lopez betrayed the plan from a sense of wounded honor, and allowed Juárez's troops to infiltrate the city the night before. Within a few hours, the streets of Querétaro were in republican hands, Maximilian and his officers were captured. A trial lasting several days was held, and the emperor was sentenced to death on the basis of the "Law of Punishment for Crimes Against the State," which had been decreed by Juárez in 1862. On the morning of 19 June 1867, Maximilian and his generals Miguel Miramón and Tomás Mejía faced an eight-man firing squad under command of nineteen-year-old Simón Montemayor. "I forgive all and ask all to forgive me. May the blood we lose be of benefit to the country. Long live Mexico, long live independence!" are reputed to have been his last words.

Reports by the few eye-witnesses who remained loyal to the emperor are contradictory in their details. It seems certain, however, that Maximilian approached his fate with an upright posture and amazing serenity. However self-contradictory, fickle, naive, and indecisive he may have been in the short course of his life, he now faced death with bravery and pride. He granted General Miramón the place of honor in the middle of the trio; Maximilian himself, contrary to Manet's interpretation, stood at the far right. The distance from the firing squad is said to have been five steps. To each of the soldiers he is supposed to have bequeathed an ounce of gold with the request not to aim at his head. Then, at 6:40 a.m., he turned his gaze to the heavens, and stretched out his arms. Maximilian's final gesture was substantiated by the testimony of his adjutant Prince Felix zu Salm-Salm: the emperor compared himself to Jesus Christ in the end, who had also been betrayed into the hands of his enemies. François Aubert, with his photograph of the blood-spattered shirt, bequeathed us the icon corresponding to his martyrdom.

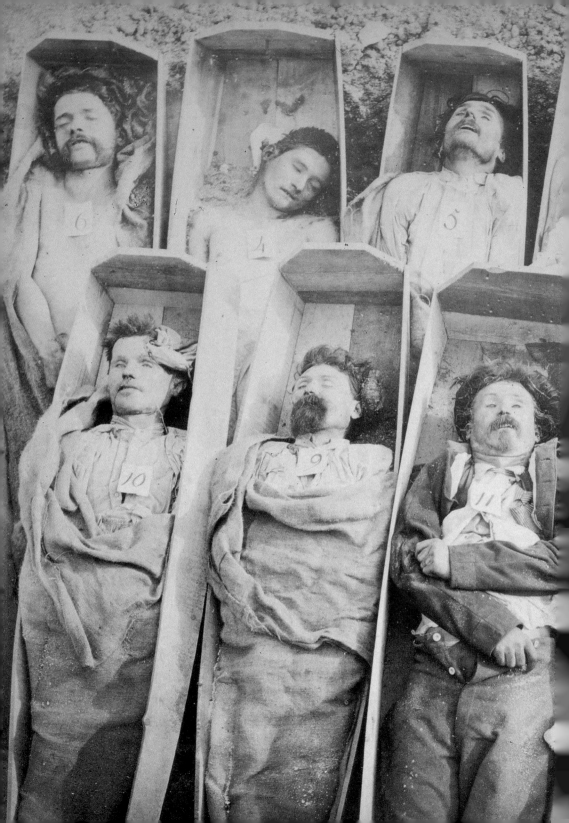

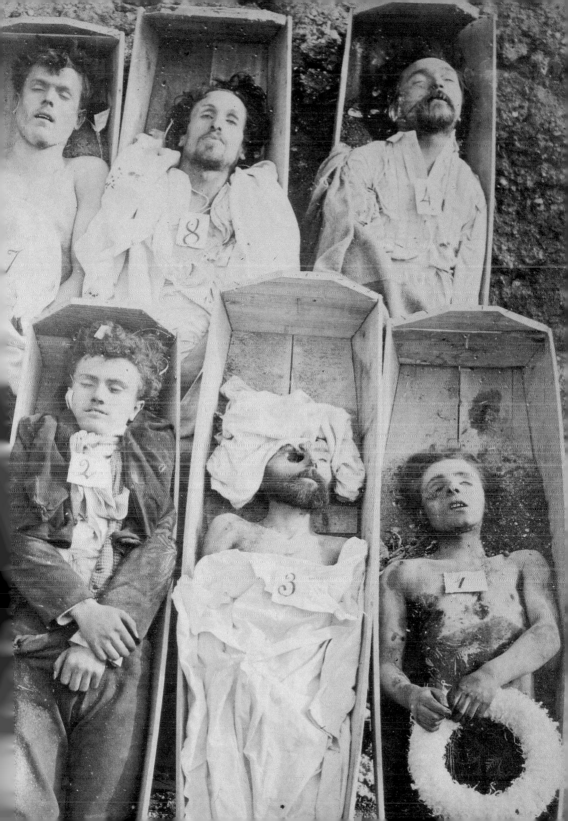

# 1871 André Adolphe Eugène Disdéri
# Dead Communards

The End of
a Utopia

**Historians are still in disagreement: Was the Paris Commune of 1871 merely an outburst of chaos and anarchy, or was it the first proletarian revolution in history? In either case, the uprising resulted in even more casualties than the French Revolution of 1789. It was a civil war, as bloody as it was brief, in which photography defined a new field for itself.**

Someone had distributed slips of paper, had given them numbers. Perhaps that is what is most shocking in this picture that breaks with taboo in two senses, consciously offending against the accepted rules of decency and morality. First, it makes the wounded, desecrated, defenseless human body into a pictorial object, and second, it subjugates suffering to a cool arithmetic. But why, one asks oneself willy-nilly, were these twelve male bodies in plain coffins made of raw spruce boards laid side by side and provided with hand-written numbers? Whoever did it could not have been following any imaginable principle. One may speculate about a coded message, but such a theory is really rather improbable. It remains astonishing that the row of numbers begins with a 'six' and ends with a 'one'; 'four' was assigned twice; 'twelve' is missing. The sum amounts to 70 – but that can hardly be significant. Literature concerning the picture has sometimes claimed that the numbers could have served for later identification of the corpses. But this, too, seems hardly plausible if one considers the fate of the men: anonymous members of the Commune, presumably arrested after 21 May 1871, shot by unknown soldiers of the regular troops, quickly buried – but first provided with a 'portrait' beforehand. Who could have been interested in identifying them? And if someone were, then why don't the numbers follow some kind of understandable logic. Don't the physiognomies provide enough evidence on their own?

## Hard years for the working class

The picture is beyond a doubt a document of power – the power of the living over the dead, who can no longer remove themselves from such degrading exhibition and classification. The power of the victor over the vanquished, the bourgeoisie over the defeated proletariat. "Hard years for the amputated, debt-ridden, working class, under surveillance and suspicion – these years under Thiers and MacMahon," as Michelle Perrot describes the situation in her book *Les ouvriers en grève*. "Paris had lost approximately 100,000 workers: 20,000 to 30,000 had probably been killed, 40,000 imprisoned, and the rest fled…"

## Mountains of bodies round the Jardin du Luxembourg

To make it clear from the beginning: we know little about this photo-graph, whose original is now in the possession of the Musée Carnavalet, the municipal museum of Paris. The lightly bleached-out albumin print bearing the archive entry 9951 is 8¼ x 11 inches in size, pasted onto grey cardboard, and was a private donation, as the handwritten remark, "Legs Hauterive," testifies. Neither does the photograph provide further in-formation on its reverse about the place and time it was taken, nor does it identify the names of the executed. Only the small stamp at the bottom right on the front puts us on the trail of the photographer: namely, Disdéri. In all probability, the photograph was taken immediately after 21 May 1871, that is, during the so-called Bloody Week during which most of the revolutionaries – or men who were held to be such – were shot by Thiers's merciless troops and buried in mass graves. The location of the picture might be the Père Lachaise Cemetery, at the time the center for the executions, or the walls around the Jardin du Luxembourg, where "mountains of bodies" were also reported. The naked torsos of the corpses one, three, four, six, and seven may be an indication that they died heroically with their chests bared. The slightly dandyish clothing of corpses two and eleven suggests that they were of the bohemian world, and in fact, there are supposed to have been an above-average number of intellectuals and artists who sympathized with the Commune. Re-search speaks of 1,725 members of the liberal professions who were ar-rested after the Bloody Week. Among them, perhaps the most prominent of them, was the painter Gustave Courbet, who miraculously survived the 'cleansing', but was fined an annual sum of 10,000 francs in the course

André Adolphe
Eugène Disdéri

Born **1819** in Paris. First dedicates him-self to painting and theatre. **1847** turns to photography Initially active in Marseille, Brest, Nîmes. **1854** sets up a studio in Paris. In the same year files a patent for a fast and reasonably priced form of por-trait (known as *carte de visite*). **1855** founding of the Société du Palais de l'Industrie. **1860–62** portraits of promi-nent contemporaries for a *Galerie des con-temporains*. Branches in Nice, Madrid and London. **1871** takes photos during the Commune. **1877** sells his business. Moves to Nice. **1889** returns to Paris. **1889** dies in the Paris Hôpital Sainte-Anne, deaf, blind and totally im-poverished

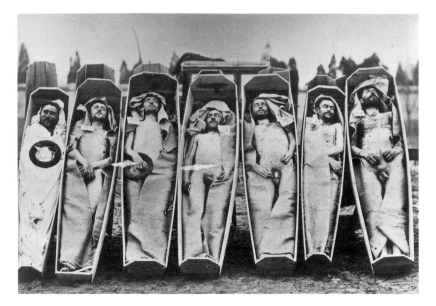

of a sensational trial. The money was used for the re-erection of the
column damaged by the Commune on the Place Vendôme.

## Through Paris with a darkroom on wheels

Why did André Adolphe Eugène Disdéri photograph the twelve executed
Communards? Probably not from 'artistic' motives – nor because he
wanted to test the limits of his medium. Disdéri, born in 1819, was above
all a businessman – not always a fortunate one, as Helmut Gernsheim
points out, but with at least a strong commercial interest and the readi-
ness to seek out his advantage wherever his nose led him. Although he
had not invented the *cartes-de-visite*, as is often claimed, he had, more
importantly, popularized them. It was his Paris studio that fostered the
breakthrough of the aesthetically unambitious portraits that were, how-
ever, fast and cheap to produce. "In 1861," writes Gernsheim, "Disdéri
was already accounted the richest photographer in the world. In his Paris
studio alone, he took in an 1,200,000 francs annually. This means, that at
a price of twenty francs for a dozen portraits, his etablissement was serv-
ing on average 200 customers per day." Disdéri, who had started as a
landscape painter, fabric maker, bookkeeper, and actor, was correspond-
ingly interested in photography as a mass medium. It was he who recog-
nized the wish of the broad majority of the bourgeoisie for portraits, and

knew how to satisfy them. Whereas the Franco-Prussian War of 1870–71 was not of interest to the majority of the studio photographers of Paris (Nadar, Carjat, Reutlinger, Thiébault), Disdéri rode through Paris with a darkroom on wheels, documenting war damage, photographing the destroyed Tuilleries, the burned-out city hall, Thiers' house, destroyed by the Communards, and the Vendôme column. After the end of the riots, he published a book with the title, *Ruines de Paris et de ses environs*. But our picture of the executed Communards does not appear on its pages, nor does a variant (now at the University of Texas in Austin), depicting seven Communards, this time unclothed, in their coffins. Anne McCauley suspects that Disdéri was at the time commissioned by the police to record the faces of the Communards – but evidence is lacking. Later, the picture is said to have been distributed by other studios as a stolen copy, and if so, that is a clue that there was no other picture available that responded to the increased public interest. Disdéri himself seems not to have commercialized the photograph. Or might it be possible that he was not the true creator of the photograph? After all, the modest stamp on the cardboard only indicates that the print had at one point or another passed through Disdéri's studio. "If his studio indeed made these negatives," argues McCauley, "its owner must have either been desperate for money or felt little sympathy for the Commune."

## Jacobin dreams of a popular uprising

The photography of the period of the Paris Commune – a still largely unresearched field – was determined by the ideological interests of its photographers. The pictures mirrored the technical possibilities of a medium that hardly allowed instantaneous shots in the sense of today's photojournalism. The photographs of the Commune can be fairly exactly dated between the 18 March and end of May 1871, the beginning and the bloody end of a popular proletarian revolt, whose life span as a social utopia lasted around 70 days. The historical background is well known. The starting point, or rather, the catalyzer of the uprising was the loss of the war against Germany. The Prussians had been occupying Paris since 18 September 1870; capitulation and the conclusion of a peace seemed inevitable. In fact, the National Assembly, dominated by monarchists and clerics, which met together in Bordeaux on 12 February 1871 decided upon an immediate and unlimited peace. Paris flaunted the decision with na-

tionalistic, chauvinistic slogans, and Jacobin dreams of a popular uprising filled the air. For the first time since 1848 red flags began to appear. On the night of 17 March, it came to armed conflict when 'regular' troops attempted to take the approximately one hundred cannons stationed on the mound of Montmarte under their control at the order of the designated prime minister Thiers. But the half-hearted raid was foiled by the rebel troops. Thiers's band was driven from the city as the rebels occupied the city hall and other public buildings. A municipal council operating out of Versailles now assumed power as a countergovernment to Thiers. Its program included such resolutions as the separation of church and state, the confiscation of property belonging to religious orders and cloisters, the official adoption of the red flag, and a law forbidding bakers to bake at night. Certainly this was no revolution in any real sense of the term, but rather a pack of Jacobin or Proudon-inspired measures that would serve to solidify the later reputation of the Commune as a proletarian revolt. Already on 2 April, conflict exploded again between the followers of Thiers and the Commune. The Paris Guard behind the ubiquitous barricades understood well enough how to fight, but problems ranging from quibbles over domains of competence, to lack of leadership, military disor-

ganization, and to dilettantism soon allowed the superiority of the regular
troops to emerge clearly. On 21 May, they succeeded in overcoming the
Paris defensive wall at an unguarded point. What followed has gone
down in the annals of history as a "semaine sanglante" – a week of de-
nunciations, persecutions, mass executions, and merciless terror such as
had not been seen since the Revolution of 1789 (with its 12,000 casualties
throughout the entire nation). The estimates for 1871 range between
20,000 and 40,000 Communards killed or executed. We have more pre-
cise numbers on the losses at Versailles: official records counted almost
900 dead and 7,000 wounded.

The Commune was a time of many photographs – and few. Many if one
looks at the troublesomeness of the then standard wet-collodion pro-
cess, in which a plate had to be sensitized and developed on location;
few, if one considers the number of photographers then active in Paris.
Gernsheim speaks of 33,000 persons in 1861 who "earned their living by
photography or in businesses that served it." Ten years later, the number
certainly would not have been less. But those who remained seem, as
Jean-Claude Gautrand has expressed it, to have exchanged "the velvet of
the studios" for the street rather unwillingly. The only photographers who

LE PARIS D'OLDES
L'HOMME LE PLUS MALADE DU MONDE SOURIT TOUJOURS

LA PHOTOGRAPHIE A CENT ANS
DÉJA ELLE RACONTE L'HISTOIRE

MARS 1871 — LES PRUSSIENS CAMPENT SUR LA PLACE DE LA CONCORDE

UNE JEUNE FILLE MÉLANCOLIQUE L'ACCOMPAGNE

*Photo report in Match, June 1, 1939: 70 years later, the Commune still occupied the minds of the French.*

stand out for larger collections of pictures are in fact Alphonse Liébert, Hippolyte-Auguste Collard, Eugène Appert, and Bruno Braquehais, whose series of a total of 109 photographs were dutifully handed over to the Bibliothèque nationale in late 1871 and represent the most remarkable contribution to Commune photography.

## Meeting of the proletariat and photography

From a Marxist perspective on art history, the photography of the Commune has at times been evaluated as the predecessor of the later development of working-class photography. The days of the Commune had, according to Richard Hiepe, brought about "the first meeting of the proletariat and photography" – which can at most apply to the early pictures of the barricades with posing Communards, although it bears emphasis that those taking the photographs were and remained members of the bourgeoisie. In no sense does the term "proletarian photography" apply to the large majority of the pictures, which range from the innumerable views of war-ravaged Paris (and express a clearly critical position toward the Commune) through to the tendentious photomontages of an Eugène Appert, or to his photographic inventory of the approximately 40,000 imprisoned Communards, which constitutes an early form of the information-gathering approach to photography later refined by Alphonse Bertillon. What is missing, surprisingly enough, between the pictures of the barricades and the ruins, are photographs of the dead; as if they never existed, the twenty to thirty thousand victims left hardly a trace on the photographic plates. For photography, as Christine Lapostolle rightly claims, "there was no *semaine sanglante*, and as a result, no painful pictorial return of the wounded and dead after the battles before the gates

of Paris. Nothing of the misery that tortured the people remained to be seen." Even if there were one or another picture of victims in addition to Disdéri's images of the dead Communards, quantitatively and qualitatively the 'proceeds' would be comparatively modest. And thus it is no accident that precisely this photograph has been able to attain symbolic status in the course of time. Whether Disdéri himself took the photograph or not, this status will not disappear. What is important that the photograph has become an icon, a pictorial metaphor for the end of a short utopia.

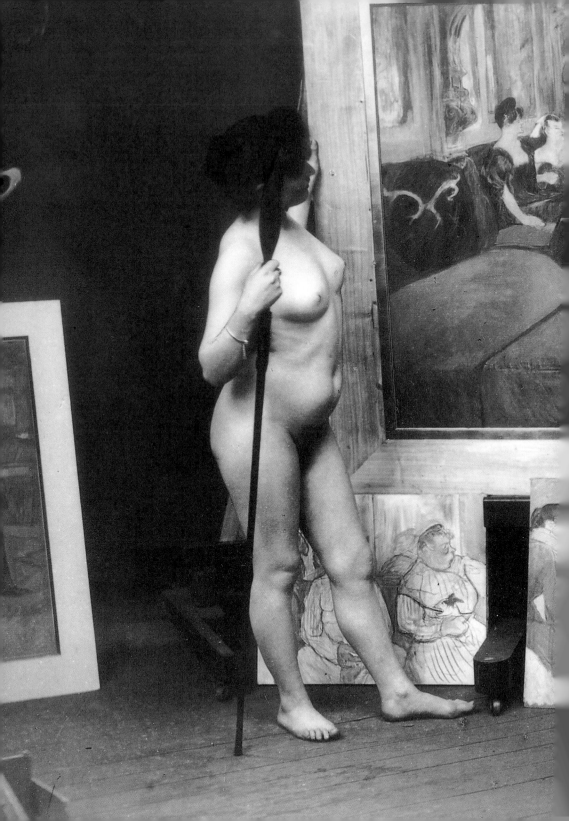

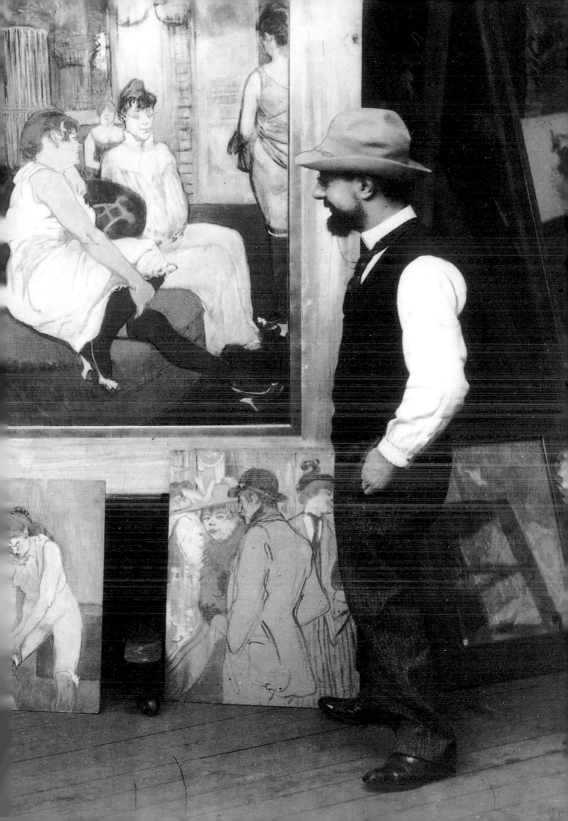

# ca. 1894

# Maurice Guibert
# Toulouse-Lautrec in His Studio

## The Artist and his Photographer

**At some point in the mid-1890s – presumably in 1894 – Maurice Guibert photographed his friend Toulouse-Lautrec in the latter's studio. Although the amateur photographer was simply following one of the common photographic conventions of the turn of the century, his ironic perspective on the subject drew emphasis to the special position of the already internationally known artist.**

He has laid his brush and palette aside, his hands in the pockets of his trousers. It's a little as if he is standing there because the director of the photograph wanted him in the picture only for the sake of a vague symmetry. And yet, he is the protagonist of the scene, even if the gaze of the unprejudiced viewer is caught initially, and is probably held for some time, by the unclothed woman to the left in the picture. That she is standing barefoot and completely naked may at first seem rather curious. Her nudity acquires a 'deeper' significance, however, when one realizes that around 1900, artists – both painters and sculptors – often had themselves photographed with their models in the studio. Usually the camera 'caught' them at their work: the visualization of the breath of genius, a literal transformation of transitory flesh into 'eternal' art, as it were. But here, there is no question of work, and furthermore, the studio appears remarkably orderly. The presentation of what are recognizably seven panel paintings reminds one rather of a kind of informal vernissage in which the naked muse, not only unclothed but also holding a lance in her hand, does not really seem to fit. Even her supposed role as 'model' is questionable if one looks more closely at the pictures on the floor and on the easels: there is not a single nude in the academic sense among them. Further doubts about the role of this 'model' arise when one considers that this genre did not really constitute the creative center of the work of

our artist, Henri de Toulouse-Lautrec, painter, draftsman, poster artist and, by the time of the photograph, a both celebrated and castigated personality of *fin de siècle* art.

## Bourgeois clothing of English cut

Toulouse-Lautrec has donned formal attire, wearing long trousers, a dark vest, a white shirt with stand-up collar and tie. It is rumored that he also owns a suit cut from green billiard-table felt – but this seems rather to be only a gag reserved for special occasions. As a rule, the artist tended toward bourgeois clothing of English cut, irrespective of his affinity for what we would today refer to as the 'subculture'. What his contemporaries may well have found odd, however, was that even in closed rooms, he never removed his hat. The brim, as he took care to explain his foible, eliminated glare when he was painting. In addition, the hat made him appear a little taller – and also covered a deformity in the formation of his head, one that nobody spoke about: a fontanel where the bones had not grown together properly. According to recent medical research, this – together with the many other bodily infirmities that the child born Henri Marie Raymond de Toulouse-Lautrec in the southern French town of Albi in 1864 suffered from in the course of his short life – resulted from the long history of incestuous marriages entered into by his noble ancestors. The artist lisped, was short-sighted, and spoke with a marked stentorian voice – but these were only the smaller problems. He had large and clearly protruding nostrils, a receding chin, and abnormally thick red lips that he concealed behind his dark beard. On a more serious order, he suffered from a generally weak constitution combined with pyknodystosis, a rare from of dwarfism. In addition, two broken legs that he suffered at age thirteen and fourteen ensured that Toulouse-Lautrec would move about only awkwardly and painfully for the rest of his life. "I walk badly," he liked to say, with a touch of self irony, "like a duck    but a runner duck."

Henri de Toulouse-Lautrec was short: five feet in height, to be exact. He was a cripple, fleeing from the many virtues extolled particularly by his father, a passionate rider and huntsman, not to mention lady-killer. The son sought refuge in the bohemian world of Paris during the Belle Epoque, in the demimonde of Montmartre, where he found friends of both sexes, and which became a spiritual home, and almost a family, to

**Maurice Guibert**

Born **1856**. Active member of the Société française de photographie as well as the Société des excursionnistes photographes. Autodidact, amateur. By profession a representative of the champagne company Moët et Chandon. **1886**–**95** photographic diary entitled *Ma vie photographique*. Becomes acquainted and then friends with Toulouse-Lautrec. The artist's first exposures around **1890**. August **1896** beach holiday in Arcachon together with Toulouse-Lautrec, where he takes snapshots of the latter swimming in a light-hearted mood. **1951** essay by Jean Adhémar on Guibert in the journal *Aesculape*, the first and only work to date on the committed hobby photographer's life and œuvre. Dies **1913**.

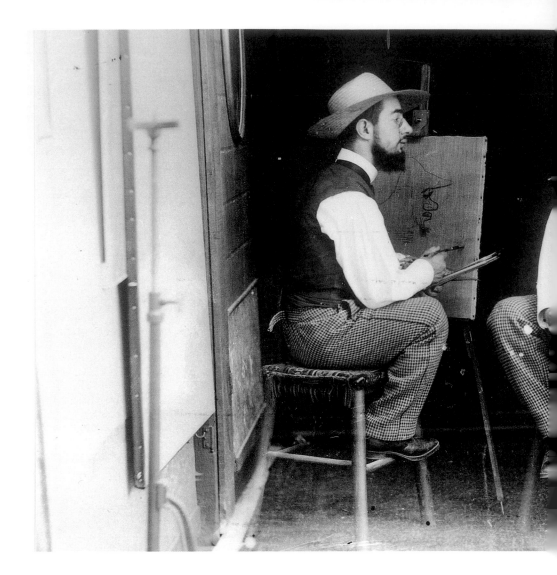

Toulouse-Lautrec,
*twice over, photo-
montage, ca. 1892*

*This picture, now
popularised by post-
cards, was also one of
Maurice Guibert's
ideas.*

him. He had been in the city on the Seine – at first with interruptions –
since 1878, studying with the animal painter René Princeteau, and later
with Léon Bonnat and Fernand Cormon, both of whom were recognized
exponents of an academic style. If their salon painting did not really fur-
ther the talented young man artistically, at the same time neither did it
interfere with the development of his free brush strokes – nor does it par-
ticularly seem to have placed obstacles in his incipient interest in the
world of the bordello, cabaret, and cafe concert. During the same period,

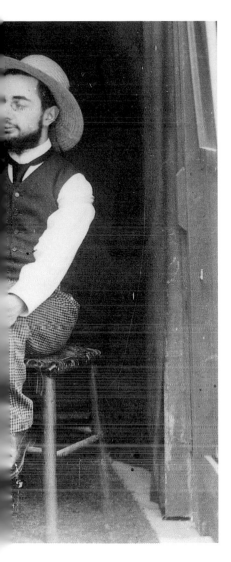

Emile Bernard and Aristide Bruant became his friends and important sources of inspiration for him, as did the ten-year-older Vincent Van Gogh, whom Lautrec immortalized in a remarkable pastel in 1887. A year earlier, in 1886, he had rented a spacious studio on Montmartre at 7 rue Tourlaque at the corner of rue Caulaincourt 27 (today No. 21). It was in this studio, where he stayed approximately ten years, that he probably finished the majority of his œuvre of 737 paintings, 275 watercolors, 5,084 drawings, as well as 364 graphic works and posters. Our photograph, too, bearing the title *Toulouse-Lautrec dans son Atelier*, was certainly taken here, even if we do not know precisely when. But the fact that his large-format painting *Au Salon de la rue des Moulins* (a major work of which several studies and variations exist), which dominates the composition, was completed only in 1894 offers at least a vague reference point for the photograph.

**The myth and cliché of the Belle Epoque**

To the left in the photograph, although partially cut off, we see the full-length portrait of Georges-Henri Manuel, which has been dated 1891 (today in the Bührle Collection, Zurich). A little further to the right, half visible through the legs of the unclothed young woman, is a sketch titled *Monsieur, Madame et le chien*. The bordello scene *Femme tirant son bas*, painted in 1894 (today in the Musée d'Orsay), constitutes the striking

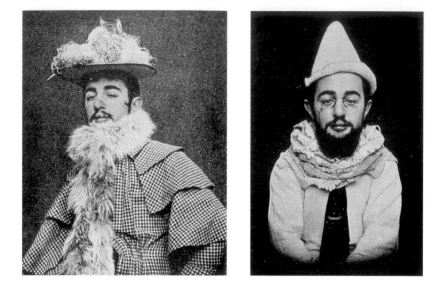

*Guibert took Toulouse-Lautrec's portrait in the most outlandish of costumes: left dressed as a woman, with Jane Avril's famous boa hat on his head (1892), right as Pierrot (1894)*

center point of the works displayed on the floor. Finally, to the right, is the last of the identifiable tableaus, *Alfred la Guigne*, painted in 1891 (today in the National Gallery of Art in Washington). Who arranged the pictures for display and why precisely these? Who is the woman with the seemingly meaningless lance? Is she perhaps to be interpreted as a parody of William-Adolphe Bouguereau's painting *Vénus et l'Amour* of 1879: a prostitute who recognizes herself in the large panel painting – an interior of the well-known bordello in the rue des Moulins, in which Lautrec is supposed to have lived for a time? The fact that she presents herself naked before the camera, the manner in which she inspects the painting, as well as her, so to speak, thoroughly non-academic measurements, which do not at all correspond to the ideal of an artist's model, argue for this possibility. Admittedly we don't know the answer, for neither Toulouse-Lautrec nor 'his' photographer, Maurice Guibert, commented on the picture. All we have is a fairly large original print of 9 1/2 x 18 3/4 inches that stems from Guibert's estate and was donated to the Paris National Library by his granddaughter. Art-lovers and visitors to Paris are familiar with the photograph as a postcard, in which format the picture has become a bestseller, effortlessly taking advantage of several clichés: Paris as a city that is both art-minded and generous, lascivious and open to sensual joys – a Paris in which the Belle Epoque has become a myth, a regular ideal of the pleasures of bourgeois life.

Toulouse-Lautrec, like Maurice Guibert, knew nothing of a 'Belle Epoque', a term that arose only in the 1950s. But no one disagrees that before 1900 both were part of the merry and carefree society centered in Montmartre, although Lautrec seems to have maintained a special relationship to Guibert. In letters to his mother, Toulouse-Lautrec is always speaking of his "friend, Maurice Guibert" (July 1891) or the "faithful Guibert" (August 1895), who seems in fact to have been something of an elongated shadow of the artist in the Paris years. There is also evidence of several journeys jointly undertaken, for example, to Nîmes; the castles on the Loire; Malromé, the estate of his mother, located near Bordeaux; Arcachon; or, in 1895, a ship voyage from Le Havre to Bordeaux, during which Guibert was able only with great exertion to restrain the painter, blinded with love for a young beauty, from following her to Africa. Lautrec accorded Guibert no such impressive portrait as the one he painted of another photographer, namely Paul Sescau (1891, now in the Brooklyn Museum, New York), but Guibert appears in no fewer than six other paintings and twenty-five drawings as exactly what he in fact was for Lautrec: a drinking partner, a friend who could hold his alcohol well and who accompanied the artist on nightly romps, a companion on visits to the legendary *maisons closes* – in short, a bon vivant whose stout figure is easy to identify in pictures such as *A la Mie* (With the girlfriend, 1891), and *Au Moulin Rouge* (1892–93). Little more is known about Maurice Guibert, except that he was born in 1856, died in 1913, lived in a handsome inherited estate in the rue de la Tour, was primarily employed as the representative of the champagne firm Moët et Chandon, and indulged in a remarkable hobby in his free time: photography. Guibert was an active member of the Société française de photographie and the Société des excursionnistes photographes, a loose association of amateur photographers with a penchant for hiking, to which the well-known science photographer Albert Londe also belonged. Several albums in the possession of the National Library in Paris, including a volume with the thematic title *Ma vie photographique* (1886–95), provide proof of Guibert's photographic interests, which – remarkably enough – were not at all aimed at ennobling the art of the camera by means of artistic photographic techniques, as the international community of the pictorialists were striving for at the time. Instead, Guibert pursued a kind of privately defined 'snapshot' photography characterized by wit and a sense of fun in setting up scenes. The

dry gelatin plates that came into use in the 1880s, which made amateur photography in our modern sense possible for the first time, proved of course very useful to Guibert and his ultimately artistically unambitious approach.

## Costumed in front of the camera

The relevant lexicons remain silent on the photographer Maurice Guibert. And without a doubt he and his small œuvre would have been forgotten, if the playboy and boon companion of Toulouse-Lautrec had not in the course of the years become something of a 'family and court photographer' to the painter. Lautrec himself seems to have taken an interest in photography from early on, although it must be said that his relation to photography on the whole still awaits a proper analysis. What is certain is that Toulouse-Lautrec, like many contemporary painters – one needs only to think of Degas or Bonnard – used photographs as patterns for his painting; in contrast to these other artists, however, Lautrec was himself not an ambitious photographer. In a photograph depicting the tipsy Maurice Guibert at the side of an unknown woman – the pictorial basis of *A la Mie* – Lautrec may have released the shutter of the camera. But basically he seems to have left the medium to Paul Sescau or precisely to Maurice Guibert, who seems to have advanced around 1890 to becoming the private and unofficial pictorial chronicler of Henri de Toulouse-Lautrec. What have survived are photographs of Lautrec swimming naked during a sailing meet on the sea by Arcachon (1896). In a letter to his mother from November 1891, the artist speaks of "wonderfully beautiful photographs of Malromé" that Guibert will send to her. It was above all Guibert who urged his friend to have his portrait taken repeatedly – and in the most ridiculous clothing: Lautrec dressed as a woman, wearing Jane Avril's famous hat decorated with boa on his head (1892); Lautrec as a squinting Japanese in a traditional kimono (also 1892); or as Pierrot (1894) – a sad clown who apparently needed little by way of costuming to create a convincing image. Jean Adhémar has subjected this portfolio to searching analysis: "Thanks to Guibert," writes the former curator of the Bibliothèque nationale, "we accompany Lautrec from 1890 to his death. One sees him in the most various surroundings and in all possible poses. It is particularly striking, however, that we meet a natural Lautrec at most only two or three times. The artist always poses himself; aware that he is

being photographed, he places himself in a scene. he never seeks to hide his deformities. On the contrary, he presents them openly, expressly emphasizing his ugliness and his dwarfish stature." Why does he engage in these travesties? Adhémar finds a logical explanation: "When Lautrec underlines his infirmity to such an extent, then it is very simply because he was suffering from it – more than we realize. In this sense, his form of masochism becomes a distracting maneuver. He would like to laugh about himself before others do so, or rather: to give his audience occasion to make jokes about something that in fact has nothing to do with his physical defects." It would have been very simple for Henri de Toulouse-Lautrec to have visited one of the prominent Paris photography studios to ensure, with the help of a practiced portraitist exploiting the photographic means at his command – lighting, pose, framing, perspective, retouching of the negative and positive – a pleasing half- or three-quarters portrait. Instead, the artist left in the hands of a friend and amateur the task of creating the photographic witness that still today defines our image of the tragic genius: Toulouse-Lautrec in his studio. Not at work. Not painting before an easel, but in visual dialogue with a naked prostitute (?). In other words, the loner of Montmartre pursued his own course also in his dealings with photography.

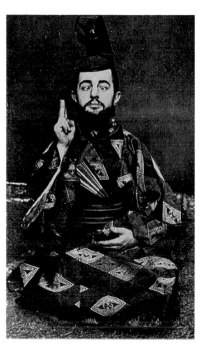

*Maurice Guibert:*
Toulouse-Lautrec
dressed as a Japanese, *1892*

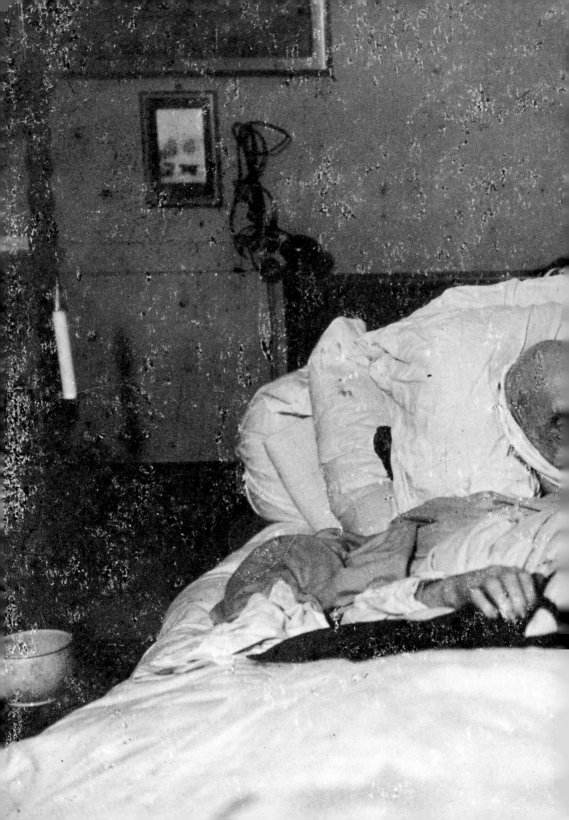

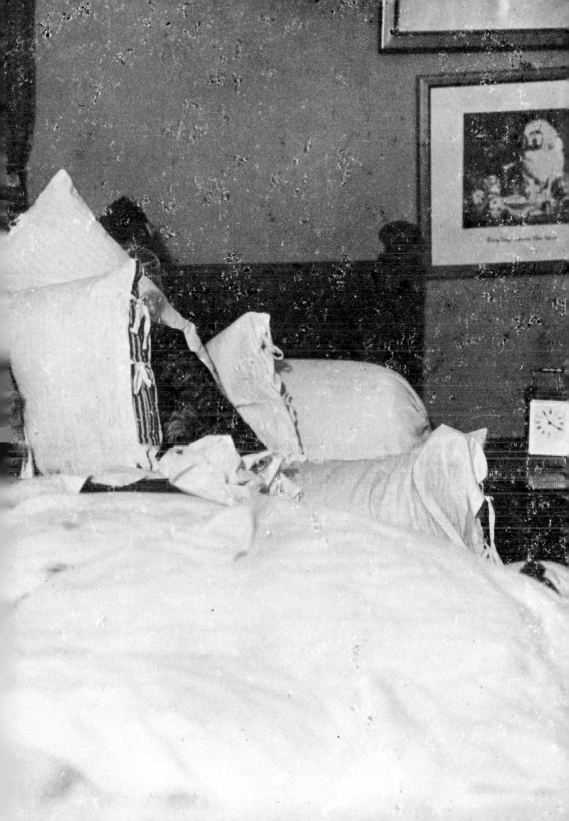

# 1898   Max Priester/Willy Wilcke
## Bismarck on his Deathbed

**The Human-
ization of a
Legend**

**Shortly after Otto von Bismarck's death, a death pho-
tograph that the public had never in fact seen led to a
sensational trial in Hamburg, Germany. The defend-
ants were two photographers who had secretly and illi-
citly captured the deceased founder of the German
Reich on film. Not until years after the end of the Sec-
ond World War was the photograph finally published.**

A great man has died. Think what one may of Bismarck – and historians
are still divided today over whether he was a visionary or reactionary, a
"white revolutionist" (Gall) or a "daemon" (Willms) – there is one thing
certain: he was one of the great figures in nineteenth-century politics,
and for a time he was the most powerful man in Europe. This claim re-
mains true even under the Hegelian understanding of history, in which
even the most influential individuals are at best the 'business managers'
of a predetermined 'purpose', that is, mere assistants in the fulfillment of
the inevitable course of history. The majority of Germans, however, would
have looked at the matter differently around 1890. For them, Bismarck
was the founder of a German Reich with well-defined borders, the creator
of a nation under Prussian leadership. In those days, people still felt unre-
served admiration for the Junker stemming from the lands east of the
Elbe, and throughout the country, Bismarck towers and Bismarck me-
morials made of bronze or stone reinforced the idea. On a popularity
scale, Bismarck surpassed both Wilhelm I and the reigning monarch Wil-
helm II – a fact which the latter realized all too well. In response, the
young kaiser therefore repeatedly sought some kind of reconciliation with
the aged chancellor whom he had disgracefully dismissed from office in
1890. But to no avail. Otto von Bismarck nursed a resentment that might
well be termed hatred and that was to have repercussions even after his
death.

Wilhelm was in no case to be allowed to view Bismarck's mortal remains. By the time the kaiser, who had been intentionally misled by those around him about Bismarck's true condition, finally arrived in Friedrichsruh near Hamburg, the coffin had already been sealed: Bismarck had thus effectively delivered an insult from beyond the grave.

## Pictures of the Chancellor produced at assembly line speed

In fact, there were very few who had been allowed to say farewell to Bismarck – family members, house servants, a handful of neighbors from Friedrichsruh. Reinhold Begas was refused permission to make a death-mask, the painter Franz von Lenbach, a death portrait. Similarly, in the beginning, no one seems to have thought about photographing the deceased – understandably from today's point of view, although it must be remarked that the photographing of the dead remained a completely common practice until the end of the nineteenth century. One needs only to think of Ludwig II, whose picture lying in an open coffin provoked almost no interest among the public. After Bismarck's death, however, there was to be no picture that contradicted the official iconography of the chancellor   in particular the image that had been professionally formulated by Lenbach, that Munich-based prince of painters, who had immortalized the Iron Chancellor in a number of oil and chalk works (as if on an assembly line, according to the ironic opinion of the painter's contemporaries). In any case, Lenbach's chancellor was a man of power, determination, and vision: a statesman in uniform, or sometimes in black civilian dress; a great figure in the literal physical sense. And now this travesty: a photograph of the deceased chancellor – the legendary Bismarck – sunk into an unmade bed, the absolute opposite so to speak of the familiar impressive figure exerting a powerful influence on the observer in Lenbach's portraits. To make matters worse, the photograph revealed a veritably shabby ambiance that one would hardly have imagined possible of the former chancellor, with the chamber pot adding an almost vulgar note to the scene. "Pure realism," as the Bismarck scholar Lothar Machtan appropriately pointed out, and thus a possible corrective to the stylized image that had been proffered by Bismarck himself – to the presentation of himself according to the motto "nothing is truer than the appearance" (Willms). For the kaiser, on the other hand, the photograph would have seemed like a belated revenge.

### Max Christian Priester

Born 1865 in Altona. Secondary school in Altona. Turns to photography. From 1886 in Hamburg. 1894 opens there his own photography shop. From 1895 photographic reports from Bismarck's home, Friedrichsruh. 1898 takes clandestine photographs together with Wilcke of the deceased Bismarck. This is followed by prosecution and trial for trespassing. Jailed for five months. Dies 1910 in a mental asylum

### Willy Wilcke

Born 1864 in Wismar. Apprenticeship in Wismar. Afterwards works as a photographic assistant in Malchin, Lübeck and Chemnitz. 1887 opens a photography shop in Ratzeburg. 1889 moves to Hamburg. There he opens a larger shop with three assistants and three apprentices. 1896 applies for the title of Court Photographer. From 1893 photographs Bismarck receiving homages and audiences in Friedrichsruh. 1898 takes photos of the dead Bismarck with Priester. Jailed for eight months. Stripped of title of Court Photographer. Dies 1945

Er war unser! Mag das stolze Wort den lauten Schmerz gewaltig übertönen.

*Bismarck in the eye of the imagination. Picture postcards of this kind went into circulation shortly after the death of the Chancellor.*

The photograph had been taken by the professional Hamburg photographers Max Priester and Willy Wilcke the night that Bismarck died — admittedly without the family's permission. The term 'paparazzo' had not yet been coined (Fellini introduced it in his film *La Dolce Vita*), but Priester and Wilcke were consummate paparazzi in the modern sense, motivated neither by personal curiosity nor even by a sense of 'art'. Like the paparazzi of today, what they wanted was money, and the ingredients for success were the same then as now, namely, the interest of the public in the private lives of the prominent. As a vehicle for conveying pictorial information, however, the illustrated press of the day was at best in a relatively archaic state. For technical reasons, photographs often made their way into the press only by way of woodcuts. But in Bismarck's case, the process never got that far. A civil suit, to be discussed below, together with the prior confiscation of all pictures, including "negatives, plates, prints, and other reproductions," by the police — meant that the pictorial material was effectively removed from the public sphere. The picture was in fact not published until approximately two generations later in the *Frankfurter Illustrierte* (No. 50/1952), a German magazine appearing from 1948 to 1962. On another occasion, *Die Welt* (No. 270, 19 November 1974) printed the photograph in connection with a review of a book, *Oevelgönner Nachtwachen*, by the Hamburg author Lovis H. Lorenz, in which he relates his version of the photograph's history. Four years later, the picture appeared once more, this time in the *ZEIT-magazin* (4 August 1978), accompanied by a text from Fritz Kempe. It may be tempting to interpret the publication of the once-taboo picture in a widely-circulated magazine ten years after the student rebellions of the late Sixties as a further station in the process of the Bismarck's demythification process. But in fact, the picture probably contributed even more to the humanizing of Bismarck. The photograph reveals that the circumstances of Prince Otto von Bismarck's death were in fact rather trivial: in death he became one of us.

The air was full of rumors that Bis-
marck was dying. The old man, in-
creasingly depressed, had been
ailing for quite some time. When
gangrene set in, it was clear that his
days were numbered. In other
words, a media event, as we would
term it today, was about to occur –
and this in turn required the 'right'
pictures; that is, the most recent
pictures had to be rounded up for

publication – and what could be more recent than a picture of the de-
ceased founder of the Reich. Two Hamburg photographers had determin-
ed to obtain the necessary image: Max Priester and Willy Wilcke, who had
bribed a reliable informant in the person of Bismarck's forester, Louis
Spörcke. Now they had only to wait for the moment of death. An hour be-
fore midnight on 30 July 1898 Otto von Bismarck died – according to
historians, after drinking a glass of lemonade. Then, "with a cry of 'For-
ward!', he sank back into the pillows and died" (Willms). Spörcke, who
had kept the night watch, informed Priester and Wilcke, lodging nearby
and fully on the alert: the forester would leave the garden gate and
ground-floor window open for them. Toward four in the morning the pair
made their way in the house, exposed several plates with the help of the
magnesium flashes that were usual at the time. The whole procedure
supposedly lasted less than ten minutes, and on the following morning,
they returned to Hamburg and attempted to make money as quickly as
possible from their – as we would say today – scoop.

### The incriminating materials confiscated

They advertised for interested parties with money. "For the sole existing
picture of Bismarck on his deathbed, photographs taken a few hours
after his death, original images, a buyer or suitable publisher is sought,"
ran the announcement in the *Tägliche Rundschau* of 2 August 1898. A
Dr. Baltz, owner of a German publishing house, replied that he was pre-
pared to pay as much as thirty thousand marks plus twenty percent of
the profit for the images. All that was necessary now was for the photo-
graphers to obtain the family's permission to publish. In response, Pries-

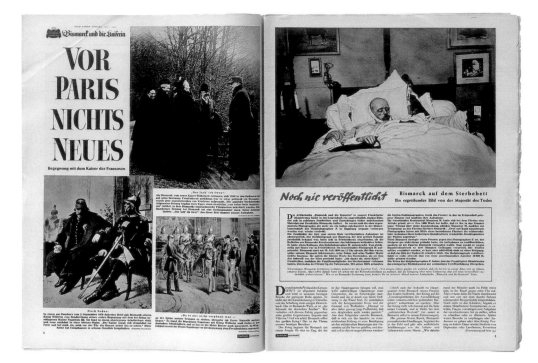

The German text within the image includes the following prominent headings and captions:

Bismarck und die Kaiserin

## VOR PARIS NICHTS NEUES

Begegnung mit dem Kaiser der Franzosen

*Noch nie veröffentlicht*

Bismarck auf dem Sterbebett
Ein ergreifendes Bild von der Majestät des Todes

ter and Wilcke quickly produced a retouched version of the picture, showing a clearly younger-looking Bismarck, without headband or patterned handkerchief. The light-colored chamber pot also fell victim to the practiced stroke of the retoucher. It is quite possible that the Bismarcks might have granted permission to publish, but in the meantime, a jealous competitor, Arthur Mennell, had already stumbled upon the plan, and denounced Priester and Wilcke to the family. The Bismarcks responded swiftly. By 4 August they had already managed to have the incriminating materials confiscated. A civil and criminal court case ensued, today remarkable in that the crime of trespassing was not the sole charge: the question of the right to one's own picture was also at issue. The case was decided in favor of Bismarck; the photographers had not acted for the sake of the German people, but merely in their own interest. The sentences handed down on 18 March 1899 were correspondingly harsh: five months for Spörcke, who also lost his position as forester; eight months for Willy Wilcke along with the loss of his title as court photographer; five months for Max Priester, who died at age 45 in an institution for the men-

*Fürst Otto von Bismarck auf dem Sterbebett. 1898*

tally ill. The 'evidence' disappeared into the Bismarcks' safe, "never to be turned over to the public," according to the express wish of the family. A clever photography assistant named Otto Reich, however, had already made a print, and from him Lovis H. Lorenz obtained possession of the picture, so he claimed, after the war. Lorenz in turn handed the photograph over to the Hamburg State Educational Institute, which kept the picture in their own collection. What had clearly caused a scandal in 1898 was hardly capable creating a public stir a decade after the Second World War. People had other concerns. Paradoxically, the picture of the dead chancellor helped to keep the otherwise distant and alien Bismarck alive, if not to bring him closer. The photograph proved: Bismarck, too, had died a completely normal, perhaps even trivial, death. A myth had become human.

*"A picture that was supposed to be destroyed": Fritz Kempe's analysis of the photograph in ZEIT-magazin, 4.8.1978*

Bismarck on his Deathbed **97**

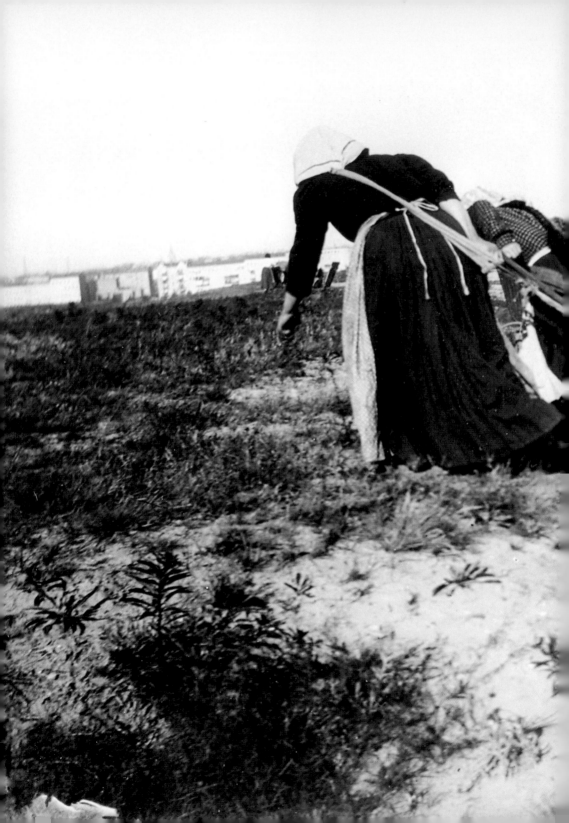

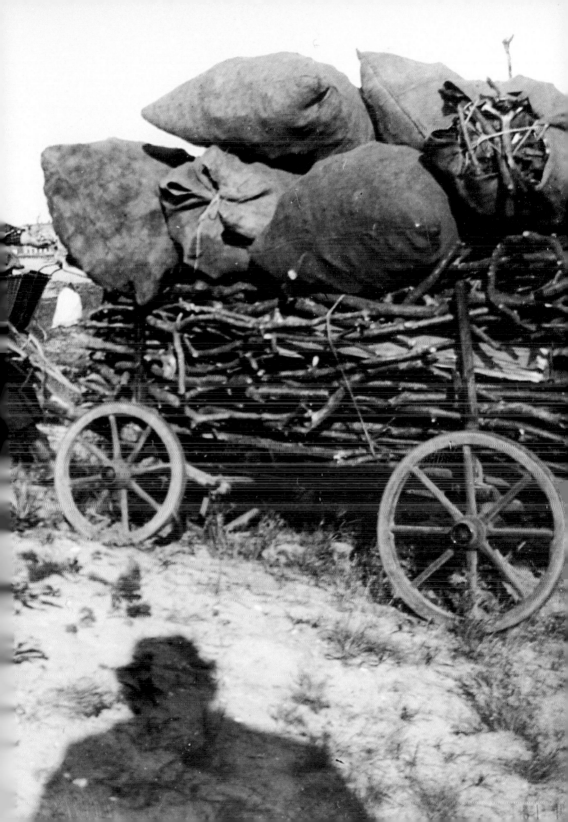

# 1898

## Heinrich Zille
## The Wood Gatherers

**Heinrich Zille, the well-known graphic artist who depicted proletarian conditions of life around 1900, was also a photographer, but his camera work was not discovered until the mid-1960s. His œuvre of more than 400 photographs is now appreciated as an important contribution to modern photography.**

Autumn in Charlottenburg, a small town outside Berlin. Two women, possibly mother and daughter, are pulling a cart loaded high with brushwood across the sandy ground typical of the region, one woman with the right hand, the other with the left clasped around the shafts of the simple vehicle whose left wheel seems to be set none too surely on its axle. The two wood gatherers have in addition yoked themselves with a shoulder band to distribute the load and are literally putting themselves in harness to bring their harvest home quickly. Home – it may be Charlottenburg itself – whose western outskirts are recognizable to the left in the picture as a lightly sloping stripe between the grassy fields and the sky. In 1900, the city with its approximately 190,000 inhabitants is still an independent community; it will not be incorporated into Greater Berlin for another two decades.

The two wood gatherers have already put a few kilometers between themselves and the forest of Grunewald. Their clothing, consisting of skirt, blouse, and apron, indicates their status as peasants. "In Grunewald, in Grunewald there's a wood auction" – the popular old street ditty looks back to the days when the forest, then located far to the west of Berlin, was an important source of natural raw materials for working-class families. Wood was used not only for heating, but also in cooking stoves, for which brushwood and sticks were the cheapest form of fuel – as dramatized by the important role such wood plays in Gerhard Hauptmann's comedy *The Beaver Pelt*.

## Eyes to the ground and swinging their arms

Although they constitute the central theme of the picture, which presumably was taken in 1898, the two women are not the only persons in the oblong-format photograph. Between the smaller woman in the background and the wagon with its high load we recognize, half hidden, a baby carriage typical of the times, which is also loaded with wood and a jute sack. And yet a further person intrudes into the picture: the photographer himself, whose long shadow stands out clearly in the bottom right against the bright dune. Somewhere in the background, but not visible in this photograph, there must be the Ringbahn, or circular railway around the city, which in those days more or less functioned as the boundary between city and countryside, that is, between Charlottenburg and Grunewald. Somewhat further to the right, one can imagine today's radio tower and the Berlin exhibition centre. The goal of the two women may well be the Knobelsdorff Bridge. From this point the path leads across the track into the western end of Charlottenburg. It is evident that the photographer is wearing a hat, but whether or not he is using a camera stand for his work cannot be determined. What is certain is that he is looking eastward; the sun must therefore be standing in the west, indicating that the time of the photograph is late afternoon or early evening. The two women are thus making their way back from a daytime outing, which indicates the completely legal nature of their undertaking. In reality, women collecting wood must have been a part of daily life in western Berlin, a situation which explains why none of the court or amateur photographers active in or around the Reich's capital hit upon the idea of capturing a scene such as this, without at least an attempt at idealizing the 'simple life'. But in this picture, there is no trace of romanticism. The women are pulling with their full strength against the harness to keep the wagon rolling, and in the process are swinging their free arms strongly, their eyes to the ground.

## Max Liebermann as engaged patron and friend

Heinrich Zille was neither a professional photographer nor an amateur in the sense of being merely a hobby photographer with artistic pretensions, a type that was occasioning much international discussion around 1900. Born in 1858 in Radeburg in Saxony, Zille was primarily a graphic artist known for his tragi-comic sketches of simple people. His work appeared

## Heinrich Zille

Born Rudolf Heinrich Zille in 1858 in Radeburg near Dresden. 1872–75 apprenticeship in lithography in Berlin. 1877–1907 works as a lithographer for the Berlin Photographische Gesellschaft. Around 1890 friendship with Max Liebermann. 1892 moves to Charlottenburg. First etchings in the same year under the influence of literary Naturalism. From 1903 member of the Berlin Secession. Published in magazines such as *Simplicissimus, Lustige Blätter, Jugend.* 1907 first illustrated book *Kinder der Straße.* 1924 awarded a professorship. Dies 1929 in Berlin. Photographic estate is in the keeping of the Berlinische Galerie, Berlin

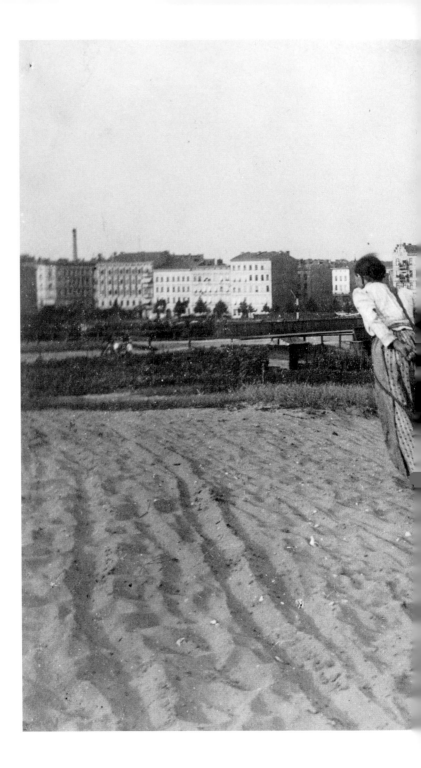

*Heinrich Zille:*
*Third series from*
*The Wood Gatherers,*
*5th picture. View*
*towards Knobelsdorff*
*Bridge, fall 1898*

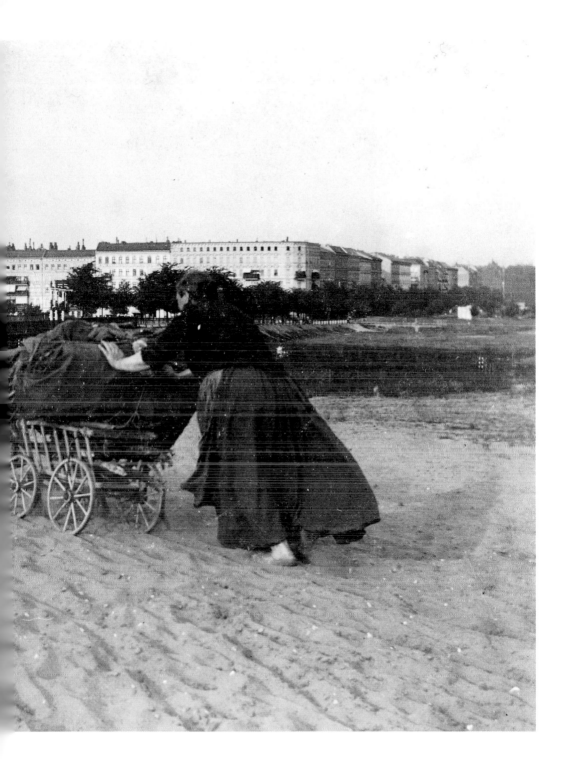

in various magazines and newspapers beginning in 1903, and five years later, was also published in book form. Zille had already achieved popularity within his own lifetime – but his was a controversial fame. Kaiser Wilhelm II, for example, discredited Zille's work, oriented as it was toward the naturalism of the age, as "gutter art." The Berlin Secessionists on the other hand valued his drawing. Particularly in Max Liebermann the trained lithographer found both a prominent and engaged patron and friend. Zille never made a secret of his photographic activity; at the same time, he did not emphasize it. Like many artists of the turn of the century – Stuck, Lenbach, and Munch are perhaps the best known – Zille also drew from photographs that he had taken himself. Unlike his famous colleagues, however, he seems to have followed this practice, commonly employed by painters and graphic artists of the day, rather rarely. Also of note are the intimacy of Zille's gaze, his particular mode of perception, and his joy in experimentation, all of which are far removed from any kind of commercial photography. One may rest assured that for Zille, the camera served primarily as a means to assimilate reality in a new way.

His contemporaries were aware of Heinrich Zille's work with the camera. Nevertheless, by the time of his death in 1929, this aspect of his work had sunk into oblivion. Not until 1966 was a cache of somewhat more than four hundred glass negatives and approximately one hundred twenty original prints discovered in his estate, out of which a selection was offered to the public for view for the first time by the Berlin Theater critic Friedrich Luft in 1967. The legacy indicates that after 1882, Heinrich Zille photographed exclusively with large-format glass-plate cameras which he may have borrowed from the Photographic Society, his employer of at the time. Surviving are also $4^3/_4$ x $6^1/_4$-inch, $5^1/_2$ x 7-inch, and 7 x $9^1/_2$-inch negatives, along with positives in the form of contact prints.

### Interest in banal, everyday life

The spectrum of Zille's themes was remarkably broad, even if the majority of his œuvre, which was largely concerned with the realities of daily life among the simple working class, consists of views of old Berlin – rear courtyards, alleys, narrow houses reached by high staircases, shops and stores. In addition, Zille's legacy contains portraits and self-portraits, family pictures, nudes, scenes of fairgrounds and beaches, and – oddly enough – trash dumps, which Zille photographed a number of times.

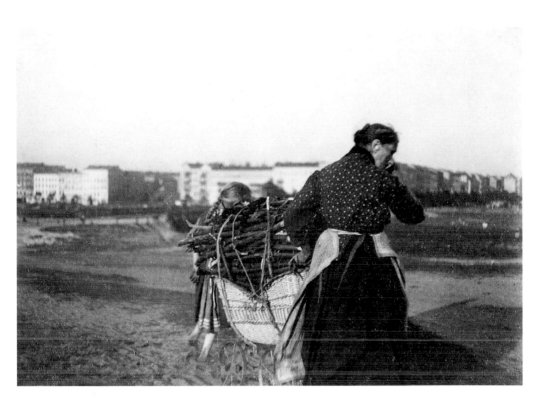

Practically absent in Zille's work are panoramic views of the quickly grow-ing Wilhelmine Berlin, such as those produced by contemporary photo-graphers such as Max Missmann, Waldemar Titzenthaler, and Hermann Ruckwardt. Similarly, photographs of the German Reichstag, the Victory Column, or the Brandenburg Gate constitute the exception in an œuvre centered on paradigms of daily life.

In keeping with his interest in banal, everyday life, Zille often made wood-gathering women the object of his lens. All in all, it Is possible to distin-guish four cycles, in the first of which, taken in 1897, Zille would still have had to combat the inconveniences that were a part of short-exposure photography. The pictures are not sharp, and the framing unsatisfactory – or the women are looking toward the camera, a circumstance that Zille, who strove for 'discretion', always sought to avoid. In this area, Zille, still very much the amateur, worked to refine his techniques, rubbing his nose in his chosen theme, which clearly interested him until 1898.

Precisely why Zille specifically made the theme of daily female labor the center of his cycle, we don't know. One thing is certain: the wood gather-

*Heinrich Zille·*
*Woman with child*
*pushing a pram*
*loaded with brush-*
*wood, with Knobels-*
*dorff Bridge in the*
*background, fall 1897*

Stadtrand
Charlottenburg 1910
(links)

Tippelbruder
im Zentrum

43/44/45

*Mein Photo-
Milljöh (Me photo-
graphic 'nvironment):
the book publication
edited 1967 by the
Berlin theater critic
Friedrich Luft first
drew attention to
Heinrich Zille as a
photographer.*

ers had become a more or less daily sight for Zille after he moved from
Rummelsburg to Sophie-Charlotte Street in 1892, where such women
passed every evening on their way back from collecting wood. "A tranquil
peace settled on the street," according to Zille's son Hans, describing his
parents' new apartment. "From the apartment windows, one's gaze
ranged into the open land. On the other side of the street, the sandy soil
was cultivated; in the middle, there was a large area for drying laundry
that was ringed with bushes and trees. Behind the Ringbahn stretched
fallow land, partially covered with low-growing pines, and finally came the
first trees of the Grunewald and the outskirts of the suburban villas of the
West End."

From the open window of his apartment, Heinrich Zille had photograph-
ed the grounds of the Ringbahn with the Knobelsdorff Bridge to the
southwest as early as 1893. Four years later, he went out into the fields
and turned his camera onto the women returning home from picking
wood, almost as if looking over the same scene from the other direction.
Only a few pictures show them at rest. All his later pictures also avoided
the direct gaze into the camera. Zille photographed the women from
behind, thus making them 'faceless' but lifting their personal trials and
tribulations onto the level of a generalizable condition.

Schatten des Photo-
graphen: Heinrich Zille
photographiert Reisig-
sammlerinnen (oben)

46/47/48

That Heinrich Zille used the photographs from his series on wood gath-
erers as illustration models does not diminish their value as independent
artistic achievements. Already in 1903, his drawing *Wünsche* (Wishes)
appeared in *Simplizissimus*, which an editor, referring to Zille's origin,
probably supplied with a text in pseudo-Saxon dialect: "If ony I hadda
won big time, jist oncet! I woulda had myself a fine cart and then I coulda
carried that brush wood back home right comfortable." Today, the com-
pletely unsentimental directness of the photograph lends it credibility, in
contrast to the drawing. Zille's radical gaze bluntly captures the essential,
and he intuitively applies photography in terms of its intrinsic character-
istics. Decades before the proclamation of the New Objectivity, Heinrich
Zille was pursuing the idea of photography as unembellished documenta-
tion with his *Wood Gatherers*. In this sense, he is properly seen as an an
cestor of the modern spirit in photography.

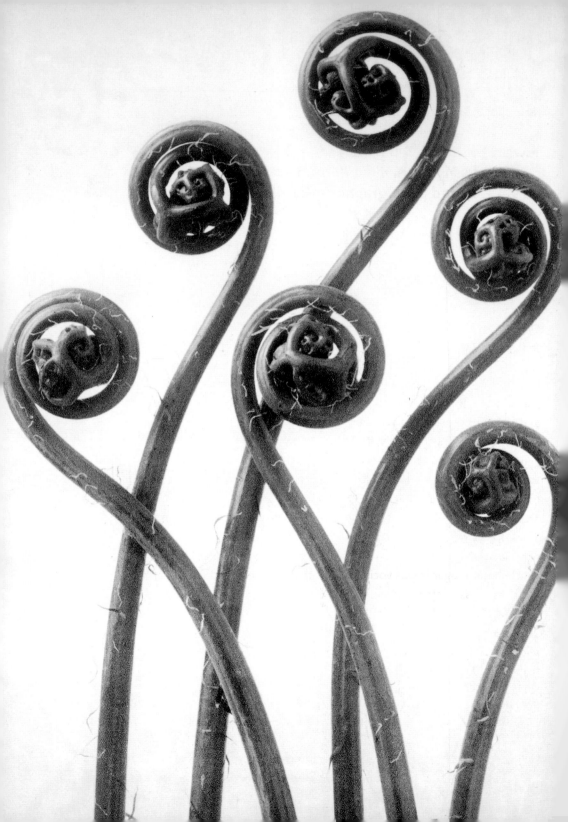

# Karl Blossfeldt
# Maidenhair Fern

ca. 1900

**Toward the end of the 1920s, Karl Blossfeldt's plates, published as *Urformen der Kunst*, became one of the most-discussed photographic books of the interval between the wars. His plant studies, originally completed with a view to the commercial art classes, fascinated the contemporary Avant-garde, and still influence both conventional and conceptual photographers today.**

A Herbarium from the Dark-room

Occasionally he stood before the camera himself, as in Italy in 1894. Or a year later, still lingering on the peninsula, this time wearing a simple felt hat, a white collarless shirt, and a plain light-colored suit of coarse material. His left hand is resting in his suspenders; his gaze, looking straight and resolutely into the camera. The combination of his wide mustache and a very relaxed posture makes abundantly clear that we are not looking at someone concerned with the socially impressive pose of a bourgeois citizen. This not-quite-middle-aged man is in fact engaged in substantiating himself as an artist. The two portraits have a good deal in common: both were taken out-of-doors with available lighting, and both are close to nature. And something more: the protagonist is always alone – not that he necessarily intended to imply that this solitude was a matter of principle. Nonetheless, the stance is noteworthy in this age during which the Avant-garde was vociferously withdrawing itself from the traditional business of art    and forming itself into secessions, or at least groups, whose members accordingly often posed themselves for group portraits in front of a camera. There can be no doubt about it: Karl Blossfeldt was an isolated figure in the bustling art world of the turn of the twentieth century. But perhaps he was not even this, if one uses the term 'isolated' to designate an individual who is first and foremost devoted to his own artistic will. What was Blossfeldt, then? A sculptor and modeler, a talented artist who primarily wanted to have his work – illustrations, plas-

ter casts, of photographs – comprehended within the context of learning and education. Until the mid-1920s, he was completely unknown as a photographer. In this connection, Gert Mattenklott even speaks of an "odd ball" who attempted to "make porcelain, but accidentally produced gold with his left hand," the porcelain in this case standing for photography and the gold for a book which overnight placed the inconspicuous Blossfeldt on a level with Sander and Renger-Patzsch as the most prominent representative of the New Objectivity in German photography.

Who was this Karl Blossfeldt, whose photographic plant studies, published in book form in 1928, achieved international recognition? We know something of the answer, even if the verifiable data of his active life, spent in the waning years of the Wilhelmine era and the Weimar Republic, are comparatively sparse and leave many questions open. In 1865, Blossfeldt was born into simple family circumstances in the town of Schielo in the Harz Mountains of Germany. He attended secondary school (Realgymnasium) in Harzgerode, and later completed an apprenticeship as a modeler in a foundry for art casting in Selketal. The attentive eye of the local pastor combined with a state scholarship enabled Blossfeldt subsequently to study art in Berlin. In 1884 he transferred to the teaching institute of the Royal Museum of Commercial Art, where Professor Moritz Meurer was particularly impressed with Blossfeldt's talent. Inspired by Semper and the writings of Erich Haeckel, the professor was exploring new paths in art teaching, and placed the replication of biological Urformen, or basic forms, at the center of his practically oriented pedagogy. This approach had its roots in the idea that nature provided important pre-formulated building blocks, so to speak, for architecture and product design. To build up a methodical collection of studies, the professor journeyed to Italy in 1890, accompanied by six graphic artists and modelers, including Karl Blossfeldt.

## Purism of design

Their main task was to gather pedagogical material by drawing and modeling plant parts that had been dried or pressed. We may assume that the technical possibilities offered by photography were soon enlisted in the work parallel to more traditional forms of reproducing images from nature. That the task of photography was handed over to Blossfeldt makes two points clear: he was already working with photography at the end of

the nineteenth century, and, more importantly, his photography was not by any means the outgrowth of an autonomous desire to be an artist, but rather stood indisputably in the service of a serious pedagogical project whose scope and content had not yet been formulated. Blossfeldt's inspiration was therefore not the pictorialism that was being vehemently discussed and pursued at the time in contradistinction to commercial photography. If the autodidactic photographer Blossfeldt sought anywhere for inspiration in his work with buds, leaves, and blossoms, then it was in the herbaria and plant books produced from the Middle Ages to the Renaissance. These old illustrations, in their attempt to demonstrate the compatibility of natural forms, evinced a purism of design that may well have pointed Blossfeldt in the direction of a similar photographic direction, which – without his initially desiring it – anticipated the pictorial language of what later came to be called the New Objectivity.

Blossfeldt remained in Italy for six years. Returning to Berlin in 1896, he first worked as an assistant to Professor Ernst Ewald at the Royal Art School and shortly thereafter became a private lecturer at the Museum of Commercial Art, where a course of instruction, "Modeling from Living Plants," had been set up at the initiative of Moritz Meurer. To the fragile preserved specimens and plaster models that were already a part of the program, we may be certain that Blossfeldt soon added photographic studies of the plants. Blossoms, buds, stems, leaves and umbels: Karl Blossfeldt patiently conjured plants and more plants onto the plates, using, it is said, a self-made camera for 2¼ x 3½-inch, 3½ x 4¾-inch, 5⅛ x 7-inch glass negatives. For Blossfeldt, photographing the plants signified work, and nothing more than work, as Rolf Sachsse has emphasized, for the artist was interested neither in cutting an artistic profile for himself nor in gaining revenue from the project. Only for teaching purposes did he use his pictures, in the form of large-format slides or prints pasted on the classroom walls. In short, until their publication in the middle of the 1920s, Blossfeldt's photographs enjoyed only a very modest and very temporal publicity.

## A technical herbarium in black-and-white: cool, clear

There is also another sense in which taking the photographs was work, especially when one associates the term with a certain tiresome monotony. From the beginning, Blossfeldt followed a standardized form of ar-

**Karl Blossfeldt**

Born **1865** in Schielo/ Lower Harz. Apprenticeship as sculptor and modeler. Lives from **1889** in Italy, Greece, North Africa. During this period he commences his systematic documentation of plants. **1896** return to Berlin. **1898** teaches at the Institute of the Arts and Crafts Museum. **1921** appointment as professor. **1926** first exhibition at the Nierendorf Gallery, Berlin. **1928** publication of his book *Urformen der Kunst.* **1929** participates in the "Film und Foto" exhibition in Stuttgart. Dies **1932** in Berlin

rangement. The plants are always placed against a neutral background and are illuminated by diffuse and evenly directed daylight that brings out their volume and three-dimensionality. He aims the camera directly, that is, vertically, at his subjects, from which he has removed visually disruptive shoots and leaves, as well as the roots. These are the photographic hallmarks that characterize his work: this is how he creates his specimens that are then enlarged between three and fifteen times — forty-five times on occasion, if necessary — to fill the pictorial space. In this manner, between 1890 and 1930, Karl Blossfeldt will complete 6,000 photographs, creating an enormous technical herbarium in black-and-white: cool, clear, and — without the artist realizing it — surrealistic.

Anyone who wishes may claim to find an extrapolation of the Art-Nouveau interest in floral designs in Blossfeldt's eight-fold enlargement of the fronds of a maidenhair fern (scientific name: *Adiantum pedatum*), or in the winding tendrils of a pumpkin, the base of an aristolochia stem, or a forsythia bud. But no interpretation could be more false. Both Blossfeldt and the turn-of-the-century reform movement that he supported were opposed precisely to Art Nouveau's "fashionable playing with mindless curlicues" (Richard Graul, 1904). Although perhaps not so vehement as Adolf Loos, whose equation of "ornamentation and crime" has become a slogan, Blossfeldt desired a turning away from the ubiquitous aestheticizing and decoration of the objects of daily life. If patterns were to be sought in nature, then let it be in the form of basic biological shapes whose tectonics were seen as providing a model for the combination of a 'natural' technology and aesthetics, of economics and material-social justice. This alone was what Blossfeldt attempted to illuminate through his visual researches. Half a century earlier, Semper's *Science, Industry, and Art* (1852) had recommended making the study of nature a duty for design of every sort. Now Blossfeldt was responding to this demand with a unique documentation deriving from possibilities offered by photography — a documentation whose influence is still evident today, perhaps even more in conceptual photography than in commercial art.

In the 1920s, Karl Nierendorf, founder of a Berlin art gallery as well as the "Catacombs" cabaret, became aware of Blossfeldt's work. Just how the clever Nierendorf — who had started his career as a banker in Cologne — discovered Blossfeldt for the realm of art remains hidden in the depths of history. All we know is that the first gallery exhibition of Blossfeldt's plant

Urformen der Kunst, *published in the English-speaking world as* Art Forms in Nature, Examples from the Plant World Photographer Direct from Nature. *Here the cover of the 4th German edition, Berlin 1948*

studies was mounted in April 1926; until that point – and this is worth emphasis – the photographs had never passed beyond the walls of the educational complex located in Berlin's Hardenbergstrasse. Through Nierendorf, Blossfeldt's photographic works appeared for the first time in an artistic context, and in this context they would later be received by the public. Although the response in the popular press ranged from positive to euphoric, the exhibit itself did not yet constitute the great 'breakthrough'. It was not until two years later that the renowned Berlin architectural publisher Ernst Wasmuth brought out Blossfeldt's book *Urformen der Kunst*. The effect was like a "thunderclap," in the words of a contemporary. The book "was to be seen in all the book stores, and the man whom many in the Hardenbergstrasse had looked upon as a friendly specimen of an extinct species – and whom some would gladly have chased out [of the academy] because they thought his two studios were a waste of space – this man had now become famous."

## Friends throughout the world

"The first edition," Karl Nierendorf announced proudly in the foreword to the popular edition of *Urformen*, "was taken up by the public in a manner that exceeded all expectation. The German edition was soon succeeded by an English and a French, and throughout the world, the work found so many friends that the publisher has now determined to release a popular edition." This first popular edition appeared in 1935, ironically a year in which important artists of the New Objectivity – a term first used by G. F. Hartlaub in 1925    had already fallen into disgrace. Nonetheless, this was not to be the last time *Urformen* would be brought to press. After the war, the book was again printed a number of times, and is said to have influenced commercial art teaching in West Germany into the 1950s.

The public's positive reaction to the work found resonance in the nothing less than euphoric reception by the critics, who immediately claimed Blossfeldt as a protagonist of a new manner of perception. Leading the pack of critical reviews was no less a figure than Walter Benjamin, whose critique appeared in the *Literarische Welt* of 23 November 1928, and became "probably the most cited review (J. Wilde). Critics, including such figures as Franz Roh, Julius Meier-Graefe, Max Osborn, and Curt Glaser, as well as authors such as Arnold Zweig and Hans Bethge, also discussed the work. The book, whose first edition moreover had sold out in eight

months, also received some negative criticism, particularly from the political left. Stanislav Kubicki, for example, writing in the *a–z*, a Rhineland magazine that reflected a socially progressive position, identified the basic assumptions behind *Urformen* in an understanding of form that was oriented on supposedly "natural principles of construction"; the truth is, he countered, that "almost all architectonic form derives from practical application...from the materials used, and from the purpose [behind it]. If we today discern a similarity between a Doric column and an enlarged photograph of a segment of horsetail, it is not at all because the horsetail constitutes the basic form of the Doric column. Rather, we have before us an accidental, quite amusing, but insignificant parallelism that tells us absolutely nothing." What Kubicki's commentary overlooks, however, is that Blossfeldt's book with its one hundred twenty full-page plates printed as greenish copper intaglio prints (*Maidenhair Fern* is Plate LV) had long since leapt over the author's initial didactic aim and had become a signal of visual modernity. Moholy-Nagy in particular expressed his reverence for the accomplishment when he presented Blossfeldt's botanic studies in the section of the epochal "Film and Foto" exhibit

*Pages from Bloss-feldt's* Urformen, *1948*

40

41

(1929) in Stuttgart. Whether Blossfeldt himself appreciated the radical newness of his activity is doubtful, when we look at the foreword he wrote to his second book, *Nature's Garden of Wonders* (1932), where he speaks of nature offering a model for the "healthy development of art," offering "fruitful inspiration," and providing an "ever-unconquerable fountain of youth." It is therefore, so to speak, only against the grain of Blossfeldt's philosophy of nature that postmodern photographers have adopted his work as a model, whether in terms of his conceptual, accretive, and comparative method of procedure, or in terms of his camera approach, which unconsciously conforms to the ideals of so-called Straight Photography. What is certain is that neither the comparative approach of the Bechers, nor the cool plant studies of Irving Penn, Robert Mapplethorpe, Reinhart Wolf, or recently, Kenro Izu, would be conceivable without the creative preliminary groundwork of Karl Blossfeldt. For this reason, Klaus Honnef has rightly granted him a place in the pantheon of twentieth-century photography: Karl Blossfeldt, an amateur photographer, untrammeled by the rules of the craft or the norms of art, was open to a new kind of perception that corresponded to a rational age.

80

81

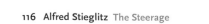

**Alfred Stieglitz** The Steerage

# Alfred Stieglitz
# The Steerage

**It is his most well-known work and, in his opinion, the most important. During a voyage from New York to Le Havre in the spring of 1907, Alfred Stieglitz photographed the steerage deck of the trans-Atlantic steamer Kaiser Wilhelm II. The aesthetic of the picture boldly anticipated what came to be called the New Objectivity in photography.**

One gazes at the gentleman wearing the straw hat approximately in the center of the upper third of the picture. This brightly gleaming headgear seems to have functioned as an especially important compositional element for Alfred Stieglitz: after all, he repeatedly made the so-called 'boater', which had become fashionable around 1880, into an unmistakable component of his pictures. One needs only to recall his photograph *The Ferry Boat* of 1910, where an entire group of young hat-wearers perhaps set off his desire to take a picture. Or a more successful variation of the motif, in which the light-colored headgear competes with a row of wooden bollards, painted white. Not that Alfred Stieglitz had any special interest in the hat styles of his age: to the contrary, the material world tended to leave him cold, unless it offered him usable 'raw material' for a photograph he was interested in taking. Stieglitz was no documentarist; the here-and-now had only a limited value for him. And if he once claimed that photography was his passion, and the search for the truth an obsession, then he was certainly not equating 'truth' with the quest after the internal contradictions of an age, society, or political system, such as contemporary photographers such as Jacob Riis or Lewis Hine were concerned with. For Stieglitz, truth implied rather a balance, a rightness, an equanimity within the picture itself; in other words, it was an aesthetic concept. Not that the social aspect failed to move him: according to his own testimony, it was precisely the sense of surfeit inherent in the bored

atmosphere of the First Class that was a part of what moved him during the steamship passage to Europe in 1907 to seek out the tween-decks of the Second and Third Class, where he took what is perhaps his most famous photograph, *The Steerage*. Typically, however, Stieglitz kept his distance, photographed downward from an elevated position. And, decades later, when he provided a remarkably comprehensive commentary to his picture, he was concerned exclusively with compositional, technical, and aesthetic questions. The social extremes evident in the picture in other words were the trigger, but not the goal, of his pictorial exploration. Stieglitz sought not to penetrate, but to aestheticize, the world by means of photography. He understood himself chiefly as an artist, an apologist for an autonomous photography, that served nothing and no one but the duty to be art.

Alfred Stieglitz was born in 1864 in Hoboken, New Jersey, into a German-Jewish family, his father having emigrated from Münden, near Hanover. The son possessed a contradictory spirit. He himself sensed these contradictions, and raised them consciously to the sine qua non of his restless, lifelong devotion to art, specifically, photography. In every person who is truly alive, he once declared, these contradictions are to be found; moreover, "where there are no contradictions, there is no life." In this sense, Stieglitz was an apologist for photography but, as an elitist in thought and deed, he lacked any real desire to popularize it. Stieglitz was an Avant-gardist with an almost nostalgic leaning toward craftsmanship; he was doctrinaire, but without a unified doctrine; he was feared, but ultimately powerless. As a critic, editor, publisher, gallerist, curator, go-between, instigator, impresario, and collector, he was probably the most brilliant figure in American art business in the new twentieth century. His role as a midwife to modern art in the broadest sense of the term is uncontested. In his excellent biography of the photographer, Richard Whelan claims that Stieglitz "is perhaps the most important figure in the history of the visual arts in the USA." Therefore, in the 1950s and 1960s, when New York finally replaced Paris as the world art capital, the revolution unquestionably owed its thanks to Alfred Stieglitz as the long-term result of his influence and effort, so to speak. It was he who introduced America to the European Avant-garde, and in turn fostered and encouraged American artists. But in spite of all this, he understood himself first and foremost to be a photographer. "When I'm finally judged," he once

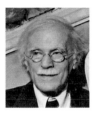

**Alfred Stieglitz**

Born **1864** the son of wealthy German immigrants in Hoboken/New Jersey. Studies in Berlin (engineering, photochemistry). **1883** first exposures. **1890** returns to New York. From **1893** editor of the journal *American Amateur Photographer*. **1902** editor of *Camera Notes*. **1902** founding of the Photo Secession. **1903–17** editor of the seminal periodical *Camera Work*. **1905** opening of the Little Galleries. **1907** tours Europe. Meets up with among others Heinrich Kühn. **1925–29** directs the Intimate Gallery **1929–46** directs the gallery An American Place. Dies **1946** in New York

said, "I should be evaluated primarily in terms of my own photographic work."

## In a sense always a pictorialist

As a photographer, Stieglitz is a giant. In today's market; his works easily bring in three hundred thousand dollars – when they come to market at all, that is. His œuvre is discussed in practically every history of the medium. And yet, his photographic creations still stand under the shadow of the artists that he publicized and fostered as his protégés: Edward Steichen, Edward Weston, Paul Strand, to name only three. Stieglitz does not appear in the 'pantheon' of the thirty most important photographers of the twentieth century established in 1992 by Klaus Honnef, who characterizes Stieglitz's work as "commercial photography – though of a high degree": a surprizing evaluation, insofar as Stieglitz succeeded in establishing pictorialism in the USA while he was almost simultaneously anticipating Straight Photography in works like *Winter, Fifth Avenue* (1893), *From the Back-Window, 291* (1915), or – precisely – *The Steerage*. In other words, at least twice Stieglitz was the leading figure in the artistic Avant-garde. Furthermore, it was he who raised the metropolis, modern civilization itself, to an object for art, introducing it into polite company, as it were. Skyscrapers, city canyons, rail and ship traffic all appear as motifs on an equal basis with classical themes such as landscape, genre, and nude photography. Stieglitz's œuvre even comprises examples of conceptual photography, if one considers his portraits of Georgia O'Keeffe, one of his later lovers, shot over a period of years, or his cloud studies, his so-called *Equivalents*, that he pursued almost obsessively. Admittedly absent from Stieglitz's photographs is the radicalism that his contemporaries such as Evans or Strand brought to their work. In a sense, Stieglitz remained a pictorialist, above all interested in adapting the classical rules of art to photography and to creating an elegant print. All of this applies specifically to *The Steerage*, a work at once ambivalently radical and affirmative. Stieglitz published the picture for the first time in 1911 in his magazine *Camera Work*; years later he designated it among his most important works. "If all my photographs were lost, and I were to be remembered only for 'The Steerage'," he once said, "I would be satisfied." In the spring of 1907 Alfred Stieglitz was forty-three years old. We can picture the artist, of whom so many portraits exist, as a respectable middle-

Camera Work, *edition from 1911, in which* The Steerage *was first published*

*Edward Streichen did the typography for the cover.*

aged gentleman with thick hair and a dark mustache, wire-rimmed glasses, and the skeptical gaze of the restrained misanthrope who has not yet given up the struggle against ignorance and poor taste. Although born in the USA, Stieglitz was strongly influenced by spending a number of school and university years in Germany. In particular, the lectures by Hermann Wilhelm Vogel, the inventor of orthochromatic film, greatly furthered his interest in photography. Stieglitz's first experiments with the camera stem from his Berlin period beginning 1882. He began to submit his work to photography contests and to write knowledgeable essays on the subject for international magazines. Upon his return to the USA, initially as editor of the journal *American Amateur Photographer* and later of *Camera Notes*, he became the apologist of an 'autonomous' photography, free from the service to any particular goals. His association with *Camera Work* (beginning 1903) and the Little Galleries at 291 Fifth Avenue (beginning 1905) provided him with influential forums for broadcasting his ideals. By 1907, he had also opened his doors to the fine arts, in particular to the work of artists like Rodin, Toulouse-Lautrec, Matisse, and Picasso. In the same year, Stieglitz himself undertook a voyage to Europe. In early June, acceding to the wishes of his wife, Emmy, he boarded the Kaiser Wilhelm II, the luxurious flagship of the Norddeutsche Lloyd lines. Along with his wife, daughter Kitty, and a governess, he brought along a Graflex for 4 x 5-inch glass negatives, and a single unexposed plate with which he was later to capture his famous 'tween-decks picture.

For photographers to speak about their individual creations is more the exception than the rule. Nonetheless, in 1942 – four years before his death – Stieglitz provided *The Steerage* with a longish commentary, which Wilfried Wiegand once with justice termed "the most precise description...ever offered on the creation of a masterpiece." Stieglitz begins his discussion with a description of the atmosphere in the First Class, which he hated: faces that "would cause a cold shudder to run down the spine," led him to spend the first few days at sea in a lounge chair on deck with his eyes closed. "On the third day," he continued, "I couldn't take any more. I had to get away from this society."

The artist moved "as far forward as the deck allowed." The sea was calm, the sky clear with a sharp wind blowing. "Reaching the end of the deck, I found myself alone, and looked down. In the steerage were men, women and children. A narrow stairway led up to a small 'tween-deck above,

directly over the prow of the ship. To the left was a slanted chimney, and from the 'tween-deck, a gleaming, freshly painted gangway hung down." Stieglitz noticed a young man with a round straw hat and the funnel leaning left, the stairway leaning right, "the white drawbridge with its railings made of circular chains – white suspenders crossing on the back of a man in the steerage below, round shapes of iron machinery, a mast cutting into the sky, making a triangular shape... For a while I stood there as if rooted, looking and looking. Could I photograph what I was feeling...?" Stieglitz hurried back to his cabin, grabbed his Graflex, and hurried back "out of breath and afraid that the man in the straw hat might have moved. If he had left his place, then I no longer had the picture than I had imagined earlier. The relation between the forms that I wanted to capture would have been destroyed, and the picture would have been gone." But the man was still standing there. Furthermore, neither the man wearing the suspenders nor the woman with her child on her lap had altered their positions. "Apparently," claimed Stieglitz, "no one had changed position. I had only one cassette with a single unexposed plate. Would I be able to capture what I saw and felt? Finally I pressed the button. My heart was pounding. I had never heard my heart beating before. Had I gotten my picture? If the answer was yes, then I knew I had reached a new milestone in photography, similar to *Car Horses* in 1892 or *Hand of Man* in 1902, both of which had introduced a new epoch in photography and perception."

In comparison with the euphoria that he later expressed, Stieglitz seems not to have been so certain in the beginning about the quality of the picture. How else can one explain the fact that the work that he designated as a milestone of photographic art appeared neither in the art photography exhibit in Dresden in 1909, nor in the Albright Gallery in Buffalo a year later. *The Steerage* was published for the first time only in 1911 in the form of a $7^3/_4$ x $6^1/_4$-inch photogravure in Number 36 of the legendary magazine *Camera Work* that Stieglitz edited. Earlier, the photographer thought he recalled showing the photograph to his friend and colleague Joseph T. Keily. "'But Stieglitz,' he protested, 'you took two pictures, one above and one below.'... It became clear to me that he did not rightly see the picture that I had taken." Even today, the photograph is regularly misunderstood as a visual witness to the masses of immigrants that were streaming to the USA around the turn of the twentieth century. In fact,

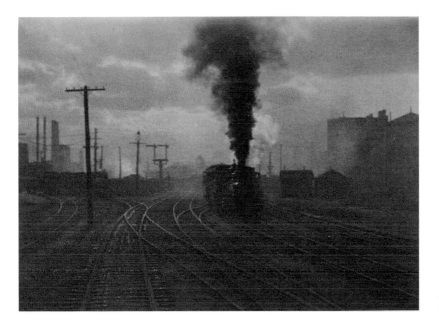

however, the ship is cruising in the opposite direction, and the people tra-
veling in steerage were in fact 'migratory birds' – manual workers and
craftspeople who, as Richard Whelan writes, "made the crossing between
Europe and the New World in two-year cycles." Stieglitz himself did not
comment on them – just as he did not seem interested in the entire
social aspect of his photography. He placed forms and structure above
any possible human implications – at any rate, the latter were not the
subject of his reflections. Thus, on the eve of the First World War, 'pure'
art was able to celebrate itself once more. Afterwards, it would be forced
to redefine its role in a new age and a new world.

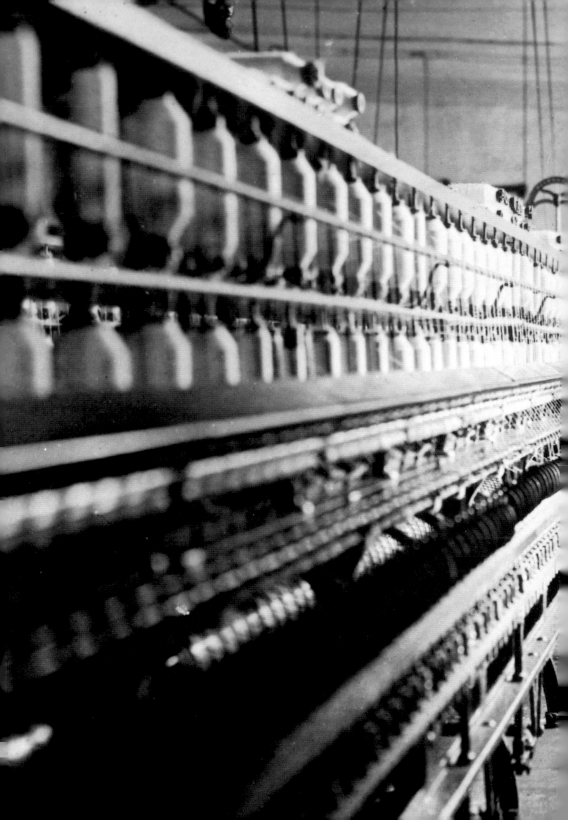

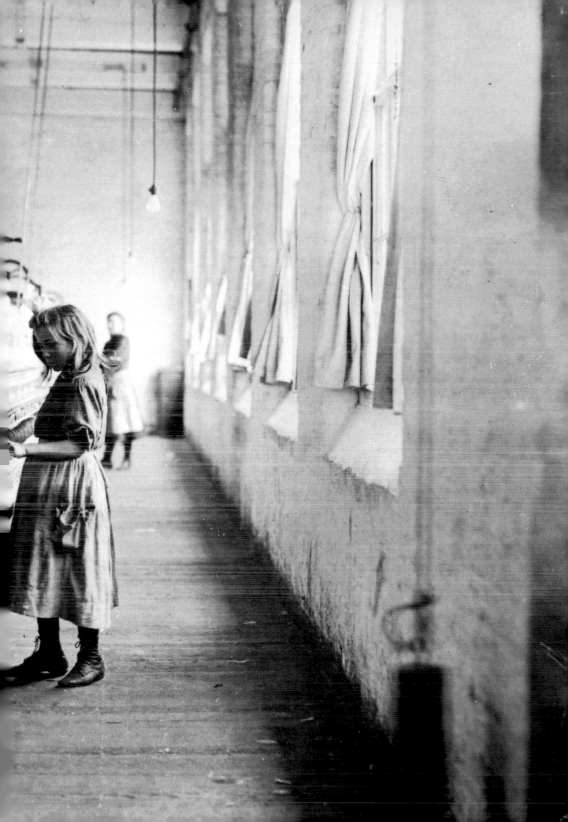

# Lewis Hine
# Girl Worker in a Carolina Cotton Mill

**Moments of Child-hood**

**The work of the American photographer Lewis Hine unites moral perspective and social engagement to a media-conscious application of photography. Especially in his cycle on child labor in the USA, he rose beyond pictorial journalism to create an early model for a humane photojournalism.**

He is said to have been always extremely exact with the inscriptions on his photographs. For he realized: only when all coordinates passed muster – place, time, situation, etc. – would his photographs be believed, and only then could he defy the skeptics and doubters, of which American politics and economy seemed to provide so many. To undertake all that was necessary so that his work might produce results – this was the so-to-speak motive force behind his at times mortally dangerous, and in any case physically and intellectually grueling, activity. "There were two things I wanted to do," the artist once explained; "I wanted to show the things that had to be corrected. I wanted to show the things that had to be appreciated." In these terms, Lewis Wickes Hine numbers among the leading figures of socially oriented documentary photography.

### His vision is always fine and often superb
*Girl Worker in a Carolina Cotton Mill*, 1908, is the simple authorized title of the original $4^1/_2$ x $6^1/_2$-inch photograph. Specific mention of the name of the factory or the date and hour of the photograph are absent. Hine's concern here is with the condition in general: the presentation of child labor in factories, coal mines, saw mills, southern cotton fields, and northern urban streets and squares. What is most important for him is that the situation appear believable, that the photograph be accepted as evidence, as a document of record – a term that, moreover, first arose in the middle of the 1920s in John Gierson's review of Robert Flaherty's film

*Moana* in the *New York Sun* of 8 February 1926, in which a similar impulse is termed a 'documentary'. Hine himself never used the expression. "A good photograph," as he once defined it, "is not a mere reproduction of an object or a group of objects, – it is an interpretation of Nature, a reproduction of impressions made upon the photographer which he desires to repeat to others."

With this statement, Hine gives a hint that he was to some extent willing to set up a scene. In the end, he was not simply seeking the naked pictorial evidence, but rather an effect in the sense of a clear, but moving, emphasis. Even in his very first series of photographs of immigrants on Ellis Island he had focused on individuals or couples from the mass of people, arranged them before a neutral background, and – one suspects – asked them to hold still a moment until the heavy Graflex camera was ready for the take and the flash powder was in the pan. Beyond a doubt, the complexity of the equipment itself required a certain level of the photographer's attention. In addition, however, Hine was always concerned also with composition, a fact that is often forgotten in the face of the simplicity of his pictures. "Certainly, Hine was conscious also of the aesthetics of photography," writes Walter Rosenblum, one of the top experts on Hine's work. "His files contain beautiful prints as well as mediocre ones. But when he organized a photograph, the effect was right. Considering the range of subject matter, the difficulties of site and execution, his vision is always fine and often superb."

A girl standing in front of a spinning machine. We can only guess at her age, for Hine did not reveal it, even though he often conducted short interviews with the subjects of his photographs, inquired about their circumstances, and asked their age. Sometimes he measured the size of the children he photographed against the buttons on his vest in order at least to estimate their ages later. This child, whom we could well imagine at a school desk, is probably between eight and ten years old. Technically, she is not alone in the photograph, but the grown woman in the background plays no role in the scene, even if she seems to be attentively watching the process of taking the photograph. The child herself is unselfconsciously working at the so-called ring spinning machine, a device invented in the USA at the beginning of the nineteenth century. The fact that at the moment of the photograph the child has paused in her work deprives the picture of none of its authority. She is hardly looking happily into the cam-

**Lewis Wickes Hine**

Born **1874** in Oshkosh/Wisconsin. Father dies in an accident during his early childhood. From **1892** various jobs, including heading a team of cleaners. Teacher training at the University of Chicago. Moves to New York. Supply teacher at the Ethical Culture School. **1903** turns to photography. **1904** immigrants on Ellis Island is his first major project with an educational purpose. **1908** quits teaching. A large scale survey commissioned by the National Child Labor Committee on the topic of child labour. **1918** documentation for the Red Cross on the impact of the war on Europe. **1930** photo-reportage on the building of the Empire State Building. **1932** publication of *Men at Work*. Dies **1940** in New York

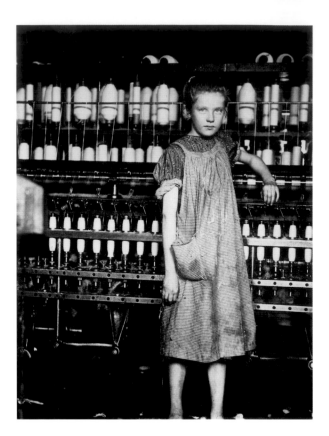

era, nor does the state of her apron indicate any especially blessed living conditions.

In 1907, that is, shortly before Hine made his photograph, a government inquiry reported that there were no fewer than 1,750,178 children between the ages of ten and fifteen years working in American factories, mines, farms, or what we would today designate as service industries (such as shoe-shine, newspaper and errand boys). Moreover, sixty-hour weeks were no rarity, in spite of child labor being forbidden by law in many of the states. In Pennsylvania, for example, children under the age of fourteen could not work in the mines, and in other fields, a minimum age of nine years had been set. Such regulations, however, were constantly being evaded, on the one hand because the booming economy required much labor, and on the other because the sheer poverty widespread among urban and city dwellers caused many families to rely on even their youngest members for financial help. For these reasons, proof-of-age certificates were forged, or false information was provided by the parents. Hordes of underage children drudged away as 'breaker boys' in mines where accidents were a common occurrence, and where darkness, cold, wet, and bad air leading to life-long health problems were a certainty; these Hine also addressed in his pictures. "Whatever industry saves by child labor," Hine recognized very early, "society pays over and over."

### The worst form of institutions exploiting children

Some of the very worse conditions seem to have existed in the cotton mills of the American South – in North Carolina, South Carolina, and

Georgia – where official statistics record that almost fifty percent of all workers were approximately ten years old. The cotton mills are "the worst form of institutions exploiting children" according to the newspaper *Solidarity*, the "Official Organ of the Worker, Health, and Death Insurance of the United States of America," in 1907. The paper cited also the large rate of illiteracy among the children: 18.8 per cent of all working children between the ages of ten and fourteen were designated as illiterate, that is, they could neither read nor write. "How many of these innocent children, created as human beings in order to populate this planet, cannot attend school because they lack shoes, and above all, enough to eat! Because the mothers must go to work in place of the thousands of fathers who have been killed in the factories, and cannot look to their children's nourishment!"

The problem of child poverty and child labor was known, statistically proven, and the object of public debate. In 1904, the National Child Labor Committee (NCLC) under the direction of Owen R. Lovejoy had formed a private organization with waving banners against the "greatest crime of modern society," the enslavement and exploitation of minors. A jointly issued journal bearing the title *The Survey* was founded to create the necessary publicity, but seems in fact to have drawn little attention to itself before Hine appeared. It was only with the help of his photographic testimony that the opposition to the often-excoriated evil gained the momentum necessary for reforms, new laws, and stricter oversight, and finally the abolition of child labor. "Although we cannot attribute a specific reform to a certain photographic image, the mass of Hine's powerful photographs could not have failed to make an impact." (Stephen Victor) Commissioned by the NCLC, Hine produced more than five thousand photographs between 1906 and 1918. He took his pictures in the factories of Cincinnati and Indianapolis, visited the glass works and mines of West Virginia and the textile mills of North Carolina. He visited homeworkers in New York, and observed the night newspaper-sellers in New England. And this was not his first and largest photographic inquiry. As early as 1904 Hine had documented the arrival of European immigrants on Ellis Island. We can assume that Lewis Wickes Hine, born into modest circumstances in Oshkosh, Wisconsin in 1874, and orphaned at an early age, had refined his self-taught photographic knowledge while attending the New York Ethical Culture School – that is, he learned the use of the

Graflex and Fachkamera for $3^1/_2$ x $4^3/_4$-inch and $5^1/_8$ x 7-inch glass negatives, the handling of the rather dangerous flash powder, and in particular the dialogue with those whom he intended to portray in the midst of the fateful circumstances of their lives. In this effort, his humor, wit, human understanding, and love of mankind undoubtedly aided him – together with his often-noted dramatic talent that is supposed to have gained the versatile Hine entry into factories whose doors were officially closed to outsiders. There are stories that he regularly assumed the role of a Bible salesman, an insurance agent, or an industrial photographer to ease his way around the occasionally militant factory guards. After all, "to most employers, the exploitation of children was so profitable that nothing could be permitted to end it." (Walter Rosenblum)

Hine's photographs appeared in the publications of Hine NCLC, in particular in *The Survey*. They became the motif for posters and appeared in exhibitions and slide-lectures with whose help Hine and the NCLC attempted to reach a broader public. Hine's photographs, in other words, were part of an advanced concept in a double sense: they looked to modern media to effectively raise the desire for social reform.

## Photography as a contemporary visual means of communication

More recent photographic criticism customarily poses Hine as the antithesis of Alfred Stieglitz – an opposition that is only partially justified. Stieglitz attempted to create recognition for photography as a modern art form by arguing for elaborate noble-metal processes and an elegant finish. Exactly these qualities seem not to have interested Hine, at least not in the sense of an artful photographic practice. "When he became school photographer in 1905, he didn't know anything about cameras, lenses, technics," according to his biographer Elizabeth McCausland. "Even today, at 64, he will say with a naiveté both lovable and sad: 'How is it that you make so much better prints than I do? Is it because your enlarger is better than mine?'"

To attempt to conclude that Hine was not interested in technical photographic questions would be false, however. What fascinated him was photography as a contemporary visual means of communication; what he ignored was the concept of the 'fine art print' as defended by the photographic community oriented on Stieglitz and his circle. And precisely here may lie the explanation for the low estimation that Hine and his work

have received up to the present time. For example, Edward Steichen, chief curator for photography at the Museum of Modern Art in New York, showed no interest in 1947 in Hine's estate after his death in 1940. And even the evaluation of Susan Sontag, who held Walker Evans to be the most important photographic artist to have concerned himself with America, reveals something of the skepticism that art criticism has shown toward Hine's œuvre primarily directed to social criticism. And yet Hine was in fact interested in formal and aesthetic questions and had, moreover, developed a visual vocabulary that could hold its own at the height of art-photography debates, being wholly based on the qualities intrinsic to the medium. In particular his early workers' portraits, according to Miles Orvell "endow their commonplace subjects with a dignity not in terms of an art-historical tradition, but in terms of a new vocabulary of representation that erased the existing ethnographic and documentary traditions of portraiture and established a new procedure for representing working-class character." But there were very few who recognized this truth during Hine's lifetime, not even a Roy Stryker, who roundly rejected Hine's application for work with the FSA project. Thus Lewis Hine died in 1940, impoverished and forgotten. He who had devoted himself lifelong to the social welfare of others had finally become a welfare case himself.

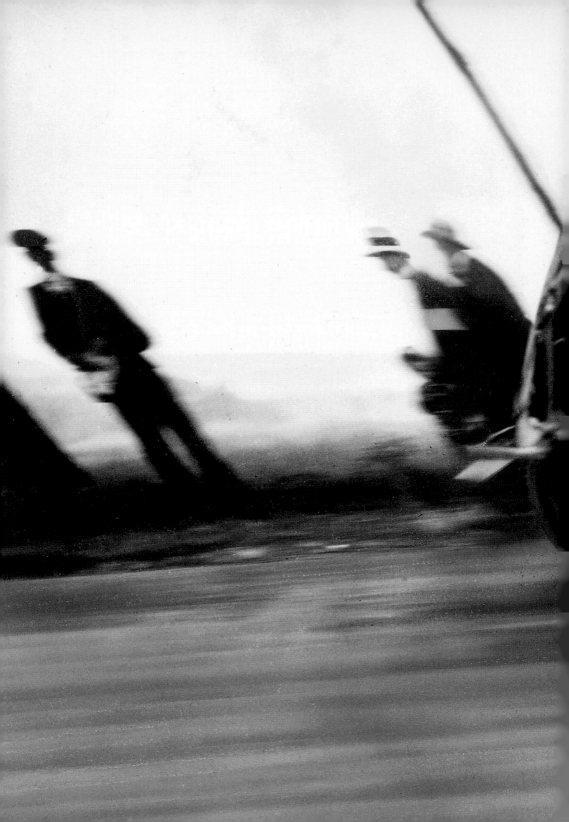

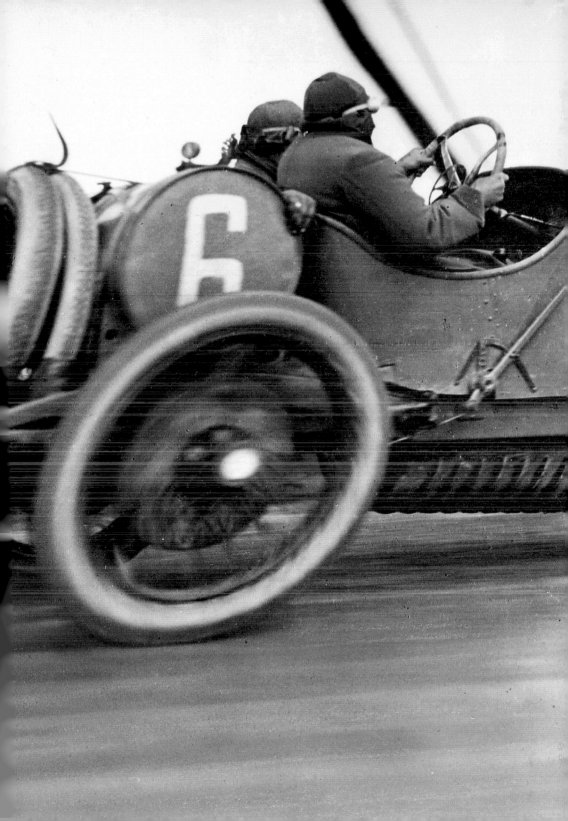

# 1912

# Jacques-Henri Lartigue
# Grand Prix de l'A.C.F.

**The Tempo of Our Times**

**Automobile racing was a keenly watched spectacle at the turn of the 20th century. Roaring down the open highways, various makes of autos strove to demonstrate their performance ability. At the Grand Prix of the "Automobile Club of France" in 1912, the young Jacques-Henri Lartigue succeeded taking a photograph that we interpret today above all as a metaphor of the speed of the technological age.**

He loved classy automobiles – but what boy of his age isn't? He watched as the first aviators swooped boldly through the skies, witnessed the advent of unheard-of technical innovations, and was fascinated by the age's intoxication with speed. Unlike most of his contemporaries the small Jacques Haguet Henri Lartigue (as he was christened) participated directly in the events. His family was wealthy – for a time, it was accounted the eighth richest in France – and his father, a well-known railroad director, banker, and publisher, exhibited a marked interest in novelty. As early as 1902 the family acquired its first automobile, a Krieger, followed by a Panhard-Levassor designed by Million Guiet. Next came a Peugeot, and finally, as the high point of the private fleet, a Hispano Suiza – before the family's wealth melted away after the First World War. But for now we're looking at a happier age. It was the fabulous era of the Belle Epoque, and the Lartigue family entertained itself with all the diversions appropriate to their class: Sundays spent in the Bois de Boulogne or, often enough, at the auto races conducted on the periphery of Paris. And here, if the enjoyment proved to be fleeting, it could at least be captured on film.

### A thing one must love immediately
Père Lartigue himself was apparently an enthusiastic amateur photographer. "Papa makes pictures," wrote Jacques-Henri in his *Mémoires*

*sans Mémoire*. "Photography is a mysterious affair. A thing with an odd smell, bizarre and peculiar to itself – a thing one must love immediately." In 1901, at age seven, Lartigue received his first camera. "Papa," he noted, "seems like Dear God to me. He says, 'I'll give you a regular photography apparatus as a present.'" This gift proved to be a heavy wooden camera for 5 1/8 x 7-inch glass negatives, a device typical for the times, but in reality much too cumbersome for the slight and delicate Lartigue. But he quickly grasped his new medium as a technical refinement of that "angel trap," as he called it, by which Jacques-Henri, almost as soon as he learned to walk, had begun to record images of the visible world around him: "I blink my eyes quickly three times, spin myself around, and whoosh!, the picture is mine." In this way, photography very soon became an important tool of visual exploration for him; it was not merely a pastime, but the young boy's serious endeavor, which already extended from carefully composed exposures through the development and enlargement processes in the dark room.

## With inexhaustible enjoyment and a remarkable eye

Lartigue photographed his own room, his toys, and furniture; then came the house, garden, servants, Mama, Papa, and his older brother Zissou. He broadened his horizons constantly. This is, after all, what he had always sought to do: to stop the process of things, to be able to brake the speed of time, to be allowed to remain a child for whom, so to speak, the world of technology unfolded itself as an over-sized arsenal of toys. Lartigue photographed automobiles – again and again automobiles. He captured airplanes on his plates. And zeppelins. And he did all this with inexhaustible enjoyment and a remarkable eye – but above all with an amazing, seemingly intuitive understanding of the iconographic characteristics of his medium. Decades later, no less a figure than John Szarkowski would claim, ""These pictures are the observations of genius: fresh perceptions, poetically sensed and graphically fixed."

Lartigue was eighteen years old when he succeeded in shooting what has since become his probably most famous photograph. The date is 25 June, 1912. The family has set out to watch the Grand Prix of the Automobile Club de France near Le Tréport. At this time, France was still the leading automobile nation: more than two hundred auto manufacturers courted the favor of prospective customers. In comparison the USA sported

**Jacques-Henri Lartigue**

Born the scion of a wealthy Parisian family in **1894** at Courbevoie. First camera at age eight, first exposures of his own at age ten. **1915** studies art in Paris. Numerous exhibitions in thirties Paris. Friendship with among others Picasso and Cocteau. **1963** first exhibition of his photography at the Museum of Modern Art, New York. First exhibition in Germany in **1966** at the "photokina". **1970** publication of *Diary of a Century*, edited by Richard Avedon. **1979** he donates his photo archive to the French state. **1984** culture Prize of the DGPh. **1986** officer of the Légion d'Honneur. Dies **1986** in Nice

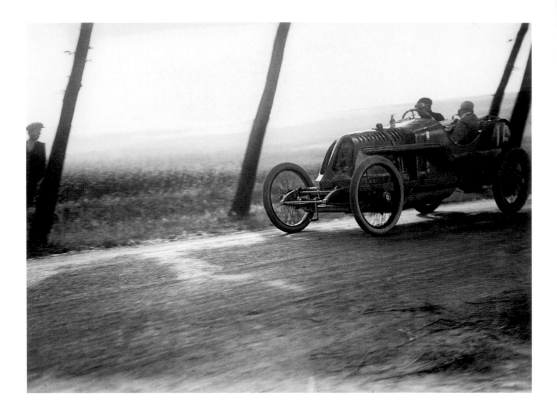

*Jacques-Henri Lartigue:* Grand Prix de l'A.C.F., *July 12, 1913*

about a hundred such firms, England around sixty, and Imperial Germany slightly more than thirty. Until the end of the 1920s, France would remain Europe's largest producer of motorized vehicles and, until the start of the First World War, its most important exporter. France also presided over the publication of the first journal devoted to the automobile, *L'Auto* in October 1900 – a publication to which, one might add, Jacques-Henri Lartigue held a subscription since 1908. Moreover, it was also in France that the first highway races took place.

The Paris–Rouen race (1894) is generally accounted as the first of its kind. Additional races and test runs stretched from Paris to Toulouse, or from Paris to Ostend and Vienna. The routes were laid out on the dusty, largely unsurfaced country roads. As a result, flat tires – caused by the horseshoe nails that littered the roads – were the norm, and broken axles were no rare occurrence. Even fatal accidents were often an unavoidable part of the spectacle that Lartigue – in spite of tragic incidents – could not tear himself away from. "At 2 p.m.," he confided to his diary under the

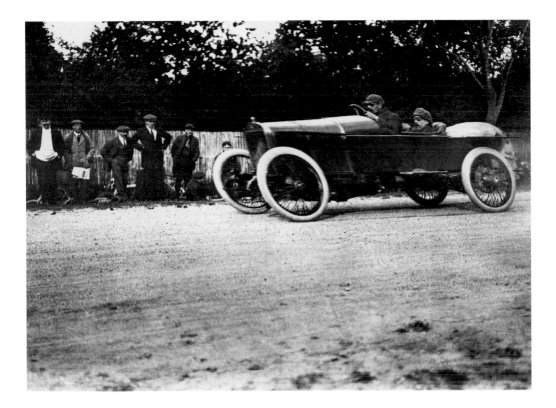

heading of June 25, 1912, "no more cars in sight. The race is over for to-day. In the hotel we were informed that Hemery is alive and well. It got Colinet. He's hurt, his mechanic dead."

## A picture accorded no significance for many years

*Grand Prix de l'A.C.F.* – so the official title of the picture – was taken during the course of 26 June 1912. This was the second day of the Grand Prix, and the photograph is one of a total series of one hundred sixty-nine shots. Lartigue was now photographing with an Ica Reflex for $3^1/_2$ x $4^3/_4$-inch glass negatives. The original camera bears the serial number 489955 and sports a Zeiss Tessar 1:4.5 150 mm objective. The peculiarity of this comparatively large camera with a top-mounted focusing screen is its horizontal focal-plane shutter, which accounts for the elliptical form of the rear wheels in the photograph. Obviously Lartigue followed the motion with his camera. This is why the surroundings are blurry, whereas in contrast the body of the automobile and the two drivers are sharply in

focus. That the entire radiator of the Schneider-made automobile is sacrificed to the framing of the shot can hardly have been the intention of the auto-maniac Lartigue, who otherwise always strove for the total image. It seems that for many years the photographer accorded no significance to the picture. Moreover, he even judged it a mistake. How else can one explain the fact that only a single, badly processed print, which furthermore is strongly clipped on one corner, has survived? The small $4^1/2$ x $6^3/4$-inch vintage print is today in the possession of the Gilman Paper Company in the USA. A further, clearly later print is included in an early volume of Lartigue's carefully kept albums. But the years between 1919 and the 1960s were rearranged and expanded in the album: one cannot exclude the possibility that the photographer added the picture in the context of its increasing international fame.

At the beginning of the 60s, Jacques-Henri Lartigue was, true to his philosophy of life, a happy individual – and was utterly unknown. As a photographer, he was an amateur in the literal sense of the word, a person who, without aiming at 'art', explored his personal environment. As a painter, he had won recognition only to the extent that occasionally one of his works found a courageous buyer. An invitation drew Lartigue to the USA in 1962. And what happened here is something that Lartigue's third wife, Florette, would later refer to as a "miracle." She accompanied her twenty-six-year-older spouse on the passage to the USA. And because she understood how boring life can be on board a freighter, Florette Lartigue carried along a stack of photographs in order to retouch them on board. Upon arrival in New York, the couple met with Charles Rado, who had operated a photo agency in France before the war and now worked as an agent in the USA. "In the course of conversation," recalled Florette Lartigue, "the discussion turned to photography, and Jacques mentioned that he himself had been taking photographs since childhood." Charles Rado's interest was piqued; the Lartigue's handed over to him the stack of photographs the couple had brought. And Rado promised to publicize them. In fact, on the very same day, he offered them to the illustrated magazine *Life*. A little later he showed them to John Szarkowski, who had recently stepped into Edward Steichen's shoes as director of the photographic department at the Museum of Modern Art. Looking back, Szarkowski described his first encounter with the works: "What I then thought to be the œuvre consisted of two large scrapbooks and a sheaf

"Hooked on Speed": Lartigue's Grand Prix de l'A.C.F. *as the lead for the* Life *portfolio, November 29, 1963*

of fifty-two loose prints; the scrapbooks contained a wide variety of prints – little yellowing contacts and bigger prints, including enlargements, on a wide variety of papers... The prints were plunked down on the pages of the album with concern chiefly for the maximum utilization of every square centimeter of the sheet, and with a heartwarming freedom from obedience to any design principle that I knew of, either traditional or modern. The pictures themselves seemed to me astonishing, primarily because of the simplicity and grace of their graphic structure. They seemed – like a fine athlete – to make their point with economy, elegance, and easy precision. It seemed that I might be looking at the early, undiscovered work of Cartier-Bresson's papa...."

Szarkowski was swept away by the material and immediately decided – even though it was the work of an entirely unknown sixty-eight-year-old amateur photographer – to devote a single-man show to Jacques-Henri Lartigue at the Museum of Modern Art. In the first place, Szarkowski reckoned, as a young director he could offer a truly new discovery right from the start. And secondly, Lartigue's photography provided the argumentative groundwork for the development of a new symbolic language for which Szarkowski would later in fact become the apologist. Lartigue, as he reasoned consequently in the catalogue "saw the momentary, never-to-be-repeated images created by the accidents of overlapping

*Lartigue's famous picture was used for Stern 52/1979 as both the cover and the lead for a portfolio.*

shapes... This is the essence of modern photographic seeing: to see not objects but their projected images."

## No end to the accidents or miracles

Lartigue's first exhibition, or, as we would call it today, his coming-out as a photographer, opened on 1 July 1963 at the New York Museum of Modern Art and subsequently went on tour to sixteen other cities in the USA and Canada. The slim exhibition catalogue containing a total of forty-three photographs presented the *Grand Prix de l'A.C.F.* on page twenty-seven. The picture was also featured, although strongly cropped, by the illustrated magazine *Life*, which devoted a comprehensive section to Lartigue in its issue of 29 November. But the end was not yet in sight of the 'accident' – 'miracle' – of Lartigue's equally sudden and world-wide fame as chronicler of the Belle Epoque (as he was initially termed, at any rate). On 22 November 1963, John F. Kennedy was assassinated in Dallas. "We responded to the news with a shock in which there was also a mixture of disappointment," recalled Florette Lartigue. "We were certain that the pages intended for Jacques would now be sacrificed to the dramatic events of this autumn of 1963. In fact, however, photographs of the tragedy in Dallas and Jacques' untroubled pictures shared the pages of *Life*. Precisely because of the title story, this issue now sold like wildfire." Moreover, as Mary Blume underscores, it was one of the highest-selling issues of *Life* ever. Thus Jacques-Henri Lartigue advanced, in a sense overnight, to become "one of the world's most famous photographers, and its best loved." Since then, particularly his photograph *Grand Prix de l'A.C.F.* has been repeatedly reprinted and reproduced. The picture is to

be found in practically every work on Lartigue. Almost as a matter of course it provides the cover motif of the small Lartigue issue in Robert Delpire's paperback edition *Photo Poche*. The German magazine *Stern* (52/1979) selected the picture as the title page to announce a special automobile issue. Recently, the picture has been increasingly in demand by mathematicians, psychologists, and phenomenologists, who have used it to illustrate particular facets in their respective areas. Even company reports have often had recourse to the picture in order to visualize the dynamics of economic life. For Lartigue himself, however, the shot was merely one of approximately one hundred thousand. As a child, he had once complained: "I am sad not to be able to photograph odors." Nonetheless, he succeeded in capturing the times. The *Grand Prix de l'A.C.F.* remains a primary exemple of the power of perception, of our ability to see in an age of supersonic speed: an image for the tempo of our modern technological world.

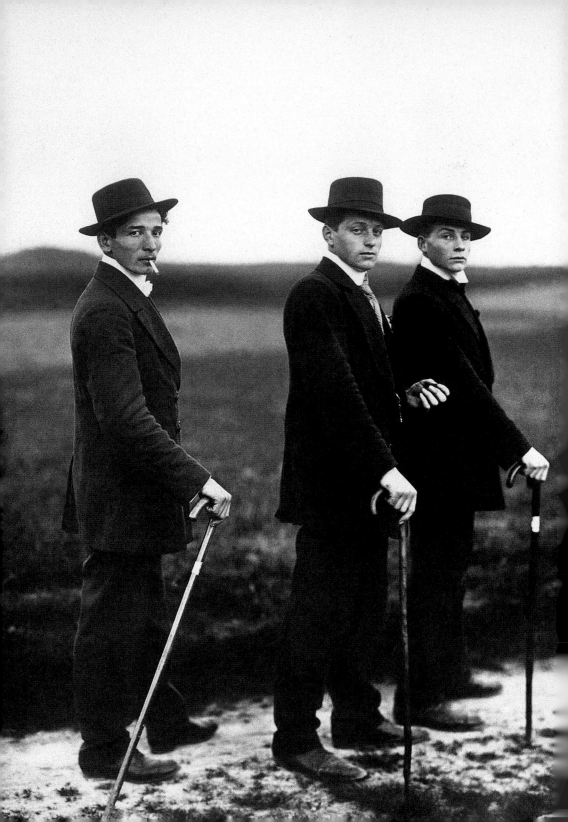

# August Sander
# Young Farmers

**1914**

In 1910, August Sander began a systematic attempt to portray and typologize his fellow countrymen. The project, undertaken wholly at his own initiative and expense, found support only among his painter friends in the Rhineland area of Germany. His book *Antlitz der Zeit* was outlawed and partially destroyed by the Nazis in 1936, but Sander's ambitious undertaking today ranks among the most outstanding contributions to the New Objectivity in photography.

**A Profile of the People**

The parameters are fairly clear: August Sander titled his picture *Young Farmers*, 1914, thus indicating both the date of the photograph and the social status of the subjects. But whether the picture was made before or after the outbreak of the First World War, felt by many of his contemporaries to mark the end of an epoch, seems not to have been particularly important to Sander. Where the three young men are coming from, or where they are headed, also remains unknown. Are they brothers? friends? neighbors? It has often been claimed that the three are on their way to a dance in town – which at first seems a reasonable assumption. But surely the weekend or even the end of the workday offer additional grounds for 'young farmers' to wash themselves, shave, comb their hair, and draw the dark suit out of the closet. At any rate, we can be sure that the trio have a common goal. But for the moment they let it slip from their minds, as they stop and turn, looking at us directly almost as if on command – and thus make us aware of another person, also present in the photograph without being visible: the man behind the camera.

At the time of the photograph, August Sander was thirty-eight years old. As the Wilhelmine Empire neared its end, he had the reputation – along with Hugo Erfurth and Hugo Schmölz – of being one of the leading pho-

tographers in Cologne. In Bavaria or Prussia, he probably would have sought the status of court photographer; in the bourgeois Rhineland, however, he attempted to prove that he was among the best through the quality of his work and the correspondingly high prices he could ask for it. Was it the loyalty of the Rhineland bourgeoisie to the older, long-established studios, or was it Sander's understanding of the recompense he deserved for his photographs, that soon forced him to look for customers outside of Cologne? In any case, it is certain that Sander increasingly found his clientele in the nearby Westerwald region – a situation that could hardly have displeased him, since Sander, who had come from a simple background himself, had a great understanding and appreciation for the area and undoubtedly struck up a sympathetic relationship with the farmers who lived there.

Antlitz der Zeit, in English: Faces of our Time, featuring "60 German people". Here the cover of this, Sander's first book, as published 1929 by Kurt Wolff in Munich

Whether the negative numbered 2648 was the response to a portrait commission, we do not know. Nonetheless, the name of a certain Family Krieger is known – and nothing else, except that they were to be sent a dozen copies of the photograph: "12 cards" is noted by hand on the negative – probably a reference to printing them in the 4 x 6-inch cabinet format. What might at first glance be misunderstood as 'instantaneous' photography is therefore actually the result of a carefully composed scene, probably preceded by Sander's intensive preparatory conversation with the subjects. In other words, he and the young farmers would have chosen the location of the photograph, decided in favor of a group portrait, and set the specific day and time. Neither the fact that the photograph was made in the open air, nor the make and age of the camera – which first had to be carried to the site, fastened to a stand, and set up for the photograph – probably struck the men, inexperienced as they were with standard photographic practice, as unusual. Sander himself explained nothing: in his remarks and theoretical explanations he was always remarkably reticent. In 1959, however, at an exhibition in the Cologne Rooms of the German Society for Photography, Sander, asked to comment on his picture, offered only technical details about the camera and chemical processes – not at all unusual for the times, but amazing for the "artist" August Sander. "Ernemann portable camera 3/18," he noted about the Young Farmers; "built-in Luc-shutter release – time exposure no diaphragm – lens: Dagor, Heliar, Tessar, old lenses – Westendorf-Wehner plates – development meteol-hydrochinon or pyro daylight."

## Clothes as an expression of social change

Sander's *Young Farmers* (original negative format: $4^3/_4$ x $6^1/_2$ inches) contains a good many oddities and contradictions. But these characteristics are probably precisely what make the picture so interesting and have made it into the most-reproduced and most well-known of Sander's photographs. Sander, it is often said, constructed his pictures in archetectonic fashion, giving his subjects sufficient time to present themselves in an arrangement that felt right to them. In fact, the group portrait of the three young farmers oddly creates a simultaneously static and active impression, almost with a trace of the cinematic about it. A cigarette is still hanging loosely from the lips of the young farmer to the left; the one in the center is holding a cigarette in his hand, and the young farmer on the right has possibly already thrown his away. The young man to the left appears as if he had just stepped into the picture, an impression underlined by his walking-stick held at a slant, whereas the young farmer in the background seems petrified into a pillar, his cane boring perpendicularly into the earth, his gaze steadfast, even dogged. Whereas the other two have just arrived, he is already a making a face as if he wants to move on.

Contemporary art critic and theorist John Berger, who has subjected the photograph to a penetrating analysis, points out another peculiarity: the dark suits of the three young men. In terms of cultural history, the suit is an 'invention' of the bourgeois era. The replacement of courtly dress by a special costume developed specifically in England is above all a reflection of deep social changes. With the 'suit', the new bourgeois elite had created an appropriate uniform for itself: simple, practical, and egalitarian. At least for men, what was now important was less social prestige, as signified by an elaborate wardrobe, than economic success in capitalist competition. The suit is, as Berger expresses it, a costume for the "serene exercise of power" in which a man with a powerful build developed through hard bodily labor, appears "as if he is physically deformed." And yet, as Berger correctly emphasizes, "no one had forced the farmers to buy these pieces of clothing, and the trio on their way to a dance are obviously proud of their suits." They are even wearing them with a certain dash in Berger's interpretation – an attitude which nonetheless does not relieve the contradiction, but rather lends an ironic accent to the picture.

**August Sander**

Born **1876** in Herdorf/Siegerland. **1890–96** works as a pit boy at the Herdorf iron mines. First contact with photography at this time. Works in a photographic studio in Trier. Years of travel. **1910** moves to Cologne. Studio in Cologne-Lindenthal. **1914–18** military service. Contact with the group the Rheinische Progressive. Conceives his long-term project *People of the 20th Century*. **1929** publication of his book *Antlitz der Zeit*, (Faces of our Time). His studio in Cologne is destroyed during WWII. **1951** one-man exhibition at the "photokina" in Cologne. **1955** participates in "The Family of Man" exhibition at the Museum of Modern Art, New York. **1961** culture Prize of the DGPh. Dies **1964** in Cologne

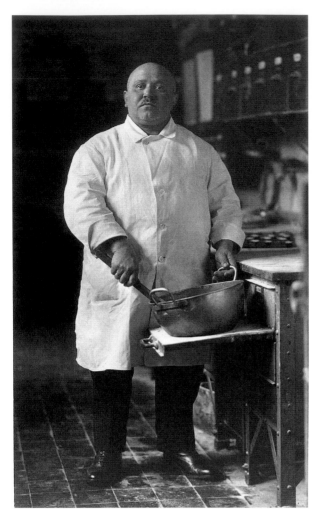

*August Sander:*
Pastry Cook, *1928,*
*from:* People of the
20th Century

## The real end of the nineteenth century

The year 1914, when the photograph was made, undoubtedly marks a break in modern history. This was the year in which Sigmund Freud published his outline *On the History of the Psychoanalytic Movement*, Duchamp presented his "ready-mades" for the first time, Walter Gropius designed the Faguswerke that was to be so important for modern architecture, Albert Einstein developed his theory of relativity, and Charlie Chaplin made his first movie. For many historians, the first year of the war marks the real end of the nineteenth century and the beginning of the increasing technological development, rationalization, tempo, and loss of individuality that characterize modernity. August Sander was almost certainly well aware of the change of paradigms – all the more so because leading exponents of what later came to be known as the "Rhine Progressives" – Heinrich Hoerle, Franz Seiwert, Anton Räderscheidt – numbered among his closest friends. Sander was born in 1876 as the son of a mine carpenter and small farmer in Siegerland. Whereas in his early years as a professional photographer he had subscribed entirely to an artistic approach to photography devoted to painterly ideals, by the time he moved to Cologne in 1910, he had transferred his allegiance to what he called "exact photography," without softening effects, retouching, or other manipulations. These principles hold both for his commercial photography and for his ambitious portfolio *Menschen des 20. Jahrhunderts* (*People of the 20th Century*), that has long

been recognized as one of the most significant contributions to the New Objective photography of the 1920s .

The idea of creating a cycle of portraits was not necessarily new. Nadar, Etienne Carjat, and the German photographer Franz Hanfstaengl had already introduced the ancient idea of a pantheon of important contemporaries to photography. At the beginning of the twentieth century, Erna Lendvai-Dircksen and Erich Retzlaff were pursuing 'folk' or pseudo-racial investigations, while their contemporary Helmar Lerski experimented with the formal vocabulary of photographic Expressionism in his *Köpfe des Alltags* (Ordinary heads). August Sander's intentions were considerably more modern that those of his forerunners, in that he not only took notice of the immense social transformations that had occurred during the process of industrialization, but also made them precisely the basis of his social inventory of the German people. Sander has long been criticized for not organizing his work according to the latest knowledge of modern social sciences, but rather arranging his social inventory into seven groups and forty-five folders according to a more or less antiquated model of professional distinctions and hierarchies. The high number of representatives of certain 'types' does not at all correspond to the social reality of the Weimar Republic. In fact, the labor force as such is hardly included in Sander's concept, whereas farmers, taken as a group that the photographer respected as 'fundamental', were clearly overrepresented. The Cologne newspaper *Sozialistische Presse*, for example, apostrophied the figure of a huntsman as "ripe for a museum" and posed the question whether the work really had anything to do with representative examples of the twentieth century. Sander's work, which remained unfinished, may in the end deserve particular criticism in view of the photographer's claim to ('pseudoscientific') neutrality (Susan Sontag). But as a contribution to photography it remains unique.

Approximately as the First World War drew to a close, August Sander turned his attention seriously to his self-appointed task, which he soon provided with the ambitious and encyclopedic title *People of the 20th Century*. Later he explained, "People often ask me how I came up with the idea of creating this work. Seeing, observing, and thinking – that answers the question. Nothing seemed more appropriate to me than to use photography to produce an absolutely true-to-nature picture of our age." Different from the artistic photographic portrait, Sander's work was

not an attempt to visualize inner values, but of interpreting social reality by photographic means. Farmers, craftsmen, laborers, industrialists, officials, aristocrats, politicians, artists, 'travelers', to name a few of Sander's categories, step before the camera. Most of his subjects he found in his immediate Rhineland environment, a fact which today gives his work a slight regional flavor. Formally Sander followed his own, self-determined standards, which do not necessarily make the photographs similar, but lend them a compatibility to each other. That is, he photographed by available light, and usually in a setting in which the subject felt at home. He handled his subjects as complete figures, selected a wide frame, and avoided extreme upward or downward shots that were popular in photography at the time. That in the case of *Young Farmers*, as with the majority of Sander's motifs, only a single negative plate exists indicates that the photographer was relatively self-assured in his visual dialogue with his protagonists.

## Commercial harbinger of the larger projected work

August Sander first garnered attention to himself in an exhibition in the Cologne Arts Association in 1927. Whether *Young Farmers* was on display in the show we do not know. But it is certain that older works, originally created as commissioned portraits, were in the meantime being gathered and selected with a view toward the creation of a portfolio that was already in the works. Sander now came to the attention of Kurt Wolff, who had previously published Renger-Patzsch's highly regarded book *Die Welt ist schön* (*The World Is Beautiful*), and in 1929 *Antlitz der Zeit* (*Faces of our Time*) appeared as a first volume, intended as a commercial harbinger of the larger projected work to follow. According to an advertisement sheet included with the work, the volume of selections was able "to convey only a weak idea of the extraordinary size and range of Sander's full achievement. What is does show, however, is the ability of the photographer to get to the core of the people that he places in front of his camera, excluding all poses and masks, and instead fixing them in a completely natural and normal image." In *Antlitz der Zeit*, a full-page print of *Young Farmers* appears as Plate VI. In other words, Sander had already selected the picture to be a part of the core of the œuvre that in the end was supposed to comprise approximately five thousand plates. Exactly what caused the National Socialists to destroy the printing plates and the remainder of

*Antlitz* in 1936 remains still somewhat unclear; similarly, we do not know why, after the war, Sander did not bring his project to a conclusion that would have satisfied him. It is clear that the photographer, now in his seventies, no longer possessed the same energy as earlier. Furthermore, his post-war living quarters in Kuchhausen, with only modest laboratory equipment, were certainly not the ideal place to finish a portrait work of this dimension in an appropriate manner. Nonetheless, Sander continued to work on the project for the rest of his life, taking up old photographs into the collection, and rearranging them all. In the process, he was accompanied by an increasingly interested public. The photo kina

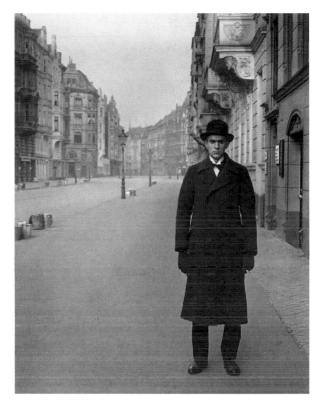

*August Sander: The Artist [Anton Räderscheidt], Cologne, 1926, from: People of the 20th Century*

fair exhibits of 1951 and 1963, as well as Sander's participation in Steichen's "The Family of Man" project (1955), were important early stations in his more recent reception. That the world had changed since the conception of the project can hardly have missed Sander's notice. Where youthful gestures of protest might express themselves in 1914 through cigarettes and a hat askew, the world after 1945 sported chewing gum, rock and roll, jeans, and petticoats as signs of the modern spirit. In a certain sense, August Sander had lost hold of 'his' people.

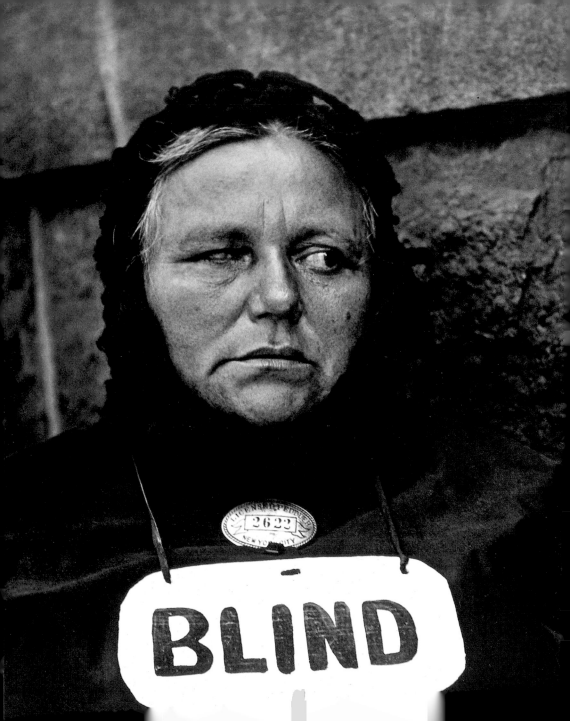

# Paul Strand
# Blind Woman

**"Strand is simply the biggest, widest, most command-ing talent in the history of American photography" – thus has Susan Sontag described her countryman Paul Strand. Especially in his early work, he transcended the limits of pictorialism and thus prepared the way for modern photography in the USA.**

Manhattan
People

New York, autumn 1915. A young man enters Gallery 291 on Fifth Avenue. This is not his first visit: he had become acquainted with the legendary gallery while he was a student at the Ethical Culture School, and perhaps even now he might have been thinking of his former teacher, Lewis Hine, who had initiated the class excursion of young amateur photographers to the gallery. Decades later, Paul Strand would report that Hine: "took us all down to a place called the Photo-Secession Gallery at 291 Fifth Av-enue, where there was an exhibition of photographs. I walked out of that place that day feeling, This is what I want to do in my life... That was a decisive day."

In 1915, Paul Strand was twenty-six years old. He had graduated from the Ethical Culture School, and was earning a living in his father's import busi-ness. In addition, he already spent a Wanderjahr in Europe and was now a member of the New York Camera Club. He was sure of his goal, but he had not succeeded in establishing himself as a commercial photographer or through his free-lance work. He had returned from Europe with well-composed landscapes in the painterly tradition of pictorialist photography. With his *Garden of Dreams/Temple of Love* (1911) he had won praise from fellow amateurs at exhibits in New York and London. Realizing that such artistic ventures were hardly sufficient, the self-critical Strand sought ad-vice from recognized exponents of artistic photography such as Clarence H. White and Gertrude Käsebier. "They were very sweet to me as a young fellow, but not very helpful." It was in fact Alfred Stieglitz himself, the

great apologist of artistic photography in the USA, who became an important mentor and helpful adviser to the young man. "I used to go and see Stieglitz about once every two years. I did not go there to bother him unless I had something to show. He was a great critic for me."

In this autumn of 1915, Strand had reached that point once again. He selected a number of more recent works to show Stieglitz. Since his last visit, the young photographer had visited the path-breaking Armory Show with works representing the European modern and had furthermore acquainted himself with the art of van Gogh, Cézanne, Picasso, and Braque. Influenced by Cubism as well as the documentary projects of Lewis Hine and the advice of Alfred Stieglitz, who was himself coming ever nearer to a straight photography, Strand had turned to urban themes and a more rigorous way of seeing. Of course, by this time, cityscapes were nothing new to photography; one has only to look as the works of Karl Struss (*New York*, 1912), for example, or Alvin Langdon Coburn (*House of a Thousand Windows*, 1912), or Alfred Stieglitz (*The City of Ambition*, 1910). Strand, however, was the first to create a valid synthesis of contemporary themes and artistically mature vision appropriate to the photographic medium. His pictures, as Maria Morris Hambourg once stated: "were tough, surprising, and had intimate weight." We have a pretty clear idea just which motifs Paul Strand presented to his mentor on this autumn day in 1915: *Fifth Avenue and 42nd Street, City Hall Park*, and *Wall Street*. And we also know Stieglitz's reaction. "We were alone in the Gallery," recalled Paul Strand. "He was very enthusiastic and said: 'You've done something new for photography and I want to show these.'" Stieglitz kept his word; shortly thereafter, in March 1916, Paul Strand had his first exhibit at 291 – the gallery that one can justly claim to be the most important forum of the Avant-garde in the USA. For Strand, it was, so to speak, the breakthrough. For the art of the camera in the USA, in the words of Helmut Gernsheim, it was the beginning of a new epoch: the "era of modern photography."

## The search for the greatest degree of objectivity

Europe was already caught in the throes of the war in which the USA became an active participant in 1917. The mood of the country had already begun to change: out of the dismay, there emerged a growing self-confidence. "In the ferment of World War I, there was also a great deal of unrest

in America," recalled Paul Strand. "It was a time of new thinking and new feeling about various forms of culture, sharpened later by the catastrophic Crash of 1929." We can only speculate about what might have inspired Strand in this age of intellectual upheaval to begin portraying anonymous people in the streets of New York. He himself always defended the series, which many consider his best work, with the desire to photograph people "without their being aware of it." But it is hardly imaginable, according to the critic Milton W. Brown "that this series of memorable and psychologically probing studies could have been the by-product of a technical gimmick." Are these photographs indeed concerned merely with a cheap effect? Insofar as Strand in a sense "stole" his portraits, had he not freed himself from traditional portrait standards: interaction, visual dialogue, the possibility of setting one's own scene? What is certain is that Strand, with the help of specially fitted cameras (initially with a side-mounted objective, later with a prism lens) was largely able to photograph without being noticed. And this anonymity also became the guarantee of what he was meanwhile striving for: the greatest possible degree of objectivity. But Strand was neither concerned with creating a sociogram of New York society (the series is too small in scope), nor did he make a claim to journalism (for this, the images are too indefinite in their historical context). Strand sought and found characters of everyday life, drew simple people into the center of his photographic attention, thus making them the unconscious 'object' of a psychological investigation.

Strand opened his cycle in Five Points, the slum where Jacob Riis had also worked. He photographed on the Lower East Side and around Washington Square. Seventeen of Strand's portraits have survived, including *Man in a Derby* and, precisely, *Blind Woman*, a picture that Walker Evans termed brutal, but in a positive, cathartic sense: Nothing, according to Evans, had as great an influence on his own photography as Paul Strand's work. In a somewhat exaggerated comparison, one might say that just as the First World War caused a break in painting – a turning away from the pictorial aesthetic that had exhausted itself in formalism – Strand single-handedly brought about a new era in the USA with the Cubist-inspired structure of his photographs: machines pulled into the frame, unposed portraits. Strand's work, according to Alfred Stieglitz, is 'pure': "It does not reply upon tricks of process... The work is brutally direct. Devoid of all flim-flam; devoid of trickery and of any 'ism'; devoid of all attempt to

## Paul Strand

Born **1890** in New York as the son of Bohemian immigrants. Works till **1911** in his parents' shop. During this time devotes his attention to photography. **1909–22** member of the Camera Club. **1916** first exhibition in Stieglitz's Gallery 291. **1917** major presentation of his photos in *Camera Work* (in its last issue). **1920** experimental film *Manhatta*. **1922–32** works chiefly as a freelance camera man. **1932–34** Mexico. **1935** Moscow. *Time in New England* as his last photographic project in the USA. **1950** moves to France. **1952–54** Italy. **1954** Hebrides. Devotes especial attention during his later years to nature studies around his home in Orgeval. Dies there **1976**

mystify an ignorant public, including the photographers themselves. These photographs are the direct expression of today."

## Excluding all situational or anecdotal perspective

A blind woman with a cardboard sign hanging from her neck. What is more disturbing here – the obvious physical deficit, or the written notice calling attention to it? In one sense, the picture is tautological, but there is a system to the tautology. In a hectic age, and specifically in a metropolis, anyone wanting to call attention to her infirmity must provide it with an exclamation point. Cynical as that may sound, the cynicism redounds upon the head of the society that gives the handicapped no other choice but to assure survival through public demonstration of her 'fault' – in other words, to make capital out of the infirmity. Stanley Burns in *A Morning's Work* calls attention to the dramatic situation of amputees and other cripples – for example all those injured in work-related accidents – in America at the turn of the twentieth century. Many of these people were forced to earn their income by selling their own photographic portraits, the public always took an interest, according to Burns, in the misfortune of others. Whether the blind woman is in fact selling something or only holding her hand out we don't know. The photographer intentionally kept the frame of the photograph small, thus excluding all situational or anecdotal perspective – an approach which at the same time eliminates any feel of pity such as otherwise might be aroused by the sight of a forlorn blind soul amid the stone canyons of New York. The photograph decisively turns its back on all that is sentimental or maudlin. The picture is also 'straight' in its reduction to only a few determining formal elements. There is for example the simple sign, dominating the composition like a title added to the photograph and reminiscent of the denunciatory 'INRI' hung over Christ in the Christian topos. Similarly, there is the comparatively modest oval of the metal license tag bearing the number 2622, which was issued by the City of New York, and gave the recipient the right to sell door-to-door. And finally there is the fleshy, clearly asymmetric face, darkly vignetted by some sort of shawl, and the lifeless eyes. These elements, in combination with the photograph's directness, without any attempt at photographic beautification, constitute a drastic presentation that would have shocked contemporaries viewers, accustomed as they were to non-committal pictorialism, Decades later, Strand remained

*Paul Strand:*
Man in a Derby,
1917

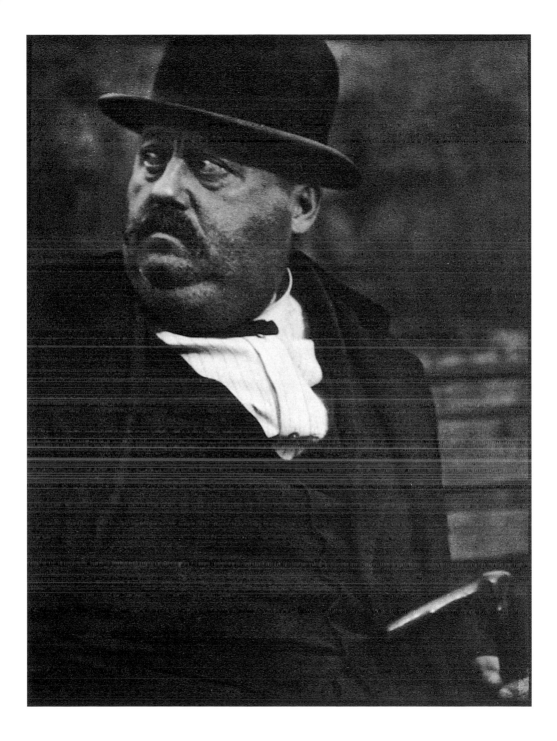

impressed by the woman's dignity and recalled that she had "an abso-
lutely unforgettable and noble face." He did not inquire after her name
or story.

It is doubtful that Strand – in contrast to Lewis Hine, for example – inten-
ded to make a symbolic gesture for social reform. Although the artist
always understood himself to be a politically thinking man, open toward
movements of the times (it is well known that he later took an interest in
Communism), the context in which the picture first appeared, in the form
of a 13$^{3}$/$_{8}$ x 10$^{1}$/$_{8}$-inch platinum print (today in the Metropolitan Museum,
New York), suggests that Strand's only interest in revolt was in the realm
of art. The *Blind Woman* was not a part of the first Paul Strand exhibit
organized by Stieglitz at his 291 gallery in 1916; but in the following year
the picture already reached a broader international public when Stieglitz
devoted the entire final double edition of his influential journal *Camera
Work* to Paul Strand. In addition to *Blind Woman*, the final Number 49/50

presented five further street portraits, views of New York, graphically conceived object studies, and an essay in which the photographer formulated his aesthetic credo. Strand's belief in an unfalsified, unmanipulated straight photography was not necessarily new, for the art critic Marius de Zayas had argued in 1913 for a use of the camera composed for "the objective condition of the facts". But Strand's explanations and arguments were delivered simultaneously with convincingly believable pictorial evidence.

Since its first publication in *Camera Work* in 1917, *Blind Woman*, together with the photographer's other street portraits have been accounted as "Strand's most exciting work," in the words of Alan Trachtenberg. Helmut Gernsheim called them "living fragments from the great kaleidoscope of everyday life." Similarly, in his history of street photography, Colin Westerbeck claimed that every street photographer surely knows *Blind Woman* and has learned from it. The question arises then, why the young Paul Strand gave up this kind of photography as early as 1916, never to return in later years. Did working with a 'hidden camera' suddenly seem immoral to him, as one critic surmises? One thing is certain: "His later images are magnificent," according to Milton Brown, "yet they don't have the journalistic quality that the early ones have."

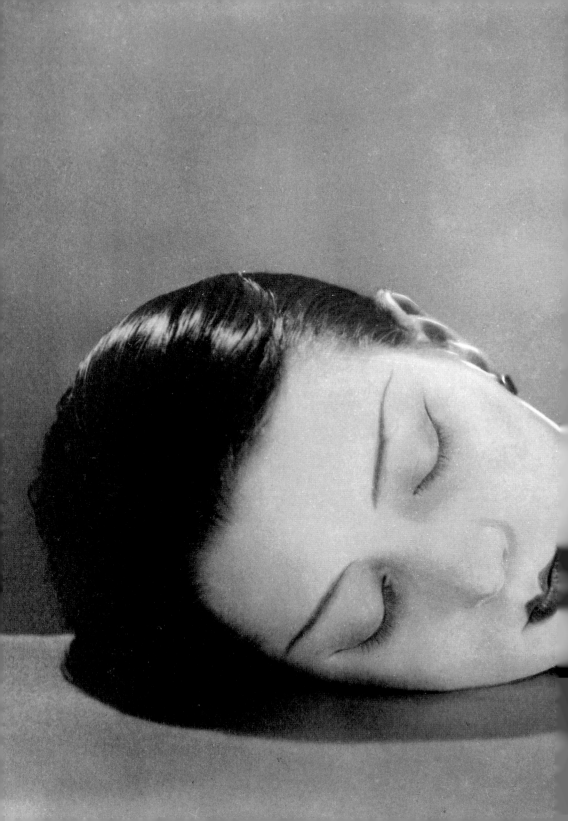

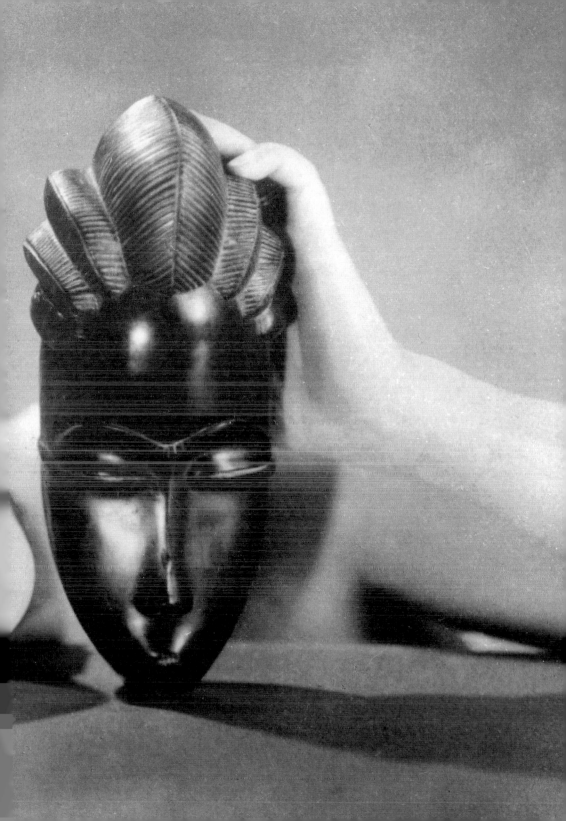

# 1926    Man Ray
Noire et blanche

**Kiki with the Mask**

**Painter, graphic artist, writer, experimenter with 'ready-made' art – throughout his life, the American artist Man Ray oscillated among various disciplines. Nonetheless it was primarily as a photographer that he achieved fame as creator of a richly varied œuvre in which the photograph serves less to illustrate reality than to express the artist's surrealistically inspired images, fantasies, and visions.**

This picture is found in every catalogue, every exhibition of Man Ray's work. In addition to *La Prière*, *Violon d'Ingres*, *Les Larmes*, and a series of more-or-less experimental portraits of Ray's Paris artist friends, the image is among his best-known photographs. The picture was already included in the catalogue of 1934, Man Ray's first programmatic summary in book form. The artist himself accounted the originally square photograph, cropped into various formats, as one of the core works of his photographic production of the 1920s and early 1930s – an evaluation still shared today by exhibition organizers, writers, as well as art dealers and gallery owners. When Klaus Honnef put together his *Pantheon of Photography in the Twentieth Century*, Man Ray was represented by *Noire et blanche* as a matter of course; similarly in the catalogue to the large and highly respected Man Ray retrospective in 1998 in the Grand Palais in Paris, where *Kiki with the Mask* formed the upstroke as it were to a discriminating aesthetic discussion of his photographic œuvre. And as far as the international art market is concerned, by the middle to end of the 1990s, *Noire et blanche* had turned up at auctions on three occasions, making the headlines every time. In the process, that had undergone fairly minor cropping print brought in a prodigious $206,000 at Christie's in 1995, just as the year earlier an unnamed buyer had paid $320,000 for Man Ray's probably most prominent photograph as a vintage print. Last

but not lease, in 1998, a collector – once again at Christie's – was prepared to pay no less than $550,000 for the motif in the form of a diptych, making *Noire et Blanche* into one of the most sought-after treasures in the international photographic trade.

## The same sleep and the same dream

About the picture itself and its creation we know little. Man Ray, born Emmanuel Radnitzky in 1890 in Philadelphia, was by no means an artist who spoke willingly about his work. Even his comprehensive autobiography published in 1963 avoided discussing concrete pieces. It is clear, however, that the photograph was made at the beginning of 1926 in Man Ray's studio at 31 rue Campagne Première, which the now-successful portrait artist had opened four years earlier in Paris, his adopted city of residence. The photograph was first published on 1 May 1926 in the French magazine *Vogue* under the title *Visage de nacre et masque d'ébène* (Pearl face and ebony mask). The picture appeared again two months later in the Belgian Surrealist magazine *Variétés* (No. 3, 15 July 1928), now under the title *Noire et blanche* (Black and White), and once more, in November of the same year, in *Art et décoration*, this time with a text by Pierre Migennes: "The same sleep and the same dream, the same mysterious magic seem to unite across time and space these two female masks with closed eyes: one of which was created at some point in time by an African sculptor in black ebony, the other, no less perfect, made up yesterday in Paris."

## The opposite of a rapid-fire shooter

Man Ray was in the habit of giving his photographic and all other creations ringing titles ever since he had visited the legendary New York Armory Show in 1913. À propos Marcel Duchamp's *Nude Descending a Staircase*, Man Ray had concluded that without its provocative title, the picture would hardly have received all the attention that the press and public paid it. Whereas *L'enigme d'Isidore Ducasse*, *Retour à la raison*, and *À l'heure de l'observatoire* belong in this sense to the most striking and inventive of Man Ray's titles, at first glance *Noire et blanche* seems in contrast to be hardly more than a simple description, even if, from the perspective of Western culture, which normally 'reads' from left to right, the correct reference would have to be *Blanche et noire* – a title valid in fact

**Man Ray**

Born Emmanuel Radnitzky **1890** in Philadelphia/Pennsylvania. **1911** moves to New York. Friendship with Stieglitz and Duchamp. First photographic reproductions of his art works. **1916** first portraits. **1921** moves to Paris. **1922** opens a studio in Montparnasse. First Rayographs. **1929** first solarisations. **1934** publication of his book *Man Ray: Photographies*. **1935–44** fashion shots for *Harper's Bazaar*. **1940** return to the USA. Waning interest in photography. From **1951** back in Paris. **1966** culture Prize of the DGPh. Dies **1976** in Paris

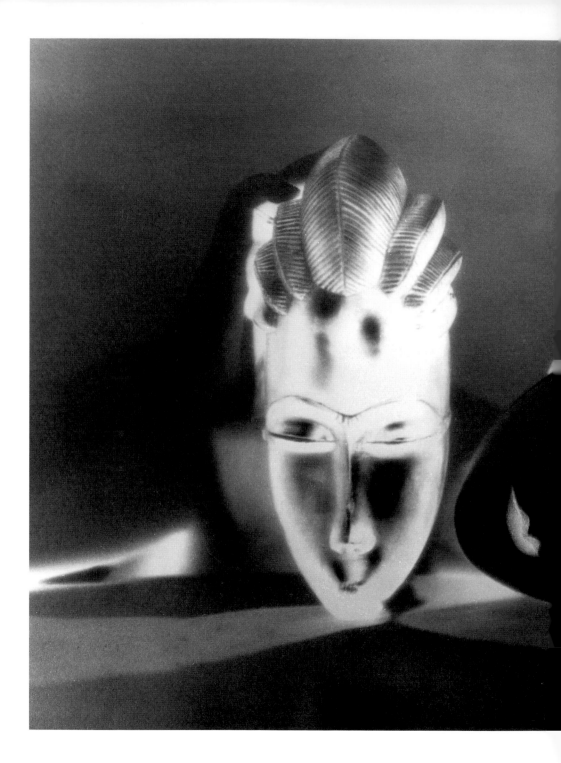

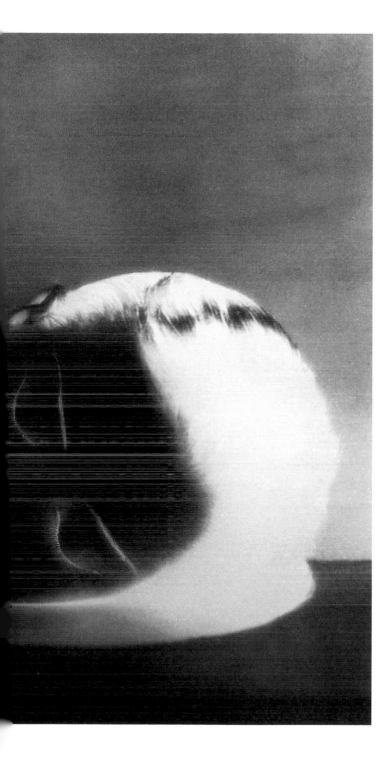

Noire et blanche, *1926: interestingly Man Ray also produced a reverse print from the negative.*

Visage de nacre et masque d'ébène: Man Ray's photograph first appeared under this title, in the French edition of Vogue in May 1926.

for the negative of the picture (which of course presents the image in reverse).

Man Ray, who began photographing as an autodidact in 1914, was initially concerned with achieving an adequate reproduction of his own painting and art objects. As a photographer, he was cautious – the opposite of a 'rapid-fire shooter', as Emmanuelle de l'Ecotais points out. Even his preference for working with a $3^1/_2 \times 4^3/_4$-inch plate camera required a carefully thought-out and economical method of procedure. Especially in the face of these hindrances, May Ray must be accounted an extraordinarily productive photographer: no fewer than twelve thousand negatives and contact prints were turned over alone by Man Ray's last wife, Juliet, to the French nation. Among them were several variations of *Kiki with the Mask* – pictures that prove that Man Ray had in this case been initially unsure of the valid formulation of his pictorial idea and that he reached the final composition only after passing several stages.

This was not the first time that Man Ray gave West African art a determinant role in his work. As early as 1924 in the creation of *La lune brille sur l'île de Nias*, he had photographed an unidentified young woman next to a sculpture of a Black African, admittedly without reaching a convincing formulation of an image that barely arose above the illustrative. Two years later, *Noire et blanche* confirmed his continuing interest in the art of 'primitive' peoples, which in fact had had an extremely great influence

precisely on the Avant-garde after 1900 (Expressionists, Fauvists, Cubists). Ray himself had first become acquainted with African art around 1910 in Alfred Stieglitz's New York gallery 291, and in his autobiography, African art is significantly mentioned in the same breath as the artistic expressions of Cézanne, Picasso, and Brancusi. The mask in this case, moreover, is a work in the Baule style, supposedly one of those cheap replicas which even in those days were available everywhere.

In the studio, Man gave form to his dialogue between 'white' and 'black', between an inanimate object and a supposedly sleeping female model (Kiki, in reality Alice Prin, once more taking on the role), in front of a neutral background. Shortly after moving from New York to Paris in 1921, Ray had become acquainted with the young woman, a favorite nude model in artistic circles, whose defiant charm was precisely such as to appeal to Man Ray. In his memoirs, the photographer described at length his first meeting with 'Kiki de Montparnasse': "One day I was sitting in a café Soon the waiter appeared to take our order. Then he turned to the table of girls, but refused to serve them: they weren't wearing hats. A violent argument arose. Kiki screamed a few words in a patois I didn't understand, but which must have been rather insulting, and then added that a cafe is after all not a church, and anyway the American women all came without hats... Then she climbed onto the chair, from there onto the table, and leapt with the grace of a gazelle down onto the floor. Marie invited her and her friends to sit with us; I called the waiter and in an empathic tone ordered something for the girls to drink."

## First lover during the years in Paris

Before long Kiki became the first of Man Ray's lovers during his early years in Paris. For him she was a model, a source of inspiration, and also an antagonist in turbulent scenes. In ever-new portraits and nude photographs, Man succeeded after 1922 in capturing something of the irascible spirit of this legendary artists' sweetheart. Perhaps the most famous of these photographs is a portrait from 1926, which may have been made on the same day as *Noire et blanche*. In any case, the pale complexion, clearly contoured lips, and the pomaded, tightly combed-back short hair suggest the proximity.

Kiki is holding the mask to her cheek, supporting it with both hands and casting a dreamy look sideways toward the art object – a shot in vertical

format, which apparently satisfied the artist just as little as the symmetrically composed, markedly static version in which Kiki's chin is set against that of the mask as a so-to-speak mirror image. Numerous details in the photograph – clothing, jewelry, Kiki's naked bust – distract from the real intention. Only the addition of the table as a stable, space-defining horizontal element, combined with narrower framing, provided a formally convincing solution. Now the horizontal stands unmistakably against the vertical, black against white, living against lifeless, European against African: the equality of the cultures is underlined by the negative print. Moreover, the subtle use of light, which emphasizes the strong geometry of the composition, plays a convincing role.

Man Ray had already published a photo titled *Black and White* on the cover of the magazine *391*, edited by Francis Picabia, in 1924. In that work, a classical statuette contrasted with an African sculpture; now, as if in a further development of the same concept, Man Ray set a human face against a 'primitive' mask. In the earlier work, Man's English title implied no reference to the sex of the subjects. With *Noire et blanche*, on the other hand, there can be no doubt: what is portrayed is, so to speak, a purely feminine dialogue that, in best Surrealist tradition, well understands how to remain somewhat mysterious. There can be no doubt that *Noire et blanche* is more than a merely formal game. At the very least, according to Emmanuelle de l'Ecotais, the work is exemplary for one of Man Ray's fundamental dictates: provoquer la réflexion.

Noire et blanche: *a rarely reproduced and thus little known variant from the cycle*

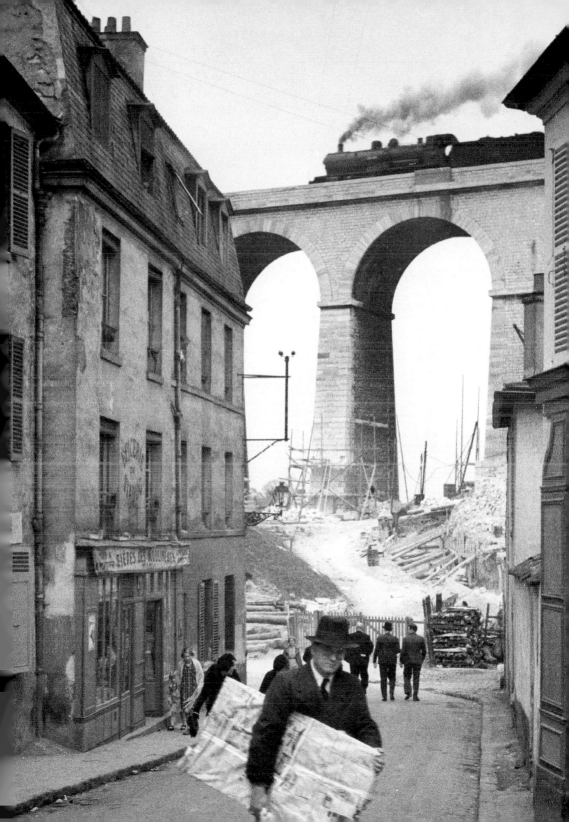

André Kertész
Meudon

**The Poetry
of the
Street**

He always saw himself as a realist and documentary photographer. But during his time in Paris, the Hungarian-born André Kertész had in fact matured into artistic greatness. Just how strongly he was also influenced by the Cubist and Surrealist developments of his age is clear in *Meudon*, taken in 1928.

At least in titling his photographs, the great poet among twentieth-century photographers was fairly prosaic: the names of what are today probably his best known works – *Chez Mondrian, Danseuse satirique*, and *Fourchette* – merely designate what is to be seen in the photograph. And also in christening this photograph *Meudon*, Kertész was referring to an actual place, a suburb to the southwest of Paris, approximately halfway to Versailles. Just when in 1928 the picture was taken we do not know, but from the leafless tree in the background, it must have been either at the beginning or end of the year, even though the photograph wasn't published until 1945, a good decade and a half after Kertész took it.
The New York publishing house of J. J. Augustin brought out *Day of Paris*, edited by George Davis and designed by Alexey Brodovitch, in a $9^1/2$ x 7-inch format, with 148 pages containing 102 illustrations – in what was a halfway decently printed volume, even though it was quite modest by today's standards. Nevertheless, for André Kertész, the publication was an important event, not so much because the design of the book had been taken over by the man who was probably the most important art director of the day, but because Kertész's collection of Paris shots taken between 1925 and 1936 formed a reminiscence of what he always referred to later as artistically the most fruitful and most beautiful period of his life. Moreover, the publication constituted a piece of publicity during a phase that otherwise must undoubtedly be regarded as the low point of his career.

## The greater part of his pictorial archive in his bags

André Kertész emigrated from Paris to New York in 1936, lured by an offer of the Keystone Agency – although it is possible that the photographer, scion of a Jewish Hungarian family, was also motivated by political developments in Europe. In his baggage, Kertész had carried along the greater part of his pictorial archive – a fact which suggests that he had determined to spend a longer time in the USA. This material was to form the basis of *Day of Paris* more than a decade later. The rest of the story is well-known – an almost immediate fall-out with Keystone; the artist's more-or-less unsuccessful attempts at finding work with all the various publishers and presses; his classification as an unfriendly foreigner in 1941, resulting in a ban on publication of his work; his jobbing after the war in magazine photography. Looking back, Kertész always designated his move to the USA as a mistake, and his work for magazines such as *House and Garden* and *Vogue* as a waste of time. Why he therefore remained in the USA remains a riddle; what is certain is that the artist, who had been active on numerous projects between the wars in Europe, could not gain recognition in the USA for his work, steeped as it was in the formal language of Surrealism. In an often-told story of his failure to acquire a foothold in *Life*, which had been founded in the year of his arrival in America, it is said that the editors told him that his pictures told too much: a highly telling comment when it comes to our picture.

## Contradictions that create both the visual interest and the oddity of the image

The publication of the monograph in 1945, the year that the war ended, must therefore have seemed to Kertész to be a priceless recompense, all the more so because it also made amends for an even earlier blow. The title of the book, *Day of Paris*, may have seemed to many like a counterpart to Brassaï's warmly received *Paris de Nuit* of 1933, but in fact the publisher had originally offered the theme to Kertész. In view of the meager stipend, however, Kertész refused the commission, thus opening the door for his somewhat younger Hungarian colleague. No less a figure than Paul Morand had composed the foreword to Brassaï's first published work. *Day of Paris*, by contrast, was served with extended captions, supposedly written by the editor George Davis. *Meudon* appears as a full-page plate on page 83. "The sharp unreality of stage-sets. Like a toy an

André Kertész

Born **1894** in Budapest under the name of Kertész Andor. Works initially as a book-keeper at the Budapest stock exchange. **1914** military service. **1917** publication of first picture. **1925** moves to Paris. **1929** participates in "Film und Foto". **1929** first *Distortions* in mirrors. **1936** moves to New York. Publications in *Harper's Bazaar*, *Vogue*, *Coronet*. **1944** American citizenship. **1945** publication of his book *Day of Paris*. **1946** exclusive contract with *House and Garden*. Dies **1985** in New York. Estate (100,000 negatives) donated **1986** to the French state (Patrimoine Photographique)

engine crosses the viaduct in a suburb," reads the caption – which indicates that the image had already irritated and alienated its contemporaries.

A train, coming from the right, is crossing a viaduct. In the foreground, as if accidentally, a man in a dark coat wearing a hat is crossing the street, while further behind, nine figures, two of them children, are heading off in various directions. Nothing in the picture is unusual in itself: there is no 'event' here, no 'transgression' of borders in the sense of the artistic theory promulgated by Structuralism. And yet the effect of the vertical black-and-white photograph is somehow disturbing. Does this feeling originate in a simultaneity of dissimilar things, that captures the observer's gaze, surprises them, leaves questions unanswered? Normally, photography presents connections, reveals causalities, reveals insights. But this picture explains nothing; it seems to be torn from some kind of unknown context. And on top of this, it is loaded with an entire series of clearly obvious contradictions that constitute the visual interest, but also the oddity, of the image. There is, for example, the massive viaduct and equally imposing steam locomotive that appear as if in miniature in the photograph, as if taken over from a model train set. And then there is the well-groomed gentleman, whose dark coat together with his tie and Homburg don't quite fit into the otherwise rather shabby surroundings. What is a man like him, whom we would rather expect to find strolling on one of the boulevards in the center of the city, doing out here in the suburb of Meudon – and furthermore, 'caught' with a newspaper-wrapped

object which the 'suspect' seems to be transporting like booty from left to right through the picture. Even though it depicts a scene clearly drawn from everyday life in Paris, something surreal clings to the photograph, something reminiscent of the paintings of de Chirico, or the inventions of a Balthus or René Magritte, or of certain scenes in the films of Luis Buñuel. More than anything else, the photograph resembles a still taken from a film; the architecture, diminishing in size as the receding street curves away to the left, and the viaduct in the deep background, lend the picture a tangibly stage-like quality.

## Friends with the Avant-garde circles of Montparnasse

At the time he made the picture, the Hungarian-born Kertész, age thirty-four, was a well-known and successful photographic artist in Paris. No less a figure than Julien Levy would soon designate him as a "prolific leader in the new documentary school of photography." Strictly speaking, Kertész was a member of the large Hungarian-Jewish Diaspora whose innovative work was making a major contribution to the development of a new look to photography around 1930. In this context one can name Robert Capa, Stefan Lorant, Martin Munkácsi, as well as Brassaï, born Gyula Halász, who had moved to Paris in 1924. Kertész's first photographs date from 1914, and his journalistic publications had already gained him a certain degree of fame in Hungary of the early 1920s. Why he moved to Paris in 1925 we do not know; after all, the majority of his photographic compatriots were drifting to Berlin, at that time the uncontested center of a dynamically growing

*Opened for use in September 1840, the 1/6 feet long and 105 feet tall railway viaduct at Meudon was considered the greatest feat of engineering in its day. Nevertheless, it seems unlikely that André Kertész travelled solely on its account to the outskirts of Paris.*

photographic press. What is certain is that in Paris he soon found his way into the artistic Avant-garde circles of Montparnasse. Although he seems to have had only a loose connection with the reserved Man Ray, he was in regular contact with more-or-less well-known Hungarian artists such as Lajos Tihanyi, Josef Csáky, István Beöthy, and even Brassaï. Kertész regularly met his colleagues in the Café du Dôme, which, located on the corner of the boulevards Montparnasse and Raspail, soon became the center for the informal group of artists.

In addition to achieving a respectable measure of success in these years as a photojournalist, especially for German and French papers, Kertész still had enough time and energy to pursue freelance projects directed toward developing his personal photographic style – one which is moreover not to be defined with any of the traditional vocabulary. According to Jean-Claude Lemagny, his pictures "have something restrained, dampened, soft, about them." Kertész was perfectly aware of the artistic tendencies of his age, especially Cubism and Surrealism, "but neither dominate his work; both remain subservient to the actual photographic task at hand... Kertész is surrealistic only to the extent that reality itself is. With every step in the real world, an abyss of poetry can open up."

### The ideal tool for the artist

*Meudon* came into being at an important moment in Kertész's life, for this was the year in which he purchased his first Leica. The small-format camera, which had been available on the market since 1925, proved to be the ideal tool for the artist. The 35-mm camera, at once handy and discrete, made Kertész's particular approach as a strolling photographer considerably easier. In addition, the 36-exposure rolls allowed pictures to be taken in sequence, thus allowing a visually more experimental approach to a valid pictorial formula – an advantage which, as we shall see, played an important role also in the conception of *Meudon*.

Portraits of his artist friends; including Mondrian, Foujita, and Chagall; interiors, as well as everyday objects and street scenes, were among Kertész's more common themes in those early years in Paris. Nonetheless from the beginning, Kertész's visual exploration of the metropolis on the Seine occupied the center of his artistic interest. In these years, according to Sandra S. Phillips, he often strolled through areas like Montmartre and Meudon. Gaining familiarity with the traditional artist-quarter

of Montmartre was, of course, a part of the required task of every new-comer to the Paris scene. Meudon, in contrast, was not a place that a strolling photographer would visit as a matter of course: one must intentionally board a streetcar to get there. But what might have drawn Kertész to Meudon in 1928?

At this point, the survival of a total of three small-format negatives, distributed on two nitrate films, becomes significant. One image is without people or train, and lacks both date and frame number on the roll. Two more images, including the published version, were taken one directly after the other. Which was the first exposure? Presumably the scene without people or train, for it seems unlikely that the visually experienced Kertész would have followed the dramatic composition of our picture with a comparatively boring variation without human figures. In any case, the photographer made two visits to Meudon. The diminishing wood pile and the alterations in the scaffolding of a building indicate that a good deal of time must have elapsed between the first shot and the two succeeding ones. If Kertész had traveled out to Meudon for the sake of the viaduct, however imposing it might be, he would undoubtedly have been satisfied with his first picture, in which the bridge is clearly evident – or he would have immediately attempted another shot. Consequently, there must have been another motive that drew Kertész to Meudon, where the critical picture was made almost in passing, as it were.

Kertész's exhibition at the gallery Sacre du Printemps in 1927 undoubtedly marked an important station in the artist's professional career. Not only was the show one of the first exhibitions emphasizing the art of photography in general, but it also constituted the first large summary of his work in progress, with which he hoped to establish connections to better known photographers, in particular Man Ray. A group photograph also dating from 1927 reveals just how much a part of the international art circle in Paris Kertész had already become. On the picture titled *After the soirée* we see Piet Mondrian, Michel Seuphor, Adolf Loos, Ida Thal, and in the background the German artist Willi Baumeister who, in his own words, had met with "recognition and very great interest on the part of the French artists" and even toyed for a time with the idea of moving to France. At least on one other occasion Kertész did a portrait of Baumeister: in 1926 in Mondrian's studio together with Gertrud Stemmler, Julius Herburger, Piet Mondrian, Michel Seuphor, and Margit Baumeister. In

André Kertész: Day of Paris: The book, designed by Alexey Brodovitch, was published 1945 by the publishers J. J. Augustin of New York, and was Kertész's first book offering in the USA.

other words, Kertész and Baumeister had met at the latest by 1926. Taking a closer look at the group portrait of 1926, there is an astounding similarity between Baumeister and the gentleman in a dark coat, whose shadowed face nonetheless emerges as powerful and broad – and who likewise seems to be wearing glasses.

### Never rearranged a subject

We know that Willi Baumeister visited Paris in 1926, 1927, and 1929, even if there is no direct evidence for 1928. In a letter to Oskar Schlemmer dated 2 November 1928, now privately owned, the German artist speaks of a certain "Miss whom I met in Paris" – a statement that certainly does not constitute proof of a visit to the city during the year in question, but which makes it nonetheless more probable. If we assume that Willi Baumeister in fact was in the French capital during the course of the year, what might have led him to Meudon? A visit to his friend and fellow-painter Hans Arp, whose studio was in fact located in Meudon at this time? Clearly, there is at least some evidence to support the hypothesis that the photograph presents us with the figure of the constructivist Willi Baumeister – whom Kertész had accompanied to Meudon and captured on film as he crossed the street. The flat, newspaper-wrapped package also suggests the possibility of a painter. But if the figure is in fact that of his friend Baumeister, why then did Kertész not identify him in the caption beneath the picture? The explanation is simple: "The difference between Kertész and Bourke-White, as well as many others who did photographs on assignment to satisfy editorial needs, is that she would sometimes rearrange a subject; Kertész never would," declared Weston

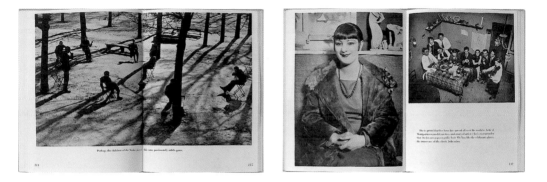

Naef. But the idea of staging a scene would certainly have occurred to Kertész's 'teammate' Willi Baumeister, who appears, moreover, as a complete figure in the uncropped photograph. The possibility of staging is all the more realistic since Kertész was demonstrably working toward an ultimate composition for his picture – as evidenced by the three 'stations' through which the photograph passed. Moreover, a reference to Baumeister in the photograph would have led to an inevitable hierarchizing of the elements in the picture. The balance among viaduct, train, and man-with-hat would shift in the direction of the human figure, and we would therefore understand the picture solely as a portrait of Willi Baumeister – and a none too good one at that. Only insofar as the photograph keeps its secret does it also retain its visual power and surrealistically inspired poetry.

Day of Paris: *double-page spreads, showing pages 82–83. (left)* Quartier Saint Denis *and (right)* Meudon; *pages 114–115:* Tuileries Gardens; *pages 136–137: (left)* Kiki of Montmatre *(sic!) and (right)* Montparnasse, Studio

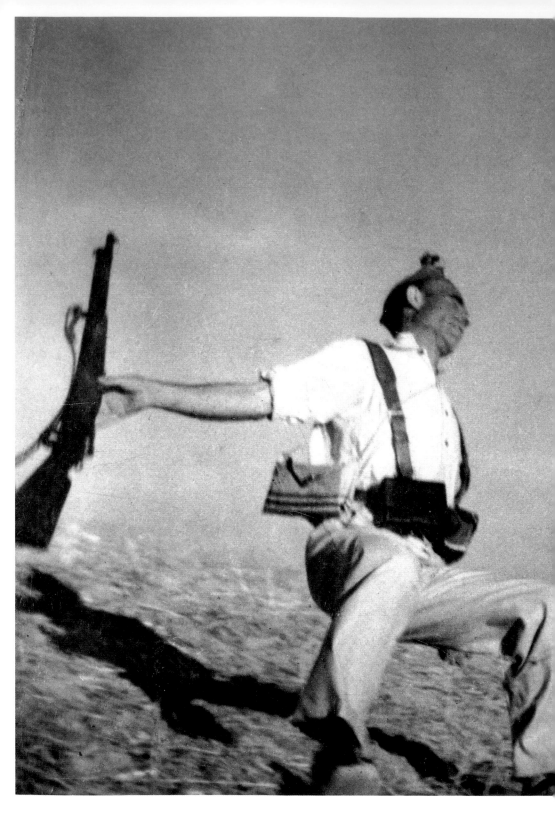

# 1936

## Robert Capa
## Spanish Loyalist

**Córdoba
Before the
Fall**

**Robert Capa was more than a war photographer, even if it was his war scenes that made him famous. In the end, his estate comprised more that 70,000 negatives – but that of his most famous picture is accounted lost.**

Finally, he has acquired a name. For decades, he was merely an unknown soldier, a nameless victim of war. He, or rather his picture, stood symbolically for the millions of deaths lost to war and violence. The caption affixed to the image was as brief as it was general: *Loyalist Soldier* was the most usual title. Or *Falling Soldier*, or even *Loyalist Militia* – but this reference to the Anarcho-Syndicalists who fought on the Republican side of the war attempted a more exact identification than the picture really allowed. For as many critics have rightly noted, this photograph drew, and still draws, its power precisely from its generalization of death. Only insofar as the photograph stands for a reality that passes beyond time can it function as an icon of dying in a higher sense. As late as 1984, the writer Peter Härtling, in his lectures on poetics given in Frankfurt-am-Main, addressed the issue of the "absence of data on the Soldier" and asked whether it was proper to create something like an identity for him. According to Härtling, "He cannot have been a soldier after the model of a Malraux or Hemingway, but rather one of those who were buried – nameless among thousands of nameless – in the Cemeteries of the Moon, as Georges Bernanos described them in helpless protest." Härtling answered his own question: "No, I would not give him a name." But now we know the facts: the name of the soldier is Federico Borrell García. He was twenty-four years young, came from Alcoy in southern Spain, and died on 5 September 1936 on the Córdoba front near Cerro Muriano.

### The most exciting shot of battle action
The soldier's death is documented in the files of the military archives of Salamanca, to which we will return later. The photographer Robert Capa,

then aged twenty-two, captured the instant of the soldier's death – and at the same time created what is probably his most famous photo. There is no information about the picture; not even Magnum, the agency co-founded by Capa and which still holds the rights to the picture under entry number CAR 36004 W000X1/ICP 154, has data about its circulation and reception. Nonetheless, historians and biographers agree on the unique status of this picture. To cite just a few voices: the Capa scholar Richard Whelan speaks of "the most exciting and immediate shot of battle action" ever taken; Russell Miller in his recent book on Magnum declares it to be "the greatest war photograph ever taken"; the German illustrated *Stern* (41/1996) termed the photograph "a symbol of the Spanish Civil War and later the ultimate image for the anti-war movement"; and finally, Rainer Fabian, in his article on more than 130 years of war photography, speaks of "the most legendary and most-published war picture in history." According to Fabian, "War photography is the use that one makes of it"; that is, a war picture defines itself primarily through the way it is used. Robert Capa's photograph of the Spanish Loyalist was not the first picture to emerge from a war, but is stands as "the first compelling action shot taken during wartime" (Carol Squiers). One tends to treat such superlatives with skepticism; after all, many photographs and films also emerged from the First World War, at a time when Capa's preferred working camera, the Leica, was not yet on the market. In those days, photojournalists had comparatively large and clumsy cameras, weak lenses, and glass negatives that debarred quick reactions or sequences. Notwithstanding, one cannot exclude the possibility that among the many thousands of photographs taken, there might be a picture of a death that is at least the equal of Capa's. What had certainly changed since the end of the First World War, however, was the situation of the media. War pictures were now treated differently, as photographs found a forum in the newly created illustrated press. As a result, there was now a demand and, in many lands, a largely uncensored public sphere. In short, a change in paradigms had taken place.

## The blossoming new genre of illustrated magazines

The specific character of the Spanish Civil War must also be kept in mind. For most Europeans, it was a distant civil war which one nonetheless regarded with curiosity because here – quasi symbolically for the rest of

**Robert Capa**

Born Endre Ernö Friedmann **1913** in Pest/Hungary. **1931** moves to Berlin. Studies at the liberal German College for Politics. **1932–33** lab assistant at the photo agency Dephot. **1932** first photos are published. **1933** moves to Paris. Acquainted among others with Gisèle Freund and Henri Cartier-Bresson. From **1936** photojournalism on the Spanish Civil War for *Vu* and *Regards*. **1938** war correspondent in China. Moves **1939** to the USA. Works for *Collier's* and *Life*. Highly acclaimed reportages on the European theatres of war. **1947** founder member of Magnum. **1954** in Indochina for *Life*. Killed that same year by a mine

the world – the struggle between the Left and the Right, between Communism and Fascism, was being fought out. In other words, in this age before television there was a strong and international interest in pictures that the new genre of illustrated magazines, which had blossomed into being since the 1920s, knew how to satisfy. Advances in printing techniques, new forms of distribution, and revolutionary layout techniques allowed the improved reproduction of images more quickly and attractively than had been possible earlier, and supplied them to the readers. In addition, a new generation of photographers had appeared: equipped with faster cameras and a new understanding of their role. The field now included photojournalists, adventurers, and parvenus who personally stood – or were supposed to stand – for the originality, seriousness, and authenticity of a story. It is not by chance that reports became more and more personalized. When the English illustrated *Picture Post* devoted all of eleven pages to Robert Capa's civil war photographs in December 1938, the cover clearly proclaimed him to be the greatest war photographer in the world. This was not the first publication of pictures from Spain, but it was the start of a myth that is still effective today.

He was young and obviously ambitious, a photographer with leftist sympathies, a charmer, a ladies' man, gambler, and adventurer all in one – thus we can imagine Capa in those years. In addition, he was undoubtedly a "concerned photographer," who above all believed in himself, his talent, skill, and courage to achieve good pictures. His real name was Endre Ernö Friedman, and he had been born in Budapest in 1913, the second of a tailor's three children. Even as a boy, he was alert and knew how to take his life in hand. In 1931 he moved to Berlin, studied at the Academy for Politics, and earned a bit of money at the legendary Dephot agency, where he carried coal, handled the laboratory work, and at some point was also permitted to take a camera into his own hands. Photographs of the camera-shy Leo Trotsky are said to be the beginning of his career as a photographer. Even here, Capa already succeeded instinctively and with a good deal of chutzpah in a brilliant report. "If your pictures are no good," he is reported to have said, "you didn't get close enough."

### The first to recognize the visual power of the photograph

Hitler's takeover hindered the further development of Capa's career, at least in Nazi Germany. Like so many of the photographic guild – Stefan

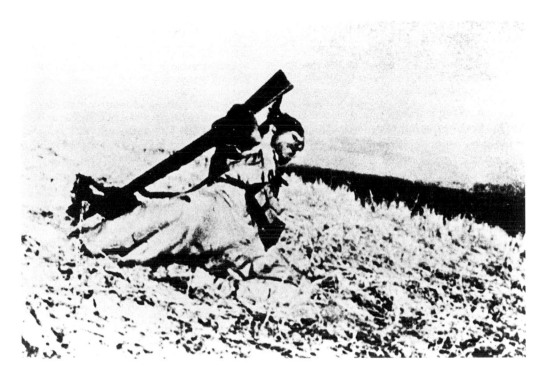

Lorant, Martin Munkácsi, Simon Guttmann, to name only Capa's fellow Hungarians – Capa, who was Jewish, felt forced to emigrate. Only after he moved to Paris did the talented novice with a sense for themes change his name to Robert Capa – a man whose work was in fact not at all limited to war photography, even if it was primarily his war reports that carried him to fame.

These were restless times politically. Spain was caught up in civil war since July 1936. An alliance of right-wing generals, large landowners, nobles, and the Catholic Church had risen up against the elected popular-front government. Political upheaval was also threatening France, with workers on strike since May to force the leftist government under Léon Blum to undertake social reform. Precisely where Capa stood politically is unknown, but a picture published in the left-oriented illustrated *Vu* from 3 June 1936 testifies to his interest in the workers' strike. Similarly, during the Spanish Civil War we can identify at least a modicum of sympathy for the Left in Capa, who had been inspired by Karl Korsch and his ideals of a people's front in Berlin. What in any case is certain is that in early August, Capa and his long-term companion Gerda Taro set out for Spain to docu-

*Comment sont-ils tombés: under this title,* VU *magazine (23 September 1936) for the first time published Capa's Loyalist Soldier together with this lesser known photograph of a falling soldier.*

*Double-page spread from* Life: *advertising and editorial in absurd, almost cynical competition with each other*

ment the two-week-old conflict from the perspective of the Anarcho-Syndicalists. Capa photographed in Barcelona and on the Aragón front, then went on to the Huesca front, until he finally arrived at Córdoba, where he took the picture that would be his most famous. The *Spanish Loyalist* initially appeared in *Vu*, No. 447, on 23 September 1936. The picture occupies the upper left half of a double-page spread entitled "La Guerre Civile en Espagne." Responsible for the layout was Alex Liberman, later art director of the American *Vogue*, who thus was the first to recognize the visual power of the photograph. Under the picture, Liberman also placed a variant, thus conveying the rhythm of a film to the sequence of images – although close observation indicates that there are really two protagonists depicted here. There is no reference to place, time, or even the names of the dead. The caption remains general in content, speaking in pathos-filled tones about the whistle of a bullet and blood being drunk by the native soil. The next to publish the picture was *Life*, in its issue from 12 July 1937. Under the heading "Death in Spain," the magazine marked the first anniversary of the beginning of the war and spoke of the victims – *Life* reported half a million lives had been lost. The article opened with Capa's photograph in large format, although slightly cropped on the right. Two days later, the Communist magazine *Regards*, which had already published several of Capa's reports, also published the photograph. Capa himself gave it a prominent position on the cover of his book *Death in the Making* (New York, 1938), along with other photographs he and Gerda Taro had taken in Spain. He still, however, absolved himself of the duty to provide data on the location, time, or circumstances of the picture.

Soon the photograph began to provoke questions; doubt as to its authenticity began to make the rounds. *Life* commented on the moment in which the solder is struck by a bullet in the head. But even a close exam-

ination of the picture fails to reveal a bullet wound anywhere on the body. One also might ask oneself how a man hit by a bullet while he is storming down an incline can fall backwards. Speculation also arose over the blossom-white uniform, hardly appropriate for the battle field. Furthermore, it is strange that Capa photographed the soldier from the front: wouldn't

this necessarily imply that he had rushed ahead of the militiaman? On the other hand, there is just as much that argues against the thesis that Capa staged the photograph, including his very professionalism as a photographer. It hardly would have been necessary for him to have staged such a picture. And that one of the members of the Confederación National del Trabajo (CNT) should have stooped to act out his own death appears equally implausible. Nonetheless, in the course of several interviews, the British journalist O'Dowd Gallagher re-ignited the discussion over the credibility of the photograph in the 1970s when he declared that he had shared a hotel room with Capa near the French border at the time the photo was made, and that later, Loyalist soldiers staged useful photos for the press. Elsewhere, however, Gallagher speaks of Franco's troops in Loyalist uniforms who carried out the deception. But, as Richard Whelan points out, aside from the journalist's self-contradictory testimony, Capa as a Jew and a self-declared anti-fascist would have found it difficult to work together on a project with the Falangists.

*Double-page spread from* La Revue du Médecin, *30 September 1936: the first issue of the magazine for doctors and pharmacists published Capa's pictures (including the variant from p. 183) in an exceptionally avant-garde layout.*

## The key picture of a longer sequence
Neither can the original negatives offer further information, for they have disappeared. Capa himself spoke about the picture only once, in an interview on 1 September 1937. According to a paraphrase by a journalist for the New York *World Telegram*, Capa and the militiaman had both been left behind by the troops: "Capa with his precious camera and the soldier with his rifle. The soldier was impatient. He wanted to get back to the

Loyalist lines. Time and time again he climbed up and peered over the sandbags. Each time he would drop back at the warning rattle of machine-gun fire. Finally the soldier muttered something to the effect that he was going to take the long chance. He climbed out of the trench with Capa behind him. The machine-guns rattled, and Capa automatically snapped his camera, falling back beside the body of his companion. Two hours later, when it was dark and the guns were still, the photographer crept across the broken ground to safety. Later he discovered that he had taken one of the finest action shots of the Spanish war."

Was Capa really alone with the militiaman? His biographer Richard Whelan expresses doubts on this point. After all, the key picture is one of a larger sequence in which several pictures clearly depict both of the soldiers who were later killed – one in the midst of a momentarily care-free group of CNT militiamen, and another in a leap over a trench. Furthermore, in the battle our protagonist is clearly recognizable. But there is something else that is suspicious: the two photographs of a wounded and a falling soldier published in the *Vu* issue of 1936 must have been taken at approximately the same time, judging by the unchanged cloud formations. The perspective is also identical. Finally, the argument for the existence of two militiamen is supported by a more exact look at their clothing. One of the soldiers is wearing a white shirt and trousers; the other, a kind of worker's overall. On one soldier, the leather suspenders follow a straight line down to the trousers; the other soldier wears them crossed. "If one then looks closely at the ground in the *Falling Soldier* photograph and in the variant image," argues Richard Whelan in his biography of Capa, "and compares the configuration of prominently up-standing stalks, it becomes obvious that the two men are shown falling on almost precisely the same spot. (The *Falling Soldier* is about one foot closer to the photographer than is the man in the other picture.) We may well then ask why it is that although the two men fell within a short time of each other...in neither picture do we see the body of the other man on the ground."

### The truth is the best picture

Neither Whelan nor Capa's younger brother Cornell, who administered the estate left by Capa after he was killed by a mine in 1954 in Indochina, have ever allowed a doubt to be raised about their belief in the truth of

the documentary photograph. Furthermore, according to Whelan, it's "a great and powerful image... To insist upon knowing whether the photograph actually shows a man at the moment he has been hit by a bullet is both morbid and trivializing, for the picture's greatness ultimately lies in its symbolic implications, not in its literal accuracy as a report on the death of a particular man." Whelan's biography of Capa was published in the USA in 1985. Exactly ten years later, a certain Mario Brotóns Jordá edited and published his memoirs on the Spanish Civil War under the title *Retazos de una época de inquietudes*. Brotóns had himself fought on the Córdoba front. In Capa's famous photograph he recognized the leather bullet pouches that were made in exactly that fashion only in Alcoy, and that only the militiamen from Alcoy carried. Based on various indications in Capa's photograph, Whelan had dated it to 5 September and deduced that the location was somewhere around Cerro Muriano. And in fact, as Brotóns was able to find out in the State Archive in Salamanca, there was only a single militiaman from the Alcoy region who was killed on 5 September 1936 on the Cordoba front near Cerro Muriano: Federico Borrell García. When Brotóns then showed Capa's photograph to a surviving brother of the deceased soldier, he identified the victim as Federico. Thus, according to Richard Whelan, the story had come full circle. Capa's "Loy alist," according to the *Stern* "really did fall in battle." And thus the over all credibility of the photographer was rehabilitated. As Capa expressed it at the time in an interview with the *World Telegram*: "No tricks are necessary to take pictures in Spain. You don't have to pose your camera [i.e., pose your subjects]. The pictures are there, and you just take them. The truth is the best picture..."

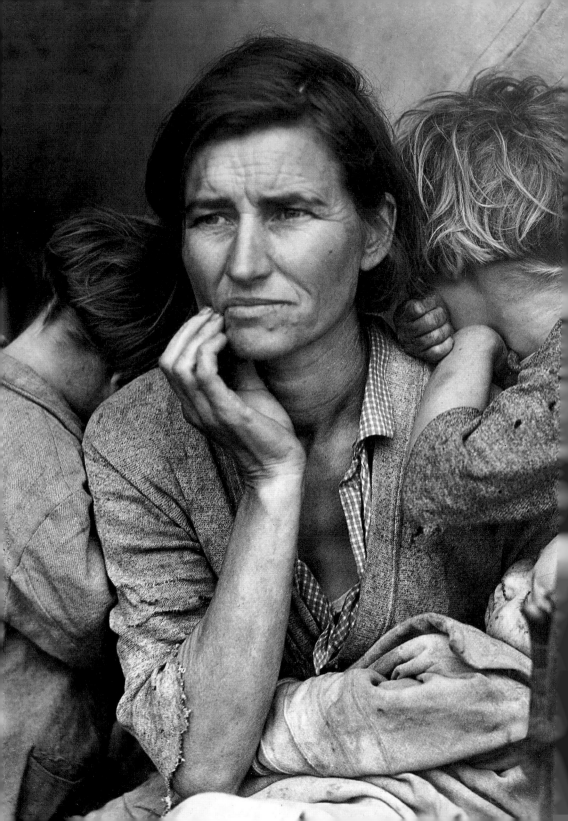

# Dorothea Lange
# Migrant Mother, Nipomo, California

## 1936

Stock market crash, economic crisis, and catastrophic drought in the southern states: with good reason the decade following 1929 came to be known in the USA as 'the bitter years'. It was during this period that Dorothea Lange made a portrait of a female migrant worker and her children, thereby creating an image that has established itself as a timeless metaphor for human suffering.

Madonna for a Bitter Age

Her name is Florence Thompson; she is 32 years old, married, with no permanent address and seven children to feed. What would constitute no mean feat even in times of economic prosperity now threatens to bring the family to the brink of disaster during the Great Depression in the USA. Florence Thompson is one of the many migrant workers, as they came to be called during these dark times, who traversed the land seeking any work they could find. But it turns out that now, in March 1936, the pea harvest is once again poor, and that means no work – and therefore no income – for the pickers. Florence Thompson has found lodgings for the time being, in a camp for pea pickers in Nipomo, California. "Of the 2,500 people in this camp," noted Dorothea Lange; "most of them were destitute."

### One of the most-cited pictorial images of our times

We know surprisingly much about the woman in the photograph, in part thanks to the comparatively precise information that the photographer provided on the back of at least the early prints. From another source we also know that one of the daughters (left in the picture) later made a futile attempt in court to stop the publication of the photograph. Furthermore, in 1983 there was a public appeal for contributions for Florence Thompson, ill with cancer. The 'bitter years', as they have been made real

to us particularly in the works of John Steinbeck and John Dos Passos, now lie well over a half a century in the past, and few persons can recall the Great Depression from first-hand experience. The portrait of the young Florence Thompson, however – thin-lipped, care-worn, gazing emptily into the distance – is familiar to almost everyone. Since its appearance in "The Family of Man" exhibit (1955), conceived by Edward Steichen and viewed by more that nine million people around the world, the photograph has become a part of the collective memory. Originally designated in 1955 simply as "U.S.A: Dorothea Lange Farm Security Adm.," the photograph is now known as *Migrant Mother*, a much more gripping title that raises the concrete historical circumstances to a level of timeless contemplation. The picture, intended as a documentary, has understandably become one of the most-cited pictorial images of our century.

Through the years, there have been numerous attempts to subject *Migrant Mother* to art-historical analysis. Comparison has often been made to images, common since the Renaissance, of the Mother of God with the Christ Child. Other interpretations explain the success of the picture through its balanced composition, or refer to the: "dignity and essential decency of the woman facing poverty" (Denise Bethel), or to the picture's "simplicity of means, its restrained pathos, and its mute autonomy of language" (Robert Sobieszek). Whatever the reasons may be, what remains certain is that Dorothea Lange largely ignored all such theoretical motives when she took the photograph. As she herself once described her approach to her work: "Whatever I photograph, I do not molest or tamper with or arrange... I try to [make a] picture as part of its surroundings, as having roots... Third - a sense of time... I try to show [it] as having its position in the past or in the present..." Ironically, the framing actually chosen by Lange here is so narrow that the tent in the background is not even recognizable. Furthermore, the image is fairly indefinite temporally: only with difficulty can one conclude – based on the children's haircuts – that the picture

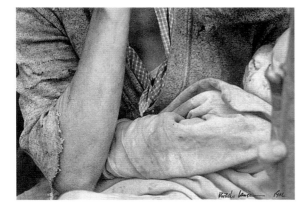

*Close-up from* Migrant Mother: *the thumb is clearly visible on this print (right edge of the picture). It seems to have bothered the photographer, and later she removed it from the negative.*

stems from the 1930s. As far as setting up a 'scene' is concerned – or rather, the attempt to avoid doing this – we know that Lange approached the family slowly, taking pictures all the while, thus giving the family members the chance to pose themselves. In fact, in the initial photographs, the children are looking into the camera; only in the final photo of the sequence do they turn away, thus demonstrating their condition as social outsiders that Lange had first documented in 1933 with her photograph *The White Angel Breadline*.

## Making human suffering into an aesthetic object

A further modest but important detail is often overlooked in the discussion of Dorothea Lange's *Migrant Mother*: namely, the thumb that appears in the lower right of the picture and that remains vaguely recognizable even in the retouched version. Dorothy Lange retrieved the picture from the archives of the Farm Security Administration approximately two years after it had been shot, which is to say in 1938. In an action that remains controversial to this day – and one which elicited furious protest especially from Roy Stryker, Lange's immediate superior at the FSA – Lange eliminated the image of the thumb, whose owner remains only a matter for speculation, although it may belong to Florence Thompson herself. Whatever the case may have been, the incident illustrates Lange's ambivalent understanding of 'documentary', which for her implied not merely demonstrating, but also convincing; that is, in addition to the simple registration of reality, her concept also includes moving the observers – in a double sense, for Florence Thompson is supposed to have in fact thanked her survival to the published picture.

In other words, Dorothea Lange was seeking visual evidence, but also quite consciously a suggestive image. In making human suffering into an aesthetic object, the photographer discovered a way of stimulating attention, interest, and sympathy in world saturated with optical images. As once formulated by John R. Lane, she carried "the concept of documentary photography far beyond the purely pragmatic domain of record-making." Lange's *Migrant Mother* exemplifies precisely this understanding, and probably for this reason it became the single best-known motif of the FSA campaign. The visible thumb, however, would have spoilt the overall composition, and invested the photograph with an unintentional humor – the reason why Lange broke with her own principles to remove it.

Dorothea Lange

Born **1895** in Hoboken/New Jersey. **1913** drops out from high school and turns to photography. **1917** courses under Clarence H. White. **1919** opens a portrait studio in San Francisco. After **1930** turns to social topics. **1935** marries the social scientist Paul Schuster Taylor, who puts her in contact with the Resettlement Administration (from **1937** FSA). Works for the organisation till **1939**. **1939** publication of *An American Exodus*. **1943–45** works for Office of War Information. **1955** participates in "The Family of Man". Dies **1965** in San Francisco of cancer

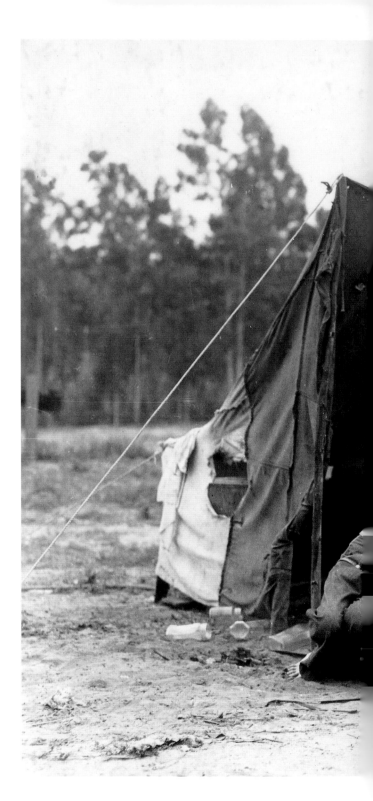

*Dorothea Lange:* Migrant Mother, Nipomo, California

*Here the situation as a whole. According to her statements, the photographer took a total of five exposures.*

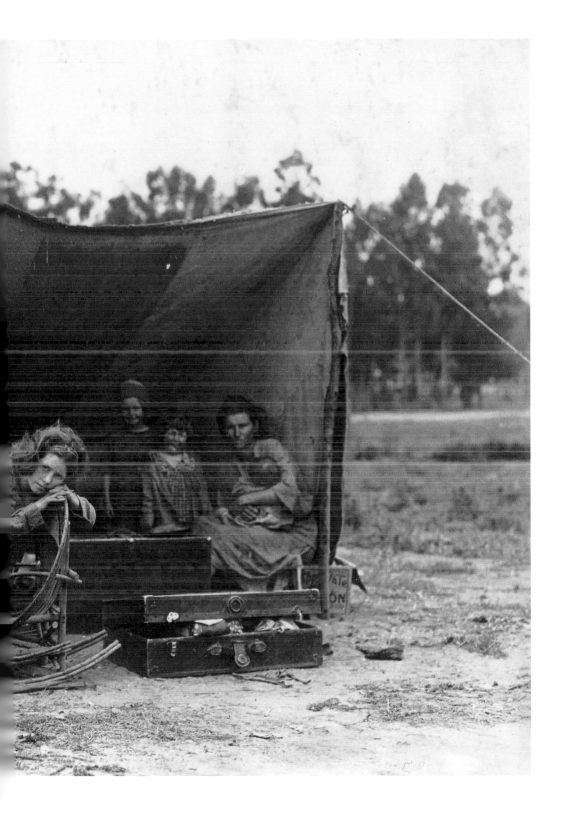

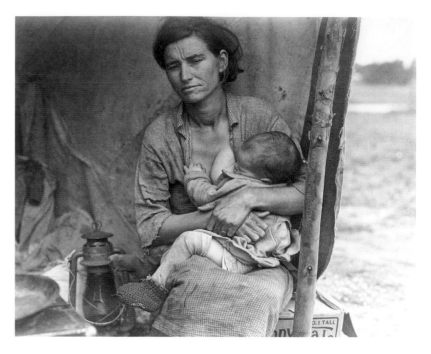

Migrant Mother:
*lesser-known version
of the key portrait*

When Dorothea Lange took the picture in 1936, she was forty years old, a committed photographer, and herself the mother of two children. Divorced from her first husband, the painter Maynard Dixon, she had now been married for a year to the sociologist Paul Schuster Taylor. Born in Hoboken, New Jersey, Lange had quit school at age eighteen more or less on the spur of the moment, in order to devote herself to photography. She studied first under Arnold Genthe and afterward with the no-less-renowned Clarence H. White. In the years following 1900, pictorialism was still at its zenith – a school of art photography which pursued the model provided by painting, and of which Clarence White (described by Lange as extremely helpful and inspiring) was one of its leading representatives. Lange's early photographs, insofar as any have survived, still reveal overtones of the pictorial approach, although, as stressed by Sandra S. Phillips Lange encompassed a social interest that reached beyond the formal principles of the pictorial approach. At age seven, Lange suffered from polio, which resulted in a deformity of her right leg, and five years later, her father abandoned the family. Thus, concludes Phillips, "[Lange's] great ability to identify with the outsider was shaped by these two emotionally shattering events, disability and desertion."

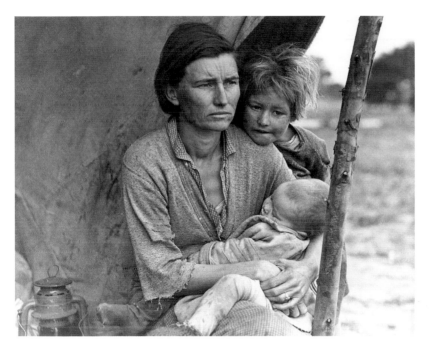

*A further variant. It is clear just how Lange resolutely approached the family with her camera.*

## An eye focussed on the social realities

Intending to widen her horizon, Lange set off on a world tour in 1918, but she and her friend got no further than San Francisco before being robbed of their savings. So Lange took a job in the photographic department of a drugstore to supply the funds necessary for survival. The following year, Lange established herself in the city with her own photographic studio, which she maintained until 1934. The collapse of the New York stock market in 1929 and the ensuing economic crisis caused a professional break in a double sense for Lange, who by then had long been a successful portraitist. On the one hand, there were now fewer customers who could afford a studio portrait, and on the other hand, especially in the agricultural American South, the unemployed, the homeless, and the migrant workers increasingly became a part of the street scene. This was the phenomenon that Lange captured with her camera: her view of the down-and-out and needy waiting in front of a soup kitchen set up by a wealthy woman, known under the title of *The White Angel Breadline*, stands as the turning point in her photographic œuvre. From that time on, it was the social realities in an increasingly industrial America that dominated her artistic work.

The Crash of 1929 had hit agriculture in the American South perhaps even harder than industry. The prices for farm products had been declining since the early 1920s, and increasing mechanization had brought unemployment to thousands of farm laborers. On top of this came the droughts that transformed once-rich farmland into deserts. According to one official estimate, in 1936 approximately six hundred and fifty thousand farmers were attempting to wring a living from almost two hundred and fifty million acres of parched and leached-out land. *A Record of Human Erosion*, the subtitle of Dorothea Lange's most important book (1939) thus bears a double meaning.

### The end of a long, hard winter

Franklin D. Roosevelt's New Deal aimed at consolidating the economy, industry, and agriculture. A great variety of state measures – which admittedly first had to be pushed through Congress – finally resulted in an unparalleled state-controlled relief program. The Historical Section of the Resettlement Administration (RA; known as the Farm Security Administration after 1937) was created to propagandize the new initiative, as it were. Headed by Roy Stryker, the chief task of the Section was to document the disastrous situation in rural America. Photographers such as Ben Shan, Walker Evans, Carl Mydans, Arthur Rothstein, Russell Lee, and Jack Delano were hired for this purpose. Dorothea Lange joined the group in 1935, but left four years later after disagreements with Roy Stryker. In total the FSA bequeathed around 170,000 negatives and 70,000 original prints to posterity.

Even before starting her work for the FSA, Dorothea Lange was already actively photographing in southern California. Her husband, Paul Taylor, had been assigned by the State Emergency Administration (SERA) to investigate the situation of needy migrants in California, and his wife accompanied him to the pea harvest in Nipomo. In other words, the photographer was already familiar with the camp in which a year later, in March 1936, she would take her most famous photograph. In was the end of a long, hard, winter, she recalled – and simultaneously the conclusion of several weeks of working with the camera. She was on her way back home in the car. It was raining. A sign on the side of the road announced the camp of the pea harvesters. But, according to Lange: "I didn't want to remember that I had seen it." She drove past, but could

not put it out of her mind. Suddenly, approximately twenty miles later, she turned the car around: "I was following instinct, not reason." She drove back to the rain-soaked camp, parked her car, and got out. Already from the distance she saw the woman, a "hungry and desperate mother," an apparition that drew her like a magnet. "I do not remember," said Lange later in a conversation with Roy Stryker, "how I explained my presence or my camera to her, but I do remember she asked no questions. I took five shots, coming ever closer. I did not ask her name or history. She told me her age, that she was 32. She said that they had been living on frozen vegetables from the surrounding fields, and birds that the children killed. She had just sold the tires from her car to buy food. There she sat in that lean-to tent with her children huddled around her, and seemed to know that my pictures might help her, and so she helped me."

As early as 6 March 1936, two versions from the series appeared in the *San Francisco News* – and in response the federal government immediately ordered food to be sent to the affected region. The key image itself was first published in *Survey Magazine* in September 1936, and was included in an exhibit of outstanding photographic achievement organized by the magazine *U.S. Camera* in the same year. Dorothea Lange therefore understood full well the suggestive power of this modern Madonna. That the picture some day would be treated as an art object, however, was hardly foreseeable: the most spectacular, if not the first, auction of an early (unretouched) print of *Migrant Mother* took place in 1998 at Sotheby's in New York, where the Paul Getty Museum in Malibu, California, bid $244,500 for this 13$^1$/₂ x 10$^1$/₂-inch vintage print .

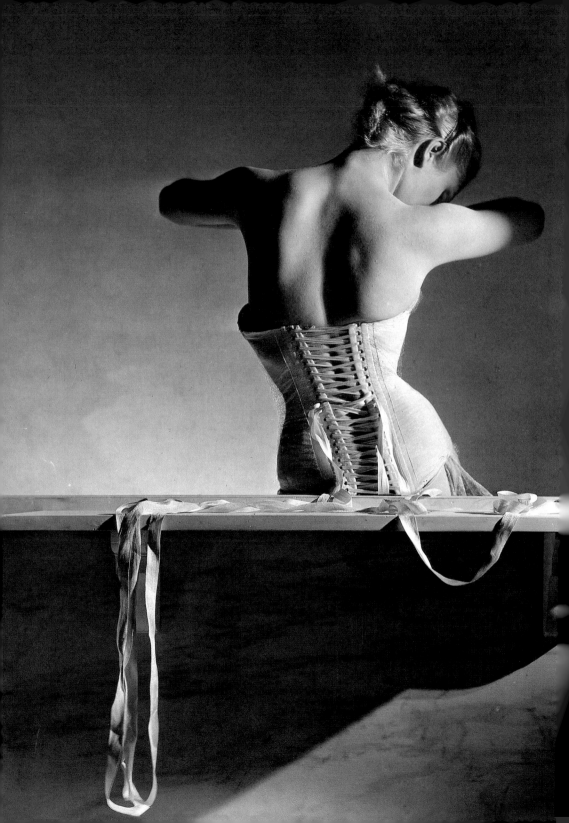

# Horst P. Horst
# Mainbocher Corset

**In August 1939, on the eve of the Second World War, Horst P. Horst took his famous photograph of the *Mainbocher Corset* in the Paris *Vogue* studios on the Champs-Elysées. The picture, which marked the end of his work for some time, later became his most cited fashion photograph.**

Eros
Reined In

There's no question: it's a "great silent picture," to borrow the expression of the media scholar Norbert Bolz – a picture that literally lends form and, by means of photography, permanence to the beautiful phantasm of fashion. Many consider the photograph to be Horst P. Horst's best work – an opinion that the photographer himself would probably agree with, for otherwise, how is one to explain that he chose the motif almost as a matter of course for the cover of his autobiography *Horst. His Work and His World*? Timeless beauty, balance, an interplay of modesty and charm, eros and humility, provocation and subtle elegance are simultaneously at play in the photograph, not to mention the flattering light and dramatic shadows. After all, wasn't the photographer called a master of dramatic lighting?

Horst P. Horst photographed his *Mainbocher Corset* in the studios of the Paris *Vogue* in 1939. Only a few years earlier, Martin Munkácsi had let a model in light summer clothing and bathing shoes run along the dunes of a beach – freedom, adventure, summertime, sun, air, movement, sporty femininity – all caught by a photographic technique schooled in photojournalism. Munkácsi's picture, first published in the December 1935 issue of *Harper's Bazaar*, caused a sensation. Its carefree dynamism marks, as it were, the opposite pole to the aesthetics of a Horst – who was, after all, a man of the studio – and of well thought-out staging, in which light was more than a mere necessity to call an object forth from darkness. With Horst, there were always settings, constructions, parts of

an architecture built for the moment. Munkácsi photographed with a Leica, and the photographer moved to keep up with the moving object. Horst in contrast favored the large camera mounted on a stand and a focusing screen that allowed him to calculate his photograph down to the last detail. In other words, Horst sought to produce elegance as the outgrowth of intuition and hard work. How long did he pull at the bands, turn and twirl them, until they arrived at the right balance on an imaginary scale between insignificance and the determining factor in the picture! Roland Barthes, the great French philosopher, structuralist, and prognosticator of photography, might well have discovered his 'punctum' precisely here, that is, the apparently insignificant detail of a photograph that gives the picture its fascination and charm, and ultimately what awakens our interest. Horst P. Horst would probably have described the effect differently. Occasionally he spoke of "a little mess" that he carefully incorporated into his pictures. In later years, when he photographed the interiors of rich and prominent Americans for *House and Garden*, this 'point' might be a not-quite-fresh bouquet of flowers, or pillows on the sofa that suggested that someone had already been comfortably seated there. Or, as rumor once had it, a full ashtray – but one searches his pictures futilely for anything of the sort: even the planned accident had its limits in the productions of a Horst.

## Representative of both the old and the new age

Horst P. Horst – his real name was Horst Paul Albert Bohrmann – had initially come to Paris in 1930 to work voluntarily for Le Corbusier. In fact Horst developed into the super-aesthete among the fashion photographers of the age. He seized the artistic tendencies of those years, amalgamated them into a new aesthetic rooted in traditional ideals, and thereby provided an orientation in taste for an age that was flagrantly questioning tradition across international borders. Born in 1906 in Weissenfels on the Saale River in Germany, Horst studied briefly in Hamburg at the School of Commercial Arts before migrating to the Seine, where the young, blond, handsome photographer soon felt himself at home. Significantly, it was not the impoverished bohemia of exiled Hungarians, Russians, or Avant-gardists such as Man Ray, that appealed to Horst; instead, he sought his friends

Horst. His Work and His World: *This large monograph, edited by Valentine Lawford and published 1984, gave pride of place to the* Mainbocher Corset *on the title page.*

among the exalted bourgeoisie with an interest in art, or among precisely those commercial artists who were especially successful in fashion and fashion publicity. The Baltic Baron von Hoyningen-Huene, already one of the great fashion photographers of his time, became a particularly important and influential friend to Horst. The younger photographer, well built but somewhat short, often stood as model for Hoyningen-Huene, and thus gradually established a foothold in fashion photography for himself. Unmistakable in Horst's early pictures are the influences of Hoyningen-Huene's typically polished approach to photography, oriented on geometric Art Deco principles. In addition, Horst was also clearly influenced by the photography of the Bauhaus, whose principles he often consciously adopted – without attempting to explore the limits of the medium, however, as did an artist like Moholy-Nagy, for example. Horst furthermore admired Greece and the classical world, an interest that he shared in turn with Herbert List, and was also was open to the Surrealists, without really becoming one. He always photographed 'straight', thus placing himself in the ranks of those who had overcome 'applied' pictorialism, such as was cultivated by Baron de Meyer or the early Stieglitz. Paradoxically, Horst was a representative of both the old and the new age.

Horst's work was first published at the beginning of the 1930s in the French *Vogue*. Later he devoted a book to the decade, which one can justly call his most creative period: *Salute to the Thirties*. Published in 1971 with photographs of both Horst and Hoyningen-Huene, the book oddly does not include the *Mainbocher Corset*. On the other hand, the volume includes a sensitive foreword by Janet Flanner, in which the legendary Paris correspondent of the *New Yorker* described once more the atmosphere that came to an end with the Second World War. Horst had photographed his famous study on the very eve of the coming catastrophe. "It was the last photograph I took in Paris before the war", he later recalled, "I left the studio at 4:00 a.m., went back to the house, picked up my bags and caught the 7.00 a.m. train to Le Havre to board the Normandie. We all felt that war was coming. Too much armament, too much talk. And you knew that whatever happened, life would be completely different after. I had found a family in Paris, and a way of life. The clothes, the books, the apartment, everything left behind. I had left Germany, Heune had left Russia, and now we experienced the same kind of loss all over again. This photograph is peculiar    for me, it is the essence

**Horst P. Horst**

Born **1906** in Weissenfels / Saale as Horst Paul Albert Bohrmann. Studies at the Hamburg School of Commercial Arts. **1930** moves to Paris. Internship under Le Corbusier. Makes the acquaintance of Hoyningen-Huene. **1931** first shots for French, **1932** American *Vogue*. **1939** moves to the USA. **1943** American citizenship. **1951** closure of the *Vogue* studios, followed by opening of own studio. Intensive work for *House and Garden*. **1961** photo series on the lifestyle of international High Society. Dies **1999** on Long Island

of that moment. While I was taking it, I was thinking of all that I was leaving behind."

## Highlights and deep shadows

Horst remained the classicist among photographers. Women, he once said, he photographed like goddesses: "almost unattainable, slightly statuesque, and in Olympian peace." Stage-like settings along with all kinds of props and accessories emphasize his affinity to the classic world – although under Horst's direction, plaster might mutate into marble and pinchbeck into gold. In his best pictures, he limited himself to a few details. In our present case, a balustrade suggesting marble skillfully turns the rear view of the semi-nude into a torso. In addition, it is the light – the direction from which it falls, forming highlights and deep shadows – that gives the photograph the desired drama. "Lighting," Horst once admitted, "is more complex than one thinks. There appears to be only one source of light. But there were actually reflectors and other spotlights. I really don't know how I did it. I would not be able to repeat it." The rear view of the nude clearly looks back to the great French achievements in art – we need only think of Ingres or, later, Degas, or the nineteenth-century photographic nudes of Moulin, Braquehais, or Vallou de Villeneuve, not to mention the ancient models. Horst, however, ironically comments on the ideal of the well-formed female body in a choice pose by means of a decidedly erotic accessory, namely the corset. The suggestiveness of the pose is increased by the loosened bands that almost invite the virtual observer to enter the game of concealing and revealing. After all, there are always two involved with a corset: the woman wearing it and someone who laces it. And in terms of the effect of the photograph on a female observer, the equally elegant and relaxed staging suggests that the proverbial torture of wearing a corset cannot really be as great as it is made out to be. Few viewers notice that the wasp waist was achieved with the help of a bit of light retouching.

So here it was again: the corset. Enlightened doctors had warned against it; Coco Chanel had combated it. In the eyes of the reform movement of the 1920s, the corset was nothing less than a relict of feudal times and the expression of a highly unhealthy way of life. But now, suddenly, on the eve of the Second World War, it had reappeared. More precisely: it appeared in the fashion shows of 1939. Dresses, coats, jackets once again

*Vogue (Paris): cover of the December 1939 issue*

showed a waist, thus making a corset a necessary item for all those for whom, as *Vogue* formulated it, things were not quite comme il faut. At first glance, it may seem absurd to attempt to locate in the corset a reference to the political situation around 1940. But fashion has always been the expression of its time, and is it not worth noting that the corset reappeared precisely at the moment when half of Europe had fallen under totalitarian rule (and the other half maintained at least sympathy for the right wing). Whatever the answer may be, the French edition of *Vogue* had the job of 'selling' its readers the idea of the corset. "Oh," said a commentary in the September issue of 1939, "stop complaining that the corset is uncomfortable. In the first place, the modern stays are well designed: one can sigh and even breathe properly. And secondly, comfort is not really the issue, but rather acquiring the bodily proportions of a siren. Or those of Tutankhamun in his golden coffin."

## Making themselves useful at least through work
In the spring of 1939, Horst had traveled with Hoyningen-Huene through Greece. Upon his return to Paris, he met with Jean Cocteau and Thornton

*Double-page spread from Vogue, December 1939: due to the War, neither the October nor the November issue appeared. Consequently, the unpublished pages (including the one with Horst's Mainbocher Corset) were offered in reduced format in the last issue of the year.*

Wilder. In August he photographed the corset creation of Mainbocher. A
few days later, on 1 September, Hitler attacked Poland and the Second
World War began. Horst's photograph had actually been intended for a
*Vogue* special in October 1939. The pictures were ready, and the layouts
were finished. But in the present situation, did anyone still have an inter-
est in fashion? England and France had already declared war on Germany,
and *Vogue* did not appear in October. The November issue of the French
*Vogue* also failed to appear. Not until December was the magazine again
delivered to the kiosks. Business as usual? Not entirely. *Vogue*, too, could
not escape the shadow of war. "Must it be, you will perhaps ask, that in
these dark hours, frivolity has come in again?" asks an editorial, and then
continues: "Whoever makes this argument is forgetting that the French
clothing industry is the second most important sector next to metal-

working..." This real issue is therefore jobs and the question of proper behavior during a state of "total War." This meant "that the entire nation finds itself at war and must fight back on all fields and in all areas. Those who are not called to the dubious glory of fighting with weapons can at least make themselves useful through work..." Furthermore, the article continues, one might ask oneself whether it is not outmoded to speak now about the fashion shows from the previous August. Rarely, according to the anonymous editorial, were the fashion creations more ephemeral than in that year. "Like mayflies they lived hardly more than a single morning." To convey the readers an impression of the fashions, the editors decided to copy the already laid-out, but unprinted and undelivered, pages of the October issue. Thus Horst's *Mainbocher Corset* appears – reduced to the size of a postage stamp – on page 35 of the December issue of the French *Vogue*. By this time, the photographer was already long in the USA, and in the following year, he would apply for American citizenship. Similarly, Mainbocher, who had still managed to make an impression through "a memorable Collection" in 1939, closed its Paris house in 1940 and also moved to America. Thus Horst's magnificent rear nude unwillingly became the apotheosis of an age and of a profession. "The Thirties," as Janet Flanner later laconically observed, "were over."

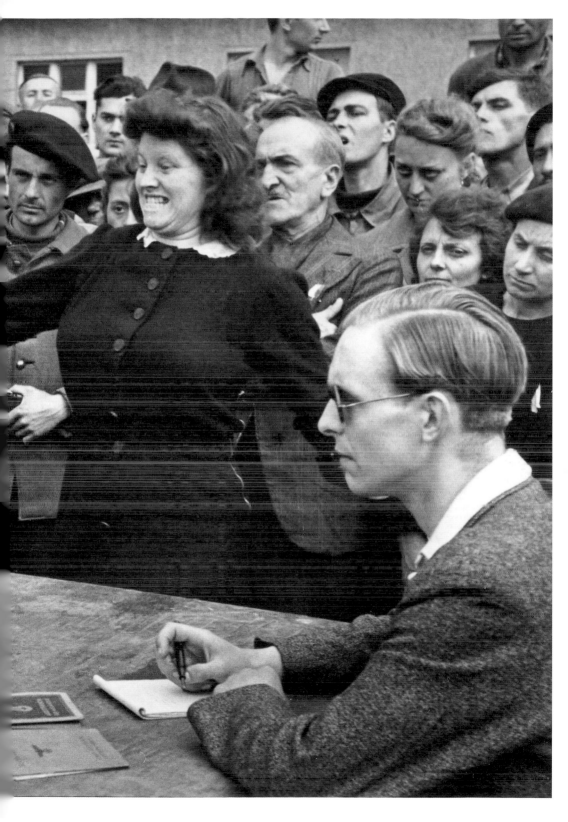

# Henri Cartier-Bresson
# Germany, 1945

**Dessau, Germany, shortly after the end of the Second World War. In a camp for so-called displaced persons, a Nazi victim suddenly recognizes a former Gestapo informant. The young Henri Cartier-Bresson was on the spot and took a photograph that became an icon of liberation and a symbol for the end of the Nazi terror.**

In the end, he allowed himself to be persuaded. He knew that he was not especially good at writing, nor was he by any means a theoretician. His background was rather in drawing, painting. Throughout his life he insisted that he was a painter, that he had learned from painting, and that he saw with the eyes of a painter. He felt a strong connection to Surrealism – but only as a visually oriented person, not as a formulator of theorems and programs. In the end, however, succumbing to the pressure of his Greek publisher Tériade, he sat himself at his desk and "in five or six days" wrote it all down. "I had it already in my head from the beginning, says Henri-Cartier-Bresson, whose first great book, which also functioned as a photographic summary of decades of work, was titled thematically *Images à la Sauvette*, (literally: pictures in passing). The comparatively large volume of approximately 12$^1/_2$ x 11$^1/_2$ inches, bearing a drawing by Henri Matisse on the cover, appeared in 1952 in the Editions Verve of the legendary publisher Tériade. It would be no exaggeration to claim that it became one of the most significant and influential photographic works of the twentieth century – even if it had to wait for the English edition to unify Cartier-Bresson's work conceptually under an appropriated title: *The Decisive Moment*. The formula stood as a perfectly tailored banner over Cartier-Bresson's introduction that, as stressed by Wolfgang Kemp, "like no other text became the basis of an engaged photojournalism." It should be noted, however, that the title was originally drawn from a quotation by Cardinal von Retz; the American publisher Dick Simon adopted

the slogan for the English edition, and thus introduced the phrase into photographic theory and camera practice.

## Brilliant slices extracted from the stream of time

Henri Cartier-Bresson – this "giant in the history of photography" (Klaus Honnef); "God the Father, Son, and Holy Ghost" (Roger Therond); the "greatest photographer of modernity" (Pieyre de Mandiargues); and "model for all later Leica photographers" (Peter Galassi) – was a master at intuiting critical moments. After the publication of *Images à la Sauvette*, or *The Decisive Moment*, critics have repeatedly described his work as brilliant slices extracted from the stream of time. Typically, Cartier-Bresson's photographs epitomize an event or happening just before it disintegrates or dissolves back into the flow of everyday life in a matter of seconds or split seconds. As a result, his work acquires something of a visionary, even prophetic, character. Yves Bonnefoy, for example, terms Cartier's photograph *Place de l'Europe in the Rain* (1932) nothing less than a miracle: "How was he able to recognize the analogy between the man running across the plaza and the poster in the background so quickly, how could he compose a scene out of so many fleeting elements – a scene that is as perfect in detail as it is mysterious in its totality?" He just has the feelers for it – thus Henri Cartier-Bresson explains the astounding results of his photographic activity in his typical laconic manner, adding: "I love painting. As far as photography is concerned, I understand nothing."

## More a matter of style

*Images à la Sauvette* presents a total of 132 black-and-white photographs, with the introductory text mentioned above prefacing the plates. Although this statement was not the author's sole verbal commentary on his work, it nonetheless was, or became, his most important: in it, he presents a combination of programmatic discourse, reflection, and technical manual all in one. It is, in fact, a prescription for a 'photography in passing', and as such was adopted as a bible by legions of ambitious photographers directly after the publication of the book in the 1950s – and is still followed by photographers of today. Henri Cartier-Bresson, born in 1908 into a prosperous textile-manufacturing family in Chanteloup, France, studied with André Lhote. The purchase of his first Leica trans-

**Henri Cartier-Bresson**

Born the son of a wealthy family **1908** in Chanteloup/ France. **1927–28** trains under André Lhote. Discovers the works of Munkácsi, resulting in a turn to photography. **1935** trains in film technique in New York under Paul Strand. **1936–39** collaborates with Jean Renoir. **1940–43** POW in Germany. **1946** first one-man exhibition at the Museum of Modern Art, New York. **1947** founder member of Magnum. **1952** publication of his book *Images à la Sauvette*. **1954** Soviet Union. **1958–59** China. **1960** Cuba, Mexico, Canada. **1965** India and Japan. **1967** culture Prize of the DGPh. **1970** marriage to Martine Franck. Dies **2003** in oCéreste/France.

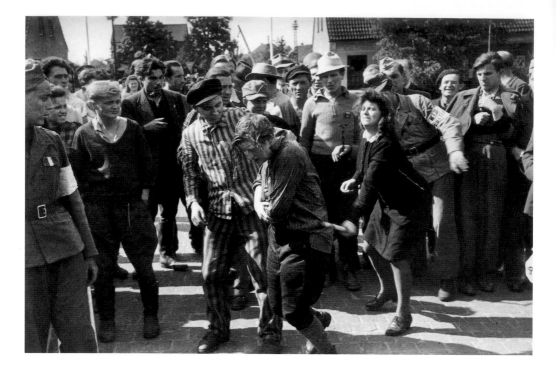

formed him into an indefatigable chronicler of his times, and he is justly
seen as one of the most influential and productive photographers of the
twentieth century. Each of his published photographs appears to be an
apparently effortless proof of his credo: "I like my pictures to be clear, or
better, climactic... This is more a matter of style than technique." To con-
jure an event at its culmination point onto celluloid – this is the magic
that his name still epitomizes today. Although Henri Cartier-Bresson did
journalistic reports, published essays, and produced photographic
sequences, he is above all the master of the single picture, in which a
theater of the world presents itself in microcosm.

*Germany, 1945* – Our picture's official short title, more or less authorized
by Magnum – appears on pages 33–34 of *Images à la Sauvette*. The pic-
ture is therefore a double-spread, running across the gutter. Lincoln
Kirstein and Beaumont Newhall had taken note of this work as early as
1947, including it both in the first large post-war exhibition of the photo-
grapher's works at the Museum of Modern Art and also it in the slim
catalogue (on page 40) accompanying the show. The photograph has
also appeared in almost all subsequent retrospective monographs, the

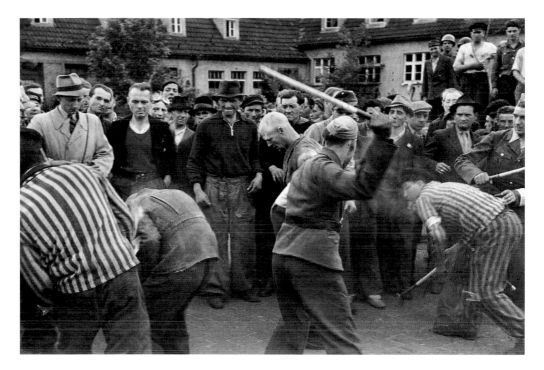

most prominent probably being Cartier-Bresson's large interim collection of photographs published in 1979 by Delpire under the simple title *Henri Cartier-Bresson photographe*. Here the famous work was of course included, along with many other classics such as *Rue Mouffetard, On the Marne*, and *Sevilla*. The ubiquity of the photograph has doubtless contributed to turning it into one of his best-known works. Moreover, the picture numbers among those deemed worthy of fuller commentary by the photographer. Thus, on the reverse of the key picture bearing the archive number HCB45003 W00115/25C, one finds the word: "Dessau. Border between American and Soviet zone. Transit camp for former prisoners held in eastern German area: political prisoners, prisoners of war, slave labor, displaced persons. A young Belgian woman and former Gestapo informer is recognized before she can hide herself in the crowd." Dessau, a middle-size city north of Leipzig in today's Saxon-Anhalt, which had made an international name for itself before the war as the home of the Bauhaus school. We do not know precisely when Cartier took the picture – the photographer himself never spoke willingly about his work – but the date must have been between 21 April and 2 July 1945 – that is,

*A further (scarcely known) motif from the Dessau-Kochstedt series dating from April through July 1945*

between the American occupation of the city and the arrival of their Russian replacements. The location is the former anti-aircraft barrack in Dessau-Kochstedt, which functioned as a transit camp during the occupation. The building, partially visible in the background, had been dedicated under the Nazis in 1937 and would later be used by the Soviets as a barrack until the unification in 1989; today the area is a housing development. On this spring day in 1945 the sky is cloudy, the light, diffuse. The sun breaks through only occasionally, casting long shadows that might indicate afternoon; more probably, however, it is morning. Cartier-Bresson in any case was carrying his Leica, fitted with a 50-mm lens. By deduction, this means he was standing about ten feet away from the protagonists – close enough to capture the event, but also far enough to do obeisance to his preferred policy of not interfering. "One must creep up to the subject on tip toes," he once said, "even when it involves a still life. One must put on velvet gloves and have Argus eyes. No pushing or crowding: an angler doesn't stir up the waters beforehand."

At the time of the photograph, Cartier-Bresson was thirty-six years old with an international reputation as a photographer, though he certainly had not yet approached the cult status that he definitively achieved with the publication of *Images à la Sauvette*. Meanwhile, in the USA Kirstein and Newhall were preparing a "posthumous retrospective" for the photographer, presuming him to have been killed in the war – an assumption not at all far-fetched, when one recalls that Cartier-Bresson had been an active resistance fighter. Captured and interned by the Germans in 1940, he had escaped only on his third attempt three years later. At this point, in 1945, however, he was in fact working with the Americans on a film for the Information Service about the home-coming of French prisoners of war. "It was a film by prisoners about prisoners," as Cartier-Bresson recalled. "The scene played itself out before my eyes as my cameraman was filming it. I had my photography camera in my hand and released the shutter. The scene was not staged. Oddly, this picture doesn't turn up in the film."

## The setting for a scene that became famous

This was not the first time that Cartier-Bresson conducted filming work and photographic work in parallel. One needs only to recall his famous

*Henri Cartier-Bresson:* Images à la Sauvette. *The French first edition of his classic book appeared 1952, produced by legendary publishers Tériade with a dust jacket from Henri Matisse.*

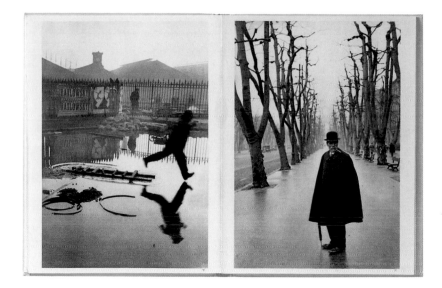

picnic *On the Marne*, created while he was an assistant director to Jean
Renoir (*La vie est à nous, Une partie de campagne*). But whereas *On the
Marne* has nothing to do directly with the filming, in Dessau the photo-
grapher and his cameraman are shooting one and the same scene simul-
taneously, even if the film does not contain the 'most decisive' moment
captured by Cartier-Bresson. *Le Retour*, as has been mentioned, was
being made at the behest of the Office of War Information and the French
Ministère des Prisonniers. The black-and-white film runs 32 minutes and
37 seconds, with a commentary in French spoken by Claude Roy in the
original version includes. *Le Retour* opens with footage taken in Dachau
in late April 1945 by the American troops who had liberated the concen-
tration camp. Following these scenes are shots of freed prisoners, strag-
gling soldiers, refugees wandering about in a daze – all of whom, accord-
ing to the narrator, were causing chaos on the roads and hindering the
sweep of an Allied victory. As a result, camps to contain these people
were set up in occupied barracks, factories, and private houses. Cut. The
film camera now does a long shot of a large interior courtyard that is
about to become a stage of the scene made famous by Cartier-Bresson's
photograph. We are looking at a crowd of several hundred people. In the
center, a circular area has been cleared. In the background is the high
gable roof of the former barrack, some of whose windows can also be

made out in Cartier's photograph. To the lower right in the picture is the table to which – cut and medium close-up – a young woman wearing dark breeches, light-colored wool socks almost up to the knee, and flat shoes is led. She walks with a stoop. With a serious expression and hanging head, she steps up to the table at which the accusation against her – whatever it is – is about to be processed. The young man on the left with sunglasses and parted hair raises his finger and seems to give a warning. His name is Wilhelm Henry van der Velden, a twenty-two-year-old Netherlander, who had been studying medicine until he, like his brother Karel, was interned in February 1943 in the Dutch concentration camp Westerbork. Now, at the behest of the Americans, he has been appointed commandant of the camp at Dessau, through which thousands of people are making their way daily, from West to East or vice versa. Above all, explains the commentary accompanying the film, it is necessary to be keep a careful watch out "for that handful of vile beings who were attempting to disappear amid the flood of deportees – to return home to 'business as usual'." The woman in the high-buttoned dark dress, who assumes a central position in a double sense of the word in Cartier's picture. is still standing several yards away on the right edge of the picture. But – cut and quarter close-up – now she, a Frenchwoman, moves up to the table, her arms still folded across her chest, a light colored purse dangling down. The commentary speaks of denunciators, Gestapo stooges, torturers, who will surely be turned over by those whom they had earlier betrayed. Again cut. The camera has now closed in on the two women. The one on the right addresses the other, screams at her: Yes! You helped the Gestapo, you are an agent. She lifts her arm and strikes, hitting the other woman in the face so that the accused is literally thrown out of the picture. Seconds later she re-enters, arranges her hair, looks briefly and confusedly at her 'torturer', bleeding at the nose. The sequence lasts exactly three seconds in the film; Henry Cartier-Bresson's exposure may have lasted 1/60 of a second.

## The decisive moment of revelation
Cartier-Bresson remembered the film correctly when he said that the scene he caught with his camera does not appear. Speculation as to whether his picture was therefore staged are quickly laid to rest, however, when one takes a closer look at the crowd of observers in the back-

ground. Consider for example the young man wearing his beret at a slant: in the film, his belt buckle is enclosed within his left hand – exactly in the same position that can be seen between the two women in Cartier-Bresson's photograph. A peripheral detail such as this would hardly find its way into a scene set up later. Why then did the film camera not capture the precise moment of identification? Chronologically, Cartier's photograph lies between the third and fourth scenes of the film. That is, the woman has not yet been identified as an agent, and the blow has not yet been struck, or she would be visibly bleeding from the nose in the photograph. Perhaps the critical moment fell victim to cutting and editing or, more likely, the cameraman – who must have been standing almost elbow-to-elbow with Cartier-Bresson – was changing the lens to capture what followed close-up. In any case, the cameraman caught the subsequent activity on film; Cartier-Bresson, however, got the more truly 'decisive moment': that of revelation, of identification, of the instant in which past, present, and future – the memory of sorrow, and painful recognition, and furious response – come together. The distorted face of the former victim, now become a perpetrator, mirrors the tension of the tense situation.

For a long time afterward, Henri Cartier-Bresson reported, he received questions and letters containing a cut-out of the photograph, with a cross over one or another of the persons in the background together with the plea: "That is my brother, that is my father – please tell us where he is now! How can we find him?" Let us look at the facts: at least ten million foreign prisoners, foreign workers, and deportees were wandering through Germany as 'displaced persons' in the years following 1945. Thus the photograph also assumed a thoroughly pragmatic function in the decades following 1945. Artistically, the picture has survived because of its "emblematic value," as Jean-Pierre Montier has expressed it. In the face of historical fact    after all, there was no concentration camp in Dessau itself – Cartier-Bresson's photograph came to function as a symbol of the liberation: in our collective pictorial memory it has come to stand for the opening of the concentration camps and liberation from terror.

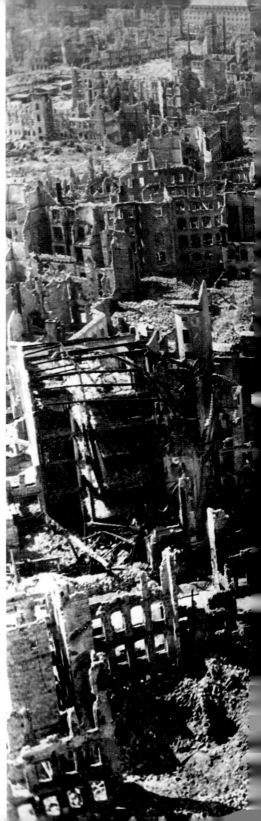

216  **Richard Peter sen.** View from the Dresden City Hall Tower

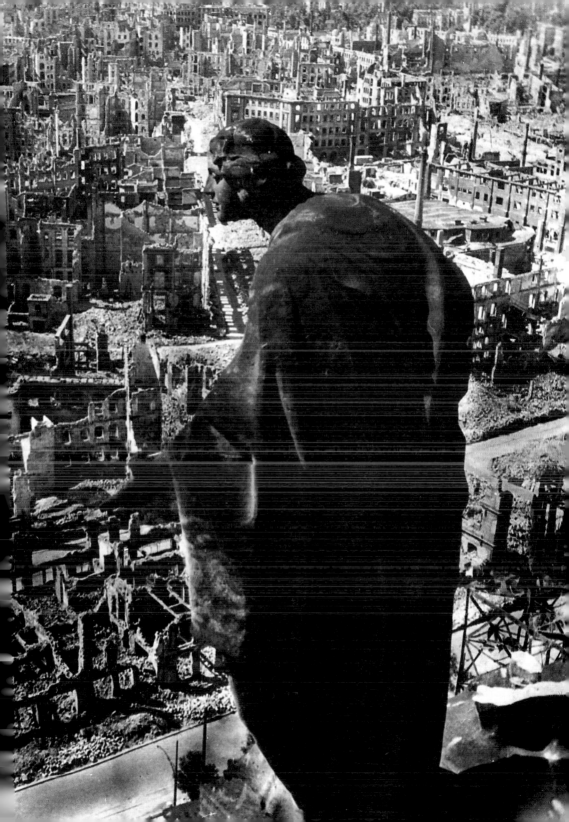

# 1945

# Richard Peter sen.
# View from the Dresden City Hall Tower Toward the South

**Angel Above the City**

**Immediately after the end of the war, the Dresden photographer Richard Peter sen. started an ambitious cycle on the demolished city that had once been known as the "Florence on the Elbe." By the end of the 1940s, he had completed approximately a thousand photographs, including this famed view from the City Hall Tower looking toward the south.**

Almost miraculously, the tower of the New City Hall, dating from the mid-eighteenth century, survived the firestorm of 13–14 February 1945. Not that it had totally escaped being damaged in the inferno, of course, but compared to the Zwinger palace or the Frauenkirche, whose former glory now lay buried under the ruins, the City Hall, located between the Ringstrasse, the City Hall Square, and Kreuzstrasse, was at least reparable. The east wing of the building had been particularly heavily damaged by fire bombs and blockbusters, but the tower, visible from a great distance, still remained standing, its hands stopped at 2:30 a.m. At a height of more than 325 feet, the tower was the tallest building in the city, but had lost its cupola. All that remained of it was a filigree-like skeleton, crowned by Dresden's recently adopted municipal emblem – a sculpted male figure in gilded bronze by Richard Guhr, which now seemed to be balancing as if on a tightrope. The famous double staircase had also survived the force of the demolition and firebombs. Richard Peter sen. climbed these steps for the first time in the middle of September 1945.

**Nearly six square miles completely devastated**
The photographer, well known in Dresden, was not the only one to make his way to the top of the City Hall Tower after the war had ended, how-

ever. The collection of the German Fotothek Dresden contains numerous views of the city taken from the tower – or rather, views of what remained of the city, the "princely Saxon residence" (Götz Bergander), "famed throughout the world as a treasure chamber of art" (Fritz Löffler), the city that had once been the Florence on the Elbe. In all these photographs, the view was always shot over the shoulder of one of the figures sculpted by Peter Pöppelmann or August Schreitmüller, looking down onto the landscape of ruins. It is just this opposition – between personified virtue and death, light and darkness, proximity and distance, height and depth – that lends the photographs by Ernst Schmidt, W. Hahn, Wunderlich, Döring, Willi Rossner, and Hilmar Pabel their excitement, their suggestive power, and their memorial value.

Although some of these photographs may differ in their manner of presenting the subject, we may rest assured that it was Richard Peter's square photograph that inspired the others to find their way up the tower of the City Hall located in the south-east of the old city. In any case, Richard Peter's photograph was indisputably the first of an entire series of similar motifs – an image that bequeathed the world a valid pictorial formula for the horror of the bombing in general and of the destruction of the Baroque city of Dresden in particular.

The fire-bombing of Dresden is often compared with the dropping of the atom bombs on Hiroshima and Nagasaki. In the totality of the destruction and the number of victims – as well as in the sense of being a 'fitting' symbol for the times – all three catastrophes have much in common. On 13 and 14 February 1945, 'merely' three attacks, each by several hundred Lancaster bombers, Mosquitoes, Liberators, and Halifax planes of the Royal Air Force, sufficed to extinguish the strategically unimportant but historically unique center of the historic city of Dresden. The number of the victims is still disputed today, but estimates begin at more than 30,000; the exact figure will never be known, because many victims were instantly cremated. Furthermore, as pointed out by Adelbert Weinstein, the "already buried dead could in any case no longer be excavated from the cellars in this landscape of ruins. Because of the danger of epidemics, the rescue troops were even forced to wall up the make-shift bunkers or to burn them out with flame throwers." The damage to the buildings, on the other hand, can be statistically compiled. A surface area of nearly six square miles was completely devastated. Seven thousand public build-

**Richard Peter sen.**

Born **1895** in Silesia. **1912** examination to become a journeyman smith. **1916–18** called up for WW I. From **1920** politically active in the German Communist Party. **1924** first camera reports for *Roter Stern* (later *A.I.Z.*). **1933** prohibited from practicing his profession. **1939** conscription. **1945** returns to Dresden. Archive is lost during the bombing. Involved in rebuilding the East German press. Founder editor of the glossy *Zeit im Bild*. **1946–49** photographic chronicles of destroyed Dresden and its reconstruction. From **1955** turns to calendar and book illustration and trade fair photography. Dies **1977** in Dresden

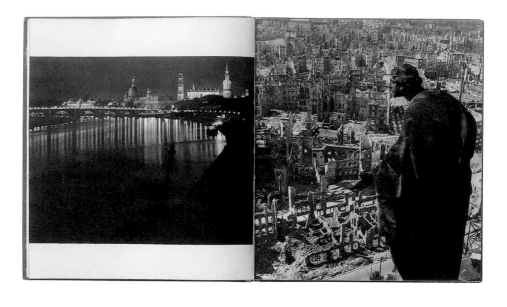

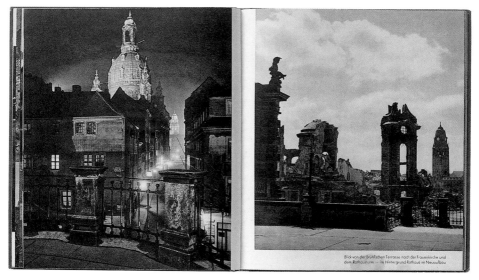

Blick von der Brühl'schen Terrasse nach der Frauenkirche und
dem Rathausturm — im Hintergrund Rathaus im Neuaufbau

*Double-page spreads from Peter's Dresden book.*
*The book appeared in an astonishingly large edition for the time – 50,000.*
*Today it is regarded as one of the classic photo books on the war ruins.*

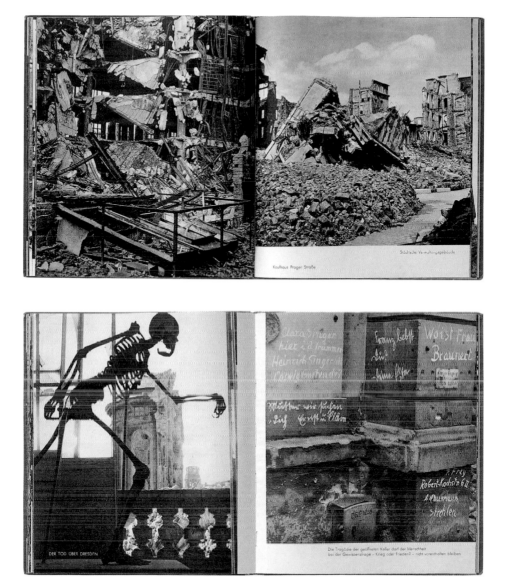

Kaufhaus Prager Straße

Städtische Verwaltungsgebäude

DER TOD ÜBER DRESDEN

Die Tragödie der geöffneten Keller darf der Menschheit
bei der Gewissensfrage – Krieg oder Frieden? – nicht vorenthalten bleiben

ings – museums, churches, palaces, castles, schools, hospitals – lay in ruin and ashes. Of the city apartments, 24,866 of 28,410 fell victim to the bombing attack. More than thirteen million cubic yards of rubble had to be cleared away before reconstruction – still continuing to this day – could begin.

In the years following war, Richard Peter sen., born in Silesia in 1895, was one of the many photographers who sought a pictorial response to the apocalypse that had ended in Europe in May 1945. Parallel to the often-discussed *Trümmerliteratur* (literature of ruins), one may also speak of a regular 'photography of ruins' – the scenes of destruction offered by every larger German city to its own pictorial chroniclers: Friedrich Seiden-stücker and Fritz Eschen in Berlin, Herbert List in Munich, Wolf Strache in Stuttgart, August Sander in Cologne, Karl Heinz Mai in Leipzig. Photographically important after 1945 were especially the cycles by Hermann Claasen and Richard Peter sen., whose books *Gesang im Feuerofen* (1947; Song in the Furnace) and *Dresden – eine Kamera klagt an* (1949; Dresden: A Camera Accuses) were among the most-discussed publications of the post-war period.

*Richard Peter: Dresden – eine Kamera klagt an (Dresden: A Camera Accuses). Cover of the original German edition of 1949*

## A feeling of emptiness and stillness

Not until seven months after the inferno – that is, only on 17 September 1945 – did Richard Peter sen. return to Dresden, his adopted city of residence. Not only did he find the city in which he had lived since the 1920s, and where he had worked as a photojournalist with the legendary *A.I.Z.*, completely devastated, but also his own pictorial archive containing thousands of plates, negatives, prints, the sum of thirty years of photographic work, had been destroyed beyond repair. With a Leica that someone gave him as a gift, he set out once more to photograph: ruins, urban 'canyons', car wrecks, and finally the corpses in the air raid shelters, which began to be opened in 1946. This work occupied him for more than four years. Among the thousands of pictures he created was his *View from the City Hall Tower*, on which Peter worked for a full week, according to his own report.

"Rubble, ruins, burnt-out debris as far as the eye can see. To comprise the totality of this barbaric destruction in a single picture," as Peter himself described the creation of the photograph, "seemed at most a vague possibility. It could be done only from a bird's eye view. But the stairs to

almost all the towers were burned out or blocked. In spite of the ubiquit-ous signs warning 'Danger of Collapse,' I nonetheless ascended most of them – and finally, one afternoon, the City Hall Tower itself. But on that day, the light was from absolutely the wrong direction, thus making it impossible to take a photograph. The next day I climbed up again, and while inspecting the tower platform, discovered an approximately ten-foot-high stone figure – which could not in any way be drawn into the pic-ture, however. The only window which might have offered the possibility for this was located around 13 feet above the platform, reachable only from inside the tower. Two stories down, I found a 16-foot stepladder that someone may have carried up after the fire to assess the extent of the damage. The iron stairway was still in good repair. How I managed to get that murderous ladder up the two stories remains a riddle to this day. But now I was standing high enough over the figure [to photograph] and the width of the window also allowed the necessary distance. The series of exposures made with a Leica, however, resulted in such plunging lines, that the photographs were almost unusable. In this case only a quadratic camera could help, but I didn't own one. After two days, I finally hunted one down, climbed the endless tower stairs for the third time, and thus created the photograph with the accusatory gesture of the stone figure – after a week of drudgery effort and scurrying about."

Peter's photograph appeared in *Dresden – eine Kamera klagt an*, pub-lished in 1949 in the former German Democratic Republic with a first run of fifty thousand copies. That the cropped figure in the picture is not the angel of peace, but the personification of 'Bonitas', or Goodness, does nothing to diminish the symbolic character of the photograph. The fact that streets were by then largely cleared of debris and rubble even in-creases the feeling of emptiness as well as the stillness, which for many people was the most striking characteristic after capitulation in May 1945. Wolfgang Kil once described Richard Peter's completely subjective im-ages, which were intended as affective warnings, as "landscapes of the soul." In these pictures, an entire generation found their experience of the war visually preserved.

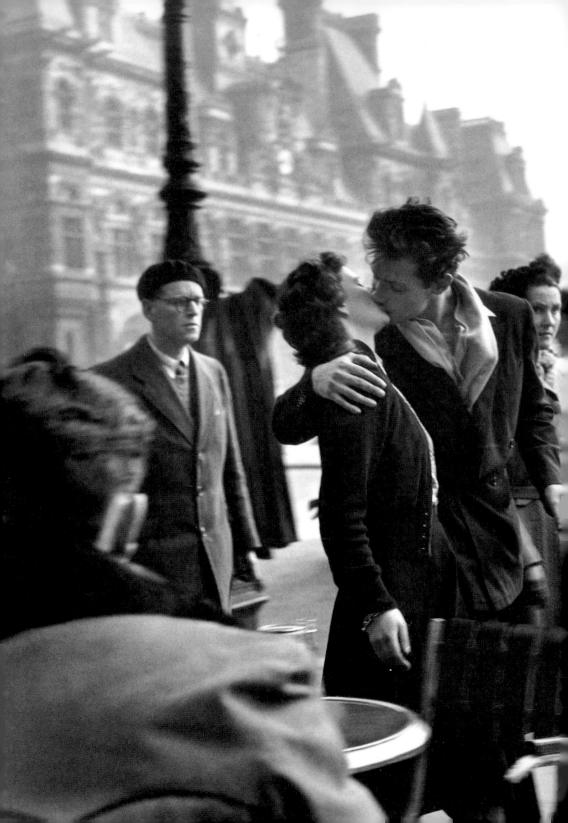

# 1950 Robert Doisneau
# The Kiss in Front of City Hall

**There is scarcely a photograph of our times that has achieved the popularity of Robert Doisneau's *The Kiss in Front of City Hall*. The image of a fleeting embrace has become an icon of Paris par excellence. Moreover, as a gripping metaphor of the sense of post-war life, the photograph brought its creator not only fame and wealth.**

This time, he dared to come in closer. Usually, however, he kept his distance and tried to remain unnoticed. Robert Doisneau was fond of citing his intrinsic shyness as the reason for his restraint as a photographer. Making necessity a virtue, he had eventually transformed keeping his distance into a pictorial style that applied to the entire social and architectural environment of the city. Doisneau is the photographer of the big picture, so to speak, and is thus the antithesis of a William Klein, who consciously intermingles with the people he photographs, seeking closeness and interaction, letting it be known that he is a photographer, provoking reactions, and thus turning the very act of taking the picture into the theme of the work. But if the French term *chasseur d'images* – literally, picture hunter – is recognized throughout the world as a description for the action of the photographer, Robert Doisneau always understood himself in contrast as a *pêcheur d'images*, a fisher of images, that is, a photographer who waited patiently until the stream of life cast its more or less rich booty before his feet – a "bystander" (Colin Westerbeck), who lifted discretion to a pinnacle and placed it at the heart of all his work. In this sense, Doisneau has entered the history of photography as the master of the 'candid camera'. Or rather, he would have liked to have been so recognized, if a widely publicized series of international law suits toward the end of his life had not revealed that he – Doisneau himself – had helped set up the events that are depicted in his photographs.

In any case, what is probably his most famous picture, *The Kiss in Front of City Hall*, was, as we now know, the result of a scene staged with the help of a hired actor and actress. But what does this fact mean for the reception and understanding of a photograph that functions as a 'popular icon' and is one of the most well-known photographic creations of its century?

## A staple of every Doisneau retrospective

According to unofficial statistics, *The Kiss in Front of City Hall* has been sold more than two and a half million times as a postcard alone. In addition, around half a million posters bearing the same motif have found buyers. The picture decorates pillows, handkerchiefs, wall and table calendars, greeting cards, and fold-out picture series. Furthermore, it is a staple of every Doisneau retrospective, and not accidentally adorns the cover of the artist's most important publication to date, *Three Seconds from Eternity*. Visitors to Paris come across some form or another of this image on almost every street corner. The question arises: why does this comparatively simply constructed and relatively unspectacular photograph still fascinate the public today.

At the exact center of the square photograph is a young couple, about twenty years old. Quite frankly, there is nothing at all striking about them. They are decently dressed – appropriately for the street. At most, the bright scarf tucked into the neck of the man's double-breasted suit is the only item lending a bohemian flavor to the Right Bank of the Seine. Approaching from the left, the couple is moseying its way down the busily populated street. The man has placed his right arm around the girl's shoulder. Spontaneously – so the picture suggests – he pulls her toward himself and kisses her on the mouth. None of the other pedestrians visible in the picture seem to have noticed the sudden testimony of love. At most the observer in the foreground witnesses the little scene. The consciously chosen 'over-the-shoulder' shot, to borrow a term from film-making, suggests this at least.

## One of those 'undecided' winter days in Paris

Why Robert Doisneau set this scene in the vicinity of the Paris City Hall, we don't know. In reality, the other bank of the Seine – in particular the Latin Quarter inhabited especially by students – stood for carefree happiness after the war: it was no accident that the Netherlander Ed van der

Robert Doisneau

Born **1912** in Gentilly/Val-de-Marne. **1929** diploma as engraver and lithographer. **1930** commercial photographer for Atelier Ullmann. **1931** assistant to André Vigneau. **1932** first reportage in the illustrated daily *Excelsior*. **1934–39** works as advertising and industrial photographer for Renault. Active in the Résistance. **1946** joins the agency Rapho. **1949** book publication *La Banlieue de Paris* (with Blaise Cendrars). **1949–52** fashion for French *Vogue*. Afterwards freelance photographer in Montrouge near Paris. **1992** major retrospective in the Museum of Modern Art, Oxford. Dies **1994** in Montrouge

Elsken chose the Rive Gauche as the location for his probably most important work in the mid-1950s: *A Love Story in Saint-Germain-des-Prés*. But Robert Doisneau determined upon the Right Bank. Blurred but clearly recognizable, the neo-baroque Paris City Hall stands in the background of the busy street, which must therefore in fact be the rue de Rivoli. The street cafe from which the picture was taken may well be what is today the Café de l'Hôtel de Ville, on the corner of rue du Renard and rue de Rivoli. Doisneau shot the picture with his Rolleiflex looking out toward the street from the second row of tables. The woman walking by in the background has noticed him, her glance giving also the photographer a presence in the picture.

In monographs, the photograph has repeatedly appeared under the title "Sunday." But in fact there is no indication in the picture itself that it is Sunday: we simply associate the idea of a stroll through the city with Sundays and holidays. Doisneau himself dated the photograph March 1950. It must, therefore, have been taken on one of those 'undecided' winter days in Paris: neither cold nor warm, certainly not sunny, but dipped rather in that diffuse light that Doisneau once described as typical of Paris – the light that is part of the perpetual "tender gray tent that the famed sky of the Île-de-France [begins] to unfold at daybreak as one would pull a protective cover over valuable furniture."

## Always looking for an eloquent moment

Doisneau's photograph was published for the first time in the legendary illustrated magazine *Life*. At that time, this son of a petty bourgeois Parisian family was thirty-eight years old. At the École Estienne he had learned the craft of engraving, and afterwards had become acquainted with the innovative tendencies of the New Objectivity movement in photography at the studio of André Vigneau. Subsequently Doisneau accepted his first position – admittedly an unsatisfactory one for him – with Renault as an industrial photographer. By 1939 he had been fired for coming to work late once too often. "So there I was on the street again, where everything was happening, I felt very happy, but also slightly worried. Five years in a factory put my initiative to sleep. But asleep or not, material need forced me to make a new beginning."

Doisneau transformed necessity into virtue, and made the street the object of his photographic explorations. It was always the Paris of the

simple people who fascinated him, however – the Paris of pensioners
and casual workers, of tramps and cabbies, easy women, workers, chil-
dren, and of landladies peering down the hall. These are the people he
sought out, always looking for the eloquent moment in which the human,
and all-too-human, was concentrated. Doisneau is the story-teller among
the exponents of a so-called *photographie humaniste.* Whereas Cartier-
Bresson followed the Constructivist dictum and composed his photo-
graphs down to the last detail, Doisneau sought out the anecdote. His
pictures evince wit, but very often there is an irony or even a slight sad-
ness hiding behind the humor. He always defended himself against intel-
lectualizing the taking of a picture. His camera art derived from springs of
sympathy and feeling, sources which ultimately explain the unparalleled
international popularity of his œuvre.

Fame came late to Doisneau – but then all the more enduringly. In the
early 1970s, the market halls were torn down in Paris. For many Parisians,
their demise signified not only the passing of a piece of old Paris, but also
the end of an entire era: that not-always-carefree, but always hopeful
post-war era, in which the metropolis on the Seine once again had ad-
vanced to the artistic and intellectual center of the world, before the city
irrevocably lost its leading position to New York. It is no accident that pre-
cisely at this painful turning point, the work of Robert Doisneau, the core
of whose work largely reflected the 1940s and 1950s, underwent a literally

unparalleled discovery. His friends had warned him: "Don't waste your time with these photos!" But Doisneau had held out, and in the end, there was almost no other photographer of his generation who could offer such a treasury of pictures from 'better times' than the rather quiet and unassuming Doisneau. Rumor has it that his archives contained no fewer that 400,000 negatives – a visual cosmos from which innumerable never-before-seen photographs of Paris still emerge.

### A city of relaxed behavior and sensual pleasure

Under the aegis of this belated acceptance of Doisneau, *The Kiss in Front of City Hall* embarked on its march of triumph after a small-format premier in *Life* as one of a total of six black-and-white photographs. The publisher had neither recognized the visual power of the picture nor seen any significance in the name of its creator: the photographer was not in fact mentioned on the double-page spread. The photograph itself was part of a story about Paris as the city of lovers. There, suggested both text and pictures, people might embrace on every street corner without anyone taking notice. Remember: we are still speaking about the 1950s, a markedly prudish era, in which a caress on the open street was hardly the rule. In this context, *Life* once more borrowed the old cliché of Paris as a city of relaxed behavior and sensual pleasure, an image also current in Hollywood films of the time. At root, *The Kiss in Front of City Hall* still functions on this level today: the picture arouses ideas of an undisturbed enjoyment of love a few years after the war. In this sense, the photograph was able to operate in a double sense as an ambassador of a peaceful, yet impetuous, harmonious relationship.

### Three kisses at the City Hall, another in the rue de Rivoli, and one more at Place de la Concorde

Doisneau himself continued to maintain an ambivalent attitude toward his famous picture, once even claiming that it represented no photographic achievement. "It's superficial, easy to sell, une image pute, a prostituted picture." All those who bought it, whether as a poster or a puzzle, a shower curtain or a T-shirt, saw it – and still see it – in another light. Throughout his life, Doisneau received enthusiastic letters, including some from people who thought they recognized themselves in the picture. In 1988, however, Denise and Jean-Louis Laverne from Ivry near

Paris contacted the photographer with a claim of the equivalent of approximately $ 90,000 for lost royalties. The outcome was a much-watched court trial, during which Doisneau admitted that he had staged the picture with paid models. The photograph, according to his argument, had been made under contract with *Life* for shots of couples kissing in Paris. But for fear of judicial problems, it was decided to use actors. Doisneau seated himself in a cafe near Cours Simon, one of the well-known acting schools, and thus discovered "a very pretty girl...She said okay, and brought her boyfriend with her to the scheduled photographic appointment. We took three kisses at the City Hall, another in the rue de Rivoli, and another at Place de la Concorde."

Denise and Jean-Louis Laverne walked out of the trial empty-handed – but the case had stirred up sufficient dust to rouse those who had actually posed for the picture: Jacques Cartaud, then in his mid-sixties, and the former actress Françoise Bornet, who now sued for 100,000 francs in damages. Her claim was also dismissed, even though she produced as evidence an autographed copy of the picture, which the photographer had given to her as a gift after the session. For his part, Doisneau was able to prove that he had paid the young woman what was normal at the time. He thus seemed to be out of the woods, but his artistry as a photographer had suffered damage in the larger sense. Ever since the affair, people have wondered how many of his pictures of post-war Paris Doisneau had in fact staged. The artist admitted arranging "all of my lovers of 1950" – but protested that he had very carefully observed "how people behave in certain situations," before he created the scene.

As paradoxical as it may sound, the discussion over whether the picture was set up or not did very little damage to the incriminated *The Kiss in Front of City Hall* itself: the image had long since left all concern with documentation behind. The photograph became a symbol – and symbols possess a truth of their own.

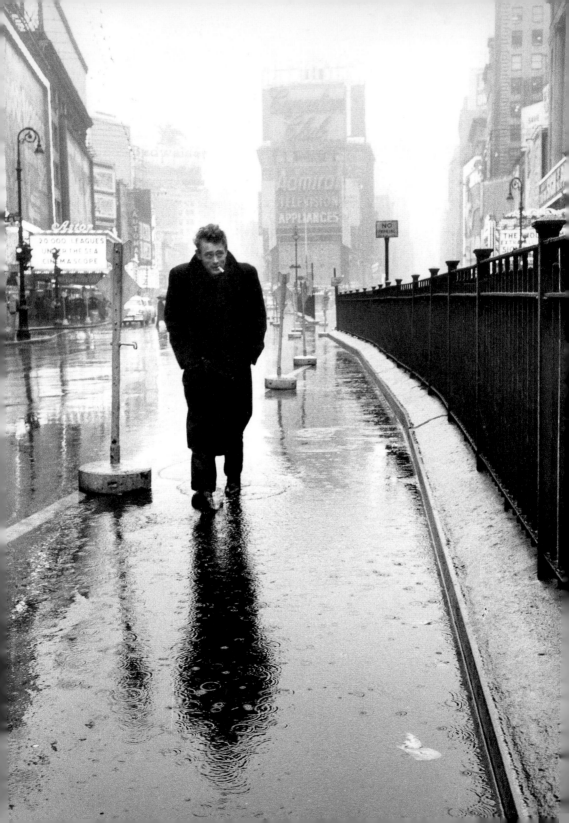

# Dennis Stock
# James Dean on Times Square

**It started out as an assignment — and became a legacy. Early in 1955, the young Magnum photographer Dennis Stock accompanied the rising screen star James Dean to Fairmont, Indiana, and New York. The resulting photographs would prove to be the best and most intimate portrait this idol of the new youth, who was to die only a few months later in an automobile accident.**

## Myth in the Early Morning

The setting is no accident, even if the weather is. But what would this picture be without the rain? It forces the bare-headed protagonist into a slight slouch, makes him pull his head into his collar. But that's what tall men do anyway. Five feet eight stands written on his passport   in other words, not particularly tall. And it may well be that his height at times was as much of a problem for him as his short-sightedness. In private life he had to wear glasses — and he needed them on the stage, too. But perhaps it was just this blurred perception of his environment that threw him back on himself and led to the oft-described intensity of his acting. New York. Times Square. For a few moments Broadway becomes his theater. But in reality, every place is a theater to him — a stage where in fact he doesn't act, but lives out his life, whether before an audience, or in front of the film camera. The boundary between reality and dream disappears; there is no need for him to take on another form as an actor, but rather to heighten the feelings, dreams, fears, neuroses, and phobias that already reside in him. Even now, at this moment, he is private and public at the same moment. It is not merely by chance that he is making his way across Times Square: what he is now doing for the camera is something that he has already done a thousand times before. And it's not an accident that the Chesterfield happens to be hanging from the corner of his mouth. Nonetheless, he smokes in private, too. He is acting, yes — but he is acting himself. He does it for *Life*; he does it for the photographers; he

does it for the fame and image whose structure he cannot leave to chance.

Of course he's vain. Even in photographs he sometimes gazes into the mirror, even if it is only his reflection in a frozen puddle. This time, it's a rain-slicked street. It's really quite skillful how Dennis Stock takes advantage of the puddle to double the form of his hero, as it were. In reality he should disappear between the skyscrapers of New York. Instead, the canyon of buildings sinks backward into the mist, and he, in spite of his rather short stature, becomes taller. A giant with drawn shoulders – but that's the way he sees himself anyway. And how the photographer manages to convey this self-consciousness graphically is a small stroke of genius. Henri Cartier-Bresson used to look at his pictures upside down to check just how compelling they were. In this case, our picture transfers the attention of the observer from the person to the mirror image. Blurred, jittery, frayed at the edges – an image that easily becomes a metaphor for the high-strung, impatient, restless life of our hero – for his rebellious character, for his ambivalence – which concentrates all the contradictions of a satiated age into an apotheosis. "I don't know who I am," he had claimed even as a seventeen-year-old high-school student. But that doesn't matter.

## With the instincts of a wild animal

Now he is twenty-four and approaching the zenith of his career – an observation that sounds strange when one realizes that he will not reach his twenty-fifth birthday. He has performed on stage and has begun to take up small roles in early television. But it is the cinema that will carry him to fame – this comparatively young, popular art form that, as he well knows, guarantees a kind of immortality even better than that of the stage. He has already made one film, and two more will follow in the coming months. His *Rebel Without a Cause* will moreover premier in the very theater, the Astor, that we see to the left at the back of the picture. Not far from here, on 68th Street West, he has a modest apartment, and Lee Strasberg's legendary Actors Studio is only a few steps away from Times Square. He had been accepted there in 1952 – certainly the most important confirmation of his talent until he won the favor of the great public. Perhaps Times Square was now no longer all that it had once been. Nonetheless, as Dennis Stock relates, before James Dean departed for

Hollywood, the Square was his home where he moved about with all the confidence of an animal in its own territory. He could not tolerate staying inside his small apartment, and instead spent the time outdoors, pacing the streets from dusk to the early morning hours.

Anything can become a myth, as Roland Barthes once pointed out. The myth is not primarily an object, a term, or an idea, but a message. The bourgeois age is the era of technical pictures: photography, movies, and television are the vehicles of modern myths. Moving images create them, static pictures lend them stability. James Dean is one of the great myths produced by America in the twentieth century – a genius who touched the nerve of his times, a rebel who made youthful rebellion into the basso profundo of his artistic creativity, and who will always retain his credibility because he was saved from growing old. "Live fast", he is said to have quoted from Nick Ray's *Knock on Any Door*, "die young, and leave a good-looking corpse." Cryptic-sounding advice, but it largely reflects how he directed his own life, in which nothing was left to chance, for his life was a self-dramatization, even if the distance between being and seeming was not especially great. According to Dean's biographer David Dalton, who is one of those most familiar with the actor's legend, the young actor identified totally with his characters.

## The craving for pictures in the glossies and fan magazines

Dean is always said to have disliked photographs. But this can at most be only partially true. In any case, his attitude toward the medium was ambivalent, and for a while he in fact took photography lessons from the photographer Roy Schatt. There are pictures showing him with a Leica or Rolleiflex – without, however, anything worthy of notice having come out of his camera. What is more important was and remains his relation toward his own image. Schatt related how the two of them were making portraits when James Dean suddenly said that he wanted to try something. He turned his head slightly to the left and looked downwards. Schatt asked himself what on earth he was up to, and the star replied: "Can't you see? I'm Michelangelo's David." Dean certainly had nothing against being photographed, at least when it flattered his ego – or served his career. Star photos are as much a part of Hollywood as the star is to the film itself, even if the great age of glamour photography, characterized by warm spotlights and retouching, was already over. Now instead

## Dennis Stock

Born **1928** in New York. Joins the navy at age 16. After the end of the war turns to photography. **1947–51** trains under Gjon Mili. **1951** first prize in the *Life* young photographers competition. Contact with Robert Capa. Magnum member from **1954**. Moves to Hollywood, where friends with James Dean. From **1957** intensive photographic explorations of the jazz world. **1960** publication of his book *Jazz Street*. **1962** withdraws to the country. Turns to nature photography under the influence of the work of Ernst Haas. In the late sixties spends several months at the Hippie communes of the American South West. **1970** publication of his book *The Alternative*. Has recently shown great interest in film and video. Lives in Centerbrook/USA

there were photojournalists and press photographers, who took over the job and served the craving for images in the illustrated journals or fan magazines. In Dean's case, these were names like Roy Schatt, Sanford Roth, and Dennis Stock. In other words there remained a great deal of Dean memorabilia in the form of photographs. But when David Dalton writes that our image of Dean is formed of many elements, it does not mean that there are not a few photographs standing out from the rest that have especially defined our sense of Dean.

Dennis Stock and James Dean had met in Hollywood under the auspices of Nicholas Ray, who was planning to cast Dean as the lead in his next film, *Rebel Without a Cause*. Elia Kazan's *East of Eden* was already finished, but had not yet appeared in the theaters. In other words, James Dean was still a completely unknown entity – at least for those who had not had a chance to experience him on the New York stage. The names of Marlon Brando and Elvis Presley signified the idols of a young, increasingly self-confident post-war generation that no longer accepted their youth as a synonym for immaturity, but rather as a valid state of being. In the end, however, it would be Dean who would lend the teenage cult its

definitive face, even if at age twenty-three, he was no longer a teen him-
self. As Dalton points out, Dean bequeathed a new body language to the
youth of the times. Dean was a Baudelairean hero in whom the contradic-
tions of youth – the impatience, aggression linked with vulnerability, the
arrogance, nervous sensibility, shyness – were creditably lifted up to view.
Stock himself was in his mid twenties, a young photographer who had
studied with Berenice Abbott and Gjon Mili. Since 1951 he was a member
of the Magnum group – and of course always on the lookout for a good
story. "Jimmy," as the photographer later came to call him, invited Stock
to a preview of *East of Eden*. At the time he was not familiar with Dean's
work, but the scene in the bean field convinced the photographer that the
young man would become a star. Stock determined that he wanted to do
something together with Dean, so he proposed an essay on Dean to *Life*.
In February 1955, the pair set out for Fairmont, and later New York, where,
among other photographs, *James Dean. New York City. Times Square* was
made.

## The ideal of happily lived materialism
Fairmont, Indiana. Dean biographers have consistently pointed out that
this is the true East of Eden. A flat piece of earth, fields as far as the eye
can see    and people whose Puritanism forms virtually the opposite pole
to the American ideal of happily lived materialism. Here, or more pre-
cisely in the small town of Marion, James Byron Dean was born on
8 February 1931 – 'Byron' being a hint from his mother who, as all
mothers, had great expectations for her son, and apparently wanted to
underline this by a reference to the great poet. Jimmy Dean spent his
early years in Marion, and later the family moved to Fairmont where, after
the early and traumatic death of his mother, he grew up with his Uncle
Marcus and Aunt Ortense. The pair operated a small farm: "Winslow
Farm."
It was here that Stock and Dean returned in 1955. The little cabin on Back
Creek represented the country roots, so to speak, of the demi-god James
Dean. His simple – extremely simple – background is significant; it offers
hope, and at the same time belongs as much as his early, fateful death to
the components of the myth, to the process of legend-making. Stock and
Dean visited the local cemetery where an ancestor named Cal Dean lay
buried. For his photographer, the rising star sat down again at his school

desk. He wandered around Fairmont, hands in his pockets, Chesterfield in the corner of his mouth. He looked at himself absentmindedly in a frozen puddle – or tested out a coffin at the undertaker's, just to try it out. Dean's longing for death has since become the object of a great deal of speculation. In any case, Stock found a valid metaphor for his hero's necrophilic tendencies by translating Dean's isolation into pictorial form: James Dean in the midst of cows; with a dog; with a pig. The affinity for animals that the star took as a matter course can in fact be read as a metaphor for loneliness.

Dean and Stock remained a week in Fairmont. It was simultaneously a reunion and a farewell. Stock later wrote that James Dean knew that he would never see the farm again, and for that reason insisted that the last shots were taken of him before the farmhouse. James posed himself, looking straight ahead, while his dog Tuck turned away. It was, according to Stock, the actor's interpretation of 'you will never return home again'. Fairmont had formed him, New York had changed him. New York was his laboratory, in which parts of him flew apart only to form together in an arbitrary manner. In New York, he had been discovered by Elia Kazan, director of *East of Eden*, the son of the land had become a god-in-the-making. Even if it took Hollywood to form his image definitively, New York was where the career of the coming star had been launched. Blue jeans, T-shirt, closed windbreaker belong to the Dean mythos just as much as the cigarette and the only partially tamed hair. Dennis Stock wrote "James Dean haunted Times Square", beneath his perhaps most famous portrait of the young actor. "For a novice actor in the fifties this was THE place to go. The Actors Studio, directed by Lee Strasberg, was in its heyday and just a block away." Dean is wearing a dark coat – because of the weather, of course. But the way in which he hides himself in it may also be interpreted as a reference to his vulnerability – it is a cocoon, even if it is in fact black. One should not perhaps over-interpret the color, even though we know that Dean will not live to see the premier of *Rebel Without a Cause*. On 30 September 1955 at 5:45 p.m., his Porsche Speedster will crash into a Ford sedan. It cannot be claimed that he made a "good-looking corpse"; but he had succeeded in living fast, and dying young – at age twenty-four.

For Dennis Stock, his short friendship with James Dean was perhaps the most important station in his life as a photographer. If he is known for

*Dennis Stock:* In the old schoolhouse of Fairmont

*Pictures like this made a major contribution to cementing the James Dean myth.*

anything, then it is for his pictures of Dean, which also circulate as post cards and posters. They form a part of every retrospective of Stock. Gottfried Hellnwein used our key picture as the motif for his own interpretation – and by not observing the copyright, underlined the quasi universal nature of the image.

*James Dean on Times Square* is somewhat reminiscent of Cartier-Bresson's portrait of Giacometti (here, also, it is raining), and it is no longer possible to imagine the core of the Dean iconography without it. Even today, the photograph remains among the most often printed images of "Hollywood's ultimate god." As Richard Whelan summed it up, Dean's bequest to Stock was a certain financial independence that allowed him to dedicate himself to work that really interested him. In return, the photographer made a movie in homage to his friend: in 1991 Dennis Stock filmed *Comme une image, James Dean?* as a thirty-eight-minute documentary on the star. And what was the image of James Dean? Towards the end of the film, Stock observes that although he was one of the last of James Dean's friends still to be alive, not one of the fans he had met during his travels had asked who Dean really was and what he had actually been like. The reason being, as Stock answers his own

question of why this was so, that everyone creates their own James Dean, according to their own tastes and their own personal needs. Which allows him to be a hero in what has become a very complicated world, someone in fact who is pretty different to the 24-year-old boy Stock had known and photographed.

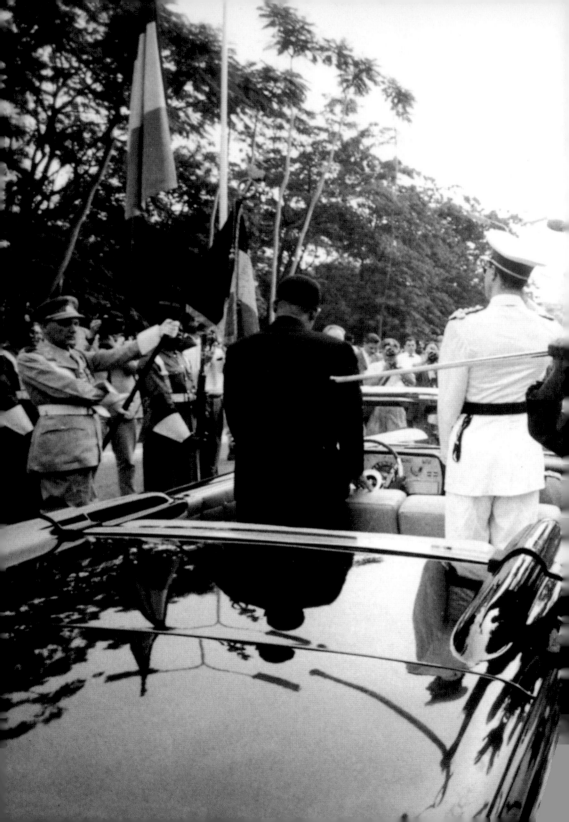

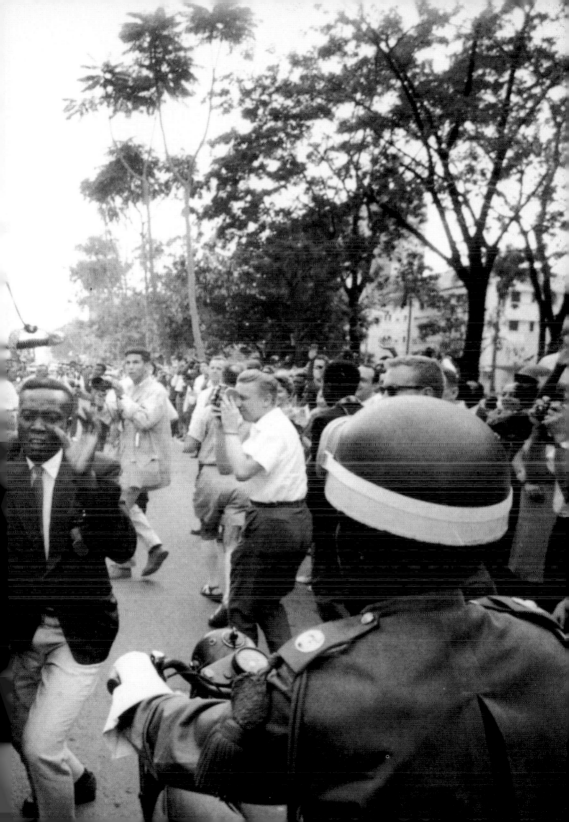

# Robert Lebeck
# Leopoldville

**Dagger in a
Black Hand**

**This photograph quickly made its way around the world: a young Black stealing the ceremonial dagger of the Belgian King Baudouin. Robert Lebeck, at the time working in Africa for the illustrated magazine *Kristall*, captured the picture with all its symbolic character during the freedom celebrations in the Belgian Congo in June 1960.**

Being at the right place at the right time, a working camera in hand, fitted with the correct lens and loaded with sufficient film: a patent recipe for creating a 'photograph of the century' – providing, of course, that the scene is not staged. But even if the photographer also knows what he or she is doing professionally, and the 'tool' is in good working order, there still remains something that needs to be explained – something that the 'picture hunter' terms the luck of the chase; the lay person, chance; the romantic, fate.

Leopoldville, 1960. Robert Lebeck is not the only photojournalist who has come to Africa to follow the independence process of the Congo with his camera. In one picture, we recognize Hilmar Pabel, equipped with two Leicas with lenses of different focal lengths. The escort has already passed by Robert Lebeck on the right. Others have hurried out in front of the limousine carrying President Kasavubu and Belgian's King Baudouin. According to the rules of the trade, they catch the approach of the protagonists, either not realizing or only suspecting that at this moment the decisive scene is being played out elsewhere. Namely, a few steps further to the left, where 'fate' places the decisive picture into the hands of Robert Lebeck, whose position already seemed to have been 'written off': a young black man suddenly sees his chance. He has already been running for some time alongside the open, dark-colored limousine. On the rear seat he spots the royal dagger which the king has laid aside, grabs it,

and runs directly toward Robert Lebeck, who now – in a certain sense as the culminating point of a sequence of before-and-after pictures – succeeds in capturing the key picture.

## Zero hour of the Dark Continent

"King's Sword in a Black Hand." Lebeck's report first appeared in *Paris Match*, No. 587 (9 July 1960). Two days later, *Life* published the crucial motif under the title; "King gives up a colony – and his sword," followed by *Kristall* and the Italian magazine *Epoca* – not to mention the many books, anthologies, exhibitions, and catalogues that have pushed Lebeck's image again and again into our consciousness and assured its position as a kind of icon, a symbolic metaphor for the end of colonialism and Africa's entry into a new age.

1960 was an important year for the African continent, bringing as it did independence to a series of largely west and central African states: Cameroon and Togo, Mali, Dahomey, Niger and Upper Volta, the Ivory Coast, Gabun and Mauritania. The Belgian Congo, too, by far the largest of the group of colonies, received its independence. The talk was already of an "African year," and of the "zero hour" of the Dark Continent – phrases signaling confidence in the political future and expressing a strong and independent Africa.

## Beautiful and rich in mineral resources

The Congo was 'given' to Belgium at the end of the nineteenth century. King Leopold II had been attempting to acquire the colony with the support of Bismarck in Germany, which sought to stymie the advance of England and France across the Dark Continent. Then at the Berlin-Congo Conference of 1884/1885, the territory left of the Congo River was finally allotted to Belgium. Thus the history of the Belgian Congo began: beautiful, rich in mineral resources, and, with its more than half a million square miles, approximately eighty times larger than its so-called mother country. In 1960, the Congo contained about two and a half million inhabitants, including eighty thousand Whites; of the native population, at the time, not more than fifteen had a university diploma – testimony to how ill-prepared the land was for independence. In fact, it had long been assumed that independence would not come until the 1980s, or at the earliest the 1970s. As late as 1957, the Antwerp scientist A. A. van Bilsen had

**Robert Lebeck**

Born **1929** in Berlin. **1944**–**45** military service at the Eastern Front. POW until summer **1945**. Studies in Zurich and New York. **1951** returns to Germany. From **1952** first photographic experiments. First photos are published that same year. Freelance photojournalist for various newspapers in Heidelberg. From **1955** director of the Frankfurt office of *Revue*. **1960** changes to *Kristall*. **1966**–**77** photo-reporter for *Stern* magazine. **1977**–**78** chief editor of *Geo*. From **1979** works once more for *Stern*. Numerous prizes, most recently Dr. Erich Salomon Prize of the DGPh. Lives in Port de Richard/France

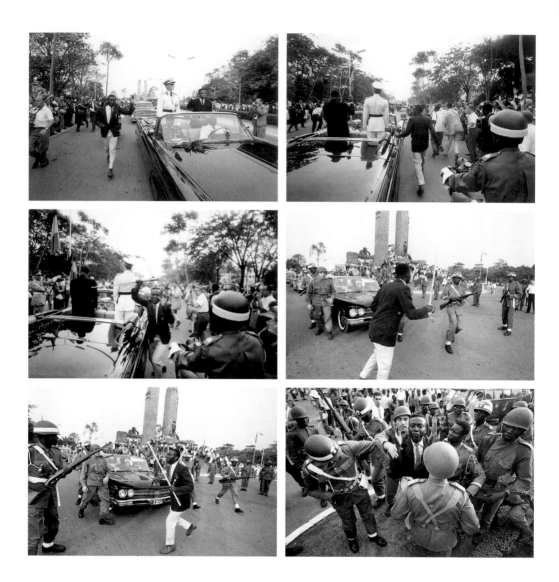

*The complete sequence underlines the advantages of 35 mm cameras for dynamic series of shots.*

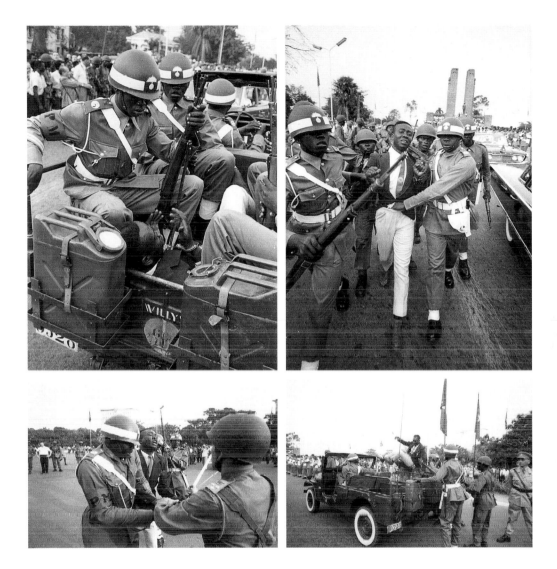

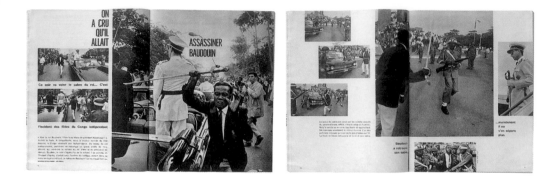

set up a "Thirty-Year Plan for the Political Emancipation of Belgian Af-
rica." But in the end, everything happened far quicker than was planned.
The riots in January 1960 had started the process in motion. From today's
standpoint, it looks as if Belgium could not have ridded itself of its colony
more quickly. King Baudouin set the day of independence for 30 June
1960, and already in early July the first mutinies started in portions of the
"Force Publique," the 23,000-man army of the Congo. Then came plun-
dering and attacks on the white officers, which resulted in the flight of
thousands of Belgians from the land. Belgian paratroopers attacked, and
Moise Tshombé took advantage of the opportunity of the moment to
declare independence for the mineral-rich province of Katanga. UN
troops landed in Leopoldville. Taking advantage of the rivalry between
President Kasavubu and Prime Minister Lumumba, Colonel Mobutu
putsched his way to power – and delivered Lumumba over to Katanga,
where he was shortly found dead. The Congo, according to the headlines
in the world press, was sinking into chaos.

But at the moment our photograph was taken, there was no trace of all
that was to come. It is 29 June 1960 – a warm and sunny Wednesday
morning. The entire country is rushing deliriously toward independence.
In the streets, crows are gathering, church bells are tolling, flags are fly-
ing everywhere. King Baudouin is due to arrive any moment at the airport
of the capital city of Leopoldville, and tomorrow, Thursday, there will be a
festive Te Deum service in the church of Notre Dame du Congo. Obser-
vers from all over the world are present to report on the historical event.
At the end of the church service, a ceremony is scheduled in which Pres-
ident Kasavubu will address "the slow awakening of the Congo's sense of

nationhood" and praise "the wisdom of Belgium... which did not stand in the way of history." Then Premier Patrice Lumumba will take the podium, whose description of "the sufferings of the native population during the colonial period" will have the effect of a diplomatic bombshell. At 11:00, the colonial history of the Belgian Congo will come to an end, and with the words, "May God protect the Congo," King Baudouin will send the land on its way into independence. "Of all the new states that are being founded, the most exciting experiment is beginning," according to the correspondent of the German newspaper *Süddeutsche Zeitung*, "here in the middle of the heart of Africa."

## A petrified symbol of the end of an era

So much for Thursday, 30 June. But today is still only Wednesday, and the King has not yet landed. Robert Lebeck is sitting with his colleagues in a Belgian restaurant enjoying a leisurely lunch. Some of his companions have left in order to catch Baudouin at the airport, but Lebeck is taking his time. After all, nothing important is going to happen at the airport. He goes instead directly to the city, to Boulevard Albert, where the convoy containing king and president is awaited. A crowd of people is already lining the main street with its monument to Leopold II, which has now become a petrified symbol of the era approaching its definitive end. Lebeck passes through the barriers: he wants to place himself exactly by the guard of honor and the waving flags, where the convoy will probably slow down. Finally the cavalcade approaches. Standing in an open automobile, Baudouin and President Kasavubu receive the ovation of the multitude. A young black man, elegantly dressed, is running in tempo at the side of the automobile. Through the viewfinder of his Leica M3 with its 21 mm Super Angulon lens, Robert Lebeck is tracking the action. Supposing the man to be a security guard, the photographer expects to be chased any moment from his position in the street. Instead, the young man runs past him, followed by a motorized police escort. Lebeck begins shooting again. At this point, the young man seems to have spotted the sword lying on the back seat of the car. A second later, he reaches for it.

## Building on the achievements of modern reporting

Once asked by a British publisher to define his understanding of himself as a photographer, Robert Lebeck gave a short, clear answer: "I am a

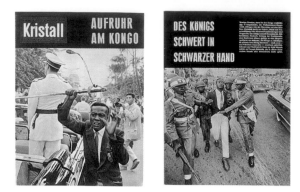

*"Turmoil in the Congo"*: Kristall *dedicated the Lebeck report the greatest space of any magazine.*

journalist." Lebeck sees himself as a craftsman – someone who is sent out on a job and returns with usable photographs. His model for this approach has always been Alfred Eisenstaedt, a photographer for all seasons. But there are also others with whom Lebeck feels himself tied: Felice Beato, for example, or Robert Capa, Eugene Smith, and Erich Salomon, whose discrete manner continued to define the standard for Lebeck.

Born in 1929 in Berlin, Robert Lebeck sees himself in the tradition of the 'classical' photojournalism that assumed the task of providing visual information along with the rise of the illustrated magazines in the 1920s. More precisely, Lebeck, who first published his reports in the mid-1950s in *Revue*, and then moved on to *Kristall*, and finally in 1966 to *Stern*, numbers among the mid-twentieth-century generation of well-known international photojournalists. The impact of the large – primarily American – magazines after the war aroused his curiosity, and Lebeck succeeded in building on the achievements of modern reporting, without having to fear the overly powerful competition of today's television. Lebeck is a story-teller in pictures, and is loath to let himself be classified according to a certain style, strategy, or aesthetic. Nor does he pursue a single theory of reporting. At most, one might speak of a certain cinematic approach that structures its theme, dissects it, circles around it, and describes it from various standpoints. His reporting on the Congo can well be taken as exemplary of his approach: from the first appearance to the arrest of the young enthusiast whom the *Kristall* editors arbitrarily dubbed "Joseph Kalonda," the story is told in a mere dozen pictures.

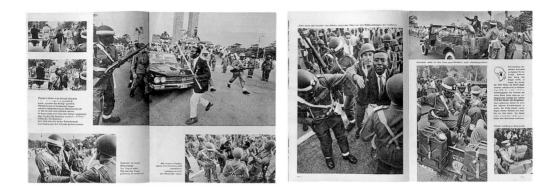

That Lebeck in fact took an interest in the people who appeared in his reports and in the circumstances of their lives is certainly not one of the necessary and self-evident properties of his profession. But these are in fact the characteristics of a photographer who numbers today among the most famed of the post-war photojournalists. On a later trip to Africa, Robert Lebeck sought to discover from President Mobutu the where-abouts of the young man who had been carried away under military guard. But there are times that one may search without finding an ans-wer: the fate of "Joseph Kalonda" remains sealed in the depths of history.

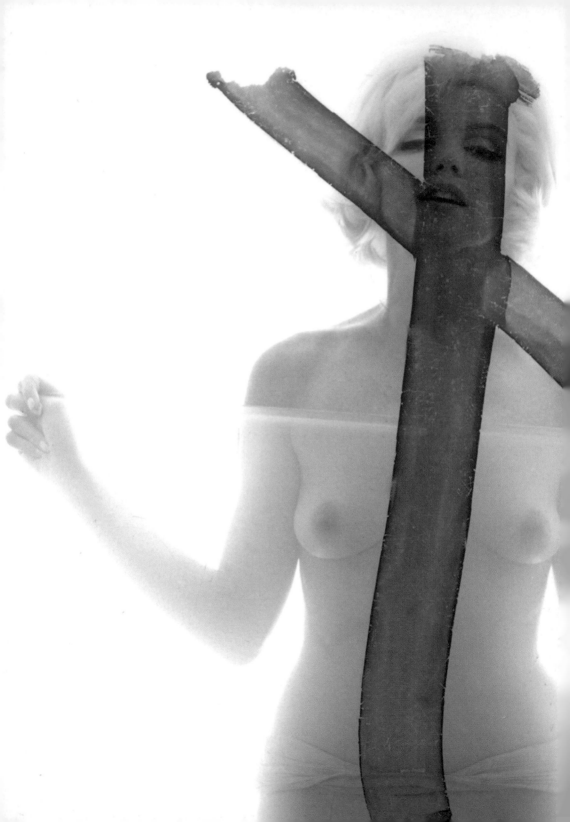

# 1962    Bert Stern
## Marilyn's Last Sitting

**He may not have been the first to photograph her, but he was certainly the last. In July 1962, the young photographer Bert Stern succeeded in three sittings in capturing a many-faceted portrait of an unusually relaxed and playful, close and direct Marilyn Monroe. A few weeks later she was dead. What had begun as an eight-page homage to the screen star in *Vogue* became an obituary, and has entered photographic history as *Marilyn's Last Sitting*.**

His first words upon meeting her were short and simple: "You're beautiful" – perhaps not exactly the most original start to a conversation, but Bert Stern does not seem to have been a man of many words. Moreover, what does a man say when he suddenly finds himself face to face with a woman whose screen presence and sex appeal have already caused millions of men throughout the world to lose their reason? A true "Stradivarius of sex," as Norman Mailer once described her. And as such, she might just as well have been a mere invention of film, a creation of make-up and curlers, light and direction. Seen in this way, Stern's entrée was nothing less than the translation of a myth into reality. Furthermore, the words were honest and spontaneous – and they seemed to have pleased her. "Really? What a nice thing to say," she answered – which also sounded self-confident: not the content, but the manner in which it was said, evoked her comment – not the 'what' but the 'how'. For she well knew that she was attractive. And she also knew that the way she looked was her capital in a world which in other respects had hardly treated her well. After a comfortless childhood with bigoted foster-parents came three broken marriages and a round dozen abortions and miscarriages. Finally an unhappy affair with the American president. She had tried to challenge the omnipotence of the studios – and lost. Nonetheless, she

had succeeded in making fifteen films – admittedly none of them productions that critics considered worth entering in the annals of film history. Furthermore, she was not even fairly paid for her work, in comparison with the brunette Liz Taylor, who was in a sense Marilyn's opposite number throughout her life. For filming *Cleopatra*, Liz received as much in one week as Marilyn did for an entire film. It may be that for Marilyn Monroe a glance in the mirror compensated for a great deal. She was beautiful, in fact, and no one could take her beauty away from her – or at any rate, only time, alcohol, and sleeping tablets, which in this phase of her life had already formed into an unholy alliance. And perhaps it was really true, as Clare Booth Luce formulated in her obituary in *Life*, that Marilyn Monroe was moved by the fear of becoming old and ugly when she took that mixture of Dom Pérignon and barbiturates that carried her from a state of drowsiness to an eternal sleep on the night of 4 August 1962. Or perhaps it was indeed murder, as many still whisper today, ordered from on high – from the very highest levels – to hide something or other? The death of Marilyn Monroe remains until today one of the great unsolved riddles of the twentieth century.

But now it is still only July. We find ourselves in the Bel Air Hotel in Los Angeles. Not a bad address, and presumably the most suitable location to realize an idea that the photographer Bert Stern hardly dares to dream about. At the time of the photograph, he was thirty-six years old and already one of the best-paid photographers in New York, which is to say, the world. Ever since he had helped a brand of vodka named 'Smirnoff' to truly sensational profits through a spectacular advertising photograph – no small feat at the time of the Cold War – he had become one of the most sought-after photographers in the branch. In addition, he had a lucrative contract with the American *Vogue*, both then and now the Olympia of all those for whom the camera is the true medium to lend a certain durability to the appearance of beauty. Stern had been eighteen years old when he saw a still life by Irving Penn, which opened a door in his mind. Nonetheless, it would not be still lifes that would inspire him and finally drive him to a career in photography, but rather life itself, especially in those places where it is sensual and full, exciting and erotic. Here Stern reflects precisely the pattern that Michelangelo Antonioni had made into an ideal in the 1960s with his film *Blow Up*. In this sense, Bert Stern dreamed his dream, although even before Antonioni he had discovered

**Bert Stern**

Born **1929** in Brooklyn/New York. Self-taught photographer. **1946–47** employee at the Wall Street Bank, New York. **1947** moves to *Look*, where initially works in the postal department. From **1948** assistant to Art Director Herschel Bramson. **1951** Art Director of the magazine *Mayfair*. Subsequently photographer in New York. Does campaigns for among others Smirnoff, DuPont, IBM, Pepsi-Cola, Volkswagen. Editorial photography for *Vogue*, *Esquire*, *Look*, *Life*, *Glamour* and *Holiday*. **1974** closes his New York studio and moves to Spain. Active once more since **1976** as an advertising photographer in New York, working for Polaroid and Pirelli among others. Editorial work for American *Vogue* and other New York magazines. **1982** publication of the book *The Last Sitting*. Lives in New York

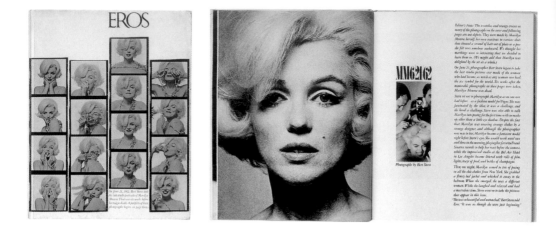

*Not the first, but to date the loveliest magazine feature on Bert Stern's cycle: lead in* Eros, *Autumn 1962*

the camera to be the ideal "dream machine" that it became for at least a generation of photographers who followed upon David Hemmings. And as he noted, it was amazing all the things it allowed him to get and the people he was able to get, as long as he had a camera on him. In this way, some of his boldest dreams came to be realized.

## Lighthouse on the horizon

And the boldest of bold ideas? To photograph Marilyn Monroe – naked. One must place oneself mentally back in the 1950s or early 1960s – furnished with a good measure of fantasy and sympathy – to evaluate the full audacity of Stern's longing. In addition, the photographer was, in spite of his promising career in photography, still a nobody – at least compared with Monroe, the superlative, who could claim to be "America's greatest sex symbol" (Joan Mellen). And that would probably be an understatement. She was already long an international idol, a global pin-up girl, and the lighthouse on the horizon of male fantasies around the globe. She was, as Normal Mailer phrased it, "the sweet angel of sex... Across five continents the men who knew the most about love would covet her, and the classical pimples of the adolescent working his first gas pump would also pump for her, since Marilyn was deliverance." Innumerable photographers had done her portrait in more or less provocative poses. And they were an impressive group: André de Dienes, for example, who can claim the credit for discovering Marilyn; or Cecil Beaton, the master of glamour in fashion; or Alfred Eisenstaedt, Ernst Haas,

Henri Cartier-Bresson – in other words, the top rung of international pho-
tojournalists. In addition, she had modeled for Richard Avedon and Mil-
ton Greene. Philippe Halsman, not to mention Frank Powolny or Leonard
McCombe, had done her portrait. She liked to be photographed. She
loved the presence of a camera. She knew how to pose. Completely with-
out clothes, however, she had been photographed only once. That was in
1949, and when Tom Kelley's photograph appeared years later in a pin-up
catalogue in March 1952, it almost brought her Hollywood career to an
end. Her films crackled with eroticism; she was always playing the easy
girl. And the most memorable scene from *The Seven Year Itch* – that is,
Marilyn standing on the subway vent – became one of the most famous
in movie history. But then, after all, an ambivalent attitude toward sexual-
ity was one of the many contradictions endemic to the 1950s.

Bert Stern was exactly twenty-six years old when he met Marilyn Monroe
for the first time. That was the upstroke, so to speak, to a fixed idea that
would take shape on this late July day in 1962 in the most beautiful sense
of the word. After Dienes and Beaton, Avedon and Green, now he, Bert
Stern, was allowed to photograph Marilyn Monroe – that same Marilyn
who had given wings to his thoughts ever since 1955, and whom he had
'desired' since that time, as he himself admitted. "The first time I saw
her", he relates, "was at a party for the Actors Studio, in New York City.
It was 1955. A friend and I had been invited, and when walked in, there
was Marilyn Monroe. She was the center of attention. All the men were
around her, and all the light in the room seemed focused on her. Or was
the light coming from her? It seemed to be, because she glowed. She had
that blond hair and luminous skin, she wore a gleaming sheath of eme-
rald-green that fit her body like a coat of wet green paint. 'Look at that
dress,' I said to my friend. 'I hear they sew her into it,' he said. How
could you get her out of it, I wondered, with a razor blade? I'd laid eyes
on Marilyn Monroe only moments before and already ideas about taking
her clothes off were going through my mind."

## The goal of his dreams and secret fantasies

In the meantime it is 1962, and Bert Stern is about to reach the goal of his
dreams and secret fantasies. The Dom Pérignon vintage 1953 has been
chilled, and Suite Number 261 in the upper floor of the Bel Air has been
transformed into a temporary studio. The lighting is in place, the portable

*pp. 258–259:
Double-page spread
from* Eros *(Autumn
1962): even some of
the shots Marilyn
that rejected were
published here for the
first time.*

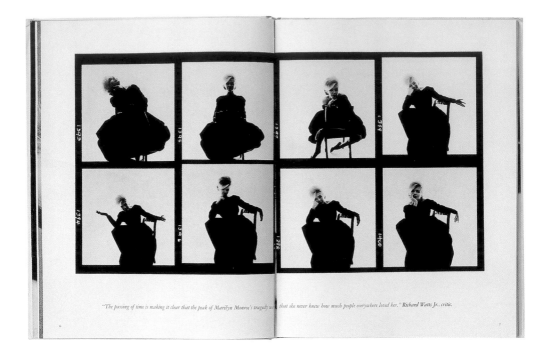

"The passing of time is making it clear that the peak of Marilyn Monroe's tragedy was that she never knew how much people everywhere loved her." Richard Watts Jr., critic.

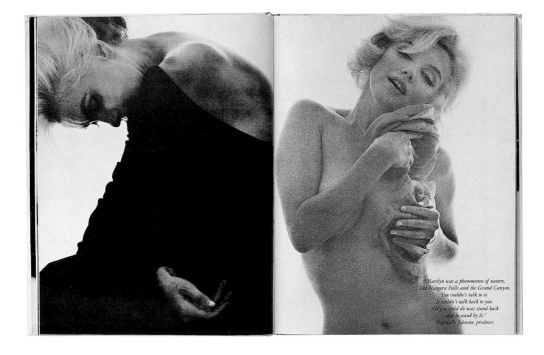

"Marilyn was a phenomenon of nature,
like Niagara Falls and the Grand Canyon.
You couldn't talk to it.
It couldn't talk back to you.
All you could do was stand back
and be awed by it."
Nunnally Johnson, producer.

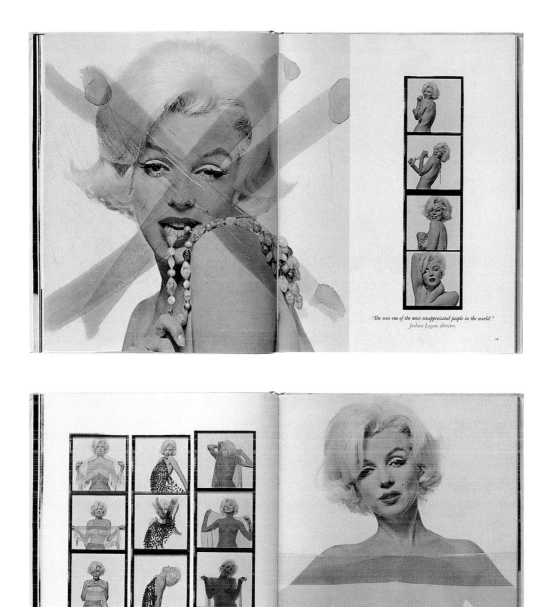

"She was one of the most unappreciated people in the world."
Joshua Logan, director.

"Gosh, there were a lot of people who loved her. There were no pretenses about Marilyn Monroe."
Carl Sandburg.

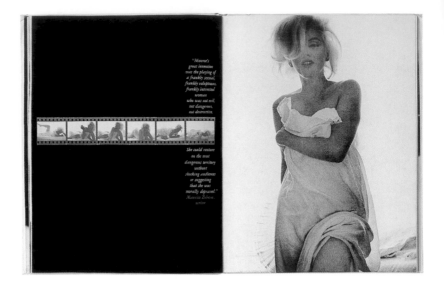

"Monroe's great invention was the playing of a frankly sexual, frankly voluptuous, frankly interested woman who was not evil, not dangerous, not destructive.

She could venture on the most dangerous territory without shocking audiences or suggesting that she was morally depraved."
Maurice Zolotow, actor

Too daring for the times: Eros publisher Ralph Ginsburg was charged and sentenced for disseminating pornography – "The last thing the magazine was about" (David Hillman).

hi-fi set up. He wanted not only to create a space out of light, as he said, but also an environment of sounds. In this case, it was not Sinatra, as Avedon had used, but the Everly Brothers. The people at *Vogue* had done him a favor and gotten him some gauze-thin cloths. That the editors had accepted his proposal to supply a portrait of Monroe had been no less surprising than the spontaneous "yes" from Marilyn Monroe herself. The luxury liner among the magazines had never published anything about Marilyn – who, it was known, really was named Norma Jean Baker, an illegitimate child hardly stemming from the social sphere to which *Vogue* usually devoted its attention and its pages. But in the meantime, Marilyn had become such an integral part of the American Dream that even *Vogue*, where dreaming was naturally at home, could no longer ignore her. The photo session was intended as her entry into Condé Nast. It became her epitaph.

It was getting toward seven o'clock and Bert Stern was beginning to get restless. He knew that Marilyn Monroe was notoriously unpunctual, but he had already been waiting for a good five hours now. What if she came only for a short time? he began to ask himself. What if the dream Marilyn had little to do with the real Marilyn Monroe? After all, the fact was that she was "well into her thirties, and she really was a little chubby", as he had seen in *The Misfits*. Still on the evening before, alone in the atmo-

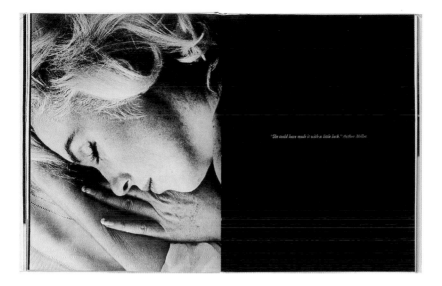

*"She could have made it with a little luck." Arthur Miller.*

spheric illumination of the Bel Air garden, the wildest ideas had coursed through Bert Stern's head – thoughts that a married man and father of a little daughter had better not entertain. "I was preparing for Marilyn's arrival like a lover," Stern recalled, "and yet I was here to take photographs. Not to take her in my arms, but to turn her into tones, and planes, and shapes, and ultimately into an image for the printed page." The photographer found himself back in reality as the telephone finally rang: Miss Monroe had arrived. "I slowly put down the phone and took a deep breath."

### Better than the full-blooded girl I had seen in the movies

He met her in the lobby of the hotel. To his great surprise, she had come alone. No bodyguards, no press agents, not even her PR girl, Pat Newcomb, had accompanied her. "She had lost weight, and the loss had transformed her. She was *better* than the full-blooded, almost over-blown girl I had seen in the movies. In her pale-green slacks and cashmere sweater she was slender and trim, with just enough softness in the right places – all of it hers. She had wrapped a scarf around her hair, and wore no make-up. Nothing. And she was gorgeous. I had expected – feared – an elaborate imitation. No. She was the real thing." In a moment he would ask her whether she was in a hurry, "No," she would answer,

"why?" – "I thought you were going to have like five minutes," he would reply. "Are you kidding," she will smilingly say, entirely the professional. "Well," he will carefully announce; "How much time have you got?" "All the time that we want!"

In the end, it would amount to almost twelve hours. And Bert Stern, the child of a lower middle-class Brooklyn family, as he described himself at one point, is able to get what he hoped for. Everything. Almost everything. At his request, Marilyn does without make-up, or applies at most a bit of eye-liner and lipstick; under his direction, she drapes herself in a boa. Even the transparent veils come into play. "You want me to do nudes?" she asks, and the stammering Stern replies: "Uh, well I – I guess so!", adding "...it wouldn't be exactly nude. You'd have the scarf." – "Well, how much would you see through?" – "That depends on how I light it." And will her scar be visible? Stern does not understand what she is referring to, but she explains that six weeks ago, her gall bladder was removed. Bert Stern assures her that it will be no problem to retouch it, and recalls a statement of Diana Vreeland that "...a woman is beautiful by her scars". Marilyn is like putty in the photographer's hand. "I didn't have to tell her what to do", as he later recalled. "We hardly talked to each other at all. We just worked it out. I'd photographed a lot of women, and Marilyn was the best. She'd move into an idea, I'd see it, quickly lock it in, click it, and my strobes would go off like a lightning flash – PKCHEWW!! – and get it with a zillionth of a second."

*Vogue* liked the pictures. Alexander Liberman, at that time still the all-powerful art director of the magazine, pronounced them "fabulous" – but Stern knew that with Liberman, everything was "divine." This time, however, he seemed to be serious: *Vogue* devoted eight pages to Stern's pictures. The magazine apparently realized that it had gotten onto something good – and wanted more. But, as *Vogue* let Stern know, they needed more black-and-white. Stern understood immediately: "That meant fashion pages. And that meant that they didn't want to run just nudes. They were probably going to get a lot of clothes, cover her up." There were in fact two more photo sessions in the Bel Air, to which *Vogue* sent along its best editor – a sign Stern interpreted as meaning that the magazine was indeed serious about the project. And so once again, the Everly Brothers sounded forth on the portable hi-fi, and once more the lightning storm of flash bulbs blitzed down on a tender Marilyn, whose

*"The blonde – a revelation". Title page of the Swiss magazine Du, July 1999, using Bert Stern's picture*

weight coroner Dr. Thomas Noguchi would determine just three weeks later at 115 lb – further describing her in his report as a well-nourished woman, 5'5" tall. But for now, the *Vogue* editor Babs Simpson had brought mountains of fashion clothing and furs along with her. And the Dom Pérignon is present once again as Bert Stern takes his photographs. In the end, he suddenly remembered the "picture I came for – that one black and white that was going to last for ever Like Steichen's Garbo". Stern entered "that space where everything is silent but the clicking of the strobes". Then all at once, as he recalled, Marilyn tossed her head, "laughing, and her arm was up, like waving farewell. I saw what I wanted, I pressed the button, and she was mine. It was the last picture."

## Not only the photos were crossed through

*Vogue* decided in the end for the black-and-white photographs, and by the beginning of August, the chosen pictures were in the layout, and the text had been composed. It was scheduled to be printed on Monday 6 August. Stern had sent Marilyn a set of pictures, but received two thirds of them back crossed out: "On the contact sheets she had made x's in magic marker. That was all right," as he later reflected. "But she had x-ed out the color transparencies with a hairpin, right on the film. The ones she had x-ed out were mutilated. Destroyed." Bert Stern was upset, even felt "some anger"; but as he later realized "she hadn't just scratched out my pictures, she'd scratched out herself." Weeks later, friends invited him to brunch. It was Saturday, 4 August, and the television in the hallway was beaming out the usual American interiors. Suddenly the program was interrupted: "Marilyn Monroe," the speaker announced, "committed suicide last night."

"I didn't know what I felt," Stern recalled. "I was just paralyzed, shocked in a dumb, numb way." But the photographer claims that "there was some way in which I was not surprised... I'd smelled trouble." And *Vogue*? They stopped the weekend presses in order to create a new headline and compose another text. "Greetings" became "a last greeting from Marilyn," at the end of which Bert Stern's final portrait came to stand. It was in any case the last large picture of the series, just as Stern's cycle is the last of the great series on the "American love goddess" who still calls to us through these pictures, as Bert Stern phrased it, like to "a moth flying around a candle."

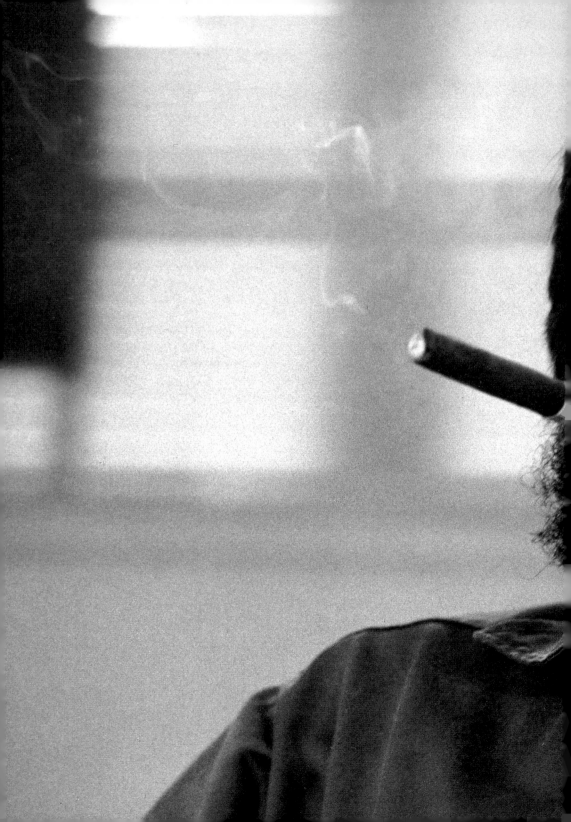

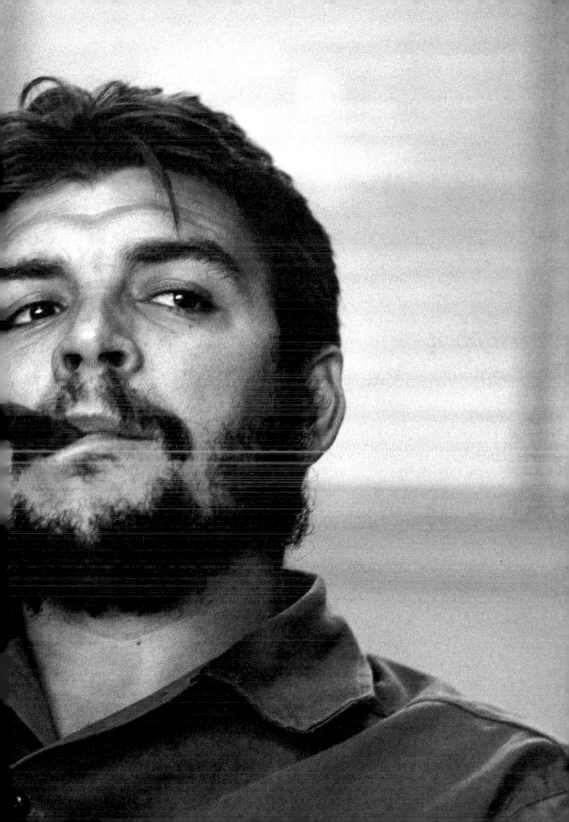

# 1963    René Burri
         Che

**When Ernesto (Che) Guevara met his death at the hands of the Bolivian army in October 1967, he was transformed from a living legend into a true cult figure. Four years earlier, René Burri had made a portrait of Che which, together with the portrait by Alberto Korda – is probably the most-reproduced icon of this twentieth-century martyr.**

January 1963: the two men who met in the Havana ministry office could not have been more different from each other. Nonetheless, one can, as usual, cite a number of elements they shared in common: a bourgeois background, for example; or a solid education, including university diploma, or a love of German literature – although in the one case it tended more toward Goethe, and in the other toward Brecht. Furthermore, both men were markedly urbane, curious about the world at large, enthusiastic about traveling and, last but not least, more or less strongly skeptical toward everything having to do with North America. In short, they had a basis for their conversation, which was conducted in French, since René Burri could not speak Spanish, and Ernesto Guevara's knowledge of German was too meager. Conversing with Che, however, was not the assignment of the young Swiss photographer. The interviewer was the then well-known journalist Laura Bergquist, who, as René Burri recalled, went at her job with a pointedness bordering on provocation. After all, wasn't she sitting here next to the man whom the USA hated more than any other in South America – except for Fidel Castro himself?

### Fully human in such moments

We find ourselves in the Ministry of Industry in Havana, Cuba, specifically in the office of Ernesto Guevara, familiarly known – and not only to his friends, comrades, and disciples – Che. It is a sunny January afternoon in

1963. A glance out the window should provide a peaceful panorama of the roofs of the capital city, but the Venetian blind remains decidedly closed, allowing only a milky light to enter the room. But the gleam of several ceiling lamps is sufficient to mean that Burri, who on principle rejects the use of flashbulbs, does not have to work against the light. To the session he has brought two Leicas and a Nikon fitted with 35, 50, and 85-mm lenses, and in the course of the three-hour discussion, he will shoot a total of six rolls of film. This occasion will not be Burri's only chance to photograph Che, however; a few days later the photographer will join Ernesto Guevara at a festival in honor of especially worthy workers. On this second occasion, the minister will in fact make a much more jovial impression, winking at the photographer; in such moments, Che seems fully human. Nonetheless, it is not a relaxed photograph that the course of time will designate as the valid icon of the Che. But it takes time to become a myth, and Burri's portrait, appearing on page 27 of the article in *Look* dated 9 April 1963, is too small and strongly cropped to serve as an icon. The cover of the magazine features a photograph of Fidel Castro – also taken by Burri – who remains America's number-one nightmare. Only later will the square-format portrait of a self-confident Che forge itself into an icon in its own right and, transformed into the sanctified image of a martyr, be found on postcards, posters, book covers, and catalogues.

## Model of a classless, communist society

Che is smoking. The large Havana, still bearing its label, is perhaps what first strikes the eye of the unprejudiced observer. The cigar appears to have just been lit, and tobacco smoke is curling its way toward the ceiling. Ernesto Guevara is leaning back, looking self-confidently and even defiantly at his interview partner, who presumably has just posed a question. Notably absent from the face is any trace of self-doubt. Other photographs from this sequence present a Che who is tired or excited, or who uses his hands to express his agitation or to explain something. But in this picture he seems completely relaxed as he peers almost arrogantly past the camera into the face of his questioner. Clearly, here is a man who looks the world squarely in the face – and thus will the photograph be later interpreted by those who reproduce it over and over again. As usual, Che Guevara is wearing a uniform; more precisely, he is wearing

René Burri

Born **1933** in Zurich. **1949–53** studies at the Arts and Crafts School in Zurich. **1953–54** military service. During this time growing interest in 35 mm photography. **1955** first photo published in *Life*. That year becomes an associate member, in **1959** full member of Magnum. **1962** publication of his book *Die Deutschen*. **1963** Cuba trip. Meets Fidel Castro and Che Guevara. Numerous pictures are published in *Life, Look, Bunte, Stern, Paris-Match, Schweizer Illustrierte, Du*, among other magazines. Several films, including *The Two Faces of China* and *Jean Tinguely*. **1984** major retrospective at Kunsthaus Zürich. **1998** Dr. Erich Salomon Prize of the DGPh. Lives in Paris

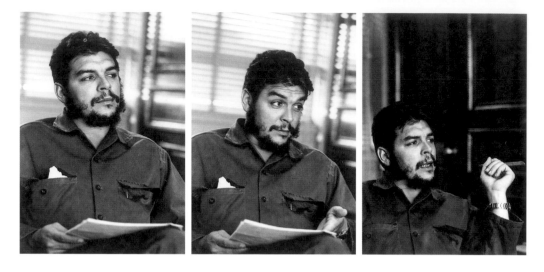

*Conversation before closed blinds: René Burri: Che, 1963. Rarely published variants*

those same inconspicuous combat fatigues that transform even a powerful Minister of Industry – his post at present – into a battle-ready guerrilla at a moment's notice. His hair is shorter than in other photographs, his beard longer; on either side of his chin, the two patches of almost bare skin have virtually disappeared. Out of focus but unmistakable in the background are the closed Venetian blinds. In a moment René Burri's question whether they might be opened a bit will call forth an unusually gruff answer from Che: the blinds remain closed! What is he afraid of? Or is his irritation rather the response to the pointed questions of the equally self-confident Laura Bergquist?

Burri and Che had met for the first time during 1962. Che – at that time thirty-four years old and already a legend – was in New York visiting the United Nations. Together with Fidel Castro, he had managed to carry off a successful revolution on the very doorstep of the USA, whose active support for the counterrevolution culminated in the debacle of the Bay of Pigs landing in 196. The American failure served only to enhance the glory of Castro and the Argentina-born Ernesto Guevara, a medical doctor who had taken his leave from bourgeois life in order to establish his model of a classless communistic society not only in South America, but throughout the world. Whether in the role of a revolutionary or national bank president (which he became immediately after the revolution), or as Minister of Industry – his assignment since February 1962 – Che was at the peak of his power during these months.

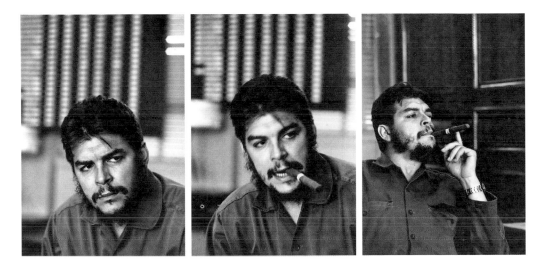

## A Yanqui journalist on the Communist island

Laura Bergquist had also been present as one of the reporters in New York in 1962. Blond and good-looking, a skilled and critical interviewer, she seems to have made a particular impression on Che with her unusually direct, not to say aggressive, questions. In any case, she subsequently received an invitation to inspect the successes of the Cuban revolution herself. Note well: it is only a few months after the end of the so-called Cuban Crisis, which had carried the world to the brink of nuclear war – a fact which makes the 28-day research visit of a yanqui journalist to the island all the more remarkable. *Look* intends to publish the results of this visit – which is, moreover, a visit without restriction, as Bergquist has insisted. With a circulation of 7.3 million, *Look*, together with *Life*, was at the time the most important illustrated journal. Accompanying Bergquist as photographer on the tour is the young photojournalist René Burri, whose Swiss citizenship has the advantage of raising him above ideological suspicion.

Burri, who was born in 1933, had studied under the legendary Hans Finsler at the Zurich School of Commercial Art, and was the author of a highly respected photographic volume entitled *Die Deutschen* (The Germans), which he also compiled in 1962. He had begun his photographic career in the late 1950s with a report on deaf-and-dumb children – a sensitive work in the tradition of humane photojournalism that soon led to publication in *Life* and inclusion in the famous photographic group Magnum. Later

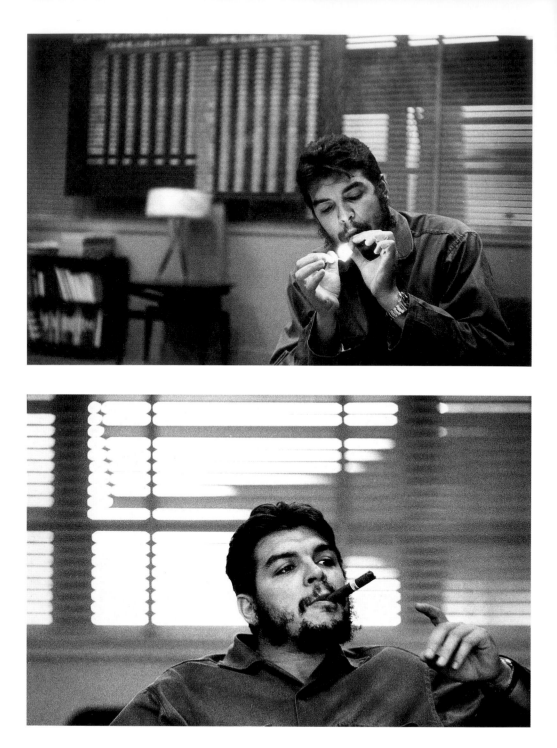

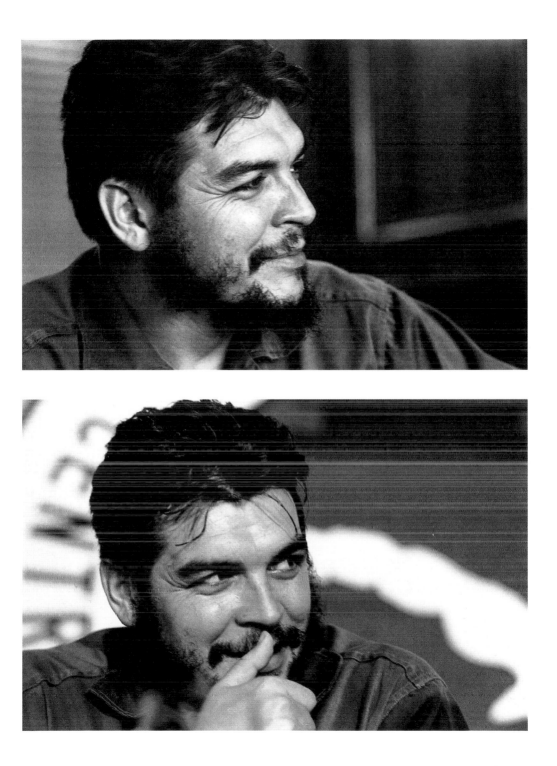

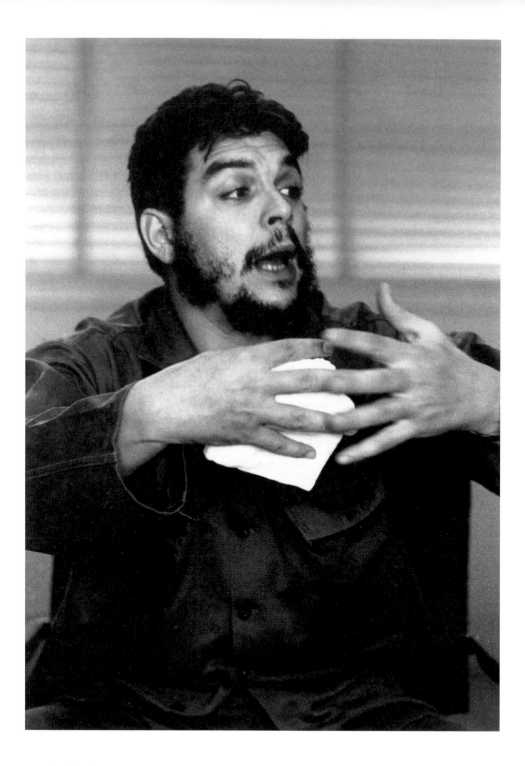

272  René Burri

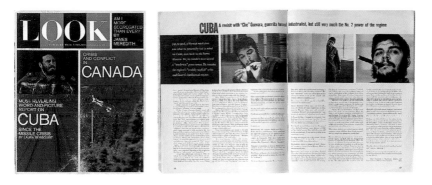

*Look, issue from 9 April 1963. Cover and double-page spread. The key picture was printed quite small and heavily cropped.*

Burri not only served as reporter in practically all the world's crisis spots, but also supplied photographs to illustrate essays and current news reports, took portraits of artist friends, and shot individual pieces whose formal austerity are reminiscent of Finsler's school. A reviewer once termed him a "complete photographer." Although his square portrait of Che Guevara is only one of many thousand pictures in his archive, it is his most famous work.

Burri had landed in Cuba on the day before. Even en route from the airport to the hotel, he had turned his camera on tanks returning from a parade. From this moment on, Cuba became a lifelong subject for him. But the high point of the visit nonetheless was the personal meeting with Ernesto Che Guevara – who in fact hardly paid attention to the photographer at his work. Che made, in fact, a nervous, driven impression on the photographer. Later Burri would compare him to a caged animal, a metaphor which supports the closed Venetian blind. Che saw his place in the armed struggle, not behind a desk, and it would not be much longer before a speech critical of the Soviet Union would marginalize him politically at home and make him decide to leave Cuba. His last public appearance would be in the middle of March 1963. At this point, Che went underground, turning up in Bolivia in 1966 under an assumed name. Barely one year later, in October 1967, Ernesto Guevara was tracked down in the jungle by the Bolivian military, captured, and executed. But the photographs of the dead revolutionary caught the public's eye for only a relatively short period of time. The student revolt of 1968 brought other pictures to the fore, namely the portraits by René Burri and Alberto Korda, both of which became ubiquitous icons of the protest movement. Commandante Che, returning as myth, had thus made himself immortal.

*Che: The last big interview. Photograph: René Burri*

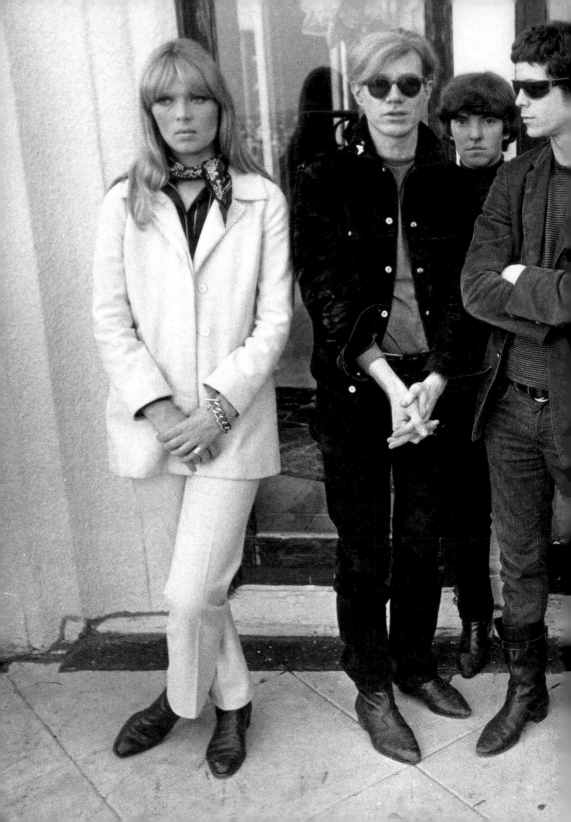

# 1966

## Gerard Malanga
## Andy Warhol and The
## Velvet Underground

**Group
Portrait
with Nico**

**May 1966: Andy Warhol is making a guest appearance
in Los Angeles together with the pop group The Velvet
Underground and Nico. This is hardly his first visit to
the city, but it marks his premier as a band 'member'.
Also present on the occasion is Gerard Malanga, who
can hardly have imagined that his rather relaxed group
portrait will go down in the history of photography as
proof of Andy Warhol's short but passionate excursion
into Rock music.**

The arrangement of the group expresses a historical reality, as it were:
it reflects the actual dynamics of the band, even if the photographer,
Gerard Malanga, has always stressed that nothing was set up or staged.
"This picture almost didn't happen," says Malanga, by which he means
that he stumbled into it almost by accident. That is, it was nothing more
than a mere snapshot, a quick press of the button without any attempt
at making 'art'. But this very artlessness is probably what lends the photo-
graph its intrinsic charm. From left to right: Nico, Andy Warhol, and
The Velvets in a relaxed atmosphere – cool and at ease because, after all,
they are just posing for their friend with a borrowed Pentax, not for etern-
ity. All that Gerard Malanga wants is a small photograph, for as a poet,
performance artist, and co-worker in Andy Warhol's Factory, Malanga has
not yet felt the call to become a photographer, and he only picks up a
camera on rare occasions. But even so, he is nonetheless conforming to
one of Henri Cartier-Bresson's famous dicta: "You can't photograph a
memory." In other words: when should you photograph something, if not
now?

## Career in the Land of Unlimited Opportunity

It is May 1966. They've all come together on the terrace of the 'Castle':
Lou Reed, the only one refusing to look into the camera; behind him,
almost hidden, the androgynous-looking Maureen Tucker; standing to the
right of Lou is Sterling Morrison. John Cale is seated. It is obvious that he
and Lou Reed form the great antipodes of the group. Without their even
wishing it, the conflict between them is palpable in the photograph,
which almost brilliantly reflects the deep rift within the band. To the far
left and completely in white is the beautiful Nico, the lead singer of The
Velvet Underground. She is a discovery of Andy Warhol's whom he has
described as weird and silent. "You ask her something, and she answers
you maybe five minutes later." Warhol has cast himself once again in the
role of a little boy, a game that he greatly enjoyed, according to Malanga.
Warhol's pose in the photograph might be described as awkward, even
inhibited. But one shouldn't be fooled by appearances, for with Andy War-
hol everything is calculated, including the mannered way he uses his
hands. Malanga says that it's a style that he picked up from Cocteau, and
adds: "Andy was very aware of this."

Andy was aware of everything. And as befits this consciousness, he be-
gan to work on his image early in his career, and the first step was a
change of name. An appellation like 'Andrei Warhola' scarcely provides a
ticket to success in the Land of Unlimited Opportunity, and the man who
was described by John Lennon as the world's best publicity star was
aware of this from the beginning. 'Warhola' pointed back to his Slavic
roots, stamped him as a weird stranger, underlined his origins as a poor
immigrant. And this was precisely what Andy wanted to get away from –
the entire milieu, and in particular the city where he spent his childhood:
Pittsburgh, a dirty, soot-filled Moloch, center of America's vast iron and
steel industry, with all the charm of the notorious Ruhr Valley, or Manche-
ster at the height of the Industrial Revolution. He wanted to escape from
all that, to get out into the great land beyond, to share in the "American
Dream," to make his mark and become rich and famous – it really didn't
matter how.

## Typical symptoms of a poor-boy-made-good

When he finally 'arrived' – after he had gotten rich and became a star –
Warhol manifested the typical symptoms of a poor-boy-made-good. Dur-

Gerard
Malanga

Born **1943** in the
New York Bronx.
Collaborates closely
with Andy Warhol in
the **1960s**. Desig-
nated by the *New
York Times* as "War-
hol's most important
associate". **1964–66**
collaboration on over
500 different 3 mi-
nute *Screen Tests*.
**1967** publication of
the book of the same
name. Publication of
his own photo-
graphic works in the
form of four mono-
graphs to date, the
last being *Resistance
to Memory* (**1998**)
and *Screen Tests,
Portraits, Nudes
1964–1996* (**2000**).
In addition, some
one dozen literary
works and two CDs.
**1999** major retro-
spective in Brussels.
Lives as photo-
grapher and Warhol
expert in New York

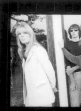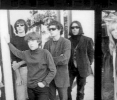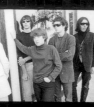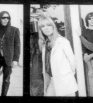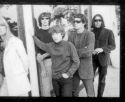

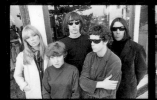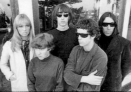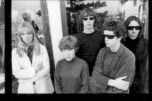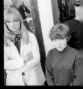

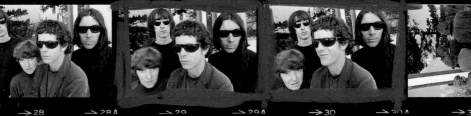

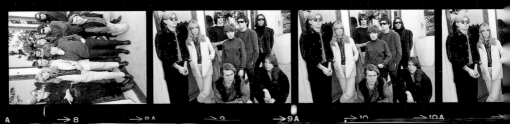

ing the week, he took on the role of provocateur, but on Sunday, he crept back into church. Warhol donated alms to ensure himself a place in heaven, but was irresponsible in paying his employees and helpers. A consummate Scrooge who appreciated nothing more than the crinkle of a crisp new dollar bill. An artist who loved money so much that he even painted it. A petty bourgeois who slept on pillows filled with crumpled greenbacks. A pack rat who couldn't let anything go, who checked every bit of trash for fear that someone might comb through it and start selling the contents as souvenirs. A peacock who let himself be chauffeured around in a Rolls Royce, all the while complaining about his financial troubles. And yet at the same time, Andy Warhol was an extremely creative spirit who left almost no field of art untouched. He was a writer and poet, a film-maker and photographer, and the founder and publisher of the now-legendary magazine *Interview*.

Through his engagement with The Velvet Underground, he even fulfilled his dream of having his 'own' rock band. With some degree of success he also designed album covers: for The Velvets, of course, but also for the Rolling Stones' famous album *Sticky Fingers*. And, if one takes his constant self-staging into account, Andy Warhol was also an actor – or rather, a

*Gerard Malanga:*
Andy Warhol with
The Velvet Underground & Nico, *The Castle, 1966 (contact sheet, detail)*

twenty-four-hour performance artist. And of course, above all he was a painter.

One has to admit, whatever he took up, he rubbed it against the grain. Every discipline to which he submitted himself (if the word 'submission' can be applied to Warhol's approach), he grasped with the naive intuition of a child – and ended up doing whatever he wanted with it, flaunting every rule of the game in the process. Thus, as a matter of principle, the book that he wrote had to be bad; that is, it was intentionally full of spelling errors and other problems. His numerous underground films transgressed not only the rules of narrative cinematography but also the sitting power of the average movie-goer. And naturally the rock group that he joined was something which, as Cher phrased it at the time, "will replace nothing – except maybe suicide" – a critique that The Velvets of course immediately conscripted into their own PR. Last but not least, Warhol was a painter; but also here, his 'painting' had nothing to do with the canvases created by the ingenious hand of the traditional artist.

## Adoption of everyday, banal objects

Andy Warhol's first coup was the creation of a new canon of motifs. Truly revolutionary for the early 1960s, a period still stamped by the abstract expressionism of a Pollock or de Kooning, Warhol's adoption of everyday, banal objects, his interest in the trivial myths of America from Coca Cola to Campbell's Soup, was truly revolutionary. But Pop – that is, the artistic treatment of everyday objects – had had its practitioners before Warhol. His true significance for recent art history lies elsewhere: Warhol taught us to redefine the concept of the artist, artistry, and art itself. In this sense, he in no way saw himself as an ingenious artist-individualist, but rather as the boss of a fractious troupe. Significantly, Warhol did not maintain a studio, but a "Factory"; and the Marilyns, Elvis Presleys, dollar bills that were produced there on the assembly line had more to do with photo-mechanic reproduction than with talented brush strokes. Lawrence Guiles describes Warhol's somewhat complicated process: first the artist searched through newspapers and magazines for a picture that intrigued him; he cut it out, and reproduced it to whatever size he wanted. Then he coated a silk screen with a light-sensitive layer and produced a stencil that enabled him to make innumerable copies of his image. As Guiles points out, photography lay at the root of the process.

## Photography as a mode of artistic expression

But in May of 1966, neither Andy Warhol nor his 'student' and co-worker Gerard Malanga had yet discovered photography as a mode of artistic expression. As a child, the latter had used his Kodak box camera to shoot a photo of his beloved Third Avenue El – the New York elevated railway – before it was torn down, and later, in 1965, he had worked with Andy Warhol on his so-called 'screen tests', activities which in a sense served as an entrance into the medium. But not until 1969 did his portrait of the writer Charles Olson and the multiple prints that he immediately produced from it become the starting point for Malanga's intensive engagement with the art of photography. Meanwhile, Warhol for his part began increasingly to take Polaroids – probably as an outgrowth of his work for Jimmy Carter, Willy Brandt, and Golda Meir – and then to produce screened patterns from them in the fashion described above. Warhol also carried his small-format Minox along with him, but, as the photographer Christopher Makos explains, a Minox requires focusing, which was not at all of interest to Warhol. As a result, Makos introduced the artist to the new auto-focus cameras.

Warhol acquired a modern Canon in addition to his small Minox camera. According to the historian David Bourdon, it was the Canon that enabled Warhol to take his notoriously indiscreet snapshots of, for example, Truman Capote visiting a plastic surgeon, or Liza Minelli stepping out of the shower. In all, there were several hundred of these candid photographs that Warhol did not hesitate to publish in his book *Exposures*. In other words, in the early 1970s, Andy Warhol emerged a diligent photographer. His importance to the history of photography, however, does not lie so much in his prima facie assemblage of photographs in itself. As paradoxical as it may sound, his real significance as a photographer arises from his painting: insofar as Warhol won recognition in the field of art through his pictures created with mechanical means and produced (i.e. printed) in great numbers, he also broke the ice for a new photography based on mechanical production and 'endless' reproducibility.

And yet, as everyone knows, Andy Warhol had begun his career in the early 1950s as a commercial and advertising artist. The work that he produced during this period for Condé Nast (*Vogue*) and I. Miller (shoes) is among his best. But Warhol wanted to be more than a simple, anonymous 'hand', and he felt himself drawn toward art without, however, having

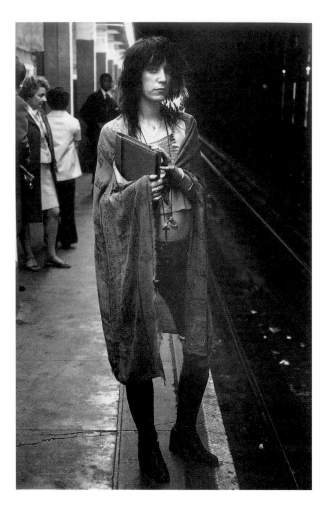

*Gerard Malanga:*
Patti Smith on plat-
form in the 68th
Street/Lexington
Ave. subway station,
New York City, *1971*

any particular theme in mind, let alone a message. Even later he managed without 'messages', of course; and in fact many critics found his pictures fascinatingly empty – candy-colored nothings. On the other hand, Warhol's biographer Guiles argues that Warhol presented this 'nothing' in such a bold and striking manner that it was impossible to overlook. At the end of the 1950s, Warhol decided to turn to Pop, that is to the artistic translation of popular objects – such as comics. But here it was already too late, for comics were already the domain of Roy Lichtenstein. Depressed, Andy complained to his friend Muriel Latow that he didn't know where to begin, and asked for some inspiration. Latow's answer: he should choose a common object, something ordinary that one sees every day, but takes for granted – for example a can of soup. Andy Warhol's face lit up in a smile: the suggestion proved the turning point both of the evening and of the history of painting.

Thus, Andy Warhol took up painting Campbell's Soup: Noodle, Tomato, Chicken. And he became famous – but such fame was still a far cry from recognition as an artist. Until the end of his life, many considered him no more than a seasoned charlatan: a talented draftsman, certainly, but as an artist, a dud – and as a human being, the dregs. The New York Museum of Modern Art, for example, stubbornly refused to mount a retrospective of his works. Only after his death – and then without hesitation – did the MoMA finally mount the show that the artist had so long wished, and afterwards, it moved on to Chicago, London, Cologne, Paris,

and Venice. In other words, the curve of Andy Warhol's career was anything but steep and continuous. His beginnings as an artist were in fact rather discouraging; for many years, his attempts to find a niche in respected galleries remained unsuccessful. "Andy, lay off," the *New York Times* advised at regular intervals; "you're not real art." Willem de Kooning, the exponent of an abstract expressionism that in many way constituted the antithesis to Warhol, spoke out even more clearly, screaming out his hatred of the Pop artist in public, and accusing him of killing beauty and joy.

## Everybody's plastic, but I love plastic

Andy Warhol understood very well how to polarize anything he touched – including his comparatively brief excursion into rock music. He had set out searching for a band already in late 1965. Theater producer Michael Myerberg was in the process of opening a new club in an abandoned airplane hangar in Queens, and declared himself ready to christen the shed "Andy Warhol's Up," on the condition that the Pop artist would provide the music. Before Christmas, on a lead from Barbara Rubin, Warhol listened to a rock group called The Velvet Underground in the New York café Bizarre. Right from the start, Warhol got along brilliantly with Lou Reed, as Warhol's biographer Victor Bockris reports. And thus, several days later, negotiations began in the Factory. Bockris tells how the 'coked-up' Velvets felt almost magically drawn to Warhol, and that Lou Reed was hit the hardest, because, like Billy Linich and Gerard Malanga, he had simply been waiting to be formed by a master hand. Andy gave Lou ideas for songs, and hammered the importance of work into him. The appearances that Warhol organized and directed turned into multimedial events. In short, he professionalized the Velvs and made them famous. But as to the identity of the true star of the show, Bockris leaves no doubt. After all, almost no one had heard of The Velvet Underground or Nico, but Andy was already a celebrity. And there he sat, elevated high above the dance floor, operating the projectors and exchanging the light filters.

At the beginning of May, the group had a gig in Los Angeles, and 3– 15 May, Warhol and The Velvets were scheduled to appear with Nico in the "Trip." The group was staying in what was known as the Castle, a private house modeled along medieval lines, and probably conforming fairly

well to Warhol's taste. "I love L.A.," he once announced, "I love Holly-wood. They're beautiful. Everybody's plastic, but I love plastic. I want to be plastic." Our picture was taken on the terrace of the Castle. Gerard Malanga set the borrowed Pentax on a stand, which accounts for his own inclusion in several variants of the photograph. In the first versions of the picture, The Velvets are laughing, or at least smiling. Here, however, they are serious, almost ill-tempered. After only a few weeks, their "Trip" had been closed down by order of the local sheriff. The local press expressed a less negative response to The Velvets, calling the arrival of Andy, the super-hippie, on Sunset Strip the greatest match since French fries dis-covered ketchup.

## Enter Valerie Solanas, radical feminist

Thirty-seven years old in 1966, Andy Warhol was almost at the height of his international fame – which is not, however, to be mistaken for popu-larity. The manner in which he stylized himself – his Gay affectations; his waxy, elfin-like being; his almost albino coloring, accented by pimples and nylon wig; his feeble charm combined with an eloquence that hardly rose above "Uhmm," "Crazy!" and "Super!" – these were not the sort of things to turn him into a national favorite. On the contrary, he had ene-mies, including some who were not content to leave the matter at verbal attacks. On 1 June 1968, for example, exactly two years after our picture was taken, Valerie Solanas, a radical feminist, turned up at Warhol's New York Factory and in a state of fury laid the artist low with several bullets. Warhol, although given up by the doctors, nonetheless survived. Robert Kennedy, also the victim of an assassination attempt in the summer of 1968, died. "That's the way things are in this world," Warhol's artist col-league Frank Stella is reputed to have said.

There's no question: two bullets from the barrel of a crazed feminist would have been precisely the fitting end for the publicity-seeking Warhol – at any rate more suitable than the simple gall bladder operation that Warhol in fact succumbed to at age fifty-nine in 1987. A few days after his unexpected death, his body was carried back to Pittsburgh, where he was buried. The city of his childhood had claimed him once again – and the local grave-digger reveled in what he termed his first famous burial. Andy Warhol's chapter in history by no means ended with his death, however. The mountain of pictures, antiques, and knickknacks that the

social climber – forever plagued by insecurity about the future – had collected in his various domiciles now awaited new owners: On 23 April 1988, Sotheby's in New York began a ten-day auction of Warhol's estate. The five volumes of the catalogue comprised 3,429 items, and more than six thousand people wanted to attend. These figures were harbingers of what was to come. As Victor Bockris reports, the auction house had underestimated the hammer price in almost every case. For example, at $77,000, Warhol's Rolls Royce brought in more than five times what had been reckoned; a ring estimated at $2,000 went for $28,000; and a Cy Twombly was taken up to a record price of $990,000. Last but not least, Andy Warhol's candy jars, with a market worth of perhaps $2,000, were sold for a total of $247,830. The entire estate, which Sotheby's had estimated at a value of $15 million brought in more than $25 million. And what would Warhol have said to all this? Fran Lebovitz, a friend and co-worker on *Interview*, is reported to have glanced heavenward and said: "Andy must be furious that he's dead."

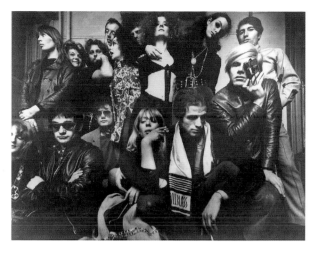

*Gerard Malanga: Andy Warhol/"Factory" group photo, New York City, 1968*

*Top row, left to right: Nico, Brigid Polk, Louis Waldon, Taylor Mead, Ultra Violet, Paul Morrissey, Viva, International Velvet, unknown. Below, left to right: Ingrid Superstar, Ondine, Tom Baker, Tiger Morse, Billy Name, Andy Warhol*

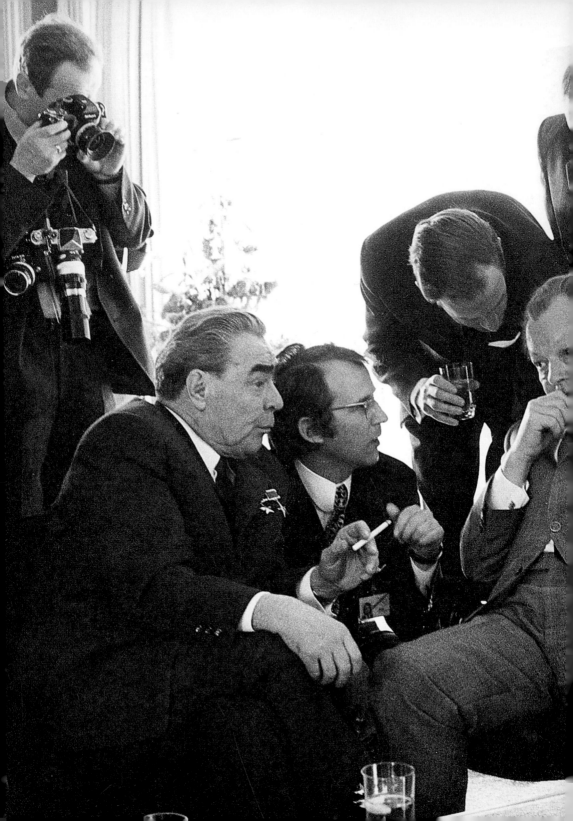

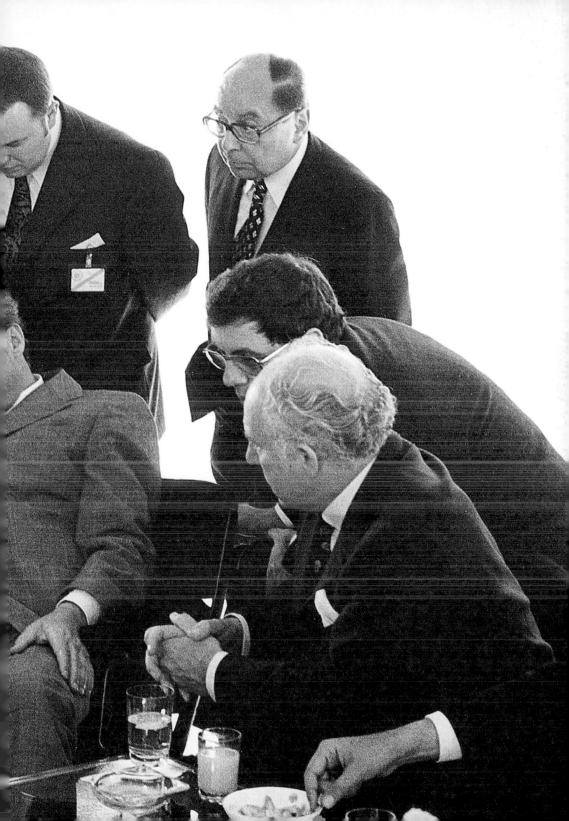

# 1973

# Barbara Klemm
# Leonid Brezhnev, Willy Brandt, Bonn

**A Visit to
the Rhine**

**In May 1973, Leonid Brezhnev, Chairman of the Soviet Communist Party, visited Bonn, Germany. This first appearance of a Kremlin leader in West Germany since the end of the war had been preceded by a controversial visit of German Chancellor Willy Brandt to the Soviet Union. Now, after so many years of Cold War, the road finally seemed to be cleared for good neighborly relations, in the words of the Soviet journalist Valentin Falin.**

The small group of three has retired into a room in the Bonn Chancellery. The date is Saturday, 19 May 1973. Actually, a standing reception had been scheduled to take place before lunch, but owing to circumstances, the men had now settled down into the dark-upholstered suite of chairs. The figures are easy to identify: from left to right are the Soviet Communist Party Chairman Leonid Brezhnev, German Chancellor Willy Brandt, and the German Foreign Minister Walter Scheel. Undoubtedly, there were other people also present in the room, but the camera concentrated on the protagonists of a meeting that appears to have entered the critical phase at just this moment. The atmosphere seems tense in the photograph, even though none of the participants are indicating any agitation or excitement by means of wild gestures. Quite the contrary, in fact: Brezhnev appears to be thinking something over; Willy Brandt, whose suit jacket has slipped up somewhat, looks at him questioningly; and Scheel, Foreign Minister and chairman of the liberal Free Democratic Party, seems at this moment more or less relegated to the role of an onlooker. Looking at this picture, one might be inclined to say that there is a sense of excitement emanating from the group of five translators and advisers who are whispering together as they stand or bend over the protagonists.

## Guests from the fields of politics, economics, and culture

The press had been regularly reporting on what the group was eating and drinking; in the picture, we see only water and what appears to be orange juice; to the right, someone finds a moment to munch on some biscuits. But the leaders had been able to pamper their palates the previous evening at a banquet in Brezhnev's honor in the Palace Schaumburg, to which the chancellor had invited more than sixty guests from the fields of politics, economics, and culture. Helmut Kohl (then the CDU opposition leader in parliament) had turned down the invitation, however; officially the reason was his displeasure that Rainer Barzel, CDU party chairman, and Gerhard Stoltenberg, chairman of Foreign Relations Committee in the Bundesrat, had not also been invited. In general, however, the German press had treated such internal political concerns as side issues. The newspaper headlines devoted themselves to what they felt was a historic visit, even if it was not at all clear what the political results might be. The arrival of the General Secretary of the Communist Party of the Soviet Union in Bonn on 18 May marked the first official state visit of a Soviet party chief since the Second World War. In terms of internal Soviet politics, Brezhnev had laid the groundwork for his journey carefully. The Germans in turn had had to be particularly careful, lest a relaxed German-Soviet dialogue cause ripples among the western Allies. In addition, there were doubts from diplomatic quarters as to whether Brezhnev – who was the head of the Communist Party, but not of the Soviet state – was the right political partner for discussion. But here, too, pragmatism ruled the day. The conservative *Frankfurter Allgemeine Zeitung*, for example, granted in its end-of-the-week edition of 18 May that in meeting with Brezhnev, Brandt was in fact conferring with the top Soviet official. According to the paper, Brezhnev had in fact as much competence as the West might wish for – "and not only because he had unobtrusively begun to co-sign international treaties for the Soviet Union."

On the whole, the signs looked favorable. The headline of the Moscow newspaper *Novge Vrenia* announced that the barometer forecast good weather, and expressed the hope for a lasting peace between the peoples of The West and the East. Fifty-one percent of the Germans rated the visit as "good and useful" – a judgment which might well have been called forth by Brezhnev himself, who behaved in a markedly jovial manner, and seemed much more open and 'western' than any of his predecessors,

**Barbara Klemm**

Born **1939** in Münster. Trains in a studio for portrait photography. From **1959** works for the *Frankfurter Allgemeine Zeitung*. Since **1970** editorial photographer for the *FAZ*. Member of the Academy of Arts Berlin-Brandenburg since **1992**. Numerous awards, including **1989** Dr. Erich Salomon Prize of the DGPh. Numerous exhibitions, most recently **1999** a major retrospective in Berlin. Lives in Frankfurt am Main

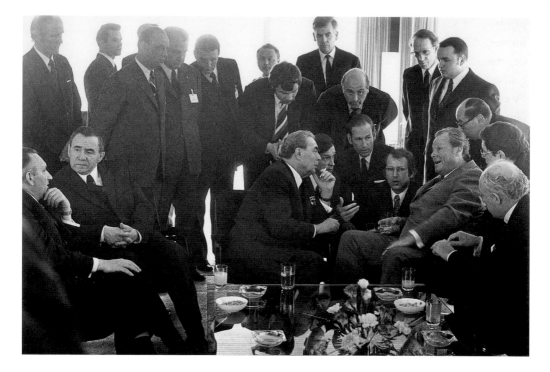

*One of the lesser-known variants of the shot, with Egon Bahr and Andrei Gromyko left of the picture*

ranging from Beria to Khrushchev. Even the Party's chief's "well-fitting gray suit" won praise from the press, which described Brezhnev as being a head shorter than the German chancellor, and went on to comment that in spite of the Russian's broad face, he was in fact thinner than Willy Brandt – who was in turn described as having acquired a "rather portly figure" since he had given up smoking.

## Aware of the particular significance of the visit

All the participants were undoubtedly aware of the particular significance of the visit. According to the *Frankfurter Allgemeine Zeitung*, "the most powerful man in the Eastern World is now on the soil of the Federal Republic of Germany." The security measures were correspondingly high: there were reputed to be approximately twenty-thousand security police, both in uniform and plain clothes, protecting the Soviet party chief so closely "that even the vast majority of the journalists were hardly able to see the whites of his eyes."

For the occasion, nine hundred journalists had gathered in Bonn. Among them was Barbara Klemm, born 1939 as the daughter of the well-known

painter Fritz Klemm. Since 1970, she had been the editorial photographer for the *FAZ*, and Brezhnev's visit was her first assignment in the West German capital. She and three colleagues were the only photographers to gain admission to the room with Brezhnev, Brandt, and Scheel; film and TV cameras were forbidden. In total, Klemm shot three or four rolls of film, and in the process caught the attention of the Communist Party leader. Brezhnev expressed surprise, so the story goes, that in Germany a woman was able to pursue "the difficult profession of a news photographer."

At the moment of the shot, however, Brandt and Brezhnev are deep in conversation. Their initial optimism appears to have given way to a skeptical reserve. At any rate, there is no trace of the hearty laughter with which Brezhnev had rung in his visit of state. What is remarkable is that the *FAZ* did not publish the key picture until several years later, namely in 1976 in connection with a report on an exhibit of Barbara Klemm's work in Hamburg. The rotogravure weekend supplement for 26–27 May 1973 gave preference instead to a total of four rather less impressive photographs.

## The beginning of day-to-day German-Soviet cooperation

The discussions between Brezhnev and Brandt – between Russians and Germans – turned out in fact to be more difficult than originally expected. Two years after the initial meeting in Crimea, which had been termed a milestone on the road to normalization, and one year after the signing of the Moscow Treaty, the constructive dialogue ground to a halt once again over the status of Berlin. The leaders by no means reached a consensus on the issue; on the contrary, negotiations were tough: ten hours on Sunday alone in order to turn the visit into a political success. The tense atmosphere so palpable in Barbara Klemm's picture, however, arises from a much more mundane cause. According to reports, the Communist Party Secretary had begun to suffer from a toothache; thus a change of schedule needed to be discussed. For this reason, a press photograph came to mirror a meeting whose political results were thin, but whose long-range significance can hardly be overestimated in terms of subsequent history – in the words of the *Frankfurter Allgemeine Zeitung*, neither more nor less than an age of "day-to-day German-Soviet cooperation" had begun.

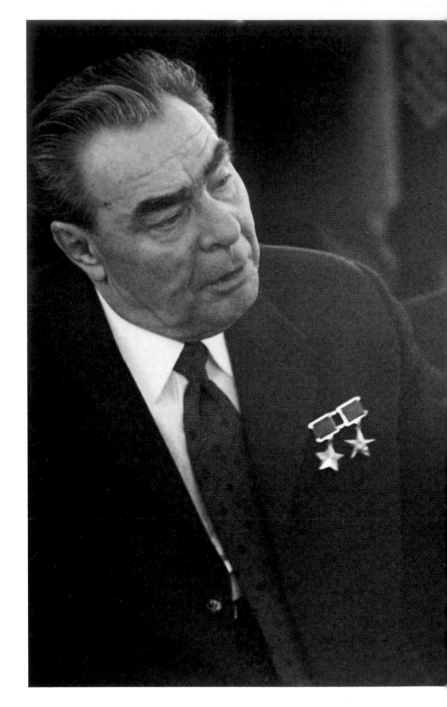

*Barbara Klemm:*
Brezhnev, Falin and
Brandt

*The photogravure
supplement of the
FAZ on 26–27 May
1973 had this group
portrait as the lead.
The actual "icon"
remain unprinted at
the time.*

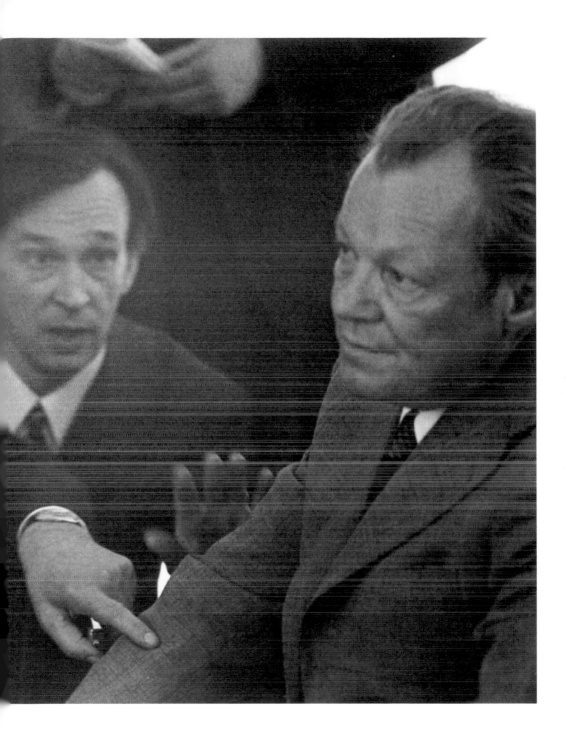

# 1981

## Helmut Newton
## They're Coming!

**The photograph marked a turning point — and it was, of course, intended to be provocative. In fact, not until 1981 did the French *Vogue* feel ready to publish Helmut Newton's diptych *Sie kommen!* as an erotic metaphor for the changing image of woman.**

This time there were no Italian gardens or fin-de-siècle hotel rooms, no beaches on the Côte d'Azur, no promenades, no New York apartments with a view, or well-appointed rooms in the 16th Arrondissement. In their place, only the sober, empty chamber of a professional studio. That was unusual for Helmut Newton, who loved to stage scenes, especially in settings that exuded life and vitality (or at least he did at one time). His photographs, which many believe to have been schooled in the German cinema between the wars, were sometimes set even on bridges or in underground passageways, in train stations or airports. It all depended on what Newton's fat notebook — that irreplaceable store room bursting with ideas that have feasted on reality — proposed. Newton was a realist — if one accepts the idea that dreams, desires, and fantasies also belong to the inventory of reality. But his inventory had one important difference from the world of things that surround us: namely, one does not need a drawer for them. Helmut Newton provided images for those forces that move the world beneath the skin, as it were — our collective passions, fantasies, suppressed desires, and sublime wishes. And he did this not for the sake of the public, but for his own sake. If he had concerned himself about what the public might like, he would never have created another picture, he said. "No, I do only what pleases me."
Helmut Newton was a gardener of our secret desires. And without doubt, he was the best-known gardener of the kind, and was therefore automatically the most controversial botanist of our collective longings. He was a latter-day pupil of Freud, whose medium was of course not the couch,

but the camera. Whether small format or 6 x 6-inch, whether ring flash or daylight – technical data are of little help in mapping the rich idea-landscape of a Helmut Newton. He created a cosmos enclosed within itself, subject to its own rules, which Newton, with his aversion to all theories, never attempted to organize into a program, but which nonetheless allow themselves to be distilled in retrospect. Newton's "film stills", his frozen scenes, are clearly artificial, but at the same time thoroughly consistent with the interior world created by the photographer; the scenes revolve around power and submission, around force and passion, seduction, pleasure, and physical love. His arrangement of his realm is unmistakably vertical: there is no sense of egalitarian togetherness among his figures, but rather clear hierarchies of power, although – and we will return to this point later – the woman is clearly given the determining role. Boots and whips, saddles and spurs, German shepherds, chains, high heels, are recurring symbols in a complex system of visual symbols set always against mirrors and broad corridors, stairs and balconies that rise to dizzying heights, swimming pools and bridge railings: in other words, flight and fall, plummeting and death are always at least implicated in Newton's pictorial world.

## Fashion as an excuse for something else

Helmut Newton loved to arrange scenes and thus to achieve absolute control over his picture. Moreover, the writer Michael Stoeber finds this to have been a tendency throughout the artist's life. Anyone who, like Newton, has been cheated out of a life plan – however it may be defined – in the course of time compensates for the loss if possible by searching for some form of "absolute control over his own life." Born the son of a Berlin button-factory owner in 1920, Newton left – that is, felt compelled to leave – Germany at age eighteen. His decision proved correct, as the fate of his photography teacher Yva in Auschwitz demonstrates, even though both his journey to Australia and his entry into the field of professional photography were difficult. In the early 1960s, Newton returned to Europe, where he found a congenial platform for his work, particularly with the French *Vogue* under its courageous editor-in-chief, Francine Crescent. Note well: at this point in time, moral boundaries were still quite narrow. Nevertheless, the unmistakable signs of change were beginning to emerge – at first (cautiously) in Ed van der Elsken's volume of photo-

Helmut
Newton

Born the son of a button manufacturer in 1920 in Berlin. 1936–38 apprenticed to the studio of the Berlin photographer Else Simon (Yva). 1938 flees from Germany. From 1940 in Australia. Australian citizen from 1944. Marriage to the actress June Brown (alias Alice Springs). 1956 return to Europe. One year in London. 1957 moves to Paris. Works for *Vogue, Elle, Marie Claire, Jardin des Modes, Nova, Queen*. From 1971 on an increasing number of autonomous projects. 1975 first one-man show in the Paris Nikon Galerie. 1976 publication of his first book, *White Women*. 1987 major retrospective in the Rheinische Landesmuseum, Bonn. 1992 awarded the Order of the Federal Republic of Germany. 2000 retrospective at the Neue Nationalgalerie, Berlin. Dies 2004 in Los Angeles

*Helmut Newton: They're Coming! (naked), 1981. The shot unquestionably ranks among Newton's best known images from the eighties.*

graphy, *Love in Saint Germain-des-Prés*, in 1956, and later (openly) in the much-cited 'sexual revolution' around 1968. In a certain sense, Helmut Newton was, or became, a part of this movement. On the one hand, he and the pictorial world he created profited from the increasingly liberal morality of the age. On the other hand, his constant exploration of the possibilities also led to an expansion of the limits of tolerance. Newton

thus simultaneously functioned as a catalyzer and an exploiter of the development.

Helmut Newton was a fashion photographer – and nothing less than that. He photographed clothes or, as one calls them in the industry, 'collections'. The cut or the fabrics – the 'buttons and bows' in the language of the fashion editors – interested him only peripherally, however. For Newton, fashion was rather a pretext for something else, although – and this makes his work easier – the path from fashion to his passion was not a long one, when one recalls that fashion, in the sense of the age-old game of revealing and concealing, lies also at the core of all sensuality. Newton's visualizations may have been connected with a contract, but they are nonetheless steeped in his personal desires, wishes and dreams, delights and fears. Furthermore, his success only goes to show that his photographs touch the depths of collective longings. Newton translated into pictures that which many hardly dare to think.

The voice whispering to Newton was that of reality. He loaded his creative batteries, so to speak, from everyday life. The artist always insisted that he was little more than a voyeur, a claim which coquettishly borders on understatement, but nonetheless reveals the conceptual core of his photographic work – an art, moreover, which is schooled in life at its fullest, gaudiest, and most pleasurable, or conversely when it radiates on lighter and softer frequencies. Newton's powers of perception were both alert and selective: the "bad boy of photography," as he liked to call himself, picked up the lascivious signals that he then translated into pictures that succeed in being provocative even in an age that is largely without taboos. "I am," as Helmut Newton pointed out, "a good observer of people." That is, he was a seismographer of those waves which people – preferably "cool girls" – emit through gestures, glances, their way of walking, or even their clothing. The street was the costume room for his pictorial ideas, enriched through a bit of haute-volé that transcends the trivial and passes into the fabulous. "The people in my pictures," according to Helmut Newton, who did not at all attempt to hide the parameters of his creations, "have been 'arranged', as on a stage. Nonetheless my pictures are not counterfeit; they reflect what I see in life with my own eyes."

In this connection, Newton liked to refer to a photograph titled *Eiffel Tower* (1974), initially published in *White Women* – Newton's first book, which was particularly important in laying the groundwork for the later

reception of his photographs. "Tower" is a late-evening view into the rear seat of a limousine that has been transformed into a 'bedroom'. A beautiful young blonde woman is lounging In the midst of the black leather cushions; apart from her leather jacket, which is already pulled open, she is wearing only transparent undies embroidered with an Eiffel Tower – images that sing of Helmut Newton's penchant for double meanings and ambiguity, in the words of Klaus Honnef. In the background, an anonymous man has begun to work on her, fumbling with the zipper and helping her out of her high-heeled boots. "The scene," according to Newton, "undoubtedly takes place after work – a business man has a date with his girl friend. He is wearing a blue suit, handsome cufflinks, and drives a black Citroen DS – the typical auto of the bourgeoisie and of civil servants in France. Lying on the seat next to the woman is a copy of the establishment newspaper *Le Monde*. And what the man is doing before he drives home – he has not yet gotten to the stage of going to a hotel with his girlfriend – is undressing her in the automobile. That happens all day long in the Bois de Boulogne," explained Helmut Newton; "the autos are lined up as in an American lover's lane."

### Basso continuo to his performance with the camera

Helmut Newton was fascinated by the idea that hiding under every woman in 'full dress' is a more (or less) well-formed body. Fashion was the theater curtain that must be pulled aside. And possibly – no, certainly – this nakedness, this ceremony, remained something of a basso continuo to his performance with the camera. Already in the mid-1970s, Newton started photographing girls in the Paris Métro: stark naked under a fur coat. An undertaking not entirely without danger, as the photographer admitted. "You can land in jail for something like that, because the Métro has very strict rules." But Newton loved to test the borders of the possible, in daily life as in art – which for him in any case flowed together. That these borders have clearly moved since the 1970s has a good deal to do with Newton himself, as mentioned earlier. Opening the curtain slowly, Newton radically altered our idea of what is allowed and what is forbidden. At the end of this process of development, his models were completely naked – without coat or furs – provided at most with the black stilettos that are a staple of his iconography: "When I look at a woman," said Newton, "my first glance goes to her shoes and I hope

that they are high. High heels make a woman very sexy and give her something threatening."

## An increasing obsession

Helmut Newton was an artist whose work has found its way into the sacred halls of international art museums – which is all the more surprising considering that most of his photographs have a commercial background, and that he did not at all attempt to hide his origins in editing and advertising. Newton succeeded in blurring the distinction between 'free' and 'applied' art for us – just as he himself never took the border seriously. "Whenever I've worked on a commission, whether editorial or advertising, I have always found my inspiration," he admitted. "Not all, but almost all of my best photographs stem from these assignments." Newton's ideas, as Sotheby curator Philippe Garner once noted, were elaborate; they demanded the noblest raw materials and masterly skill from experts – makeup artists, hairdressers, stylists. Newton, in other words, needs a 'back office' that could be offered only by large newspapers and publishing houses, with all the logistic and financial support they provide. Therefore, the humus from which his work grew was the commission – even if not everything thrived in this soil, at least not in the early years. This was a situation that bothered Newton, at least in the official legend. "A dream of a contract," the photographer recalled; "I'm supposed to take photographs in this grand hotel for the magazine *Réalités*. I've got two interesting models, but I've also got a problem: my first book, *White Women*, is almost done – just a few pictures are missing. For the book, the pictures should be rather bold nudes, but for *Réalités*, I need elegant photos to fit in with the character of the magazine. I decided to make two versions: one nude, the other clothed." From then on, Newton admitted, his interest in the opposition between 'naked' and 'dressed' developed more and more into a passion.

*They're Coming!* was published for the first time in the November issue of the French *Vogue*, and represented naturally the high point, and even in a sense the crowning moment, of a passion which seemed hardly capable of being carried any further. The editor-in-chief Francine Crescent devoted a bold eight pages to Newton's series, a decision which, as Karl Lagerfeld recalls, "placed her job at risk" once again. Admittedly, complete nakedness combined with stilettos is almost part of the basic vo-

cabulary of Newtonian photographic art; one needs only think of *Rue Aubriot* (1975) or *Mannequins quai d'Orsay II* from Newton's second book, *Sleepless Nights*, which twice took up the opposition between 'naked' and 'dressed' (not to mention the artist's explorations of lesbian love, a theme which always intrigued the photographer). But the one picture was taken under protection of darkness, so to speak, and the other in the seclusion of a salon. Both photographs therefore exude something of an intimacy that Newton's pictorial vision clearly passed beyond – from his *Big Nudes* to the sequence discussed here.

The title *They're Coming!* – applied to the photographs only after their appearance in *Vogue* – underlines the resolution behind a nudity that is now 'worn' as a matter of course, but which also and especially signifies vulnerability. Seen in this way, Newton's women of the 1980s are "big nudes" in a double sense: large, strong, goal-oriented, and – whether 'dressed up' or unclothed – ready to conquer the world of men.

## A horror of too much smoothness, too much perfection

The idea of dissolving the opposition between 'naked' and 'clothed' in diptychs is one Newton had already experimented with earlier in Brescia during the summer of 1981, in a sea-side Fascist-style villa. "The same situation, the same woman," recalled Karl Lagerfeld; "once dressed and once naked (but with high heels – for Newton, a woman isn't naked unless she's wearing high heels). The reconstruction is perfect; only one thing could not be replicated – the light. The sun had changed, and the unique hours were gone forever." Helmut Newton learned from his work in northern Italy; afterwards, he exchanged the admittedly charming ambiance of a summer villa for the antiseptic atmosphere of a Paris studio. The single model furthermore gave way to a group of well-built graces. The unclarity of motion that had been suggested in the Italian sequence was now replaced in favor of a truly 'frozen' entry in *They're Coming!*. Careful observers will note, however, that not all the details are logically followed through. Somehow, the pumps have gotten mixed. And the model on the back left has reversed the stationary and moving leg. In film one would say that the continuity is missing. Oversight – or intention deriving from a horror of too much smoothness, too much perfection? Newton emulated his women. He always valued dominant femininity. The high-heeled shoes, the strong upshot, the light, neutral background

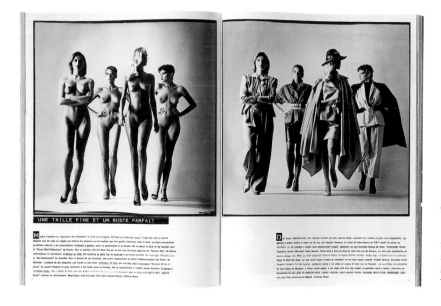

UNE TAILLE FINE ET UN BUSTE PARFAIT

*"Beauté –
Silhouette 82":
double-page spread in
French* Vogue, *November 1981, with
the first publication of
the motif now com-
monly known as*
They're Coming!

against which the contours of the women stand out as if chiseled all
strengthen the impression of the threat, especially in the 'undressed' ver-
sion. In the magazine business, the right side is usually considered to be
the more important. In the *Vogue* premier, the naked variant is to the left,
the clothed to the right – a layout that seems logical as long as one fol-
lows the direction of reading and reckons that the human being is initially
naked and only afterwards clothed. When, however, Newton was re-
sponsible for the order of the sequence, as in his *Big Nudes*, he reversed
them – perhaps indicating which of the motifs held more importance for
him. At the same time, the charm of the two photographs clearly resides
in their character as a diptych: only in terms of such a thesis and anti-
thesis does the theme develop its full interest. *Vogue* presented the
sequence under the title "Beauté – Silhouette 82". The lead-in was brief:
"Work on your body so it can wear the fashions of the coming season
with grace." Interestingly, in the autumn of 1939 a similar theme had
appeared in the French *Vogue*: looking toward the coming lines that were
fitted to the contours of the body: the corset had been reinvented and
was now being recommended once more to women. Today, one offers
them a fitness studio and hand-weights. Helmut Newton was without a
doubt a witness of the dramatically changing role of women in society.
And he was their important, if often misunderstood, iconographer.

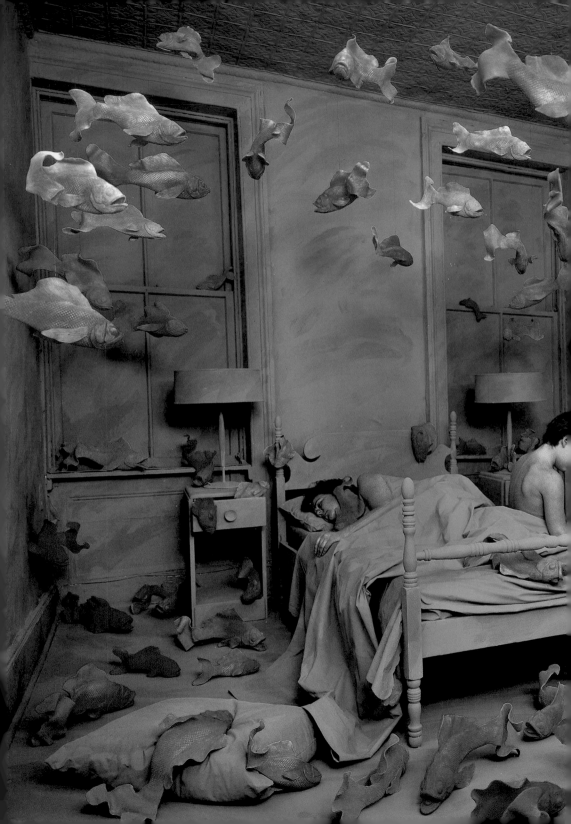

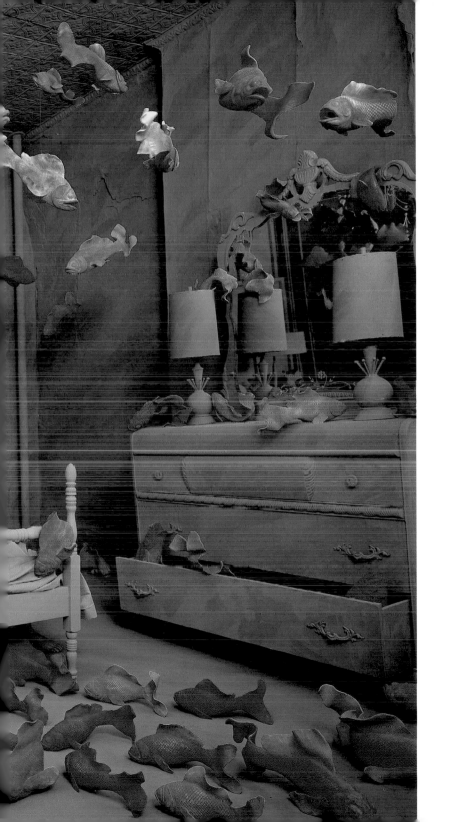

# 1981

# Sandy Skoglund
# Revenge of the Goldfish

**The Mel-
lowest of
Night-
mares**

**Since the 1980s, photographic artists have increasingly
taken to 'designing' their pictures. Consciously follow-
ing the trail blazed by advertising, they have used
imagination and wit to overcome the strictures of the
Classical Modern. Rather than seeking themes in real-
ity and 'taking' it straight, they invent new pictorial
worlds. They often manipulate their pictures in the
name of brilliant and outrageous ideas, and thereby
take up the challenges posed by the Postmodern.
Along with Cindy Sherman and David LaChapelle,
Sandy Skoglund numbers among the outstanding ex-
ponents of this so-called 'staged photography' – al-
though the New-York-based artist also wishes her con-
structed environments to be understood as art in their
own right.**

*Revenge of the Goldfish*: it's impossible not to feel the contradiction in the
name given by Sandy Skoglund to the work she created in 1981. Her later
tableaus would feature foxes– or dogs. The viewer may well be overcome
by disgust on seeing *Germs are Everywhere* (1984), or succumb to a sense
of discomfort in the face of the shimmering green felines in *Radioactive
Cats* (1980). Even the fidgety squirrels in *Gathering Paradise* (1991) some-
how seem more threatening than the over-sized goldfish that have some-
how found their way into a middle-class bedroom. In fact, the two pro-
tagonists of the scene – mother and son (or is it brother and sister?) –
seem to not even have noticed the arrival of the fish. The woman is sleep-
ing, the boy is dozing as he sits on the edge of the bed. The scene oscil-
lates oddly between the real and the surreal. What sounds threatening in
the title reveals itself in the picture to be markedly peaceful and relaxed.

At most, it is the mass of the reddish-orange creatures taken as a whole that creates a rather alarming effect – fish that somehow have mistakenly wandered into an environment where they really do not belong. Much easier to understand is the room, in which we find everything that a conventional bedroom ought to offer: bed, dresser, lamp, mirror, latticed window. Admittedly, everything has been dipped into a swampy green wash – in fact the whole scene is somewhat reminiscent of an oversize aquarium. Can it be that the picture is thematizing the reverse of a standard assumption? Namely, that the people have becomes captives of nature, caught as it were in a foreign environment, just as in a 'normal' household aquarium, nature has been imprisoned by people?

## Sculptures of papier-mâché, plaster, or polyester

Anyone confronting the photographic works of the American artist Sandy Skoglund for the first time – anyone who has recovered sufficiently from the trompe-l'œil effects of her minutely detailed installations to make out her goldfish, squirrels, cats, dogs, or babies for what they in fact are, namely sculptures made from papier-mâché, plaster, or polyester – will inevitably ask how she does it. In other words, once viewers realize that the scenes are amazing theater sets, located somewhere between fact and fiction, reality and artifice, they inevitably inquire after the technical and artistic processes she employs. To set the cards straight right from the beginning: Sandy Skoglund is responsible for all the creative steps involved in her work; she is consummately the author of her photographs, in the sense introduced by the French nouvelle vague. Skoglund develops her ideas and constructs her worlds in her gigantic Soho studio located in the midst of New York's art district. Here she designs and models her figures from photographic patterns that she has abstracted from magazines and other printed matter; she sets up her 8-by-10-inch large-format camera, checks the development of her 'scene' through the focusing screen, arranges the lighting – and then takes her photograph.

## A plethora of photographic 'power acts'

According to her own understanding, Skoglund is neither sculptress, nor painter, nor photographer. Douglas Crimp once denoted the phenomenon of her work as a 'hybridization' of the arts. More precisely, Skoglund belongs to the generation of artists who are applying academic skills ori-

Sandy
Skoglund

Born **1946** in Quincy/Massachusetts. **1964** high school degree. **1964–68** Smith College, Northampton/Massachusetts. One year in France studying art at the Sorbonne. **1969–72** studies Film and Multimedia Art at University of Iowa (M.F.A). **1972** moves to New York. Panel painting along the lines of Minimal Art. **1979** move to photography. Breakthrough **1981** at the Whitney Biennale with *Radioactive Cats* **1980** and *Revenge of the Goldfish* **1981**. Numerous one-woman shows, including **1992** in Paris, **1995** in Arolsen, **1998** in Northampton and **2000** in West Palm Beach. Lives and works in New York City

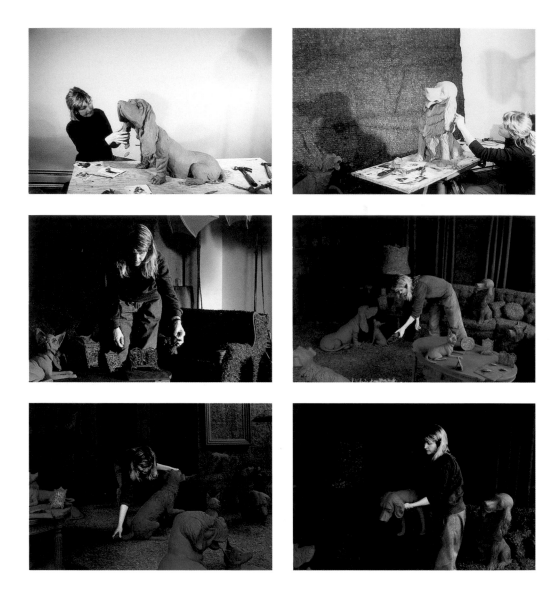

*Sandy Skoglund:* The Green House. *Preliminaries to her work finished in 1990. The artist only began in the late eighties to document the growth of her elaborate installations. Still more or less alone at the time, Sandy Skoglund now has her own team which helps her in the realization of her complex ideas.*

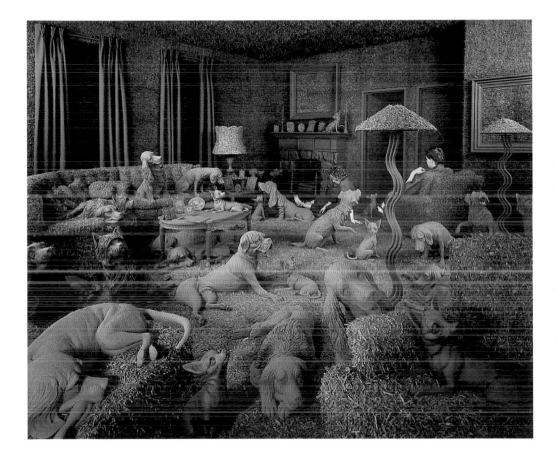

The Green House: *The finished piece. Skoglund's works exist both as installations as well as on celluloid.*

ginally acquired in the areas of sculpture or painting to what has become known since the beginning of the 1980s as 'staged photography'.

The photographer may either find or invent what appears before the lens. The resulting picture may be a documentation, or a reaction to a situation specially created or arranged for the camera. "Document and discovery" – thus Jörg Boström has termed (1989) the two fundamentally divergent paths that photography has unconsciously pursued ever since Niépce's *View Out of the Window* (1827), on the one hand, and Daguerre's *Still Life* (1837) on the other. Whereas the Classical Modern apotheosized Paul Strand's definition of absolute objectivity as the ultimate task of all photography, including 'artistic' photography, the Postmodern photographer has in contrast shown a fascination for design. "Right now we are experiencing a plethora of photographic 'power acts' within the original medium of photography," Gottfried Jäger points out concerning the trend. He enumerates "staged works, montages, decollages, expansions of every sort that run directly and completely against the original intentions of the photographic process, and begin to undermine it, dissolve it. The picture's truth-to-reality is thus shaken and confronted with radical questions that make this 'truth' itself into the theme."

Cindy Sherman, Jeff Koons, and Teun Hocks 'stage' themselves before the camera; Joel-Peter Witkin and Joe Gantz on the other hand create narrative tableaus of sometimes shocking character. Arthur Tress and David Levinthal have meanwhile specialized in miniature stages; Calum Colvin and Victor Schrager, in still lifes. In a highly respected analysis published at the end of the 1980s, Michael Köhler comprehensively addressed these various approaches to staged photography, and brought Sandy Skoglund's work to the attention of a European audience, which in fact tended to be surprised, particularly by the fineness of the details. In America, Skoglund's work has been praised as towering over anything else being done in the pictorial field. Skoglund herself admits that her work demands much effort – not only on her part, but also on that of her viewers. "Obsession and repetition in the process of making things is one constant element in my work," the author has noted.

### Traces of the American horror film

Oscillating as it does between the witty and the ridiculous, Skoglund's œuvre has been hard to place. Critics have variously attempted to locate

it somewhere between dream and nightmare, or within the art-historical tradition of Duchamp and Magritte, or under the categories of Dada and Surrealism. But strictly speaking, Skoglund's œuvre reveals the inspiration of much more trivial influences. Disneyland and the colorfulness of American West-Coast photography in general have made their mark on Skoglund. Also present are traces of American horror films and, naturally, the anxieties of middle-class America, which Skoglund handles with ironic flair. A breath of suburban tristesse wafts unmistakably through her work. She admits that mediocrity interests her, and "My own background is middle class, and class perceptions in terms of taste are at the root of a lot of the choices that I make."

Skoglund, the descendant of Swedish immigrants, knows what she is talking about. Born in Quincy in 1946, she grew up in California and went to school in the Midwest. 'Middle America' – the petty-bourgeois underside of the U.S. – is thus as familiar to the artist as the back of her hand. Hitchcock sent forth his flocks of gulls and crows in an attempt to crack open deadening small-town assumptions; Skoglund does the same with the cats, foxes, squirrels, and new-born babies that swarm forth to transform petty-bourgeois dreams into nightmares. Skoglund has been strongly influenced not only by American cinema, but also by European. As a nineteen-year-old art student, she spent a year in Paris, where she became fascinated by the possibilities of film. She acquainted herself with the nouvelle vague, watched movies by Chabrol and Godard, and flirted with the idea of film herself, but the division of work and responsibility in film-making contradicted her perfectionist impulses. Sandy Skoglund requires absolute control over every step, every detail. She ended her studies in the U.S., moved to New York, and took up minimalist painting. After years of searching and experimentation, she finally turned to photography: She found herself thoroughly bored by the work of traditional masters such as Steichen, Stieglitz, or Weston: even commercial art seemed preferable to that! She discovered the work of Ed Ruscha, terming it "the first photography...I really related to. I loved the anti-aesthetic – the dust, the scratches, the stupidity of the repetition..." What she basically values in photodesign is the calculability and manipulability of the end product – the contradiction between being and seeming, reality and artificiality. Skoglund feels that turning to natural images for stimulation is deeply embedded somehow in the American culture.

With her first, full-colored still life in hand, Skoglund approached a gallerist. Marvin Heifermann, at the time director of photography for Castelli Graphics. In spite of his interest in color photography, he initially found the artist's work exaggeratedly shrill. Skoglund did not give up, however, and Heifermann soon found himself fascinated and genuinely amused both by the detailed realism and the eclectic content he discovered in Skoglund's photographs – everything from Walt Disney to horror films. With *Ferns* and *Radioactive Cats* at the end of the 1970s, Skoglund had in fact discovered an art strategy for herself that corresponded equally to her affinity for painting, film, and photography. Now she could successively take on the role of script-writer, stage designer, painter, sculptress, director, and, ultimately, photographer. "In this approach," remarks Michael Köhler, "the whole point is to use photography as an aid in presenting imaginary worlds, inventing pictures. Out of this, an interesting double-layered base is called into existence, because observers assume that what has been photographed is real, but by looking more closely, they notice that they have been fooled. This whole trend plays with this reverse, or flip-flop, effect."

## Environments with unparalleled attention to detail

As mentioned earlier, Sandy Skoglund is by no means the sole exponent of staged photography, but she is the only artist who conceives, constructs, and sells her installations as works of art alongside their photographic representations. The critic Ann Sievers speaks of the "interdependence and equal status" of the two forms. Carol Squiers explains; "The photo and the installation are nominally the same and yet they are different in both obvious and maddeningly subtle ways." Skoglund's procedure is correspondingly exact; she is not satisfied to make a sham just for the camera, but instead, creates complete environments with unparalleled attention to detail, working a half year to produce a single scene. Her work is extremely labor intensive, requiring far more effort than would be needed to produce a photograph alone.

Today, viewers may respond to Skoglund's elaborate tableaus with fascination, shock, or amusement, but in the early days, her scenes chiefly elicited confusion and irritation in the art world. Diane Vanderlip, curator of the Denver Museum of Art, recalls a conversation with Lucas Samaras and Philip Tsiaras in the early 1980s in which she asked for their opinion

of two of Skoglund's works. They pronounced it highly intelligent, but questioned whether it was serious art. Vanderlip let the works go; later she discovered her errors and purchased *Fox Games* for the Denver Museum of Art – at a price of $40,000.

Cindy Sherman has staked out media and cultural criticism as the special areas for her self-stagings. Skoglund, by contrast, does not pursue any similarly identifiable

intention with her pictures. The artist denies that her works reflect a single intention. Nonetheless, many viewers sense a connection between *Radioactive Cats* and the debates on the atom, or interpret *The Green House* as a contribution to the discussion about the greenhouse effect, and take *Maybe Babies* as a comment on the abortion debate. According to the artist, however, similarities with contemporary problems are, so to speak, merely accidental. She defends a less narrow approach, arguing: "If the politics are open rather than closed, the piece adapts to the environment rather than the other way around."

Skoglund's works appeal more to the senses than to the intellect. As an artist, she relies upon the emotional intensity of her work and finds a similarity between their effect and the manner in which Hollywood films manipulate emotions. So-called 'high art' does not interest her. In a moment of epiphany early in her career, she realized "the idea of making [conceptual] art was not a good way to approach things... Instead, I saw myself as trying to make something that my relatives could understand." This direct approach has been her trademark through the decades.

# Robert Mapplethorpe
# Lisa Lyon

**1982**

**Portrait of
a Lady**

The most-talked-about photographer of the 1980s, Robert Mapplethorpe was a belated classicist who understood how to present provocative themes in catchy visual images. After his photographic work with the New York leather scene, male nudes, and erotically-charged flower studies, Mapplethorpe turned his lens on the first female world champion in body-building. The resulting cycle is probably his most comprehensive work, and at the same time constitutes an homage to the new, strong woman, who is aware of her body.

The name of the woman is Lyon. Lady Lisa Lyon. The alliteration is no accident. The same holds for the reference – at least phonetically – to the king of the beasts, for this, too, is part of a broader strategy. The young woman has a sense for effective publicity gestures. Furthermore, the physical strength of a wild animal – natural, untamed, and by no means the sole province of the male sex – has in any case always been her ideal. And it has aided her in defending women's body building when she has had to it in the face of a generally skeptical public. As she admits in 1981 in her best-selling *Lisa Lyon's Body-Building*, she feels like an animal. For her, physical signs of strength, charm, and suppleness do not have to be limited to a single sex. This association only exists in people's limited conception of things.

### Formerly a rather uptight individual

Lisa Lyon is admittedly not the first woman to take pleasure in strikingly well-developed biceps. In her book, she reminisces about the Viennese strong-woman Caterina Baumann, one of the greatest athletes in history, who was able to lift ten times her own weight in the 1920s. But it was Lisa

Lyon who brought the discipline out of the ghetto of the circus, removed it from its historical niche in bourgeois reform movements, and declared it to be a matter of course in the life of the 'new woman'. Her timing was unquestionably right. The utopian ideals of the 1960s were now history; the 1970s were nearing their end, and values were once again undergoing a turnover. It was a good moment to introduce a fresh concept: that of a new, physically conscious, and above all physically powerful woman, and to integrate this ideal into the developing consciousness of the 1980s. In this sense, Lisa Lyon is unmistakably a child of the Reagan era, even if at first glance her entry, armed with dumbbells, seems not precisely to coincide with the ultraconservative spirit of the times. But in the struggle for wealth and success, in the glorification of power and the fetishism of material happiness (it's no accident that *Dallas* and *Denver Clan* are ruling the air-waves at this time), there was a meeting of the minds. As part of her fitness program, Lisa Lyon recommends zero tolerance towards what she designates as losers. As cynical as it may sound, the advice corresponded fairly well to the political climate of the day.

Lisa Lyon is dressed in mourning. But that doesn't signify anything – except that the creator of the picture, Robert Mapplethorpe, had been raised a Catholic and throughout his life retained an affinity with everything smacking of Catholicism. Robert Mapplethorpe is also obsessed with sex – a combination which may appear to be a self-contradiction, but on the other hand, explains his approach to his own homosexuality: an unusually long road marked by repression and denial. To claim that precisely the artist who had made homosexuality the theme of his photography at the end of the 1970s had once been a rather uptight individual is therefore not far from the truth. But Mapplethorpe, who had so many problems with his own coming-out, discovered in photography a medium for self-exploration – and applied it excessively. The cold smoothness of his emphatically formalistic photography, so well-schooled in principles of design, has made it easy to overlook this exploratory aspect of his work. His pictures give the impression of being finished pieces, at least at first glance. But they are just the opposite. His work abounds in contradictions – along with a good shot of irony – all of which indicate that his creations are in fact children of Postmodernism.

*Lisa Lyon, 1982.* What do we see here? A young woman, perhaps in her early twenties. One could call it a profile portrait – to be more exact, a

half-length portrait – but with this difference: the side-view is rather unusual within the genre of portrait photography. A traditional professional photographer would invariably choose the more flattering half- or quarter-profile, all the while giving the subject precise instructions on the direction in which to turn their gaze – above all, course, to look past the camera. But our young woman is standing or sitting with an admirably erect posture, looking straight ahead. One is almost reminded of the photographs of criminals systematically taken by the French photographer Alphonse Bertillon around 1890: his strategy for identification rested on only two exposures, one of which was precisely this 'hard' profile. The dark veil with its suggestion of sorrow, however, provides an ironic comment on this association. What we can make out under the veil is correspondingly little. For example, that the subject has carefully painted lips, and seems to be waiting without expression for whatever might come her way. That she is looking straight ahead, we have already noted – but is this really true? Hasn't she in fact closed her eyes? The veil obscures her gaze and, together with the elegant hat decorated with artificial flowers, stands in clear contradiction to the erotic appeal of the gleaming black bustier. The picture, one might say, splits into a 'serious' upper half and a less 'serious' lower half. It is the combination of the two that gives the scene its fascination. In addition, what the observer will certainly notice first and then give more attention to: the steely upper arm with its large number of unretouched moles – certainly a contradiction to the ideal of the self-confidently presented, beautifully formed body? Or can it be that these 'impurities' not only belong to the iconography of the image, but also to the ideology of a new ideal of beauty?

## Someone from a different planet

Depending on the version one follows, they met for the first time in 1979 or 1980 at a party in Soho. Lyon was wearing a leather jacket and black rubber pants, an outfit that Mapplethorpe, with his unwavering interest in bizarre eroticism, could not help but notice. "Mapplethorpe," according to his biographer Patricia Morrisroe, invited her to Bond Street the following afternoon for a photo session, and she appeared at his door in a miniskirt, thigh-high leather boots, and a wide-brimmed hat decorated with feathers. He immediately responded to what was then an exotic notion – a muscle-packed woman – by photographing her in the frilly hat,

### Robert Mapplethorpe

Born **1946** in Queens, New York. **1963–69** studies fine art at the Pratt Institute, Brooklyn. From **1970** growing interest in photography. First instant photographs. **1973** first exhibition in the New York Light Gallery. **1976** changes to square medium format photography. **1977** included in the "documenta VI" at Kassel. **1979** first one-man show in Europe (Galerie Jurka, Amsterdam). **1980–83** cycle *Lisa Lyon*. Films, book projects, exhibitions. **1988** major retrospective in the Whitney Museum of American Art in New York. In the same year the Robert Mapplethorpe Foundation is inaugurated to support Aids research and artistic photo projects. Dies **1989** in Boston

flexing her biceps. Never before, as Morrisroe relates, had he seen such a woman: "It was like looking at someone from another planet."
Robert Mapplethorpe was thirty years old at the time – not yet a star, but well on his way to becoming the most internationally known photographer of the 1980s. Born in Queens, New York, in 1946, he had, so to speak, photographed his way out of his petty bourgeois background and over the rim of the New York subculture, all the way to the top – an amazing trajectory that is only partially explained by the active support of his influential friend Sam Wagstaff. With his simple but elegant, classically oriented interpretation of the "unspeakable", Mapplethorpe had touched the nerve of the age – an era in which the emancipation of homosexuals had already advanced considerably, without the increased gay self-confidence having yet developed an appropriate aesthetic of its own. Precisely herein lies the importance, and moreover the achievement, of Robert Mapplethorpe. Certainly, there had been photographers with homosexual interests earlier; one needs only to recall Fred Holland Day, Thomas Eakins, or George Platt Lynes. Or the illustrations of Tom of Finland might be considered here. But what these artists had created under cover, or at best in the context of the subculture, Robert Mapplethorpe made palatable, consumable, for wider circles, and thus moved the theme into the mainstream of art. But the protection provided by the success of his work fostered more that a broader recognition of gay eroticism. The move in the understanding of photography in the 1980s from merely a technical picture-producing medium to an art form with a place in the museums is very largely thanks to Robert Mapplethorpe. The only other artist to achieve such a strong and international reception was Mapplethorpe's original model, Andy Warhol.

**An androgynous manifestation with unkempt hair and a man's shirt**
To the same extent that Mapplethorpe defined a new image of the male, who was now allowed to be black and horny, strong and beautiful, physically conscious of his body, sexy, and capable of taking pleasure in himself, he also participated in the transformation of the contemporary image of woman. The artist's black-and-white portraits of the Rock poet Patti Smith, whom Mappelthorpe had lived with for an extended period at the beginning of his artistic career, provide an example. Smith's pale, elf-like being flew in the face of all standard ideals of beauty, extending

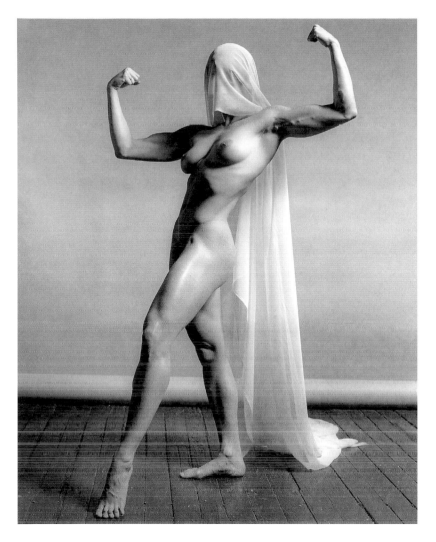

*Robert Mapplethorpe:*
Lady Lisa Lyon
viewed slightly from
below

*A strategy consciously
employed by the
artist in order to lend
heroic stature to the
comparatively short
athlete*

from Veruschka to Raquel Welch. Mapplethorpe took numerous photo-
graphs of Smith, the most famous probably being an androgynous mani-
festation with unkempt hair, a white man's shirt, and tie. The record com-
pany is said to have repeatedly refused to use the photograph on the
cover of Patti Smith's first record, *Horses*. Years later, when the music ma-
gazine *Rolling Stone* made a list of the 100 best covers of all time, *Horses*
was number twenty-six on the list.

Mapplethorpe's liaison with Patti Smith had already come to an end when
he met Lisa Lyon in 1979/80. For the photographer it was, so to speak,

like the continuance of a fascination by other means. Where Patti Smith clearly represented the ideals of the 60s generation in her life and art, Lisa Lyon was an unmistakable product of the 1980s: ambitious, success-oriented, goal-directed and, last but not least, clever in a very pragmatic way. While still at university, the five-foot-three young woman – not precisely tall – had become acquainted with kendo, the traditional Japanese martial art. She enjoyed discovering what her body could do, testing it to its very limits, and eventually joined Gold's Gym in Los Angeles, the center of body-building in the USA – initially, in must be said, with the opposition of her male environment. Hormonal differences, so it was then assumed, would prevent a woman from developing her muscles. Furthermore, Lyon faced doubts about her perseverance. But inspired by her great example Arnold Schwarzenegger, and guided by well-known body-builders like Franco Colombo or Robbie Robinson, she threw herself into training, "rigorously counting bicep curls and leg lifts" (Morrisroe). In the evening, she trained at home in her apartment – taking, instead of steroids, LSD in order to "reprogram her cellular structure". In 1979, in the virtual absence of competition, Lisa Lyon won the first world championship in women's body-building; the following year, she did not even bother to enter. From this perspective, she had a short but effective career. Even before the sport had been properly born, Gaine and Butler claim in their 'bible' of heavy athletics, Lisa Lyon was not only the leading protagonist for female body-building, but also its media star, making numerous appearances on television and radio, and presciently extolling the virtues of (strong) girl-power.

*Cover and double-page spreads from* Lady Lisa Lyon: *the original edition of the book was published 1983 by The Viking Press, New York*

## Homage to the erotic force of the human body

For Robert Mapplethorpe, Lisa Lyon offered a welcome opportunity to at least balance out his image as a gay or sado-masochistic photographer. He took the first pictures in his loft at 24 Bond Street, with others to follow in an unnamed fitness studio and outdoors under the Californian sun. It is probably fitting that the Lisa Lyon cycle is considered the most comprehensive of all Mapplethorpe's works. Just how many exposures were made between 1980 and 1982 we do not know; in any case, 117 black-and-white, largely square, pictures found their way into the first volume of *Lady Lisa Lyon*, published in 1983. Some of the images are obviously drawn from the fashion photography of Horst P. Horst, others

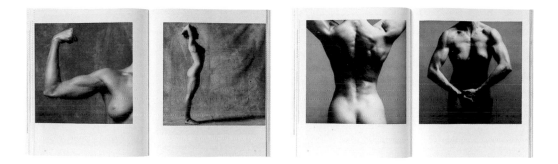

refer to the Art Deco pictorial language of Hoyningen-Huene. Borrowings are also recognizable from Weston's dune nudes as well as the early photography of the nudity movement. Mapplethorpe likes to quote. In return, his pictorial style had an influence on photodesign and on the advertising of the 1980s. Contemporary art criticism, however, looks at his work rather critically. Ulf Erdmann Ziegler speaks of "technoid pomp," A. D. Coleman of "warmed-over pictorialism." However it may be, Mapplethorpe's work remains an expression of its time. In retrospect, his pictorial homage to the erotic force of the human/male body seems almost like a futile protest against the latter-day plague that in the end also claimed his life. Robert Mapplethorpe died of AIDS early in 1989. By then, Lisa Lyon had already long since fallen back into anonymity. Their meeting was short, but powerful – and not without results for our understanding of the being and appearance of the modern woman.

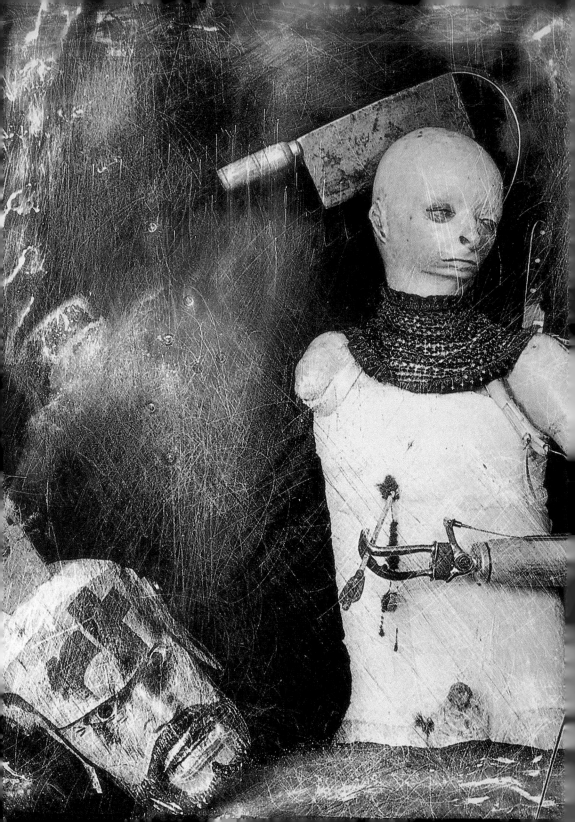

# Joel-Peter Witkin
# Un Santo Oscuro

**A Martyr of Life**

**Some see his bizarre allegories as the quintessence of western decadence and moral decline; others compare him to Goya or call him the Hieronymous Bosch of photography. No other photographer of our age has polarized both art critics and the general public more than the American artist Joel-Peter Witkin.**

Taken unaware, the unprepared gaze finds itself looking at what seems quite unbelievable. What are we looking at? A man? A human figure? Or simply a masquerade? A nightmare from another age, or perhaps an image created by contemporary Postmodernism? The uncertainties are multi-layered, resulting in alienation coupled with curiosity and a vague sense of horror.

As a rule, we are able to assign a photographic image spontaneously and confidently to a certain time frame or epoch – the nineteenth or early twentieth century, the 1950s, or a more recent date. This picture, how-ever, seems to want to withdraw grotesquely from all temporal para-meters. On the one hand, the observer has the impression that the image stems from a strange, sinister world, which has somehow left its traces on the photograph as it journeyed to the present: spots, scratches, a 'leap', such as one identifies with the age of the glass negative. On the other hand, the prosthesis, at least, points to the late twentieth century. Ergo, a digitally created horror vision, using the most modern technology to present a stifling variation of St. Sebastian, pierced with arrows – an image which has been a part of Christian art since the Renaissance and Baroque?

### Incredible even to more tolerant contemporaries

To set matters straight right from the start: the American photographer Joel-Peter Witkin does not work with a computer, but with traditional pho-

tographic means. A twin-lens Rolleiflex vintage 1960 remains his camera of choice; he uses conventional roll film, and rarely shoots more than two frames per motif. And nor does he make collages or montages. The sole way in which he distances himself from the normal photography that takes 'straight' shots of its subjects is the way he works the negative – but more on that later. And, of course, by the way he creates scenes, a process in which he does not simply take the world as seen through the viewer, but creates rather a universe according to his pre-formulated ideas, visions, and fantasies – a cosmos rich with allusion, references, quotations – whose 'inhabitants' Witkin discovers in those places from which the proponents of more conventional ideals of beauty normally shy. And what is he interested in? Witkin unashamedly calls a spade a spade, and lists: freaks of every kind, idiots, dwarves, giants, deformations, pre-op trans-sexuals ... All the people who were born without arms, legs, eyes, breasts, genitals, ears, noses, lips. All those with unusually large genitals, dominas and slaves...Recently, Witkin has added dismembered bits of corpses to his list, which he arranges in the manner of seventeenth-century Flemish still lifes – an approach which must seem incredible even to his more tolerant contemporaries – and which especially in the USA has repeatedly stirred up the ire of district attorneys and self-appointed cultural censors. Without a doubt, Joel-Peter Witkin is one of the most controversial artists of his time. But where fundamentalist preachers stamp him as a monster in front of millions of TV viewers, the art world has come to recognize him as one of the most original and profound of contemporary artists. Accordingly, the prices of his limited editions, rarely consisting of more than a dozen prints, are the highest that Postmodern photography commands.

## The extraordinary as part of everyday life

Anyone who looks will find that Witkin's biography gives more than enough evidence for what at first glance seems to be a morbid obsession, but which is in fact nothing more than an attempt to examine the basis of earthly existence, to take issue with categories of norms and deviations, to transgress boundaries with open eyes, in order to discover pictorially what Witkin likes to term the 'divine'. As a child, equipped with a used Rolleicord, he once tried to photograph God: someone had told him of a rabbi who had seen God. Witkin visited the rabbi, but God remained in-

Joel-Peter Witkin

Born 1939 in Brooklyn/New York. 1961–64 military service as war correspondent. Studies sculpture at the Cooper Union School of Fine Art (B.F.A.). 1969 first one-man show at the Moore College of Art, Philadelphia. 1975 moves to Albuquerque. 1976 studies photography at the University of New Mexico. 1984 much acclaimed one-man exhibition at Pace/MacGill, New York. 1985 publication of his first book *Joel-Peter Witkin*. Also edits various works on the history of medicinal photography: *Masterpieces of Medical Photography*, 1987, and *Harms Way*, 1994. Lives in Albuquerque/New Mexico

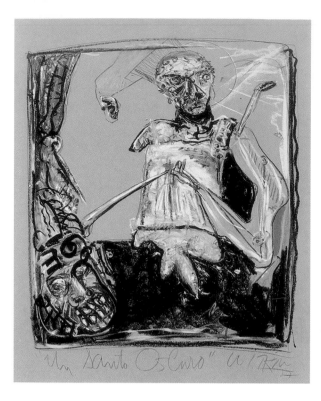

*Joel-Peter Witkin: sketch for* Un Santo Oscuro

visible. Where was God to be found, he asked himself. In people, as the Christian message teaches? And if so, then in which people? Might it not be that God reveals himself in a special way precisely thorough those beings who are clearly different from the majority bodily or mentally? It is, in fact, philosophical-religious reflections like these which lie at the core of Joel-Peter Witkin's œuvre. Witkin was born in Brooklyn in 1939 as the son of poor immigrants. His father was an Orthodox Russian Jew, his mother an Italian with strong Catholic beliefs – differences that were to become the primary reason for the couple's separation. Joel-Peter and his twin brothers were raised by his mother and his grandmother. "My grandmother had only one leg," Witkin recalls, "and in the morning I would wake up and smell her gangrenous leg. Where most kids would wake up and smell coffee, I would wake up and smell grandmother's rotting leg." Witkin thus became early acquainted with the strange, and the extraordinary became a natural part of everyday life. He learned to accept illness and suffering in life, of which death was also necessarily a part, even if the thought is often suppressed. "My first conscious recollection occurred when I was 6 years old. It happened on a Sunday when my mother was escorting my twin brother and me down the steps of the tenement where we lived. We were going to church. While walking through the hallway to the entrance of the building, we heard an incredible crash mixed with screaming and cries for help. The accident had involved three cars, all with families in them. Somehow, in the confusion, I was no longer holding my mother's hand. At the place where I stood at the curb, I could see something rolling from one of the overturned cars. It stopped at the curb where I stood. It was the head of a

little girl. I bent down to touch the face, to ask it – but before I could touch it – someone carried me away."

## His own world of personal fantasies

Already at age sixteen, Joel-Peter Witkin began taking a serious interest in photography. At the Museum of Modern Art, he introduced himself to Edward Steichen, who in fact accepted one of his pictures into the permanent exhibit. This experience motivated him to become a photographer. Witkin made a trek to Coney Island, where a freak show particularly caught his interest. He photographed the three-legged man, the 'Chicken Lady', and the hermaphrodite, with whom he claimed he had his first sexual experience. The freak show became his "home", the true environment where his lively fantasies could play themselves out. Unfortunately, they didn't need a photographer, and nor was he a freak, for otherwise Witkin would have gone on the road with them. So he remained in New York and worked in commercial studios, while at home he began to create my own world of personal fantasies that he could photograph. Witkin was drafted into the army in 1961, where he documented accidents that occurred on maneuver – and the fatalities they sometimes resulted in. He volunteered for Vietnam, attempted suicide, and was released from the army. He then took up studies at the Cooper Union School in New York, switching later to the University of New Mexico, where he graduated in 1981 with a Master of Fine Arts degree. By 1980, with his first one-man show curated by Sam Wagstaff in New York, Witkin became the object of passionate and controversial discussion.

## Christian taboos of Eros and the body

"Witkin's philosophical/spiritual beliefs," according to Hal Fisher, "are exceptionally complex, a not particularly decipherable synthesis of Jewish cabalistic thought, Roman Catholic practice, Eastern philosophy and 1960s counterculture consciousness." Last but not least, Witkin's work can be read as an artistic revolt against both traditional Jewish iconoclasm and the Christian taboos of Eros and the body. Witkin mistrusts established norms and places them consciously in question. He even uses his own medium 'against the grain': for Witkin, recognition and understanding do not grow out of the mere duplication of reality, but only from the creation of an artificial world at whose center hermaphrodites,

dwarves, cripples, Siamese twins, and amputees function as the catalysts of an expanded spiritual horizon. Probably the most common protest against Witkin's photography is that he misuses the handicapped to create a macabre spectacle. Jackie Tellalian, New York theatrical agent and lead actress in Witkin's *Woman in the Blue Hat* (1985), who is herself confined to a wheelchair, reacted to these charges saying: "I've had many people say: 'Didn't you feel exploited by that?' and I always said no, because first of all he never made me feel as though he was using my disability as a sensational aspect in the picture."

Others have also reacted in a similar manner, openly speaking of the humane manner in which Witkin treats them, how he makes them into the subject of his art, and thereby open to public view with full dignity, in contrast to the society which had hidden them away and pushed them aside. And in fact, in Witkin's photographic creations, deficiencies acquire

a metaphysical power. "The formless and misshapen, the lowly and that which causes shudders are brought back into the light" (Germano Celant).

Created in 1987, *Un Santo Oscuro* exemplifies Witkin's artistic approach. As so often, also in this case, it was a person with a physical handicap who inspired the photograph. Friends had told him about a man in a wheelchair who lacked a face and arms. On the spur of the moment, Witkin made a first draft – a scribble or sketch – of an idea. But where in Los Angeles could he possibly find the man? "With my friend," Wirkin recalls, "we went down to the area where we thought he lived. There was an old run-down hotel, and when we got inside we finally saw him, because the door was open on the room he lived in. He was asleep. What we saw was this kind of plastic head, this little body, and we didn't want to disturb him. It was our conviction that we had to wait for other people to arrive,

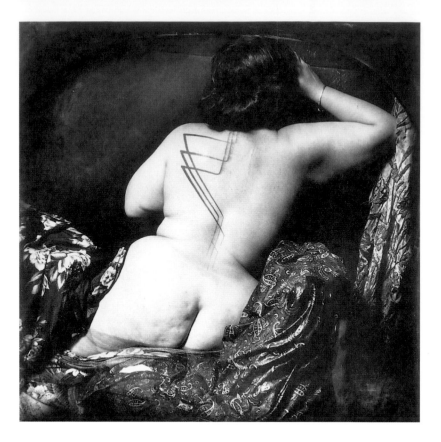

and sure enough they did. Two men actually arrived to take care of him.
We got into the room and talked. We found out from our conversation
that this man was a Thalidomide victim. He was Canadian. His mother
took Thalidomide, and he was born without skin, without arms or legs,
without hair, eyelashes or eyelids. Early on, from the time he was a child,
he was the subject of ridicule and curiosity and wanted by side-shows and
freak-shows. I talked about how I wanted to photograph him. I wanted to
photograph him as clerics would have been depicted, mostly in seven-
teenth and eighteenth-century Spain, as martyrs, and I told this man that
he was a martyr to life."

## A popular subject for religious painting commissions

Joel-Peter Witkin's photographs are the result of elaborate staging in the
studio, during which an interior image, a vision, finds its outward expres-

sion. Often works of the great masters – Velásquez, Cimabue, Giotto, Rembrandt, Arcimboldo, Picasso, Goya, Delacroix – stand at the start of Witkin's artistic creations. Without hesitation, he reaches back to myths, fairy tales, the traditions of western art history, all of which he seems to know well. The titles of works like *Sander's Wife, Courbet in Rejlander's Pool*, or *Von Gloeden in Asia* make the sources of his inspiration clear. In addition to painting and graphics, the photography of Ernest James Bellocq, Eadweard J. Muybridge, and Charles Nègre also provided stimulation. *Un Santo Oscuro*, however, does not draw from a particular individual picture, but rather from a pictorial genre that was a popular subject for religious painting commissions, in particular during the Spanish Baroque. Priests appeared in the pose of honored saints in order to increase their own power by association, their social position, and their clerical aura. What remained a mere travesty, however, in the historical panel painting, Witkin creates from real earthly torture. "Instead of a voluntary, playful masochism, Witkin cites real pain" (Chris Townsend).

## The darkroom becomes a kind of holy house

Witkin may arrange his scenes, but he does not manipulate his pictures. The photographs are called into being without any technical tricks; they are therefore 'straight'. All the elements of the given scene are components of an often slowly and painstakingly arranged ensemble. Only later is the negative reworked to acquire the patina that gives Witkin's pictures the aura of being withdrawn from time. In the author's own description, he becomes a kind of priest of aesthetics. "I work alone during printing and begin by communicating with my equipment and chemistry, thanking them in advance. I place a negative in the enlarger and the darkroom becomes a kind of holy house, a refuge for phenomena..." By changing the texture of the picture, Witkin effectively moves it in time and space. As if through a hidden crack, we catch a glimpse into a strange cabinet. Witkin's pictures, as the writer Ludwig Fels states, are "Witnesses of a profound spirituality that creates from archaic sources." Witkin's art takes up the basic categories of human existence: love and pain, joy and suffering, Eros and Thanatos. He is the philosopher among the photographers of our age.

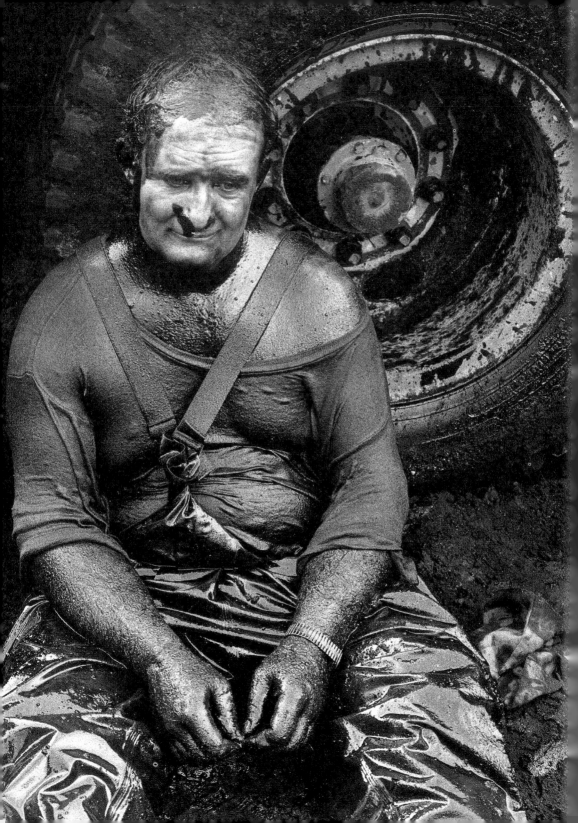

# Sebastião Salgado
# Kuwait

**Saddam Hussein's troops have been vanquished, but Kuwait is in flames: the Iraqis have set approximately 900 oil wells on fire. Now international specialists are trying to extinguish the fire. Sebastião Salgado observed them – labor heroes in an age of automation.**

Apocalypse
in Oil

Like every well-made play, this drama too has three acts, and we find ourselves at the beginning of the third. It is April 1991, and no one knows how the act will end. The man who staged it left the ending open – with an option for a *Götterdämmerung*. Dictators seem to like binding their personal finale together with a universal apocalypse. Saddam Hussein remains, as before, in power. Somewhere beneath Baghdad, he's holed up in a bunker built by German or British or American specialists. And this is not the only cynical aspect of a conflict that will go down in the annals of the 1990s as the Gulf War, and that will cost an estimated hundred to hundred and fifty thousand lives before it's over. Much of Iraq has been destroyed. The newest technical weapons – cluster bombs, smart bombs, and cruise missiles – have thrown the biblical cradle of Middle Eastern culture back to medieval conditions. But beyond this, the war has changed little, if we take Saddam's attack on Kuwait on 2 August 1990 as its starting point. It has certainly brought about no changes in the map, nor in the tendency of human beings to turn to violence in settling disputes, nor even in the balance of power in the region. Saddam has been weakened, but he's not yet been banished to oblivion, as America's president George Bush would gladly see, without knowing precisely whom he would set up in Saddam's place. And the Kuwaiti rulers are also back on their old thrones as if nothing had happened. Apart from which, the balance stands at 138 dead and 66 listed missing on the side of the Allied forces – along with a series of new experiences. For example: in the psychology of conducting a war. Or in the way the military deals with the

media. Or in the question how one gets the upper hand over almost 1,000 burning oil wells.

On 28 February, after exactly 210 days of combat, the Gulf War comes to an end – at least the military part of the drama. Saddam's troops have more or less withdrawn from Kuwait, but not before fulfilling the threat the Iraqi dictator had made from the beginning, namely, "to set the whole region, including the oil fields, on fire." Before the war, Kuwait had the world's highest average income; its oil reserves, the third-largest in the world, overflowed, creating prosperity for the approximately one million Kuwaitis. Now the liquid gold was in flames: the advancing Allied troops were greeted by a single vast inferno. The German news magazine *Der Spiegel* was moved to comparison with the Bible to describe the extent of the catastrophe: the destruction of Sodom and Gomorra, so it seemed, could now be assigned a date, namely March–April 1991. Everything was on fire. At least nine hundred of the once wealth-producing oil wells – pessimists spoke of up to a thousand torches in the desert sands – were burning up to a height of nearly a thousand feet. A cloud of soot and smoke darkened the heavens, causing a decline in temperatures throughout the Gulf region. In Kashmir, nearly 1,700 miles away, black snow was falling; in the deserts and savannas of East Africa, dirty rain. A natural catastrophe of unimagined dimensions seemed to be approaching. Scientists prognosticated abnormal weather patterns and questioned whether India would still receive its critical monsoon rains. If not, the result would be hundreds of thousands of deaths by famine on the subcontinent. Health risks were discussed, including possible delayed reactions after people had breathed in the poisonous soot particles. By the middle of the year, according to the estimates, forty million tons of raw oil had been burned, releasing two hundred and fifty thousand tons of nitrous oxide into the atmosphere, along with thirty millions tons of carbon dioxide. And no end of the catastrophe was in sight. Asked by the German magazine *Stern* in early 1991 whether all of the Kuwaiti oil fires could be extinguished within a half year, the American fire expert Paul Neal Adair, nicknamed 'Red,' had a simple answer: "Nonsense." Cautious estimates reckoned two to three years would be needed. Even more skeptical was Ali Qabudi of the Kuwait Oil Company at the end of March, who spoke of a worst-case scenario of ten years before all the fires were extinguished.

## Additional problems in extinguishing the fires

What made the situation so difficult was not merely the number of fires. The area had been studded with mines, which greatly restricted the mobility of the fire-fighting troops who had been sent to the region. Furthermore, the oil flowed from the Kuwaiti wells under natural pressure. The force which had once made it easy to obtain the raw material now caused additional problems in extinguishing the fires. In addition, there was the problem of the proximity of the burning wells to each other: some were less than a mile apart. This concentration increased the temperatures to infernal levels, causing the desert sand to melt to glass. Red Adair joked that they had not even brought a thermometer along with them, because if they knew how hot it really was, no one would stay there to work. Texas-born Red Adair is already a legend among fire-fighters, "the most famous fireman in the world" (*Stern*). His specialty is blowing out burning shafts with a carefully placed load of dynamite, but Kuwait seems to be more than even an expert can handle. In the end, other teams from the USA and Canada, Romania, Italy, France, China, Hungary, Iran, and Russia also arrive to help solve the problem – attracted naturally by the impressive rewards that are being offered. And they try everything – every conceivable idea or plan     for time is money. Three million barrels – that is, ten per cent of the world's daily oil consumption – is going up in flames every day; which in turn means a forty-three billion dollar loss in two years for the Kuwait oil industry. "Big job, big money," as Red Adair succinctly phrases it. In other words: no matter how much it costs, the work of his team will not be too expensive for the country. After all, as he and his co-workers realize – and only for this reason are they willing to face these hellish temperatures – every one of them will return home a millionaire. That is, those who return home at all – for, as the *Spiegel* emphasizes, "the work is fraught with mortal danger."

## An inferno of oil and mud, heat and gas

A man is taking a break. Possibly waiting for supplies. As reported by the western media, there's not enough of anything here. Not enough water for extinguishing and cooling – instead, it must be pumped for miles through pipelines from the sea. Not enough specialized equipment and machines, nor welding gear and bore heads. Red Adair speaks of a Mickey Mouse job, a remark which sounds like a bad joke. But he doesn't

Sebastião Salgado

Born the sixth of eight children **1944** in Aimorés/Brazil. **1964–67** studies economics at Vitoria/Brazil. **1968** employed at the Brazilian Ministry of Economic Affairs. **1969** moves to Europe. Research studies in Paris. **1971–73** works from London for the International Coffee Organisation. Move to photography. **1973** reportage on the drought-ridden Sahel zone begins his international acclaim. **1974** member of the newly-founded agency Sygma. **1975** changes to Gamma. **1979–94** member of Magnum. Subsequently sets up his own agency (Amazonas Images). Numerous prizes, including **1985** and **1992** Oskar Barnack Prize, **1988** Dr. Erich Salomon Prize, and **1989** Hasselblad Prize. Lives in Paris

mean it comically. The issue is survival: for the firefighters on the job, for the country, for the region. There's nothing funny about it. And if we think we see something like a smile on the face of the man in the picture, then it arises more likely from complete exhaustion than from any sort of amusement. The worker is clearly at the end of his strength. Kaput. Dreaming of nothing as he stares into space – minutes of regeneration amid an inferno of oil and mud, heat and gas, soot and stench. He is covered from head to toe in slippery oil. Anyone who has worked on an automobile will wonder how he will ever get himself clean again. But it's even worse, for he stands under this shower of oil every day. The observer's response to such a filthy layer of oil might be disgust. But here the opposite is the case. What we are looking at is an anonymous labor hero – no ordinary human being, but an icon: not a mere 'hand', but a monument, cast in bronze for eternity.

Sebastião Salgado: Workers. An Archaeology of the Industrial Age, *Aperture*, New York, 1993

## With the passion of an adherent of liberation theology

Sebastião Salgado is a specialist in icons. Whatever he photographs becomes a formula for pathos. His pictures – always in black-and-white – are well-composed, suggestive, direct, and believable in their depiction of the world's misery. Salgado is a master at making the frightening into something beautiful, and as a result is certainly the most admired international photographer today. In terms of his influence on present-day photojournalism – his function as a role model – one can designate him justly as the most important camera artist of the times – a kind of Cartier-Bresson of the late twentieth century. But whereas Cartier approached his work with the knife-sharp calculation of the Constructivists, Salgado pursues the emotions. Compared to what one finds in the sensational press, his pictures do not look spectacular; rather, their effect lies in the manner in which they lift up an event. Every one of his photographs thus becomes something special: "Their pathos," says the *Zeit* author Peter Sager, "their elegiac gesture derives from the subject itself, but also from the way it is presented. Mother-and-child groups, scenes of passion, masses of people caught up in a great movement – such pictures narrate biblical stories, and Salgado quotes them with the passion of a Marxist-oriented adherent of liberation theology."

Salgado sees himself as a documentary photographer, and he can celebrate his success not only in the illustrated press throughout the world,

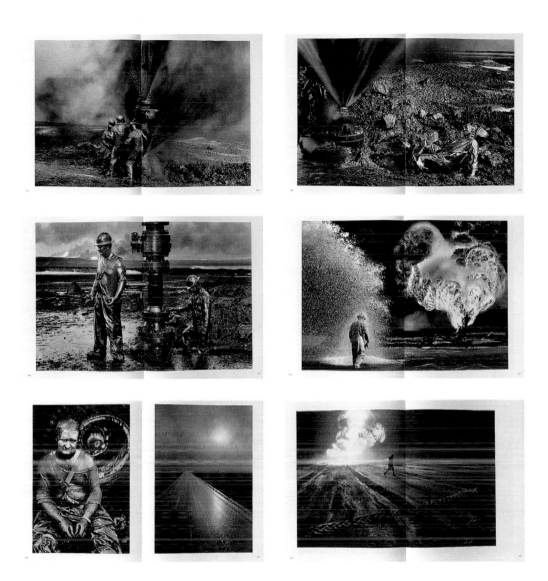

*Double-page spreads from Sebastião Salgado's*
Workers. An Archaeology of the Industrial Age,
*Aperture, New York, 1993*

but also in the realm of galleries and museums — a rather unique and much admired triumph in the world of photography. It is sometimes said that he aestheticizes suffering, that he exploits the misery of others for the sake of his art. But one thing is certain. There are few who have gotten as close as he, and with such an alert and interested eye, to misery. Salgado, as the writer Márcio Souza points out, has brought a completely new element to photography, one which is perhaps traceable to his Brazilian origins: namely, the complete absence of a bad conscience in relation to poverty, suffering, and social injustice. This does not mean, however, that Salgado feels no sympathy for what he sees. What distinguishes him from others is his attitude toward those he photographs. As oil engineer Dave Wilson puts it: "It's kind of an aggressive act to take someone's picture. Somehow or other, he melts all that away." Salgado was born in 1944 in southwestern Brazil, the only boy in a family of eight children. He studied in São Paulo and Paris, and seemed to be headed for a career with the World Bank. But then, almost overnight, he changed his mind. Inspired by the engagement of photographers such as Lewis Hine and Dorothea Lange, Salgado took up the camera and set out for Africa to document the famine in the desert regions of the Sahel. That Salgado was the photographer who caught the attempted assassination of Reagan in 1981 seems today to be almost a mistake, for Salgado — the global player with a touch of Marx — is primarily interested in the Third World. At the core of his engagement stand the peoples of Latin America, Asia, and Africa, or the International Union of Manual Workers, about whom he has been working on a major cycle since 1980, calling his project on the dignity of labor simply *Workers*. According to Salgado, he is not necessarily directing criticism at a certain development, but rather trying to "portray the disappearance of the community of laborers."
This is not his first excursion into the Near East. At the end of the 1980s, he had accompanied a troop of Iraqi military actors at the front during the war between Iraq and Iran. Western media had actually been denied access to the war, but on occasion a Brazilian passport can have its advantages.

## On average twelve rolls of film per day
Here, in the midst of the burning oil fields, Salgado is of course not the only reporter. Stephane Compoint is present, and will eventually receive a

photography prize for his work. Also the Magnum photographer Bruno
Barbey is on the scene, as well as the photographers Steve McCurry
(*National Geographic*) and Peter Menzel (*Stern*). What distinguishes Sal-
gado from the others, though, is that he photographs in black-and-white.
Equipped with three Leicas and 28 mm, 35 mm, and 60 mm lenses, he
shoots on average twelve rolls per day. In Kuwait, he made approximately
seven thousand exposures, from which six per roll are processed as work
prints. On average he presents fifty photographs to magazines, who then
make their selections. Salgado's report with the working title "Oil Wells"
appeared for the first time in the *New York Times Magazine* on 9 June
1991 under the title "The Eye of the Photojournalist." The *Spiegel* pub-
lished several samples of his work in issue 24 of the same year (10 June).
In the World Press Contest, Salgado's work secured him the Oskar Bar-
nack Prize. And the Kuwait cycle is also represented in his thematically-
oriented book *Workers* (1993): our picture occurs as a full-page print on
page 340.

At the beginning of November 1991, against all expectations, the last fire
in Kuwait was extinguished. Red Adair and his workers, the gang from
Boots & Coots, Wild Well Control, and Safety Boss have returned to their
various homes. In the meantime, the catastrophe has become history,
and as such, is (almost) forgotten. What still remains are the photo-
graphs by Sebastião Salgado: icons that transcend time, made not for the
daily press, but for the collective pictorial memory. Salgado's pictures are
a visualized Bible which extol the core of all that we find human. This is
why his pictures are understood – and treasured – around the world.

# Bibliography

**General historical overviews of photography**

**Auer, Michèle and Michel**: *Encyclopédie internationale des photographes de 1839 à nos jours.* Geneva, 1985

**Baier, Wolfgang**: *Geschichte der Fotografie.* Leipzig, 1980

**Baier, Wolfgang**: *Quellendarstellungen zur Geschichte der Fotografie.* Leipzig, 1980

**Barthes, Roland**: *Camera Lucida: Reflections on Photography.* London, 1982

**Benjamin, Walter**: "A Small History of Photography". In: *One Way Street and Other Writings.* London, 1979

**Benteler, Petra**: *Deutsche Fotografie nach 1945.* Kassel, 1979

**Daval, Jean-Luc**: *Die Photographie. Geschichte einer Kunst.* Aarau/Stuttgart, 1983

**Van Deren Coke, Frank**: *The Painter and the Photograph from Delacroix to Warhol.* Second edition. Albuquerque, 1972

**von Dewitz, Bodo** (ed.): *Alles Wahrheit! Alles Lüge! Photographie und Wirklichkeit im 19. Jahrhundert. Die Sammlung Robert Lebeck.* Cat. Agfa Foto-Historama/Museum Ludwig Köln, Dresden, 1997

**Frizot, Michel** (ed.): *Nouvelle Histoire de la Photographie.* Paris, 1994

**Gernsheim, Helmut**: *Geschichte der Photographie. Die ersten hundert Jahre.* Frankfurt on the Main/Berlin/Vienna, 1983

**Hambourg, Maria Morris/Pierre Apraxine/ Malcom Daniel/Jeff L. Rosenheim/Virginia Heckert**: *The Waking Dream. Photography's First Century. Selections from the Gilman Paper Company Collection.* Cat. The Metropolitan Museum of Art, New York, 1993

**Hiepe, Richard**: *Riese Proletariat und große Maschinerie. Zur Darstellung der Arbeiterklasse in der Fotografie von den Anfängen bis zur Gegenwart.* Cat. Städtische Galerie Erlangen, Erlangen, 1983

**Hochreiter, Otto/Timm Starl**: *Geschichte der Fotografie in Österreich.* Bad Ischgl, 1983

**Honnef, Klaus**: *Pantheon der Photographie im XX. Jahrhundert.* Cat. Kunst- und Ausstellungshalle der Bundesrepublik Deutschland, Bonn, Stuttgart, 1992

**Kemp, Wolfgang**: *Theorie der Fotografie I. 1839–1912.* Munich, 1980

**Köhler, Michael/Gisela Barche**: *Das Aktfoto. Geschichte, Ästhetik, Ideologie.* Cat. Münchner Stadtmuseum, Munich, 1985

**Newhall, Beaumont**: *History of photography.* New York, 1982

**Newhall, Beaumont** (ed.): *Photography: Essays & Images.* New York, 1980

**Sontag, Susan**: *On photography.* London, 1978

**Tausk, Peter**: *Geschichte der Fotografie.* Cologne, 1977

**Weiermair, Peter**: *Das Verborgene Bild. Geschichte des männlichen Akts in der Fotografie des 19. und 20. Jahrhunderts.* Vienna, 1987

**Aubert, François**
    **Reinke, Jutta/Wolfgang Stemmer** (ed.): *Pioniere der Kamera. Das erste Jahrhundert der Fotografie 1840–1900*. Cat. Fotoforum Bremen, Bremen, 1987

**Bisson, Auguste Rosalie**
    *Die Brüder Bisson. Aufstieg und Fall eines Fotografenunternehmens*. Cat. Museum Folkwang Essen, Essen, 1999
    **Leroy, Marie-Noelle**: "Le monument photographique des frères Bisson". In: *Études photographiques*, no. 2, 1997, pp. 82–95
    **Stenger, Erich**: *Die beginnende Photographie im Spiegel von Tageszeitungen und Tagebüchern*. Würzburg, 1943

**Blossfeldt, Karl**
    **Blossfeldt, Karl**: *Photographien*. Munich, 1991
    **Blossfeldt, Karl**: *Photographs 1865–1932*. Cologne, 1993
    **Blossfeldt, Karl**: *Art forms in Nature*. Munich, 1999
    **Van Deren Coke, Frank**: *Avantgarde-Fotografie in Deutschland 1919–1939*. Munich, 1982
    **Ewing, William A.**: *Flora Photographica. Masterpieces of Flower Photography from 1835 to the Present*. London, 1991
    **Herzog, Hans-Michael** (ed.): *Blumenstücke – Kunststücke. Vom 17. Jahrhundert bis in die Gegenwart*. Cat. Kunsthalle Bielefeld, 1995
    **Nierendorf, Karl** (ed.): *Urformen der Kunst*. Berlin, 1928
    **Photographische Sammlung/SK Stiftung Kultur** (ed.): *August Sander, Karl Blossfeldt, Albert Renger-Patzsch, Bernd und Hilla Becher – Vergleichende Konzeptionen*. Cologne, 1997
    **Wilde, Ann and Jürgen** (ed.): *Karl Blossfeldt – Photographien*. Munich, 1991
    **Wilde, Ann and Jürgen** (ed.): *Fotografie*. Cat. Kunstmuseum Bonn, Ostfildern, 1994

**Burri, René**
    **Burri, René/François Maspero**: *Che Guevara*. Paris, 1997
    **Burri, René**: *One World*. Zurich, 1984
    *Che. Fotografisches Album*. Berlin, 1991
    *Look*, 9 April 1963

"Los Cubanos. Metamorphosen einer Revolution. Aufnahmen von René Burri". In: *Du*, no. 12/ 1993, pp. 12–73
    **Loviny, Christophe**: *Che. Die Fotobiografie*. Munich, 1997
    **Ulmer, Brigitte**: "Ich dachte, Burri, du spinnst". In: *Cash Extra*, no. 49, 5 December 1997

**Capa, Robert**
    **Born, Katharina/Rita Grosvenor**: "Dem die Stunde schlug". In: *Stern*, no. 41, 1996
    **Capa, Cornell** (ed.): *The concerned photographer*. New York, 1968
    **Capa, Cornell/Richard Whelan**: *Children of War, Children of Peace. Photographs by Robert Capa*. Boston, 1991
    **Capa, Robert**: *Death in the Making*. New York, 1938
    **Capa, Robert**: *War Photographs*. Cat. Museum of Modern Art, New York, 1960
    **Fabian, Rainer/Hans Christian Adam**: *Bilder vom Krieg. 130 Jahres Kriegsfotografie – eine Anklage*. Hamburg, 1983
    *Heart of Spain. Robert Capa's Photographs of the Spanish Civil War*. New York, 1999
    **Squiers, Carol**: "Capa is Cleared. A famed photo is proven authentic". In: *American Photo*, May/June, 1998

**Cartier-Bresson, Henri**
    **Burri, René**: "Alter Meister". In: *Süddeutsche Zeitung Magazin*, no. 31, 1998
    **Cartier-Bresson, Henri**: *Europeans*. London, 1998
    **Cartier-Bresson, Henri**: *Images à la Sauvette*. Paris, 1952
    **Cartier-Bresson, Henri**: *Die Photographien*. Munich, 1992
    **Cartier-Bresson, Henri**: *The Decisive Moment*. New York, 1952
    **Eger, Christian**: "Schnappschuss wurde eine Fotolegende". In: *Mitteldeutsche Zeitung*, 27. 7. 1995
    **Kirstein, Lincoln/Beaumont Newhall**: *The photographs of Henri Cartier-Bresson*. Cat. Museum of Modern Art, New York, 1947

Montier, Jean-Pierre: *Henri Cartier-Bresson and the Artless Art*. Boston, 1996

**Daguerre, Louis-Jacques-Mandé**
**Gernsheim, Helmut and Alison**: *L. J. M. Daguerre. The History of the Diorama and the Daguerreotype*. New York, 1956
**Gunthert, André**: "Daguerre ou la promptitude. Archéologie de la réduction du temps de pose". In: *Études photographiques*, no. 5, 1998, pp. 4–25
**Haugsted, Ida**: "Berichte aus Paris, 1839. Zu den Briefen Christian Falbes an den dänischen Kronprinzen". In: *Fotogeschichte*, no. 31, 1989, pp. 3–14
**Pohlmann, Ulrich/Marjen Schmidt**: "Das Münchner Daguerre-Triptychon. Ein Protokoll zur Geschichte seiner Präsentation, Aufbewahrung und Restaurierung". In: *Fotogeschichte*, no. 52, 1994, pp. 3–13
**Reynaud, Françoise**: *Paris et le Daguerréotype*. Cat. Musée Carnavalet, Paris, 1989
**Starl, Timm**: *Ein Blick auf die Straße. Die fotografische Sicht auf ein städtisches Motiv*. Berlin, 1988
**Starl, Timm**: "Sicht und Aussicht. Zu den Aufnahmen Pariser Boulevards von Daguerre und Talbot". In: *Camera Austria*, no. 24, 1987, pp. 81–86
**Stenger, Erich**: *Die beginnende Photographie im Spiegel von Tageszeitungen und Tagebüchern*. Würzburg, 1943

**Disdéri, André Adolphe Eugène**
**Barret, A.**: *Die ersten Fotoreporter 1848–1914*. Frankfurt on the Main, 1978
*La Commune photographiée*: Cat. Musée d'Orsay, Paris, 2000
*Le Corps et son Image. Photographies du dix-neuvième siècle*. Cat. Bibliothèque nationale, Paris, 1986
**McCauley, Elizabeth Anne**: *André Adolphe Disdéri and the Carte de Visite Portrait Photograph*. New Haven/London, 1985
**Neumann, Thomas**: "Fotografie zur Zeit der Pariser Kommune". In: *Pariser Kommune 1871*. Cat. Neue Gesellschaft für Bildende Kunst, Berlin, 1971, pp. 152–159

**Doisneau, Robert**
**Anon.**: "Ein Klassiker unter den Küssen". In: *Süddeutsche Zeitung*, 24. 12. 1992
**Anon.**: "Der Kuss der Küsse". In: *Süddeutsche Zeitung*, 4. 6. 1993
**Anon.**: "Der schönste Kuß – nur ein Bluff". In: *Abendzeitung München*, 4. 6. 1993
*Doisneau, Robert*. Paris, 1983
**Doisneau, Robert**: *Three Seconds from Eternity*. Boston, 1979
**Doisneau, Robert**: *A l'imparfait de l'objectif. Souvenirs et portraits*. Paris, 1989
**Doisneau, Robert**: *Trois Secondes d'Éternité*. Paris, 1979
**Gautrand, Jean-Claude**: "Au revoir Monsieur Doisneau!". In: *Le Photographe*, no. 1514, May 1994, pp. 8–11
**Hamilton, Peter**: *Retrospective Robert Doisneau*. London, 1992
**Hamilton, Peter**: "Robert Doisneau. Born Gentilly, 14 April 1912, died Paris, 1 April 1994". In: *The British Journal of Photography*, 13 April 1994, pp. 16–17
**Koetzle, Michael** (ed.): *Robert Doisneau – Renault. Die Dreißiger Jahre*. Berlin, 1990
**Langer, Freddy**: "Das Flüchtige des Glücks. Zum Tod des französischen Fotografen Robert Doisneau". In: *Frankfurter Allgemeine Zeitung*, no. 78, 5 April 1994
**Ollier, Brigitte**: *Doisneau Paris*. Paris, 1996
**Zollner, Manfred**: "Der Foto-Poet". In: *Foto-Magazin*, no. 5, 1992, pp. 34–41

**Duchenne de Boulogne**
*À corps et à raison. Photographies médicales 1840–1920*. Cat. Mission du Patrimoine photographique, Paris, 1995
**Burns, Stanley B.**: *A Morning's Work. Medical Photographs from The Burns Archive & Collection 1843–1939*. Santa Fe, 1998
**Ewing, William A.**: *The Body*. London, 1994
**Guilly, Paul**: *Duchenne de Boulogne*. Paris, 1936
**Hambourg, Maria Morris/Françoise Heilbrun/Philippe Néagu**: *Nadar*. New York, 1995

**Marbot, Bernard/André Rouillé**: *Le Corps et son image. Photographies du dix-neuvième siècle*. Bibliothèque nationale, Paris, 1986
**Mathon, Catherine**: *Duchenne de Boulogne 1806–1875*. Cat. École nationale supérieure des beaux-arts, Paris, 1998

## Durieu, Eugène/Delacroix, Eugène

*L'art du nu au XIX$^e$ siècle. Le photographe et son modèle*. Cat. Bibliothèque nationale de France, Paris, 1997
**Aubenas, Sylvie**: "La collection de photographies d'Eugène Delacroix". In: *La Revue de l'Art*, 1999
**Heiting, Manfred**: *At the Still Point. Photographs from the Manfred Heiting Collection*. vol. I, 1840–1916. Los Angeles/Amsterdam, 1995
**Jobert, Barthélémy**: *Delacroix. Le trait romantique*. Cat. Bibliothèque nationale de France, Paris, 1998
**Koetzle, Michael/Uwe Scheid**: *1000 Nudes. Uwe Scheid Collection*. Cologne, 1994
**Paviot, Alain**: *Le Cliché-Verre. Corot, Delacroix, Millet, Rousseau, Daubigny*. Cat. Musée de la vie romantique, Paris, 1994
**Sagne, Jean**: *Delacroix et la photographie*. Paris, 1982
**Vaisse, Pierre**: "Delacroix et la photographie, un livre de Jean Sagne". In: *Photographies*, no. 3, December 1983, pp. 96–101
**Zerner, Henri**: "Delacroix, la photographie, le dessin". In: *La revue du musée d'Orsay*, no. 4, 1992, pp. 83–87

## Guibert, Maurice

**Adhémar, Jean**: "Toulouse-Lautrec et son photographe habituel". In: *Aesculape*, no. 12, December 1951, pp. 229–234.
*L'art du Nu au XIX$^e$ siècle. Le photographe et son modèle*. Cat. Bibliothèque nationale de France, Paris, 1997
**Schimmel, Herbert D.**: *The Letters of Henri de Toulouse-Lautrec*. Oxford, 1991
*Toulouse-Lautrec*. Cat. Galeries nationales du Grand Palais, Paris, 1992

## Hine, Lewis

*America & Lewis Hine. Photographs 1904–1940*. Millerton, New York, 1977
**Doherty, R. J.**: *Social-Documentary Photography in the USA*. New York, 1976
**George Eastman House** (ed.): *Portfolio*. Rochester, New York, 1970
**Gutmann, Judith Mara**: *Lewis W. Hine and the American Social Conscience*. New York, 1967
*History of Photography*, no. 2, 1992 (special number about Lewis Hine)
**Kaplan, Daile**: *Lewis Hine in Europe: the lost photographs*. New York, 1988
**Kemp, John R.** (ed.): *Lewis Hine: Photographs of Child Labor in the New South*. Jackson, 1986
**Lunn Gallery** (ed.): *Lewis W. Hine. Child Labor Photographs*. Washington, D. C., 1980
**Orvell, Miles**: "Lewis Hine. The Art of the Commonplace". In: *History of Photography*, vol. 16, no. 2, 1992, p. 87f.
**Rosenblum, Naomi**: *The Lewis Hine Document*. Brooklyn, 1977
**Rosenblum, Naomi/Walter Rosenblum**: *Lewis W. Hine*. Paris, 1992
**Steinorth, Karl** (ed.): *Lewis Hine. Die Kamera als Zeuge. Fotografien 1905–1937*. Kilchberg, 1996
**Victor, Stephen**: *Lewis Hine's Photography and Reform in Rhode Island*. Providence, 1982

## Horst, Horst P.

**Brugger, Ingried** (ed.): *Modefotografie von 1900 bis heute*. Cat. Kunstforum Länderbank, Vienna, 1990
**Devlin, Polly**: *Vogue Book of Fashion Photography. The First Sixty Years*. New York, 1979
**Ewing, William A./Nancy Hall-Duncan**: *Horst P. Horst. Photographs 1931–1984*. Milan, 1985
**Honnef, Klaus/Frank Weyers**: *Und sie haben Deutschland verlassen ... müssen. Fotografen und ihre Bilder 1928–1997*. Cat. Rheinisches Landesmuseum, Bonn, 1997
*Horst*. Cat. Münchner Stadtmuseum et al, Milan, 1987
*Horst P. Horst: Photographs of a Decade*. New York, 1944

**Horst P. Horst/George Hoyningen-Huene**: *Salute to the Thirties.* New York, 1971
**Lawford, Valentine**: *Horst. His Work and His World.* New York, 1984
**Tardiff, Richard J./Lothar Schirmer** (ed.): *Horst. Photographien aus sechs Jahrzehnten.* Munich, 1991
*Vogue* (France), no. 9 and no. 12, 1939

**Kertész, André**
*Aperture Masters of Photography: André Kertész.* New York, 1993
**Borhan, Pierre**: *André Kertész. La biographie d'une œuvre.* Cat. Pavillon des Arts, Paris, 1994
**Kertész, André**: *Day of Paris.* New York, 1945
**Kertész, André**: *A. K. in Paris. Photographien 1925–1936.* Munich, 1992
*Kertész on Kertész. A Self-Portrait.* Photos and Text by André Kertész. New York, 1983
**Lemagny, Jean-Claude**: *L'ombre et le temps.* Paris, 1992
**Phillips, Sandra S.**: *The Photographic Work of André Kertész in France 1925–1936. A Critical Essay and Catalogue.* The City University of New York, 1985
**Phillips, Sandra S./David Travis/Weston J. Naef**: *André Kertész. Of Paris and New York.* Cat. The Art Institute of Chicago, Chicago, 1985

**Klemm, Barbara**
*Frankfurter Allgemeine Zeitung*, editions from 18 until 22 May 1973, 26 May 1973 and 9 April 1976
**Hess, Hans-Eberhard**: "Die Zeitungsfotografin". In: *Photo Technik International*, no. 6, 1995, pp. 74–83
**Klemm, Barbara**: *Bilder.* Frankfurt on the Main, 1986
**Klemm, Barbara**: *Unsere Jahre. Bilder aus Deutschland 1968–1998,* Munich, 1999

**Lange, Dorothea**
**Davis, Keith F.**: *The Photographs of Dorothea Lange.* Kansas City, 1995
**Dixon, Daniel**: *Dorothea Lange: Eloquent Witness.* Chicago, 1989

**Doherty, R. J.**: *Social-Documentary Photography in the USA.* New York, 1976
**Elliott, George P.**: *Dorothea Lange.* Cat. Museum of Modern Art, New York, 1966
**Heyman, Therese Thau/Sandra S. Phillips/John Szarkowski**: *Dorothea Lange: American Photographs.* San Francisco, 1994
*Dorothea Lange.* Cat. Caisse nationale des monuments historiques et des sites, Paris, 1998
**Lange, Dorothea**: *American Photographs.* San Francisco, 1994
"Lange, Dorothea: An Assignment I'll Never Forget". In: **Liz Heron/Val Williams** (ed.): *Illuminations. Women Writing on Photography from the 1850s to the Present.* London, 1996, pp. 151–153
**Lange, Dorothea/Paul Schuster Taylor**: *An American Exodus. A Record of Human Erosion.* New York, 1939
**Levin, Howard M./Katherine Northrup** (ed.): *Dorothea Lange: Farm Security Administration Photographs, 1935–1939.* Glencoe, 1980
**Meltzer, Milton**: *Dorothea Lange. A Photographer's Life.* New York, 1978
**Partridge, Elizabeth**: *Dorothea Lange: A Visual Life,* Washington/London, 1994
**Steichen, Edward**: *The Family of Man.* Cat. Museum of Modern Art, New York, 1955
**Stryker, Roy Emerson/Nancy Wood**: *In this Proud Land: America As Seen in the FSA Photographs.* Greenwich, 1973

**Lartigue, Jacques-Henri**
**Astier, Martine/Mary Blume**: *Lartigue's Riviera.* Paris/New York, 1998
**Avedon, Richard**: *Diary of a Century.* New York, 1971
**Chapier, Henry**: *Jacques-Henri Lartigue.* Paris, 1981
**Lartigue, Florette**: *Jacques-Henri Lartigue. La Traversée du siècle.* Paris, 1990
**Lartigue, Jacques-Henri**: *Jacques-Henri Lartigue et les autos.* Paris, 1974
**Lartigue, Jacques-Henri**: *Mémoires sans mémoire.* Paris, 1975

**Lartigue, Jacques-Henri:** *The Photographs of J.H. Lartigue.* New York, 1963
*Lartigue, Jacques-Henri.* Munich, 1984
*Lartigue, Jacques-Henri: Album.* Cat. der Stiftung für die Photographie, Berne, 1986
*Life.* 29 November 1963
*Sprung in die Zeit. Bewegung und Zeit als Gestaltungsprinzipien in der Photographie von den Anfängen bis zur Gegenwart.* Cat. Berlinische Galerie, Berlin, 1992
**Szarkowski, John:** *The Photographs of Jacques-Henri Lartigue.* New York, 1963
**Szarkowski, John:** *The debut of Jacques-Henri Lartigue.* New York 1991 (unpublished typescript, archive Association des Amis de Jacques-Henri Lartigue)

**Lebeck, Robert**
**Koetzle, Michael:** "Zeitzeuge mit der Kamera". In: *foto-scene,* no. 6, 1991/92
**Lebeck, Robert:** *Afrika im Jahre Null. Eine Kristall-Reportage.* Hamburg, 1961
**Lebeck, Robert:** *Begegnungen mit Großen der Zeit.* Schaffhausen, 1987
**Lebeck, Robert:** *Rückblende.* Düsseldorf, 1999
**Lebeck, Robert.** *Vis-à-vis.* Göttingen, 1999
**Steinorth, Karl/Meinrad Maria Grewenig** (ed.): *Robert Lebeck – Fotoreportagen.* Ostfildern, 1993
**Tabel-Gerster, Margit:** *Durchschnitt fotografiert sich (nicht) doch! Ein Gespräch mit Robert Lebeck.* Hamburg, 1988

**Malanga, Gerard**
**Avedon, Richard:** *Evidence. 1944–1994.* Cat. Witney Museum of American Art, New York, 1994
**Avedon, Richard/Doon Arbus.** *The Sixties.* New York, 1999
**Bockris, Victor/Gerard Malanga:** *Up-tight. The Velvet Underground Story.* London, 1983
**Malanga, Gerard:** *Genesis of an Installation.* New York, 1988
**Malanga, Gerard.** *Screen Tests, Portraits, Nudes 1964–1996.* Göttingen, 2000
**Malanga, Gerard:** *Selbstportrait eines Dichters.* Frankfurt on the Main, 1970
**McShine, Kynaston** (ed.): *Andy Warhol. Retro-*

*spektive.* Cat. Museum Ludwig Köln, Munich, 1989
**Steinorth, Karl/Thomas Buchsteiner** (ed.). *Social Disease. Photographs '76–'79.* Cat. Kodak Kulturprogramm, Ostfildern, 1992
*Andy Warhol: Photography.* Cat. Hamburger Kunsthalle, Schaffhausen, 1999
*Andy Warhol's Exposures.* New York, 1979

**Man Ray**
**Billeter, Erika** (ed.): *Skulptur im Licht der Fotografie. Von Bayard bis Mapplethorpe.* Cat. Wilhelm Lehmbruck Museum Duisburg, Berne, 1998
**l'Ecotais, Emmanuelle de/Alain Sayag:** *Man Ray. La photographie à l'envers.* Cat. Centre Georges Pompidou, Paris, 1998
**Jaguer, Edouard:** *Surrealistische Photographie. Zwischen Traum und Wirklichkeit.* Cologne, 1984
**Krauss, Rosalind/Jane Livingston/Dawn Ades:** *Explosante-Fixe. Photographie & Surréalisme.* Cat. Centre Georges Pompidou, Paris, 1985
*Man Ray.* Cat. Galerie der Stadt Stuttgart, Ostfildern, 1998
*Man Ray: Photographs.* London, 1987
*Man Ray: La photographie à l'envers. Album de l'exposition.* Cat. Centre Pompidou, Paris, 1998
*Man Ray: Photographs 1920–1934.* New York, 1975
*Man Ray: Sein Gesamtwerk 1890–1976.* Schaffhausen, 1989
*Man Ray: Self Portrait.* Boston, 1963

**Mapplethorpe, Robert**
**Coleman, A.D.:** *Critical Focus,* Munich, 1995
**Dunne, Dominick:** "Robert Mapplethorpe's proud finale". In: *Vanity Fair,* february 1989, pp. 124–132, 183–187
**Gaines, Charles/Butler, George:** *Pumping Iron II: The unpredecented Woman.* New York, 1984
**Lyon, Lisa:** *Lisa Lyon's Body Magic.* New York, 1981
*Mapplethorpe, Robert: 1970–1983.* Cat. Institute of Contemporary Arts, London, 1983
**Mapplethorpe, Robert:** *The Black Book.* Munich, 1986

**Mapplethorpe, Robert**: *Ten by ten*. New York, 1988

*Mapplethorpe, Robert*. New York, 1992

**Morrisroe, Patricia**: *Robert Mapplethorpe. A Biography*. New York, 1995

**Weiermair, Peter**: "Homosexuelle Sehweisen in der Fotografie des 19. und 20. Jahrhunderts. Einige Anmerkungen unter besonderer Berücksichtigung des Werks von Robert Mapplethorpe". In: *Fotogeschichte*, no. 19, 1986, pp. 23–28

**Nadar**

**Barret, André**: *Nadar. 50 photographies de ses contemporains*. Paris, 1994

**Gosling, Nigel**: *Nadar*. New York, 1976

**Hambourg, Maria Morris/Françoise Heilbrun/Philippe Néagu**: *Nadar*. New York, 1995

**Honnef, Klaus** (ed.): *Lichtbildnisse. Das Porträt in der Fotografie*. Cat. Rheinisches Landesmuseum Bonn, Cologne, 1982

**Newton, Helmut**

**Haenlein, Carl** (ed.): *Anton Josef Trčka, Edward Weston, Helmut Newton. Die Künstlichkeit des Wirklichen*. Cat. Kestner Gesellschaft Hannover, Zurich, 1998

**Honnef, Klaus**: "Die Lust zu sehen. Mehr als ein Fotograf – Ein Meister der Bilder: Helmut Newton". In: **Honnef, Klaus**: *Nichts als Kunst ...* Cologne, 1997, pp. 447–457

**Newton, Helmut**: *Big Nudes*. New York, 1982

**Newton, Helmut**: *Pages from the Glossies. Facsimiles 1956–1998*. Zurich, 1998.

*Helmut Newton. Aus dem Photographischen Werk*. Cat. Deichtorhallen Hamburg, Munich, 1993

**Newton, Helmut**: *Sleepless Nights*. Munich, 1991

**Newton, Helmut**: *Welt ohne Männer*. Munich, 1984

**Newton, Helmut**: *White Women*. Munich, 1976

*Vogue* (Paris), no. 621 (November) 1981

*Vogue* (German), no. 11 (November) 1979

**Niépce, Nicéphore**

**Fage, Jean**: *La Vie de Nicéphore Niépce*. Bièvre, 1983

**Harmant, Pierre.-G./Paul Marillier**: "Some Thoughts on the World's First Photograph". In: *The Photographic Journal*, no. 107, April 1967, pp. 130–140

**Jay, Paul**: *Nicéphore Niépce. Lettres et documents choisis par P. J.* Paris, 1983

**Jay, Paul**: *Niépce. Genèse d'une Invention*. Chalon-sur-Saône, 1988

**Jay, Paul**: *Niépce. Premiers outils – Pemiers résultats*. Chalon-sur-Saône, 1978

**Peter sen., Richard**

**Domröse, Ulrich** (ed.): *Nichts ist so einfach wie es scheint. Ostdeutsche Photographie 1945–1989*. Cat. Berlinische Galerie, Berlin, 1992

*Frühe Bilder. Eine Ausstellung zur Geschichte der Fotografie in der DDR*. Cat. Gesellschaft für Fotografie im Kulturbund der DDR, Leipzig, 1985

**Honnef, Klaus/Ursula Breymayer** (ed.): *Ende und Anfang. Photographen in Deutschland um 1945*. Cat. Deutsches Historisches Museum Berlin, 1995

**Peter, Richard**: *Dresden – eine Kamera klagt an*. Dresden 1949. Second edition. Leipzig, 1982

**Peter, Richard**: *Dresdener Notturno*. Dresden, 1961

**Peter, Richard**: "Gute Fotos kosten Zeit und Mühe". In: *fotografie*, no. 4, 1960

**Pommerin, Rainer/Walter Schmitz**: *Die Zerstörung Dresdens am 13./14. Februar 1945. Antworten der Künste*. Dresden, 1995

**Wurst, Werner** (ed.): *Richard Peter sen. Erinnerungen und Bilder eines Dresdener Fotografen*. Leipzig, 1987

**Priester, Max/Wilcke, Willy**

**Anon.**: "Bismarck auf dem Sterbelager". In: *Die Welt*, no. 270, 19. 11. 1974

**Kempe, Fritz**: "Ein Bild, das vernichtet werden sollte". In: *Zeit-magazin*, no. 32, 4. 8. 1978

*Franz von Lenbach*. Cat. Städtische Galerie im Lenbachhaus, Munich, 1987

**Lorenz, Lovis H.**: *Oevelgönner Nachtwachen.* Hamburg, 1974
**Machtan, Lothar**: *Bismarcks Tod und Deutschlands Tränen. Reportage einer Tragödie.* Munich, 1998
**Ruby, Jay**: *Secure the Shadow. Death and Photography in America.* Cambridge Mass./London, 1995

## Salgado, Sebastião

**Salgado, Sebastião**: *Serra pelada.* Paris, 1999
**Salgado, Sebastião**: *Workers. An Archaeology of the Industrial Age.* New York, 1993
*Der Spiegel*, nos. 10, 11, 17, 24, 26, 1991
*Stern*, no. 46, 7. 11. 1991
**Wald, Matthew L.**: "The Eye of the Photojournalist". In: *The New York Times Magazine*, 9 June 1991
*World Press Photo 1992.* Düsseldorf, 1992

## Sander, August

**Berger, John**: *Das Leben der Bilder oder die Kunst des Sehens.* Berlin, 1989
**Keller, Ulrich/Gunther Sander**: *August Sander – Menschen des 20. Jahrhunderts. Portraitphotographien 1892–1952.* Munich, 1980
**Molderings, Herbert**: *Fotografie in der Weimarer Republik.* Berlin, 1988
**Photographische Sammlung/SK Stiftung Kultur** (ed.): *August Sander, Karl Blossfeldt, Albert Renger-Patzsch, Bernd und Hilla Becher – Vergleichende Konzeptionen.* Cologne, 1997
**Powers, Richard**: *Three Farmers on Their Way to a Dance.* London, 1989
*Sander, August: "In der Photographie gibt es keine ungeklärten Schatten!"* Cat. August Sander Archiv Köln, Berlin, 1994
**Scholz, Christian**: "August Sander, Photograph aus Deutschland". In: *Neue Zürcher Zeitung*, no. 159, 12./13. 7. 1997, pp. 57–59

## Skoglund, Sandy

**Hülsewig-Johnen, Jutta/Gottfried Jäger/J. A. Schmoll gen. Eisenwerth**: *Das Foto als autonomes Bild. Experimentelle Gestaltung 1839–1989.* Cat. Kunsthalle Bielefeld, Stuttgart, 1989

*50 Jahre Moderne Farbfotografie.* Cat. photokina, Cologne, 1986
**Köhler, Michael**. *Das konstruierte Bild.* Schaffhausen 1989
**Lemagny, Jean-Claude/Alain Sayag**: *L'Invention d'un Art. Simulacres et Fictions.* Cat. Centre Georges Pompidou, Paris, 1989
**Picazo, Glòria/Patrick Roegiers**: *Sandy Skoglund.* Cat. Paris Audiovisuel, Paris, 1992
**Piguet, Philippe**: *Sandy Skoglund.* Cat. Galerie Guy Bärtschi, Geneva, 2000
*Skoglund, Sandy: Reality Under Siege. A Retrospective.* Cat. Smith College Museum of Art, New York, 1998

## Stern, Bert

*Eros*, no. 3, Autumn 1962
**Greene, Milton H.**: *Milton's Marilyn: The photographs of Milton H. Greene.* Munich, 1998
*Marilyn Monroe und die Kamera. 152 Photographien aus den Jahren 1945–1962.* Munich, 1989
**Stern, Bert**: *Marily Monroe – The Complete Last Sitting.* Munich, 1992

## Stieglitz, Alfred

**Eisler, Benita**: *O'Keeffe & Stieglitz. An American Romance.* New York, 1991
**Finsler, Hans**: "Das Bild der Photographie". In: *Du*, no. 3/1964
**Greenough, Sarah/Juan Hamilton**: *Alfred Stieglitz. Photographs & Writings.* Cat. National Gallery of Art, Washington, 1983
*Stieglitz, Alfred: Aperture Masters of Photography.* New York, 1989
*Stieglitz, Alfred: Camera Work. The Complete Illustrations 1903–1917.* Cologne, 1997
"Stieglitz, Alfred: Wie es zu 'The Steerage' kam". In: **Wilfried Wiegand** (ed.): *Die Wahrheit der Photographie. Klassische Bekenntnisse zu einer neuen Kunst.* Frankfurt on the Main, 1981, pp. 173–177
**Whelan, Richard**: *Alfred Stieglitz.* New York, 1996

## Stock, Dennis

*James Dean. Photographien.* Munich, 1989

Roth, Sanford und Beulah: *James Dean*. Corte Madera, 1983
Schatt, Roy: *James Dean. Ein Porträt*. Munich, 1984
Stock, Dennis: *James Dean Revisited*. New York, 1978
Stock, Dennis: *Made in USA. Photographs 1951–1971*. Ostfildern, 1994

Strand, Paul
    Burns, Stanley B.: *A Morning's Work. Medical Photography from the Burns Archive & Collection 1843–1939*. Santa Fe, 1998
    Fleischmann, Kaspar (ed.): *Paul Strand*. vol. I. Zurich, 1987
    Fleischmann, Kaspar (ed.): *Paul Strand*. vol. II. Zurich, 1990
    Hambourg, Maria Morris: *Paul Strand circa 1916*. Cat. Metropolitan Museum of Art New York, New York, 1998
    Haworth-Booth, Mark: *Paul Strand*. New York, 1987
    Hill, Paul/Thomas Cooper: *Dialogue with Photography*. New York, 1979
    Lyons, Nathan: *Photographers on photography*. Prentice-Hall, 1966
    Stieglitz, Alfred: *Camera Work. The Complete Illustrations 1903–1917*. Cologne, 1997
    Strand, Paul: *An American Vision*. New York, 1990
    Strand, Paul: *Circa 1916*. Cat. Metropolitan Museum of Art, New York, 1998
    Strand, Paul: *Essays on his Life and Work*. New York, 1990
    Strand, Paul: *Photographs 1915–1945*. Cat. Museum of Modern Art, New York, 1945
    Strand, Paul: *A Retrospective Monograph. The Years 1915–1946*. New York, 1971
    Strand, Paul: *Sixty Years of Photographs*. New York, 1976
    Strand, Paul: *The World on My Doorstep*. New York, 1994
    Tucker, Ann W.: *Five American Photographers*. Cat. Museum of Fine Arts, Houston, 1981

Witkin, Joel-Peter
    Celant, Germano: *Witkin*. Zurich, 1995
    *Enfers*, no. 1. Biarritz, 1994

Fels, Ludwig: "Grimassen der Lust". In: *Süddeutsche Zeitung Magazin*, no. 40, 1995
*Glanz und Elend des Körpers/Splendeurs et Misères du Corps*. Cat. Musée d'art et d'histoire de Fribourg/ Musée d'Art Moderne de la Ville de Paris, Fribourg/ Paris, 1988
Thijsen, Mirelle: "Die Form Gottes. Interview mit Joel-Peter Witkin". In: *European Photography*, no. 42, 1990
*Witkin, Joel-Peter*. Cat. Stedelijk Museum, Amsterdam, 1983
*Witkin, Joel-Peter: Fourty Photographs*. Cat. San Francisco Museum of Modern Art, San Francisco, 1985
Witkin, Joel-Peter (ed.): *Masterpieces of Medical Photography. Selections from the Burns Archive*. Edited by Joel-Peter Witkin. Pasadena, 1987
*Witkin, Joel-Peter*. Cat. Forum Böttcherstraße. Bremen, 1989
*Witkin, Joel-Peter*. Cat. Centre National de la Photographie, Paris, 1989
*Witkin, Joel-Peter*. Paris, 1991
*Witkin, Joel-Peter*. Cat. Galerie Baudoin Lebon, Paris, 1991
Witkin, Joel-Peter: *Gods of Earth and Heaven*. Altadena, 1991
Witkin, Joel-Peter (ed.): *Harms Way. Lust & Madness. Murder & Mayhem*. Santa Fe, 1994

Zille, Heinrich
    Bohne, Friedrich: *Heinrich Zille als Fotograf*. Cat. Wolfgang-Gurlitt-Museum, Linz, 1968
    Brost, Harald/Laurenz Demps: *Berlin wird Weltstadt*. With 277 photographs by F. Albert Schwartz, Hof-Photograph. Stuttgart, 1981
    Van Deren Coke, Frank: *The Painter and the Photograph from Delacroix to Warhol*. Second edition. Albuquerque, 1972
    Fischer, Lothar: *Heinrich Zille*. Reinbek bei Hamburg, 1979
    Flügge, Gerhard: *Mein Vater Heinrich Zille*. Berlin, 1955
    Flügge, Matthias: *Heinrich Zille. Fotografien von Berlin um 1900*. Leipzig, 1987
    Flügge, Matthias: *Heinrich Zille. Berliner Photographien*. Munich, 1993

Kaufhold, Enno: *Heinrich Zille. Photograph der Moderne*. Munich, 1995

Luft, Friedrich: *Mein Photo Milljöh. 100 x Alt-Berlin aufgenommen von Heinrich Zille selber.* Hannover, 1967

*Photographie als Photographie. Zehn Jahre Photographische Sammlung 1979–1989.* Cat. Berlinische Galerie, Berlin, 1989

Ranke, Winfried: *Draughtsman and Photographer*. Cat. Goethe Institute, Munich, 1982

Ranke, Winfried: *Heinrich Zille. Photographien Berlin 1890–1910*. Munich, 1975. Second edition. Munich, 1979. Third (revised and relithographed) edition. Munich, 1985

Ranke, Winfried: *Vom Milljöh ins Milieu. Heinrich Zilles Aufstieg in der Berliner Gesellschaft.* Hannover, 1979

# Photo Credits

chen; repro photographs: Hans Döring, München: 13, 56, 78 left, 78 right, 79 left, 79 right, 94, 95, 97, 106, 107, 112, 114, 115, 140 right, 141 left, 141 right, 144, 176 left, 176 right, 177 left, 177 right, 184, 185, 200, 212, 213, 220 above, 220 below, 221 above, 221 below, 222, 240 left, 240–241, 241 right, 256 left, 256 right, 258 above, 258 below, 259 above, 259 below, 260, 261, 262, 303, 320, 321 left, 321 right, 336, 337 above left, 337 above right, 337 middle left, 337 middle right, 337 below left, 337 below right

Sammlung Robert Lebeck, Port de Richard © Robert Lebeck: 242–243, 245, 246 above left, 246 above right, 246 middle left, 246 middle right, 246 below left, 246 below right, 247 above left, 247 above right, 247 below left, 247 below right, 248 left, 248 right, 250 left, 250 right, 251 left, 251 right

Sammlung Horst Moser, München; repro photographs: Hans Döring, München: 139, 140 left, 140 right, 141 left, 141 right

© Sammlung Uwe Scheid: 28, 29, 30

© Sandy Skoglund, New York: 308, 309; © 1981 Sandy Skoglund, New York: 304–305; © 2000 Sandy Skoglund: 161

Sotheby's, New York: 190

© Bert Stern/courtesy Staley-Wise Gallery, New York: 252–253

Alfred Stieglitz © VG Bild-Kunst, Bonn, 2005

Universität München, Institut für Kommunikationswissenschaft: 96

Joel Peter Witkin courtesy Pace/MacGill Gallery, New York: 322

To stay informed about upcoming TASCHEN titles, please request our magazine
at www.taschen.com or write to TASCHEN America, 6671 Sunset Boulevard, Suite 1508,
USA-Los Angeles, CA 90028, Fax: +1-323-463.4442. We will be happy to send you
a free copy of our magazine which is filled with information about all of our books.

© 2005 TASCHEN GmbH
Hohenzollernring 53, D–50672 Köln
**www.taschen.com**

Original edition: © 1996 Benedikt Taschen Verlag GmbH

Project management: Ute Kieseyer, Cologne
Editorial coordination: Daniela Kumor, Cologne

Translation: Sally Schreiber, Cologne
Editing: Frances Wharton, London
Malcolm Green, Heidelberg

Design: Claudia Frey, Cologne
Cover design: Sense/Net, Andy Disl and Birgit Reber, Cologne
Production: Thomas Grell, Cologne

Printed in Singapore
ISBN 3–8228–4096–3